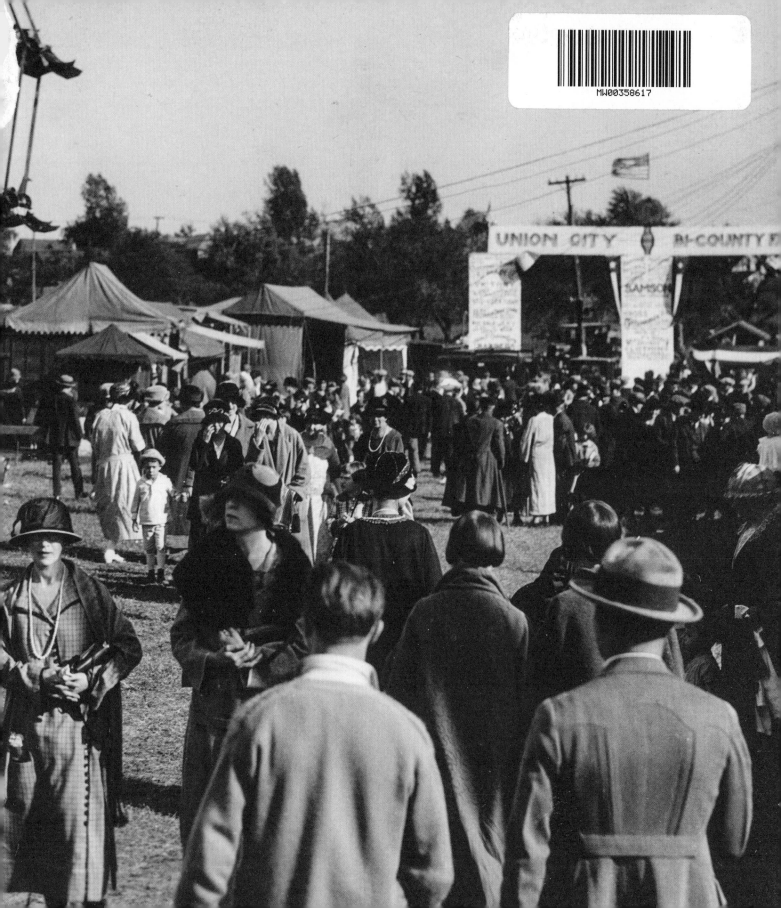

REAL PHOTO POSTCARDS

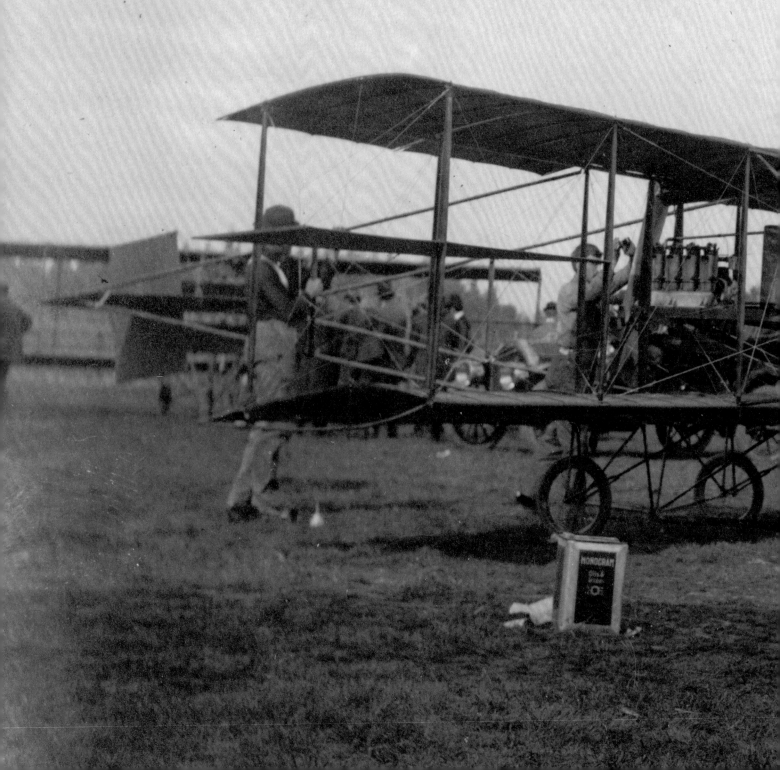

REAL PHOTO POSTCARDS

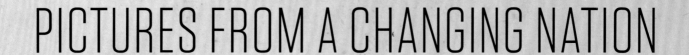

PICTURES FROM A CHANGING NATION

Lynda Klich and Benjamin Weiss

With contributions by Eric Moskowitz, Jeff L. Rosenheim, Annie Rudd, Christopher B. Steiner, and Anna Tome

The Leonard A. Lauder Postcard Archive

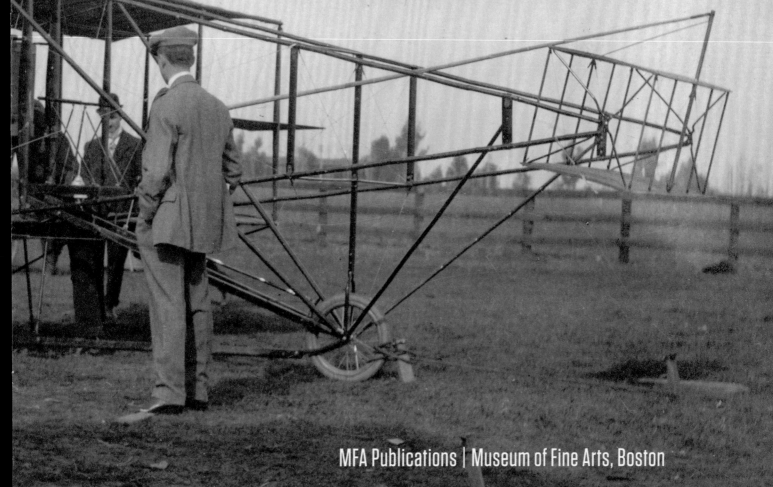

MFA Publications | Museum of Fine Arts, Boston

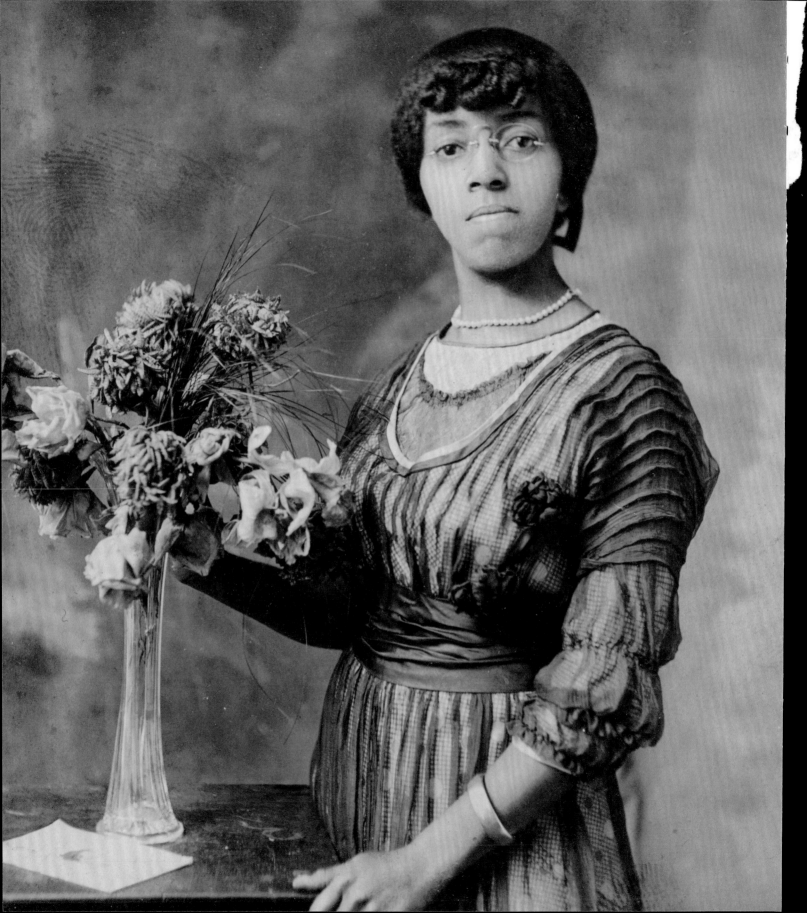

Contents

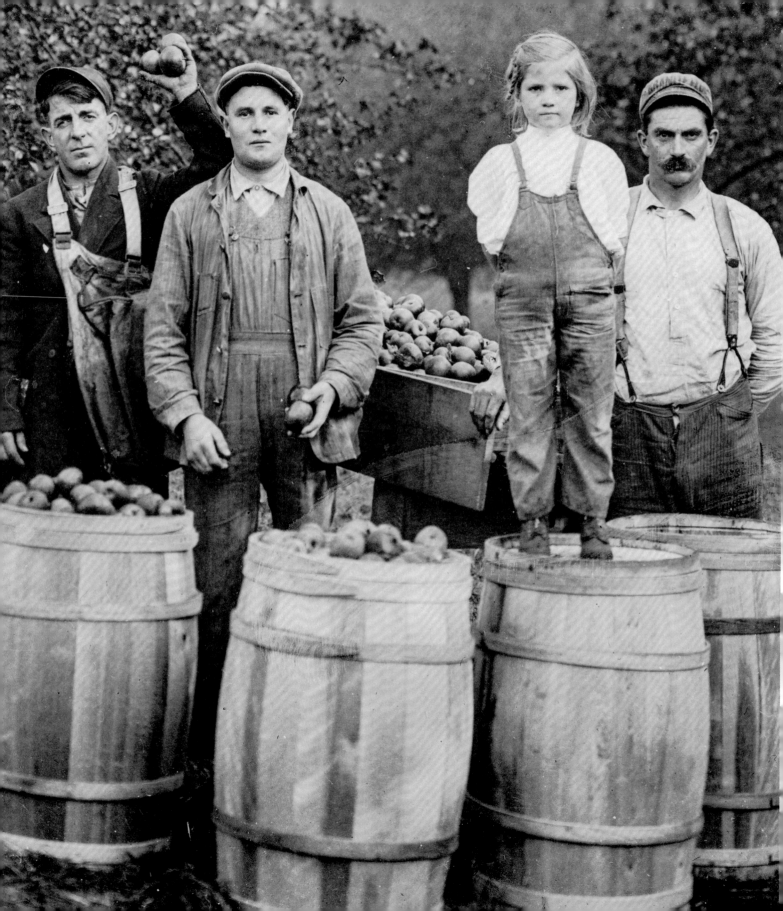

Director's Foreword

Museums are places where art, history, and community come together. The conversations that come out of that convergence — about creativity and society; who we are, where we have been, and where we need to go — are at the very heart of what museums do best.

The Museum of Fine Arts, Boston, safeguards objects from around the world and from across the long span of human history. The objects in our care tell an infinite variety of stories. And yet, of all the kinds of art in our trust, few are as well suited to the urgent task of grappling with the links between history and our present moment as the real photo postcards in the Leonard A. Lauder Postcard Archive.

The photographs on these cards capture the United States in the early twentieth century with a striking immediacy. It was a time of rapid industrialization, mass immigration, technological change, and social uncertainty — in other words, a time much like our own. The cards show all of this, and the joys and the struggles of the era come through in all their complexity. By extension, so do those of our own time, for we are the descendants of that nation. It is not always an easy story, but it is a revealing, often a provocative, and always an engaging one. Intentionally or not, these photographers captured history as it happened, and their work asks the modern viewer to reflect on that history — to recognize it, to learn from it.

The Leonard A. Lauder Postcard Archive is the life's project of its creator, one of the great collectors of our time. Leonard's collections are varied — taking in Cubism and contemporary art as well as posters and postcards. He brings the same passion, focus, and urgency wherever he turns his eye. For him, collecting is not just a passion, it is a calling; and he sees himself as a steward, not an owner. His purpose is to bring collections together for a greater good, and always with museums in mind. Great collections draw connections between moments in time, between cultures, and between communities. We are honored that he has chosen the MFA as his partner.

Funds for this publication and accompanying exhibition provided by the American Art Foundation, Leonard A. Lauder, President.

MATTHEW TEITELBAUM
Ann and Graham Gund Director
Museum of Fine Arts, Boston

Citizen Photographers

LEONARD A. LAUDER

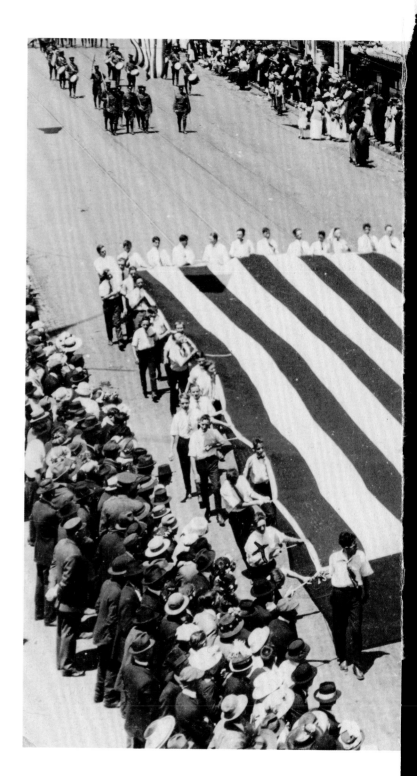

eal photo postcards are like whole worlds. In one postcard from my collection, a group of men parade a giant U.S. flag down the middle of a street emblazoned with stars-and-stripes bunting (1). Behind them marches a military band, suggesting that this scene was part of a bigger parade. The lines of people wearing hats and the signage and awnings along the street may give this scene a nostalgic air, but the electric street signs, the motor vehicle pulling a float at the lead, and a racially mixed crowd remind us that this is a modern scene as well. We don't know the location of the card, but it almost doesn't matter. Such patriotic displays could be found in any city or small town in the United States in the first decades of the twentieth century, a time of rising nationalism as the country's international presence grew.

I can get lost examining the details — the clothing, the shop windows, the figures' faces — through the large magnifying glass that I keep handy in my top desk drawer specifically for looking at postcards. I notice that someone has marked an "x" on the white shirt of the man at the bottom left corner of the flag; maybe he was the original owner of this postcard, purchasing it to commemorate his participation in this parade, or to send to a faraway

1 Parade with forty-six-star United States flag, 1916

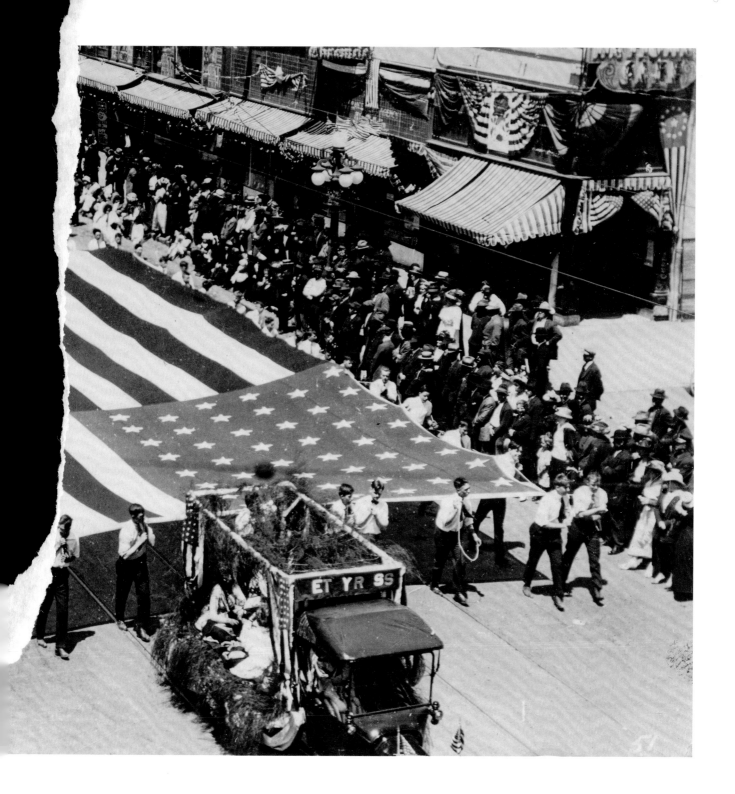

friend or relative. Perhaps he is also the unidentified person who scrawled the date May 12, 1916 on the back of the postcard. That date holds no clear significance in U.S. history, but it was a busy one in Europe. On that day, the British executed two Irish Republican leaders of the bloody Easter Rising in Dublin. And on the Continent, the devastating Battle of Verdun, the longest of the First World War, continued to rage on the Western Front. Perhaps the people marching here wanted the U.S. to enter that war, or perhaps they were isolationists.

The flag moving down this crowded street is the forty-six-star flag, official for only four years, from July 4, 1908, (just under eight months after Oklahoma joined the Union) until July 4, 1912, when stars were added for New Mexico and Arizona. I count fifty-five men carrying it — making it likely at least the size (30 x 42 feet) of the original "Star Spangled Banner" that flew over Fort McHenry during the War of 1812, and which inspired Francis Scott Key to write what would become the national anthem. Though the passengers on the float at the front are obscured, the name "Betsy Ross" across the float's top suggest how they might be costumed. Those words also remind us that the flag's mythical origin story had only become common a few decades before, around the time of the Civil War, along with public flag waving, reciting the pledge of allegiance, and singing the national anthem; demonstrations of patriotism that remain common practice. Though this postcard opens up more questions than it answers, for me it speaks volumes — the dynamics of that bygone era still have strong echoes today.

A real photo postcard means that it is an actual photograph printed directly onto photo-sensitive paper with a postcard back (unlike the billions of printed photographic postcards that circulated at this time). When the Eastman Kodak Company started marketing this special paper in 1903, it represented a new chapter in postcard production, one that allowed for a whole army of citizen photographers to capture their towns and the events — big and small — that shaped their everyday lives. In capturing one such daily moment, this card displays the optimism that I believe undergirds the belief in the American experiment, and what this country can be, even at its most difficult times. It conveys the power of a flag — whether it signals pride and patriotism or inspires opposition — and how it connects with varied facets of identity. It also underscores the role of everyday people in the writing of history and the creation of national myth. That's why I collected so many cards like this one, and share them with you in this book and the accompanying exhibition.

Collecting is a journey, and the best journeys lead to unexpected places. It's what happened to me with postcards like this one. I was born in 1933, just a few years before Henry Luce bought *Life* and transformed it to a magazine devoted to pictures of U.S. and world history in the making. I inhaled those photos and the stories they carried, to the extent that as a young boy I collected every issue until I went to college. *Life* opened my eyes to the concept of photojournalism, which is essentially story-telling through photographs. The photographs you see on these pages represent a modest selection from my collection, but they show the impact that *Life* had on me. When Kodak started making portable cameras, they created an environment where every person could become a photojournalist, perhaps without knowing that's what they were doing. The photographs on these cards were part of that moment, and offer a peek into the everyday, creating a portrait of the nation in which we live.

Though real photo postcards like this one have been an obsession of mine during the past few decades of my collecting, I didn't focus on them at first, and instead bought photographic cards that marked the historical signposts that told the big picture, like the 1914 assassination of

Archduke Franz Ferdinand, the 1918–19 German Revolution in Berlin, and the Mexican and Russian Revolutions in the 1910s. As time went on, I became increasingly fascinated with the everyday journey of the United States as told on real photo postcards. Through conversations with friends including Joel Wayne, George Gibbs, and the late Andreas Brown, who had established themselves in the real photo realm, I became ever more intrigued by these special cards, which document the journey of America, especially during the era of the two World Wars.

What attracted me most to U.S. real photos, and changed my collecting journey forever, was the thrill I got that realizing that everyone who had their picture taken for a postcard became a part of the great American journey. Yes, these cards witness patriotism in times of war and exhilarating phases of the nation's growth. But just as important for me, they reveal quieter daily moments that, without these cards, would have been lost to history, like parades and union picnics; the pride many individuals took in their work tools and in the new uniforms worn as a fireman or policeman; the economic mobility shown in someone's crisp and stylish new Sunday best; and the heroic efforts of a community coming together to clean up after a flood or tornado.

The cards in this book and exhibition document my personal dialogue with the American experience, bringing together my collecting journey with the great national journey. Each of them shows a step — whether a significant event or a modest happening — in this emergence of the America that I love, warts and all. Together they document a vibrant time of change, as Theodore Roosevelt led the United States into a greater role on the world stage; as inventions like the motor car and skyscraper forever changed the way the country moved and looked; and as immigration remade the face of this nation. The road was bumpy then, as it continues to be today. But the country's great journey provides me with an endless source of pride and optimism. As I look at these cards, which reveal the country as a great mosaic, I am reminded that its journey gets ever more fascinating, as it becomes more and more challenging. All of these complications are embodied in the flag that graces this postcard that I show you here — patriotism can be a contested word, some have burned the flag as a form of protest, and others have changed its colors to make a political point. What that shows me is that the U.S. flag embodies freedom. And, as always, for me it represents my firm optimism in the abiding promise of this American experiment.

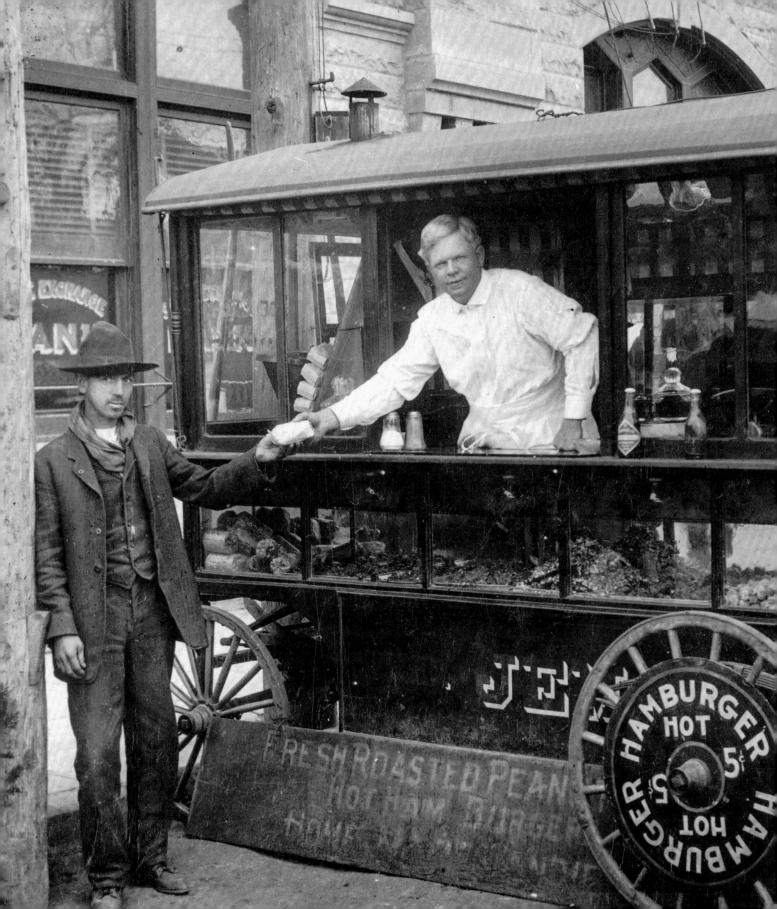

In and Out of Focus | BENJAMIN WEISS

This is a tale of two hamburger stands. In the first, a blond-haired man with a broad face and an immaculately clean apron leans out of the window of a food truck (**2**) It's hard to tell his age, but he is older than young and younger than old. He hands a paper-wrapped parcel, probably a hamburger, to a somewhat more careworn fellow in an outdoorsmen's hat. The exchange is slightly awkward, one of those casual-but-not-casual poses that people assume when trying to look relaxed and lifelike; if you think about it, neither man is in a natural pose or position for a transaction at a food truck. The photo is clearly staged but aims to convey a moment of offhand reality. It is an advertisement, and advertisements must be read with care. But even in advertisements, details reveal a lot, and there's much to see in this small photo.

There is little doubt about the purpose of this stand, for the word "hamburger" appears at least five times that we can see, including on the wheels, right side up and upside down, just in case. The burgers are cooked (or at least warmed up) on the premises, as there is a small chimney at the left side of the roof. And the truck clearly goes out in all sorts of weather and at all times of day. There is a striped sun-and-wind shade rolled up and tucked under the roof, and there is an electric lightbulb, rigged to illuminate the "Hot Hamburger 5¢" sign on the roof at right. It is hard to trace exactly where the wire that lights that bulb goes, but the fact that the van is parked next to a telephone pole suggests that the proprietor might be running power off that pole. In other words, the van has no electric power of its own.

In fact, the van has no power at all, but is horse-drawn. Once the van is in its chosen spot, it stays there for a while. The chassis and the springs at the rear wheels look like they were manufactured by professional carriage builders, but the rest could easily have been knocked together by a housewright, or maybe even by the owner of the cart. The whole structure looks to be made of wood and plate glass. There are lathe-turned spindles at the corners, and a four-panel door that would be right at home in a turn-of-the-century house on the back. These are house parts, from a carpenter's tool kit, not the products of industrial manufacture, so the odds are good that this cart was made special for the owner, not bought from a catalogue.

Hamburgers are the main attraction, but the business is more than just burgers. There are bags in the left compartment, probably peanuts, as well as other roasted nuts in the windows along the side. Salt and pepper jars sit, along with a sauce (perhaps ketchup), on the outside counter, while what look to be pickle or onion jars stay inside. That division of public and private suggests the owner knows his business. Let the customer customize,

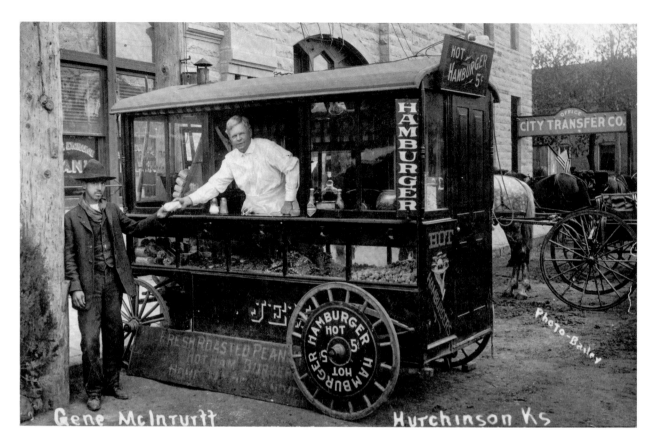

2 Eugene McInturff's hamburger stand, about 1914 MARION W. BAILEY

but only up to a point and only with the cheap stuff. The signboard resting on the ground below also suggests that the cart has been around the block a few times. Its paint has worn away at the bottom, perhaps from customers rubbing up against the lower edges of the words.

This postcard tells us about itself in words as well as with its picture. The captions, scratched onto the photographic negative so they appear in white on every copy of the card, do not tell us that this is a hamburger van. We know that already, so there's no need; but they do tell us whose truck it was, and where it stood. This is Gene McInturff, of Hutchinson, Kansas, a medium-sized town

in the south-central part of the state. When the photo was taken, around 1910, Hutchinson was home to just shy of seventeen thousand people and was growing fast. The town was a major center of salt mining, a stop on the Santa Fe and Rock Island railroads, and host to the biggest annual fair in Kansas.

Irwin Eugene McInturff — known to all as Hamburger Gene — was a well-known figure in town. Gene operated the hamburger truck for more than twenty years, from around 1908 until just before his death in 1931. Though the truck was on wheels, it almost always occupied the same spot, on the southwest corner of 1st and Main.[1] The

building that peeks out behind the truck in the photo still stands, and the very spot where Gene and his customer are posed can be identified by the ornaments carved in the characteristic sandstone that is so ubiquitous in that part of Kansas. The truck was one door in from Main Street, in a spot where there is angled parking today.

We know a lot about Gene and his life. We know where he was born, in 1865, and where he was buried, in 1931. We know about his brothers and the photography business they ran, in which Gene was a silent partner. We know that Gene occasionally took the food truck to other locations, like the annual fair or a cattle auction. We know that he took a vacation to Flint, Michigan, in 1917, for his absence was remarked upon — "Gee, Gene's Car's Gone," noted the local paper. And we know that all his life, Gene collected bells. Gene was well remembered in Hutchinson; more than three decades after his death, *The Hutchinson News* ran a reminiscence about him and his stand, illustrated with this very photo.[2] One postcard can open up an extraordinary historical treasure: big stories about economics and class and race and gender, but also more granular ones about individual people and the small moments that gave texture to their lives.

There is a sense that if you keep looking hard enough, there is almost nothing you cannot know about this scene. That feeling repeats itself over and over again when you work with photographic postcards of this era. Partly, it is due to the character of the technology behind the cards. Most postcard photos were shot on a very large negative — postcard-sized — that gives these images an almost surreal amount of detail. In other words, these are contact prints, reproduced at the same size they were exposed. In the hands of a skilled photographer — and many postcard photographers were very skilled indeed — this means that the images contain levels of detail almost unmatched in the history of photography. You can read

street signs and advertisements; you can read the numbers on license plates; you can even make out labels on a bottle. The words on the label of Gene's ketchup are just out of reach, but the shape and pattern are clear; someone, somewhere can identify that ketchup. The sense of infinite knowability is embedded in the image itself.

But the knowability is also the product of the culture in which these cards were made. The great boom in real photo postcards began in 1903, when Eastman Kodak first got into the postcard market. For the next three decades, photographic cards were everywhere. The postcards, produced by studios large and small, and even by lone, itinerant photographers, entered into a vast reservoir of information that has come down to us in a volume that is unique in the history of the world. For the decades on either side of the turn of the twentieth century were a time of both mass literacy and almost no electronic communication. If something was to be known or discussed or made public, there was a very high likelihood it would be written down or printed on paper. There was no television and minimal "wireless." Telephone calls, especially long-distance ones, were for special occasions or very brief messages. Even telegrams had a physical manifestation that could be preserved, for they were delivered as printouts.

News came in newspapers and magazines, and every town had a newspaper, filled mostly with local gossip and notices — "Gee, Gene's Car's Gone." In the 1910s, local news was often what would have been pub talk and drawing-room gossip a century before, or posts to internet bulletin boards and tweets a century later. Tweets are fleeting and ephemeral, but those century-old newspapers persist, on paper, on microfilm, and now on the web. In many ways, the early twentieth century represents the high-water mark of historical knowability. It is the period when the impulse to make and publish records — both visual and textual — comes together with the survival

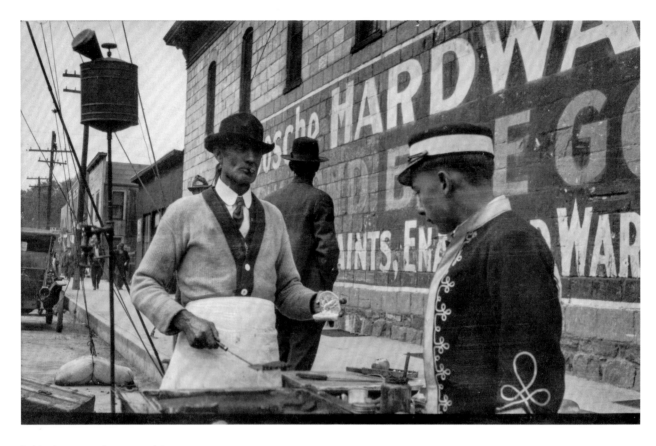

3 Hamburger vendor, 1907 or later

of those records in a way that is probably unmatched for any other moment in human history, including our own.

In recent decades, the fine-textured picture of everyday life preserved in the newspapers and archives of the early twentieth century has been given a new life by the very digital tools that took their place. As local newspapers have faded and failed, their morgues, held in state historical societies and local libraries, have found their way onto the internet, fully scanned and fully searchable. Archives, which even thirty years ago often had no published catalogues at all, have scanned documents and photographs by the billions, many of which are also now available at any

time of day, from nearly anywhere in the world. This information was always there, but finding it was arduous and time-consuming work. Now, Hamburger Gene's story can begin to assume something like the depth and complexity of a real life just with a series of computer searches made from thousands of miles away. Our ability to know, and to know easily, about the intimate texture of the past, and to rebuild the web of connections and passing events that existed a century ago, is truly extraordinary.

Until it isn't. And that's where a second hamburger stand comes into our tale (**3**). This photo truly is an action shot. It may be staged, but it is far less stagey than the one

featuring Hamburger Gene. This hamburger stand is barely more than a streetside grill, perhaps set up quickly during a parade. The photographer has caught the proprietor, chomping on a cigar, at an angle and a bit from below, just as he is lifting the burger into a fluffy bun. Unlike Gene, this guy was clearly working before the photographer appeared, for there are stains on his apron. There's an onion on a grater and the ketchup jar looks convincingly messy, with a dried crust around the rim.

It's a great postcard, but it is mute. There are no words on the front, and none on the back. There's no postmark or address, for it was never sent — so no clues from which to triangulate a place or a date. The card is a remorseless tease. One face in shadow, another in profile; a generic uniform (maybe for a marching band?); a tantalizing painted billboard that reveals nothing much; a street of buildings that could exist pretty much anywhere in the country. And, as if to rub it in, a lone Model T Ford, the most ubiquitous automobile of the time — indeed, perhaps the most ubiquitous car of all time. This card holds tight to its air of long ago and far away. It chooses to retain its poetry and refuses to surrender its secrets; or, at least, it refuses to surrender those secrets to us.

And therein lies some of the power and pleasure of these postcards. In working with them, there is a constant sense of pulling back and forth, bouncing from a world that comes into vivid focus to one that is almost completely unavailable. That shifting in and out of focus is key to the postcards' charm, but it is also a valuable lesson about the nature of history. The very specificity of the cards is a reminder that the past was occupied by human beings, people with distinct and individual stories, whose daily concerns were often not so different from our own. That sort of card serves as a salutary reminder that the past is not inhabited by archetypes or exemplars of large historical phenomena; it is inhabited by people. For a historian, ferreting out their stories and secrets and filling out the everyday texture of those people's lives can provide a sense of near omniscience that is thrilling.

And then that power goes away, whipsawed by the completely hermetic mystery of the other sort of card. It's just luck, of course, for the figures on those cards are unidentified, not anonymous. They have names and stories, and, somewhere, there is probably another copy of the card that provides the very clues that will unravel those mysteries. But you need the decoder ring. And maybe someone else has one, but *you* don't, so the card sits there, quietly keeping its own counsel. Cards like our second hamburger stand keep you humble, and serve as a reminder that history is not, in the end, knowable. It is a different place, one that, however much it chooses to share with you, also keeps its secrets.

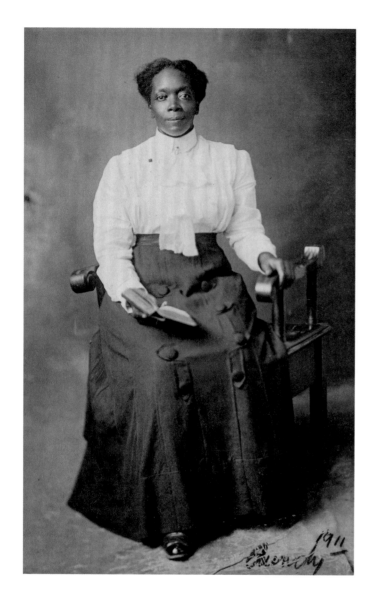

4
Woman with book, 1911
MAXWELL

5
Man reading a newspaper, 1922 or later
SUN STUDIO

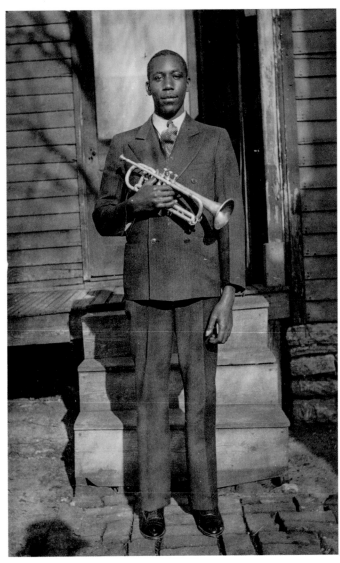

6
Bar mitzvah boy, 1917 or later

7
Trumpet player, 1926 or later

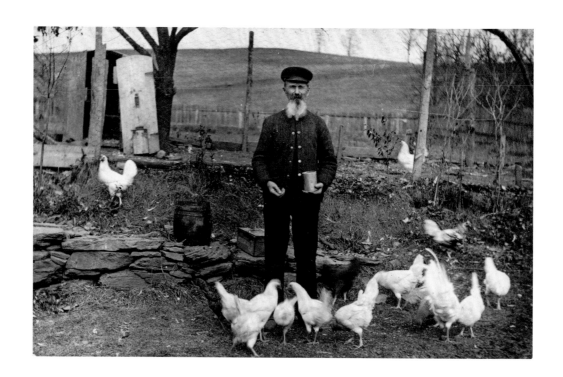

8
Feeding chickens, 1907
or later

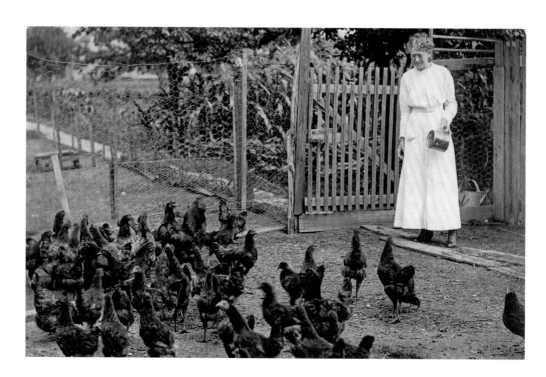

9
Mary F. Mitchell feeding
chickens, Wichita, Kansas,
about 1912

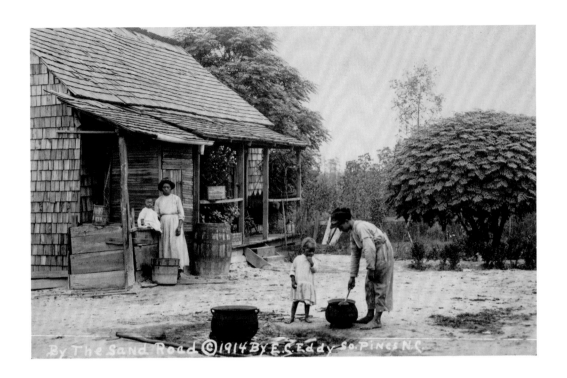

10

By the Sand Road, 1914

E. C. EDDY

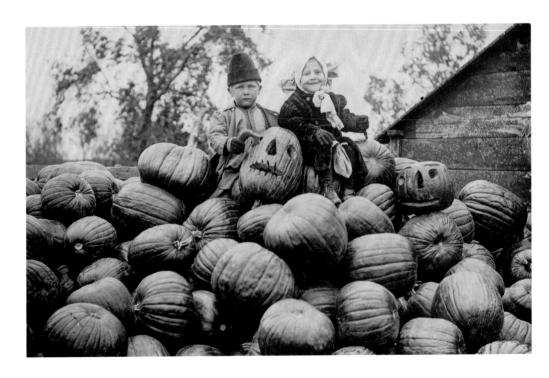

11

Children with pumpkins,

about 1914

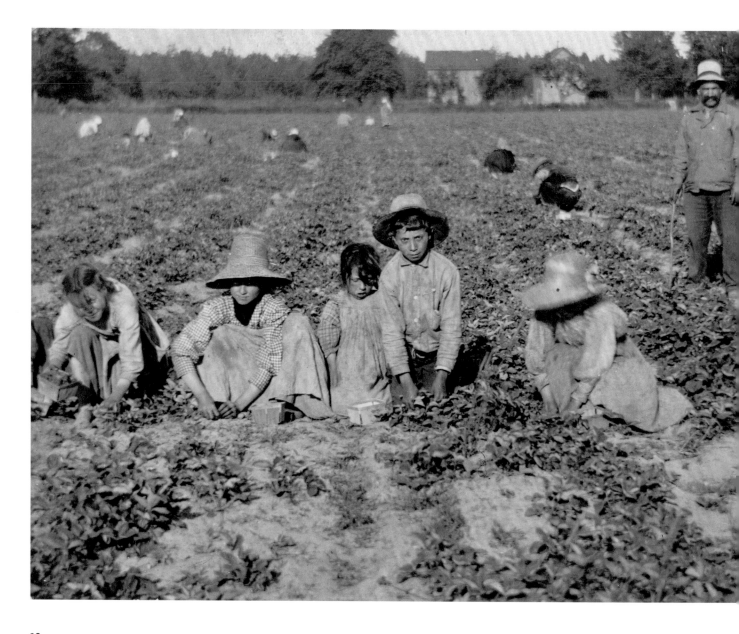

12
Children harvesting strawberries, about 1914

13
East Ward first grade class, Wymore, Nebraska, about 1914

14
Irving School, about 1914

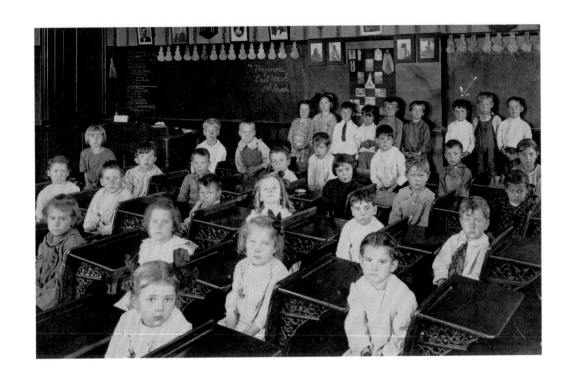

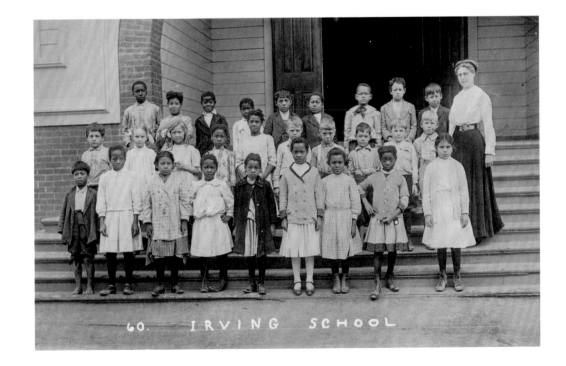

60. IRVING SCHOOL

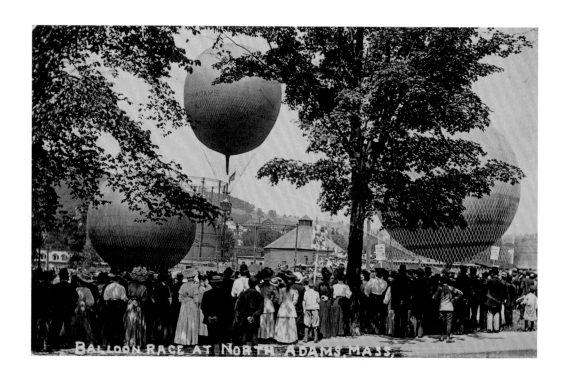

15
Balloon race, 1909

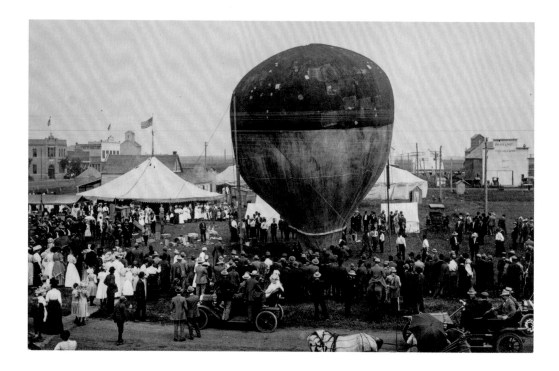

16
Hot-air balloon, Polk,
Nebraska, 1910

17
Circus at Union City
Bi-County Fair, Indiana,
1917 or later

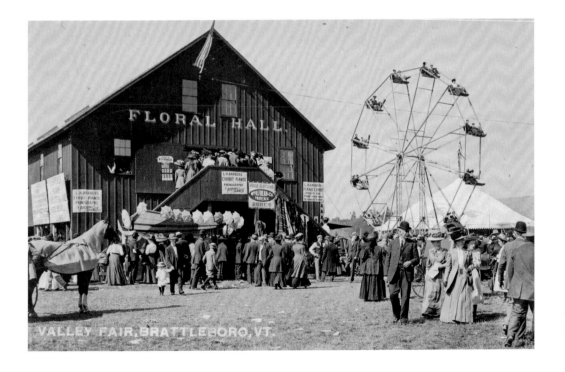

18
Floral Hall at Valley Fair,
1910 or later

25

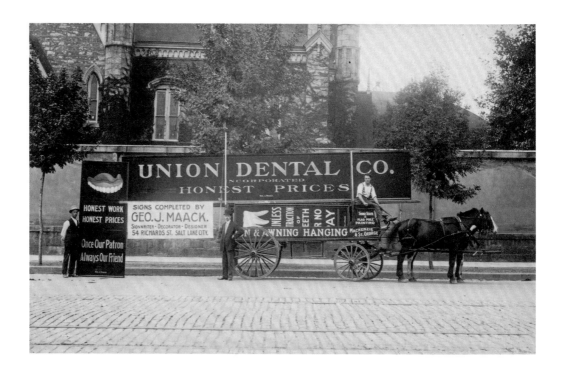

19
Union Dental Company
advertisements, Salt Lake
City, Utah, 1907 or later

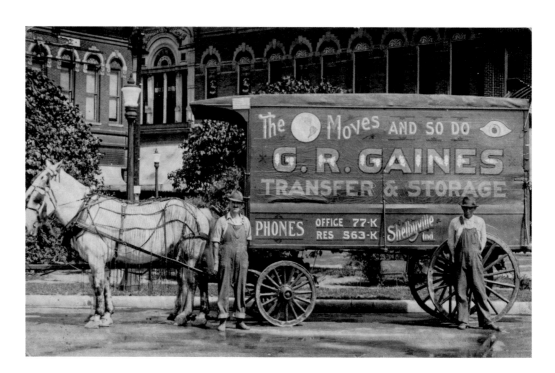

20
G. R. Gaines Transfer
and Storage wagon, 1913
or later

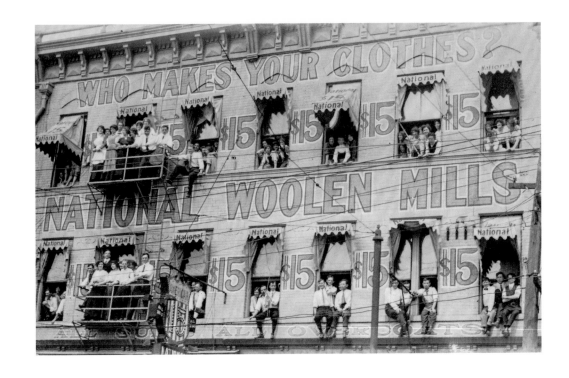

21
National Woolen Mills,
Wheeling, West Virginia,
about 1914

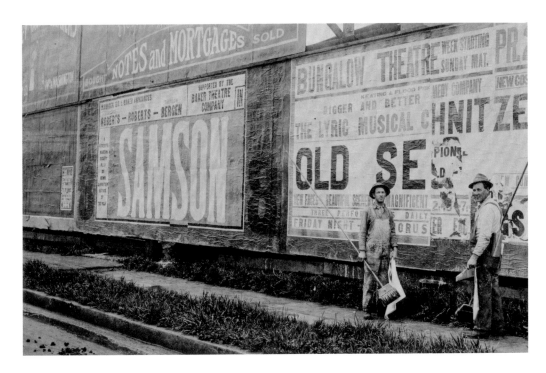

22
Poster hangers, Portland,
Oregon, about 1914

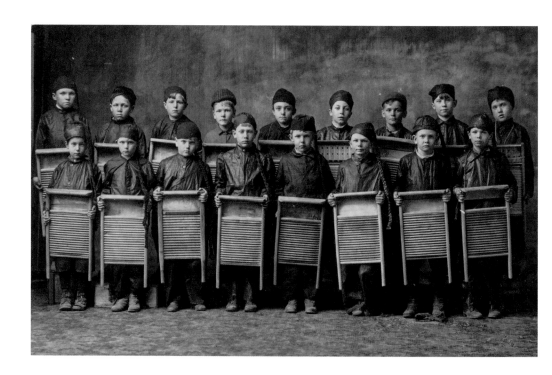

23
Child laundry workers,
about 1923

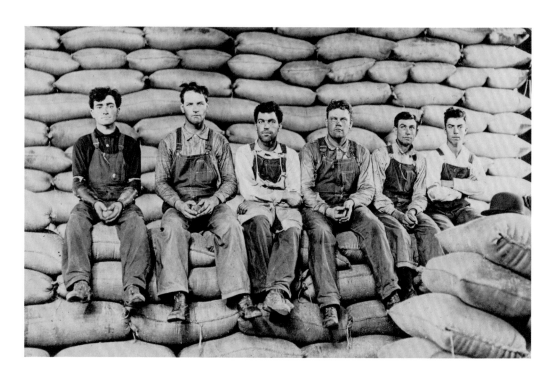

24
Flour mill workers,
about 1914

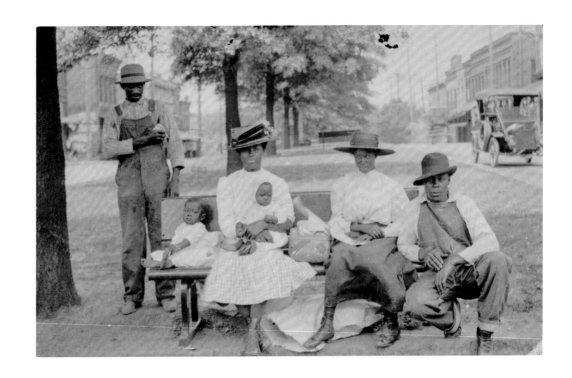

25
A family, Griffin, Georgia,
about 1913

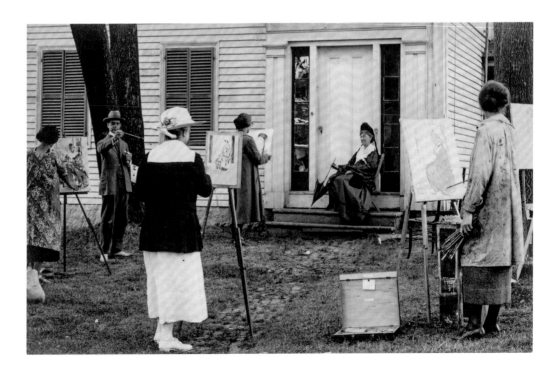

26
Women painting, Boothbay,
Maine, after 1917

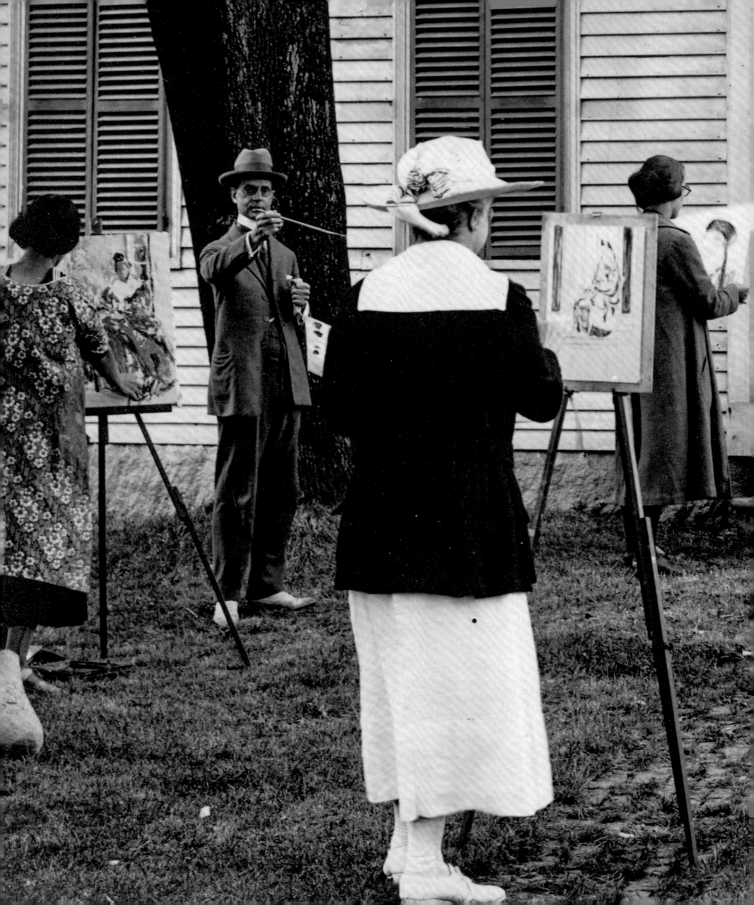

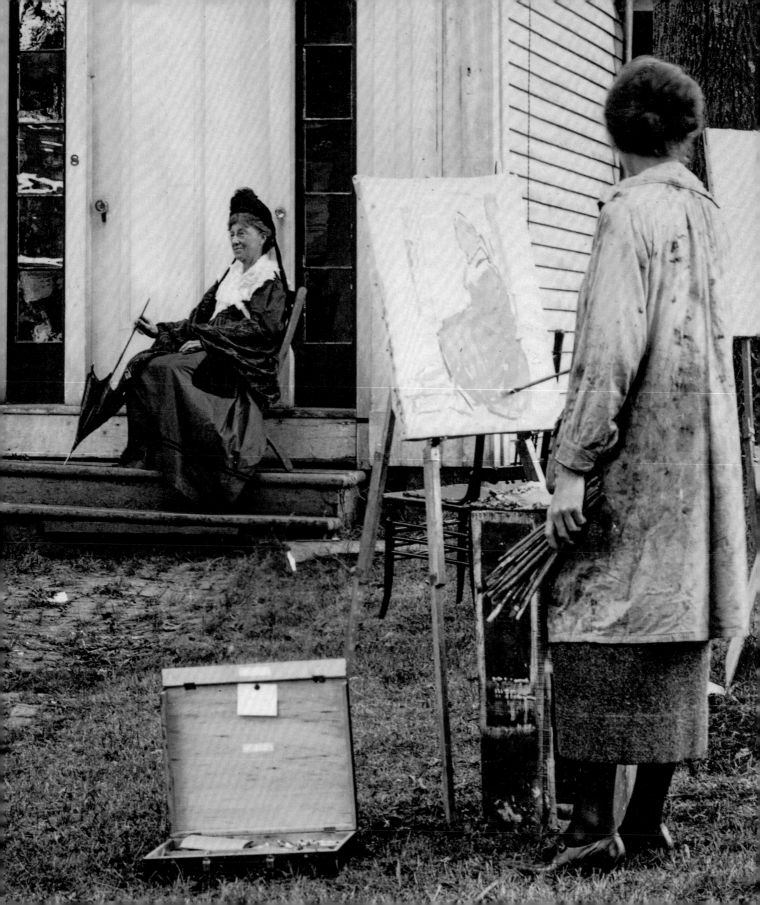

Making Postcards and (Sometimes) Making Money | BENJAMIN WEISS

On New Year's Day in 1905, a photographer we know only as Fannie took her new camera — likely a Christmas present — into a wintry Harvard Yard and took a picture of a squirrel (**27**). It was an ordinary squirrel, likely the ancestor of hundreds of squirrels who pose for pictures in Harvard Yard to this very day; and it is an ordinary photo, of no particular distinction. But this very ordinary photo of this very ordinary squirrel became, in its way, a radical object. For Fannie did not simply snap her picture and paste it into an album; instead, Fannie's squirrel was about to embark on a grand adventure.

After developing the negative, Fannie printed the photo (or had it printed) on a 3¼- by 5½-inch card that was coated with a light-sensitive emulsion. Once the image had dried and set, Fannie scribbled a quick note around the picture. On the back of the card, she wrote the address of Mrs. Jennie E. Brierly at the Hotel Brewer, 412 West Seventh Street, in Los Angeles. She added a one-cent postage stamp and took the card to the post office in Worcester, Massachusetts. The squirrel began its cross-country journey on January 3, carrying a bit of scenic New England winter to sunny Southern California.

In other words, Fannie sent a postcard. So why was this a radical act? Photography was not an especially new technology in 1905, having been around in various forms since 1839; nor was amateur photography particularly novel either. Indeed, the camera Fannie took with her into the snow was probably a Brownie, the easy-to-use model that Eastman Kodak introduced in 1900. The Brownie had been the capstone to a decade of increasingly sophisticated mass marketing by Kodak: "You push the button and we do the rest," went the ad from 1888. People took up the call by the hundreds of thousands, and in 1905 photography was a very popular hobby that was getting more popular all the time.

Nor was it a radical act to send a postcard, though postcards were, to be sure, a newer technology than photography. Pre-paid postal cards had been introduced in Austria-Hungary in 1869, and in the United States in 1873. They caught on fast, and, by the first decade of the twentieth century, tens of millions of people were sending billions of postcards (and collecting even more) every year in the United States. Postcards had been a somewhat radical and disruptive means of communication when new — the very idea of sending a private letter through the public mails without an envelope was disturbing to some — but by 1905 they had become a fully essential piece of modern life.

Rather, the radical act was the combining of photography and the postcard. Surprising as it may sound, in 1905 the idea of sending a personal photograph through

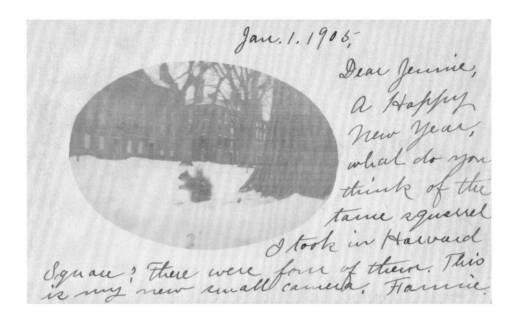

Jan. 1. 1905.

Dear Jennie,
A Happy
New Year,
what do you
think of the
tame squirrel
I took in Harvard
Square? There were four of them. This
is my new small camera. Fannie

27 Squirrel in Harvard Yard, 1905

the mails was quite novel. Up until then, most postcards had been fully commercial products, mass produced and printed by lithography, often in editions of tens or hundreds of thousands. Such cards could be personalized with words and drawings and funny notes, but Fannie's card was something different: a unique card that bore a personal photograph — one that could be sent out into the world, just like its social media descendants of our own time.

Fannie sent her squirrel on its journey at the very moment when the popularity of such cards was shaking up the world of photography in dramatic ways. The photographic magazines of the years around 1900 were full of articles giving advice on how to make photo cards, with suggestions about equipment and emulsions and printing techniques. But the technology was not ultimately the point, for the cards' appeal and power lay in the ways that they transformed people's relationship to the pictures. As one article put it, "it is the personal touch which makes the difference, giving the photographic post-card, made at home, a value far above any commercial card."[1]

The earliest history of such cards is a little murky. Products like photo-sensitized postcard blanks started to come to market as early as 1899, but they did not achieve instant success. In 1901, one commentator, apparently unaware of the available products, wondered why the photo companies had not yet picked up on the idea and offered prepared blanks ready to be printed at home.[2] Yet at the time he wrote, at least two brands of photographic paper designed specifically for postcards were already on the market, from Rotograph and Velox. In addition, the concept was being promoted by marketing ploys such as Kodak-sponsored competitions for the best homemade photo card. These were often advertised in photo-magazine "advertorials" that posed as news stories or advice columns (**28**).

And then, almost all at once, photo postcards took off. Everything came together starting in 1902, when a series of competing brands of photographic paper hit the market, all designed specifically for the manufacture of postcards. The names had a family feel — Cyko, Argo,

28 Kodak advertisement, 1914

Kruxo, Azo, and more — despite the fact that they were all in competition. Perhaps more important, though, in 1903 Kodak introduced its model 3A camera, which could expose a postcard-sized negative. The perfect fit offered by such negatives meant that photographers no longer had to worry about making sure their negatives fit onto a blank. There was no enlarging to be done, which saved time, and the large negative also meant that the resulting photos could have remarkable detail, since the postcards were contact prints. The camera was relatively compact and could be folded neatly for transport, making it easy for photographers to get out into the world. The 3A was far from the only postcard camera on the market, but it is probably the one that opened the floodgates.[3]

The effect of the new Kodak cameras was somewhat akin to that of the introduction of the Model T Ford in 1908. Kodak's and Ford's products were both carefully considered refinements of existing technologies, geared to generate mass sales, rather than new inventions in the strictest sense. Their companies' genius lay as much in

marketing as in manufacture, though both organized production and distribution operations in innovative ways that proved easier to scale up than those of their competitors. By twenty-first-century standards, Ford's cars and Kodak's cameras were cumbersome and complex, but both were significantly easier to use — and less expensive — than anything that had gone before. This meant that, quite suddenly, vast numbers of people who had only dreamed of driving could legitimately aspire to own a motorcar, and all sorts of amateur photographers could at least imagine setting themselves up as professionals.

The result was something of an existential crisis for professional photographers. On its own, the boom in amateur photography, and even the amateur real photo postcard, could have seemed a boon to professionals. After all, the very fact that more people were playing with cameras was likely to serve as a reminder that it can be quite difficult to take a good photograph. But the arrival of the commercial real photo postcard presented professional photographers with a direct challenge to their identity.

Now, it seemed that almost anyone with a small amount of capital and a tiny bit of technical skill could set up a photo studio.

At the very least, photographers thought that the photo postcard presented such a danger, for they certainly held forth about and debated the issue a great deal in the pages of the photographic press. For years after the appearance of the 3A, there was a constant churn of debate and suggestion about whether the photo postcards represented opportunity or threat: to prices, to standards, even to the very dignity of the profession. There was great difference of opinion about these subjects, but there was unanimous agreement that the postcards represented a seismic shift in the photographic world.

In the first years, a few optimistic souls argued that the fad for photographic cards, especially for portraits, was just that — a fad. People would tire of the cheap photos, and the phenomenon would burn itself out in due course.[4] That hope was quickly proved false, and in response some photographers became adamant that the profession must take a stand. Jessie Robinson Bisbee, who ran a studio in Twin Falls, Idaho, with her husband, Clarence, encouraged her colleagues to fight back by simply refusing to make postals: "Have well-dressed people ever driven up to your studio door in a $2,000 automobile and . . . come rustling in requesting 'half-a-dozen' postals made? Portraits, mind you! What is to be done about it? We solved our especial problem years ago by simply refusing to make postals at any price." Bisbee acknowledged that postcards had their place, "but post cards are post cards, and, regardless of price, the making of post cards cheapens any studio."[5]

Even as late as 1921, Carl Harry Claudy, who had a long and fascinating career as a photographer and journalist, specializing in aviation, exhorted his fellow photographers to resist customers who come and order "just a postal" to test the photographer's skills: "If your groceryman comes in and demands one post card to see if you can make a good picture, ask him if he will sell you a slice of watermelon so you can see if the melon is good, or one sardine out of a can so you can sample the quality!" Claudy continued with a rousing call to standards: "Photography is a dignified profession. It requires skill, time, labor, materials, experience. Stand up for your job; make people believe in its worth, as you do. Don't cheapen it. And if customers insist that you cheapen it, or they will not order, let them go elsewhere."[6]

Many of the arguments in the press focused on quality and dignity, but price was just as big an issue. A photographer simply couldn't charge as much for postcards as for more traditional pictures. Formal portraits needed to be mounted on cardboard or printed on bigger sheets than postcards, so many photographers feared that the postcard trade would devalue their skills in the most literal sense. Those with longer memories reminded their colleagues that this problem was nothing new. In 1911, the editors of *Abel's Photographic Weekly* asked readers to recall that tintypes had presented "serious" photographers with a similar challenge decades before: "We remember when the photographer used to find fault with the tintype man because he was giving four pictures for a quarter, just as they find fault now that the post card man gives six for 50 cents." For *Abel's*, at least, the correct response was not to reject the postcard itself, but for photographers to work together as professionals and ensure that the ubiquity of postcard competition didn't result in a race to the bottom on prices.[7]

Studio Light's editors took a similarly long view, begging their readers to be pragmatic. "It seems there are those who will always object to any branch of photographic work intended to catch the spare change of a pleasure-loving, money spending public, but the fact remains that if this money is not caught in the pockets of the photographer who makes Post Cards, it will go elsewhere, for it

is the kind of money that gathers no moss — it goes too fast. Do away with the Post Card and there will be some other photographic novelty spring up to take its place."[8]

In the end the market won, as everyone probably knew it would all along. The cards were too convenient, too versatile, and too inexpensive to fail, and for every professional photographer who tried to stem the flow, there were others who were simply more realistic about their own prospects. "We are not all Garos, Hoyts or Duhrkoops," noted Edward Trabold in 1914, citing three of the leading portrait photographers of the day. "We are most of us ordinary photographers who turn out average work, while the great artists that can choose their customers and the class of work they will do for them, can be counted on the fingers. I would not advise any one to mix the two grades of work if he can keep the post cards out; but, at the same time, I fail to see where one can lose much by doing both."[9] Or, more pointedly, as the editors of *The Professional and Amateur Photographer* asked in November 1908: "Why not make post cards and compete with the post card man on his own ground, only make your post cards better than his?"[10]

It was good advice, and when you look closely a surprising number of quite famous photographers dabbled in the world of postcards. Even Edward Weston, who had grand artistic ambitions from the very beginning of his career, did commercial postcard work in the 1900s. The cards he made of buildings around Tropico (now Glendale), California, where he established his first studio, have no particular "Weston" quality. In fact, were they not documented as having come from his camera, they would attract very little attention even among postcard collectors, but the postcard business was a key piece of Weston's early years nonetheless.

After all, as J. Peat Millar noted with a sort of resigned shrug, if one photographer didn't take photos for postals,

the customers would just go elsewhere anyway. At least the lower prestige and price commanded by postals was offset by how quickly they could be made, for postcards required far less work than "finished" photos like cabinet cards. Even "a slow worker and a boy can print and finish a thousand postcards in two days, and a good hard working printer and assistant can print, develop, fix, wash, and finish one thousand in one day, and have time for a smoke now and again as well, so it cannot be said that postcard work cannot be made to pay."[11]

In retrospect, the cards' ubiquity and success should have come as no surprise. From the beginning, there was a huge marketing machine behind the industry, designed to drive it along. Photo magazines were replete with advertisements for postcard cameras and enticing promises of easy riches. For those who wanted to dig deeper, there were the books. The early twentieth century was a great era for how-to books, and there were plenty that promised a path to wealth, or at least comfort, in the photo business, often in their very titles. Paul Glenn Holt's *Fifty Dollars a Week with Car and Camera* of 1926, for example, was an odd mash-up of technical handbook and pitch-man's paean to the joys of the open road. He made the life of an itinerant commercial photographer seem like the greatest of romantic adventures, complete with the pleasure of being your own boss, bigger profit margins than those offered by the "hen-farm mania" of the door-to-door egg-selling business, and poetic evenings spent watching the stars from your car-cum-studio in clearings by a remote forest pond (**29**). Really, who could resist?[12]

But was there truly money to be made? Or, as one brash young man from Cincinnati, who had secured a good location for a studio but owned no photographic equipment and had no experience as a photographer, asked of one advice column: "Do you think a hustler could make a living at it?"[13]

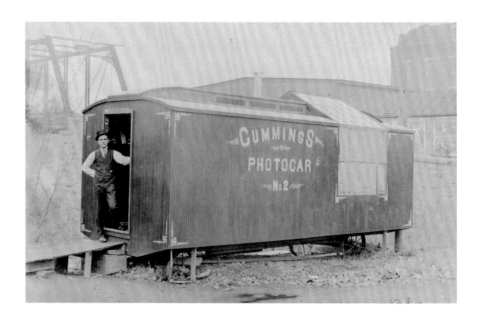

29 Cummings Photocar, Bonaparte, Iowa, 1908 A. H. CUMMINGS

On that subject the answer from the photo press was a near-unanimous "yes"— but you had to be savvy about it. The breezy optimism of people like fifty-dollar Holt aside, it wasn't enough simply to set up a business and take pictures. There was already a robust photographic ecosystem, and postcards, like any invasive species, had to find the niche where they could flourish. In some cases that niche was geographic. Early on, astute observers realized that postcard studios were particularly apt to succeed in smaller towns, "where there would not be room for a regular studio, principally for the reason that the cards can be produced and sold cheaper than mounted photographs."[14] A browse through the boxes of old cards at nearly any postcard fair today reflects the truth of that observation. It is, paradoxically, easier to find real photo cards of small towns in Vermont or Indiana or Kansas than it is of big cities like New York or Chicago.

But once one had picked the town, the same basic rules applied, no matter how big the market. Postcards were not fancy work. They depended on speed and volume, and that meant photographers needed to be where the clients were going to find them. In 1913, F. M. White noted: "you must settle where there are more people of the middle class per square foot passing your window display than in any other part of the city or town."[15] On the other hand, margins were low, so costs needed to be as well. Charles Ogilvie recommended putting oneself in "a vacant store rented at a low rate until a regular tenant comes along" and outfitting the space as cheaply as possible. If you organized your business properly, with "some burlap partitions, a cheap outfit, some home-made accessories, negatives developed mechanically . . . , no retouching and immediate delivery for cash," it was possible "with a low-priced assistant, to make money, and no doubt good money, turning out post cards."[16]

Ogilvie's advice to keep it simple was echoed again and again in calls to practicality, simplicity, and opportunistic pragmatism. There is regular emphasis on the importance of cheap labor, often done by children, and careful customer management. D. E. Jakot was notably

blunt in his 1913 guide to running a portrait studio: "As in cheap pictures one does not look for perfection, the finishing can be very nicely done by boys of thirteen or fourteen years." On customer relations: "The receptionist in a postcard gallery is just as important as in a higher-priced place. She must be pleasant and tactful and able to handle people quickly without seeming to do so." And, on the ever recurring question of how to handle the unsatisfied client: "customers frequently ask what redress they have if [the likeness] is no good; but if the receptionist explains that a clear picture only is guaranteed and no more, much after-unpleasantness would be avoided, . . . for this reason the operator must be a good technician rather than artistic."[17] At least in Jakot's view, the postcard business had no place for sentiment.

The most consistent piece of advice was to be open to the main chance, and to find your market. Portraits were the bread and butter of the postcard man — and, indeed, most were men — but there were other subjects to explore as well. There was a market for views and news photos and local attractions; for commemorative pictures, oddities, and novelties. But there were lots of players in the postcard market, and it was important to pick fights you could win. As James Everton noted in 1912 "if the individual photographer wishes to be successful in postcard work, he must tackle the subjects which will not pay the large firms to touch." Everton lamented that even in small towns, big firms had often snapped up the obvious subjects, but "where local events . . . are concerned, the individual photographer, being on the spot, has a far better chance."[18] Even a small bit of customization could help. For example, "a view of the church will always sell better if a small portrait of the pastor is 'inserted' at a corner."[19]

In other words, just as postcard studios could flourish in the quieter corners of the country, away from the commercial photo studios of the big cities, so could postcard

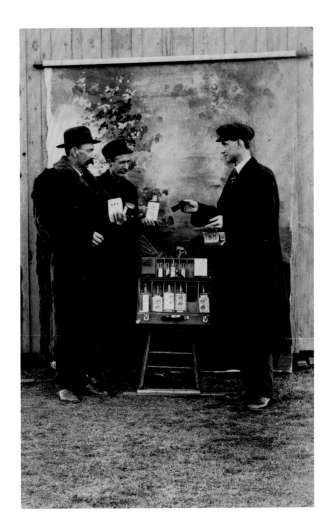

30 "KKK Tonic" salesmen, 1909

photographers find success close to home. They just needed to make sure that their products were tailored to local tastes: local celebrities, local sports teams, champion livestock and vegetables, the midway at the county fairgrounds, or the local quack-medicine salesmen (**30**). Even real estate development provided an opportunity, as "pictures of the successive stages of construction of buildings also find a market quite often."[20] All were excellent fodder for the postcard photographer, precisely because

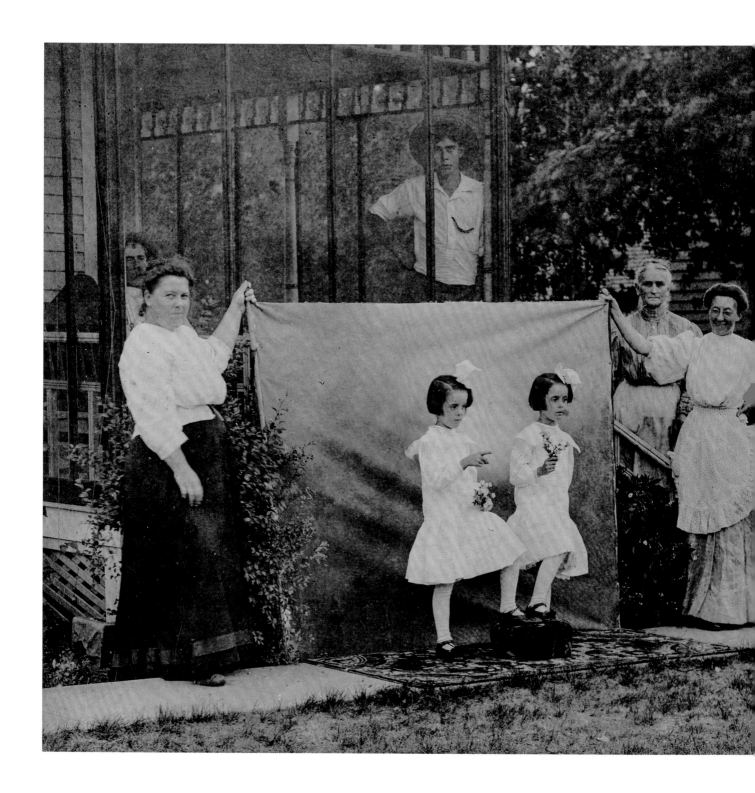

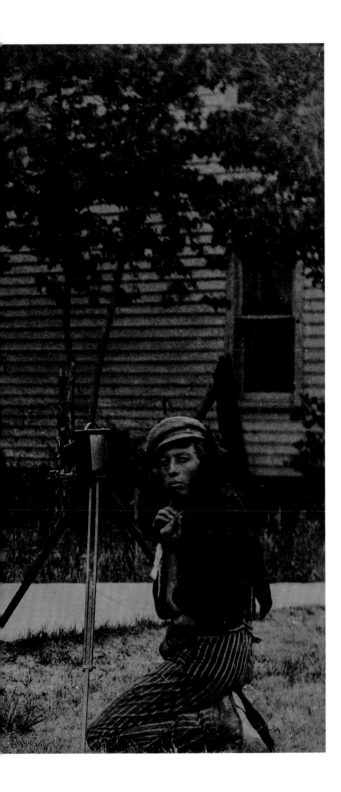

the market for such pictures was too small to interest the big commercial publishers. This axiom became less and less true as the century wore on, as big postcard firms became more adept at creating customized cards for small markets, but for several decades, there was a space for the small operator to flourish.

The most exciting opportunities came in the form of news cards. Fires, floods, explosions, political rallies, strikes, and parades — all provided postcard photographers with opportunity for sales. But here, even more than elsewhere, speed was of the essence. As Frederick Visick wrote: "I need hardly point out that when there is an opportunity of a local 'scoop' by selling post-cards of such things as the scene of a big fire, the opening of a public building, or even the mysterious 'sea-serpent,' . . . even a few hours, let alone several days, might spell the difference between augmenting the freelance's income . . . or, on the contrary, allowing the opportunity to go by."[21] Success, James Everton reminded his readers, depended "almost entirely on the shrewdness and initiative of the photographer."[22]

Of course, having the pictures was one thing; finding a market for them was another. The primary audience for local stories was, of course, local (see chapter 7), but for events of national significance there was a larger market as well. A close reading of the classified ads in the photographic press reveals a steady stream of offers to sell photos of train wrecks, ferry sinkings, and floods, no doubt with the hope of placing those photos into the larger pool of the national press. There, they could find a longer life not just as postcards, but also in illustrated supplements to newspapers and the quickly produced books that followed nearly every disaster and often featured images derived from postcards.

31 Photographer in the field, 1907 or later

For the postcard photographer, the recurring call to get out of the studio and onto the road was not an artistic imperative so much as it was a commercial one. Success meant chasing business, and that meant being ready to grab opportunity wherever it might present itself: "A photographer traveling from house to house does well to go equipped to take a picture anywhere, any time. A portable background, flashlight outfit, and sample pictures are necessities. . . . Each card should embrace a different subject. The shadow of a building, with the sun high in the sky, makes an ideal outdoor studio."[23] A photographer had to make do with the situation as it presented itself and seek out opportunities — if the photos were good, that was an added bonus (**31**).

Most of the time, we get no glimpse of the photographers at work. But every now and then, history drops the fourth wall, and someone gives us a picture of the life of the photographer from the outside. One magazine story from 1908 provides just such a chance. In September of that year, Prince Hall Masons from across the United States gathered to celebrate the one hundredth anniversary of the very first African Grand Lodge, in Boston. The local organizing committee pulled out all the stops, and for three days there were speeches and parades and dinners, all capped by a gala celebration at Symphony Hall. The mayor and the governor issued proclamations celebrating the achievements of the "colored Masons," and all the local newspapers covered the celebrations with rather breathless descriptions of the week. It was a civic ceremonial of a high order, and of a kind repeated thousands of times in the speech- and banquet-loving years at the beginning of the twentieth century.

Finally, on Sunday, September 12, the pomp was done, and it was time for play. Boarding chartered trolley cars, hundreds of the Masons and their families made the journey to the seaside playground at Point of Pines, at the northern tip of Revere Beach, where the sun shone, and a salt breeze filled the air. The joy of the day was captured in an article in *Alexander's Magazine*, unsigned but probably from the pen of George Washington Braxton, who had been grand master of the parade two days before:

The spacious halls and wide piazzas could scarcely hold the vast number of picnickers. The dance hall was crowded with couples and spectators, a good natured jumble of humanity, elbowing their whirling paths. The grounds were alive with merrymakers. High jumping, foot races, shot-putting and of course baseball attracted large crowds of quickly applauding audiences. Photographers cornered couples; men single, in two's or trios or quartettes; Grand officers, officer masters, just plain people, they cornered them all and leveled their apparatus at them double quick. Large groups, squatted on the piazza steps, were photographed with the revolving machine; and from the numbers and continued activities of the camera-men, they must have been 'making hay while the sun was shining.'[24]

There were memories to be caught, and money to be made, in that happy crowd. But to do that you had to meet the world where it was. The photographers made sure they did.

This, ultimately, was the life of the "camera man." Hustle, hustle, hustle, to be sure — but at their best, the results of that hustle are remarkable. Taken together, the postcards those photographers made provide an unmatched visual chronicle of a nation at a time of great dynamism and wrenching social change. Indeed, the very energetic informality the cards convey seems a perfect symbol of the age.

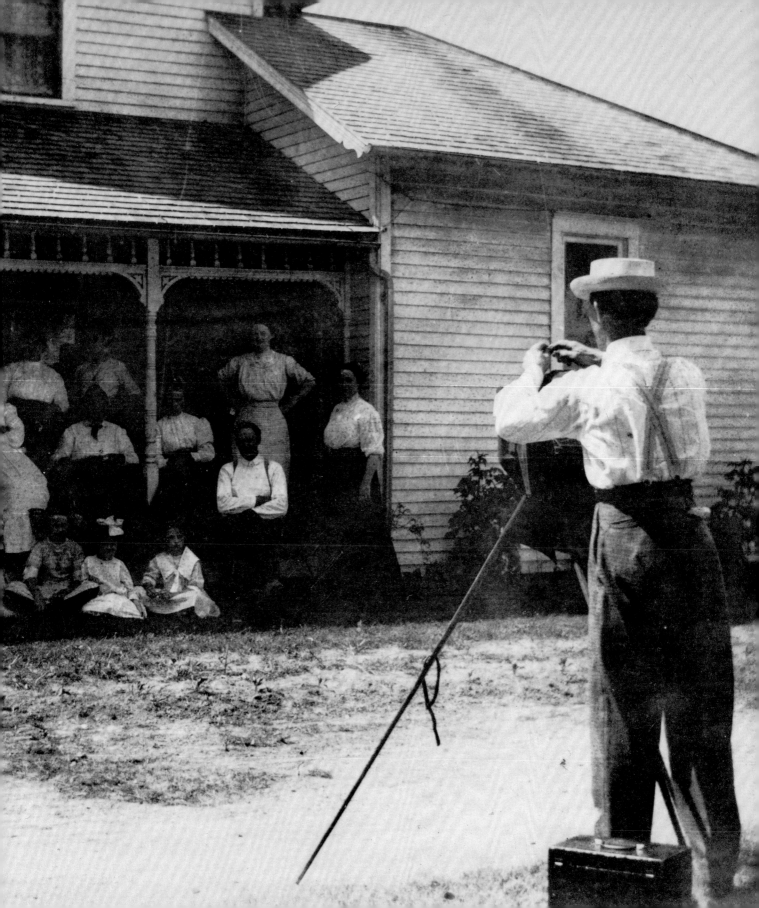

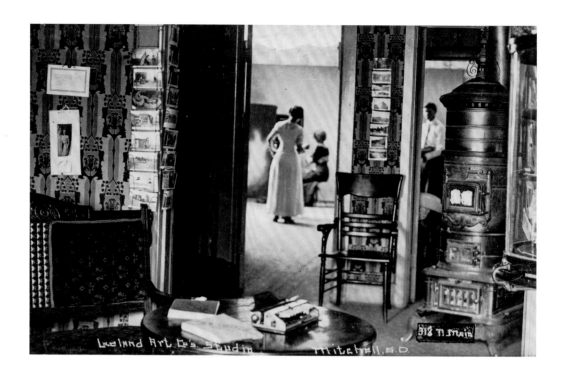

32
Leeland Art Co.'s studio,
1914 or later

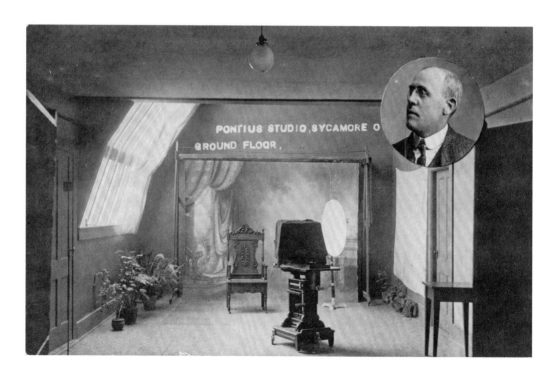

33
Pontius Studio, 1907
or later
DAVID RILEY PONTIUS

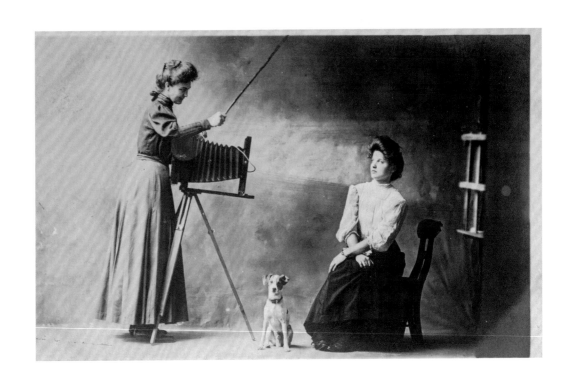

34
Photographer and sitter
with dog, 1907 or later

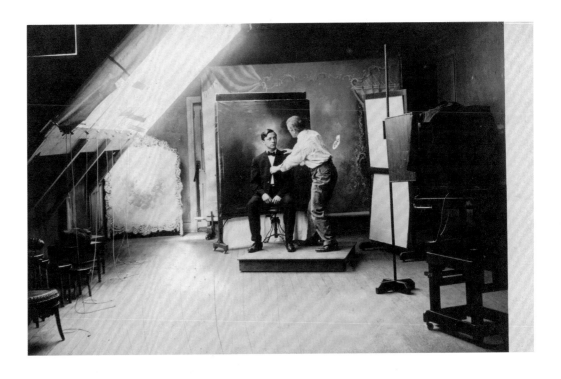

35
Posing for a portrait, 1907

45

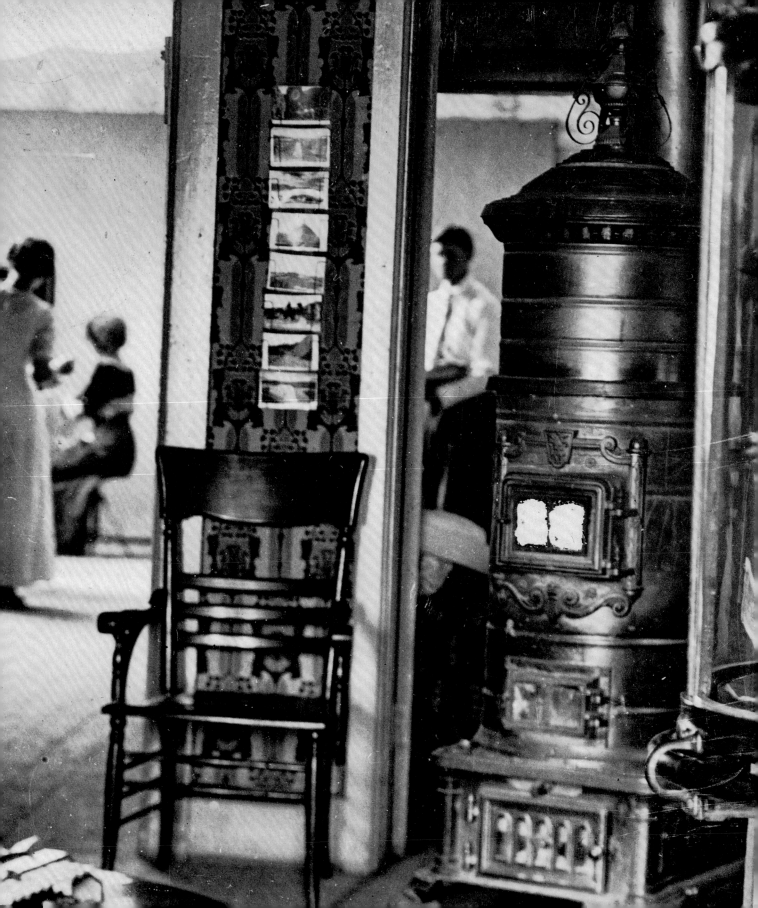

36
American Film Company employee,
about 1913

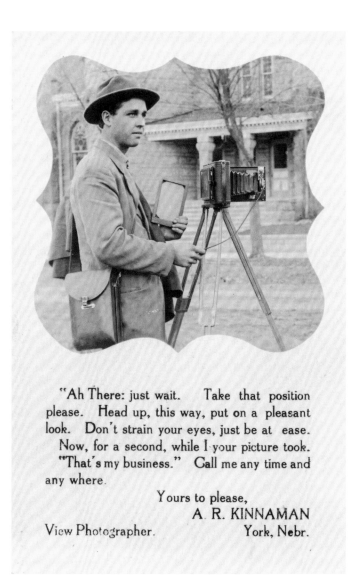

"Ah There: just wait. Take that position
please. Head up, this way, put on a pleasant
look. Don't strain your eyes, just be at ease.
Now, for a second, while I your picture took.
"That's my business." Call me any time and
any where.

Yours to please,

A. R. KINNAMAN

View Photographer. York, Nebr.

37
Kodak advertisement, 1910
A. R. KINNAMAN

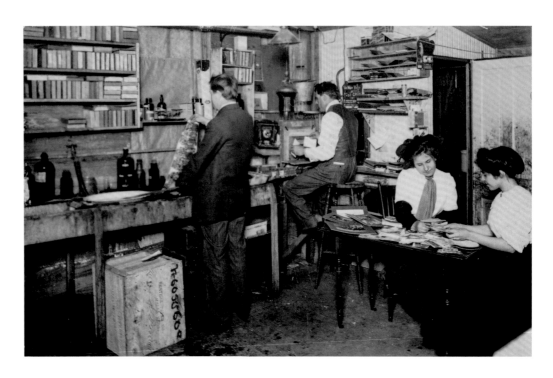

38
Photography studio, 1911
or later

39
Kodak Amateur Finishing
Department print envelope
OLSEN'S STUDIO

40
Kerr's Studio, 1908

41
Mobile photography studio,
Sweetser, Indiana, 1912

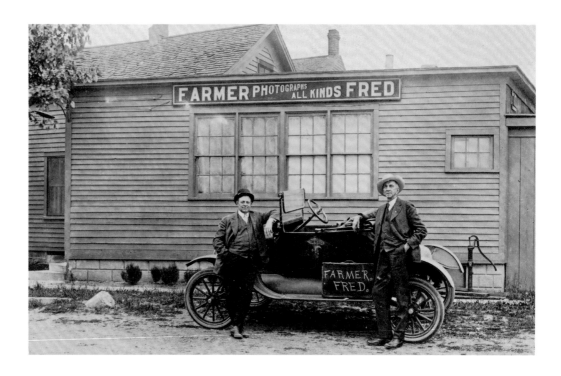

42
Farmer Fred, Pleasant Lake,
Indiana, 1917 or later

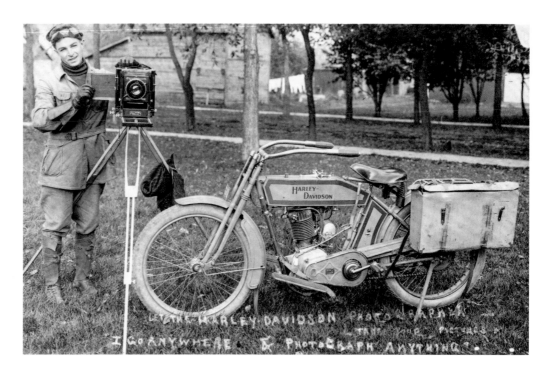

43
Motorcycle photographer,
Goodell, Iowa, 1915
H. R. ALLABEM

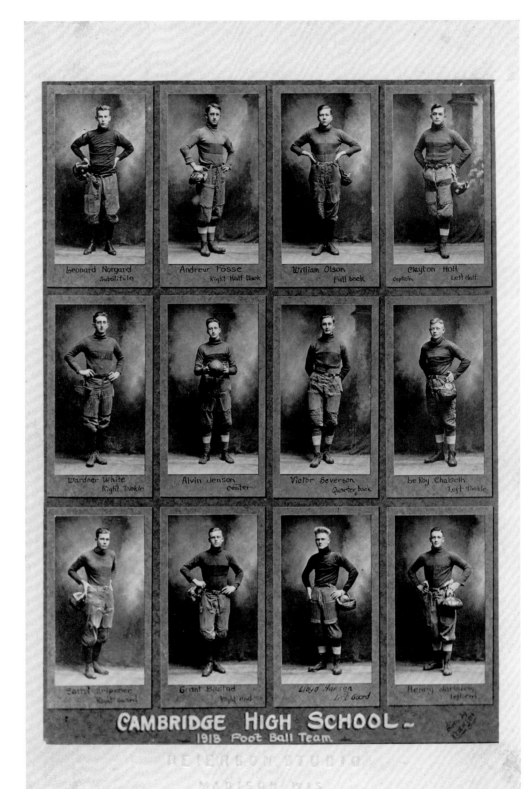

44
Football team, Cambridge
High School, Madison,
Wisconsin, 1918
PEARSON, REIERSON STUDIO

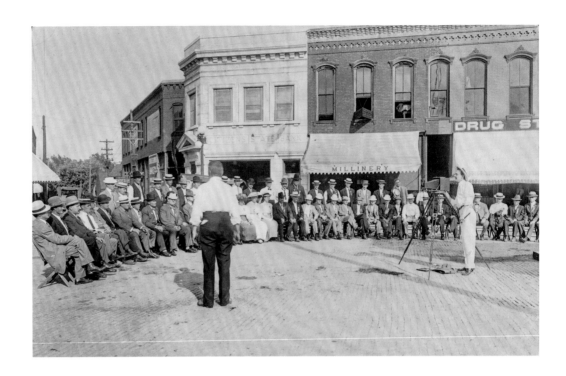

45
Photographer in the field,
about 1914

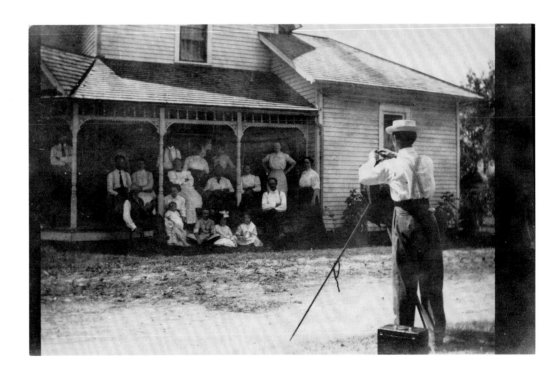

46
Photographer in the field,
about 1914

47
George A. Hale,
Photo Supply Dealer,
about 1918

48
A Suggestion for Displaying
Post Cards, 1907 or later
BRUHN & ZEHNPFENNIG

49
Postcard rack in the
Oneonta Department
Store, 1907 or later

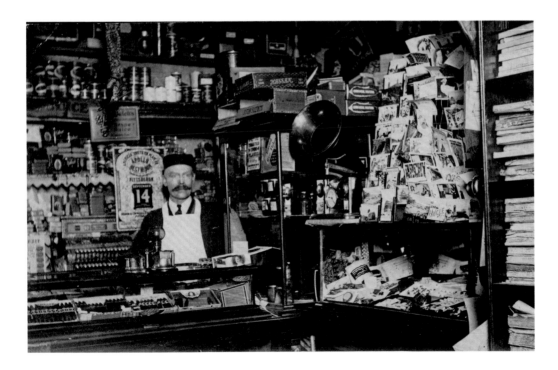

50
Shop with postcards,
1910 or later

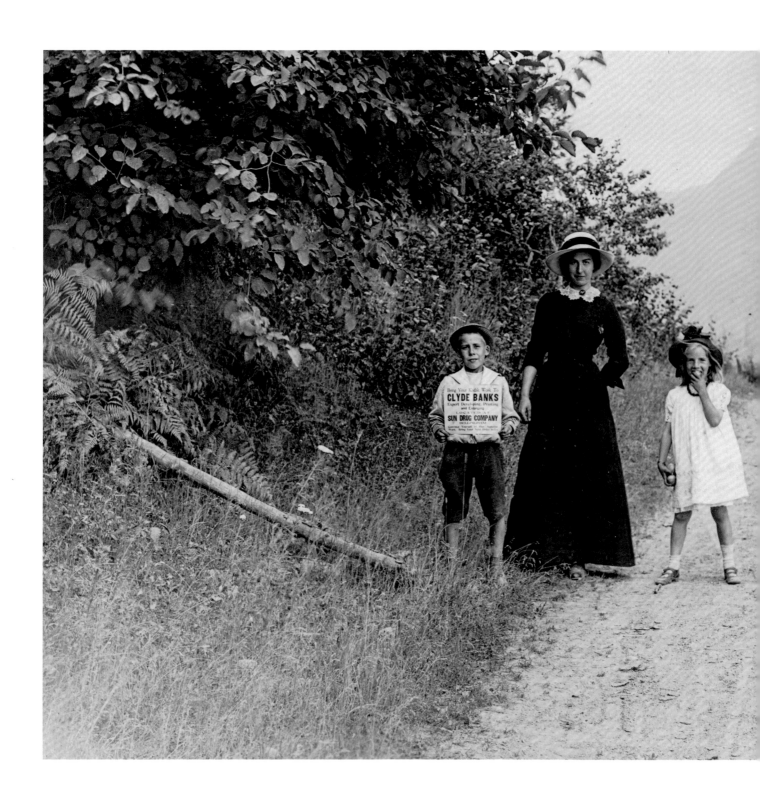

MAKING POSTCARDS AND (SOMETIMES) MAKING MONEY

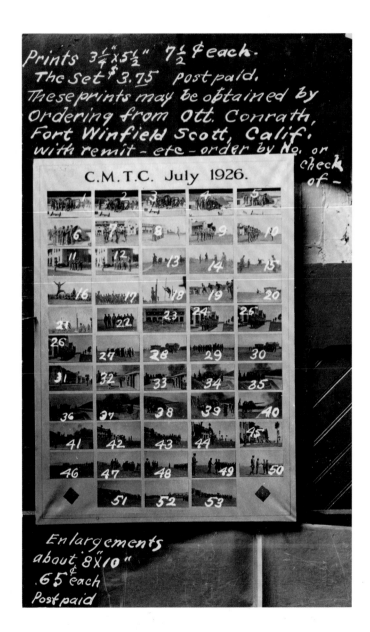

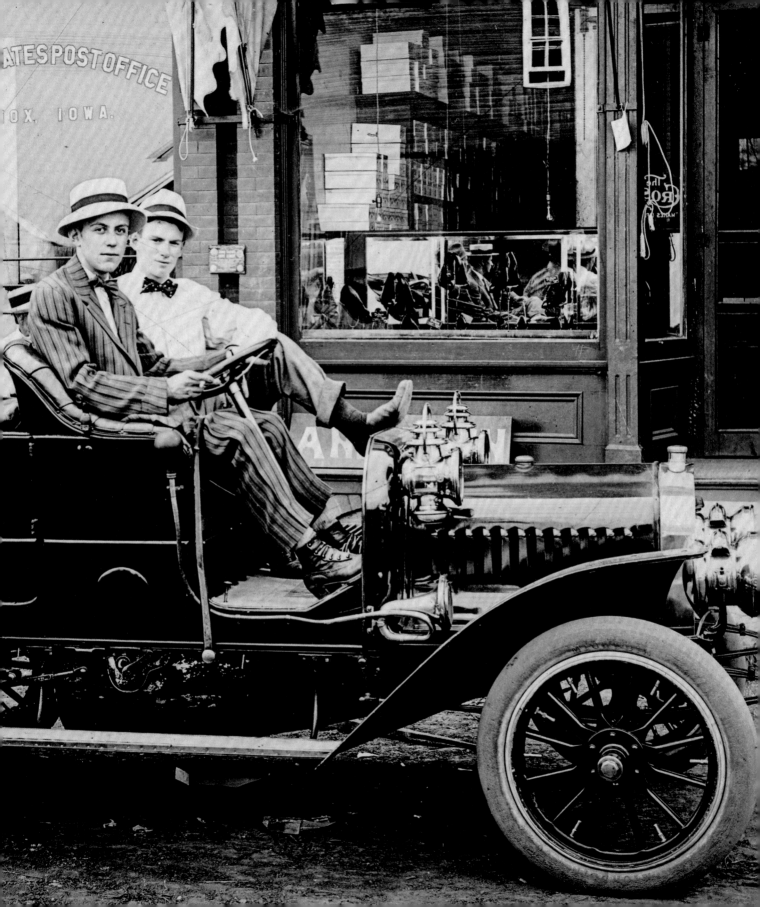

Main Street | SINCLAIR LEWIS

n the United States, Main Street is an idea as well as a place. Most towns and cities in the country have a street that bears the name, and Main nearly always is — or once was — both the center of commerce and the showcase street. It is the place where the banks and stores and courthouses line up to demonstrate wealth and pride and civic virtue. So when Sinclair Lewis sought to distill the United States of the years around 1920 into a single novel, he chose Main Street as his metaphor.

Lewis intended *Main Street* to capture the tenor of life in the myriad small and medium-sized towns that dotted the United States "from Albany to San Diego." A long-winded writer, Lewis also had a paradoxical gift for distillation and an exceedingly keen eye. Even when his pen portraits cast their subjects in sharp and critical light — and, to be sure, *Main Street* is no valentine — it was hard to gainsay the kernels of truth the portraits revealed. Indeed, Lewis's deadpan exploration of the fictional Gopher Prairie, Minnesota's, downtown is as dyspeptic and ungenerous as it is closely observed. The quick, telling details of this prose poem recall the experience of shuffling through a stack of real photo postcards — cards that were, to a large degree, made in exactly the sort of medium-sized places dissected in the novel. Yet despite Lewis's ungenerous eye, *Main Street* clearly struck a chord;

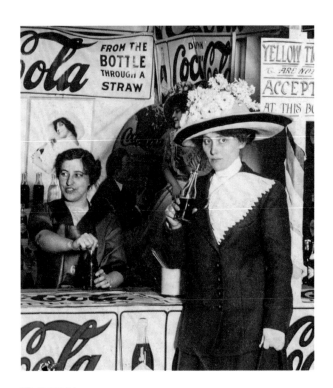

81 (DETAIL)

it sold two million copies in its first two years — in a country whose population numbered only 106 million.

This section is from chapter 4, where Carol "Carrie" Milford, newly arrived in her husband's hometown, sets out with her big-city eyes to assess the place. — BW

I

"The Clarks have invited some folks to their house to meet us, tonight," said Kennicott, as he unpacked his suit-case.

"Oh, that is nice of them!"

"You bet. I told you you'd like 'em. Squarest people on earth. Uh, Carrie —— Would you mind if I sneaked down to the office for an hour, just to see how things are?"

"Why, no. Of course not. I know you're keen to get back to work."

"Sure you don't mind?"

"Not a bit. Out of my way. Let me unpack."

But the advocate of freedom in marriage was as much disappointed as a drooping bride at the alacrity with which he took that freedom and escaped to the world of men's affairs. She gazed about their bedroom, and its full dismalness crawled over her: the awkward knuckly L-shape of it; the black walnut bed with apples and spotty pears carved on the headboard; the imitation maple bureau, with pink-daubed scent-bottles and a petticoated pin-cushion on a marble slab uncomfortably like a gravestone; the plain pine washstand and the garlanded water-pitcher and bowl. The scent was of horsehair and plush and Florida Water.

"How could people ever live with things like this?" she shuddered. She saw the furniture as a circle of elderly judges, condemning her to death by smothering. The tottering brocade chair squeaked, "Choke her — choke her — smother her." The old linen smelled of the tomb. She was alone in this house, this strange still house, among the shadows of dead thoughts and haunting repressions. "I hate it! I hate it!" she panted. "Why did I ever ——?"

She remembered that Kennicott's mother had brought these family relics from the old home in Lac-qui-Meurt. "Stop it! They're perfectly comfortable things.

They're — comfortable. Besides —— Oh, they're horrible! We'll change them, right away."

Then, "But of course he HAS to see how things are at the office —— "

She made a pretense of busying herself with unpacking. The chintz-lined, silver-fitted bag which had seemed so desirable a luxury in St. Paul was an extravagant vanity here. The daring black chemise of frail chiffon and lace was a hussy at which the deep-bosomed bed stiffened in disgust, and she hurled it into a bureau drawer, hid it beneath a sensible linen blouse.

She gave up unpacking. She went to the window, with a purely literary thought of village charm — hollyhocks and lanes and apple-cheeked cottagers. What she saw was the side of the Seventh-Day Adventist Church — a plain clapboard wall of a sour liver color; the ash-pile back of the church; an unpainted stable; and an alley in which a Ford delivery-wagon had been stranded. This was the terraced garden below her boudoir; this was to be her scenery for ——

"I mustn't! I mustn't! I'm nervous this afternoon. Am I sick? . . . Good Lord, I hope it isn't that! Not now! How people lie! How these stories lie! They say the bride is always so blushing and proud and happy when she finds that out, but — I'd hate it! I'd be scared to death! Some day but —— Please, dear nebulous Lord, not now! Bearded sniffy old men sitting and demanding that we bear children. If THEY had to bear them ——! I wish they did have to! Not now! Not till I've got hold of this job of liking the ash-pile out there! . . . I must shut up. I'm mildly insane. I'm going out for a walk. I'll see the town by myself. My first view of the empire I'm going to conquer!"

She fled from the house.

She stared with seriousness at every concrete crossing, every hitching-post, every rake for leaves; and to each house she devoted all her speculation. What would they

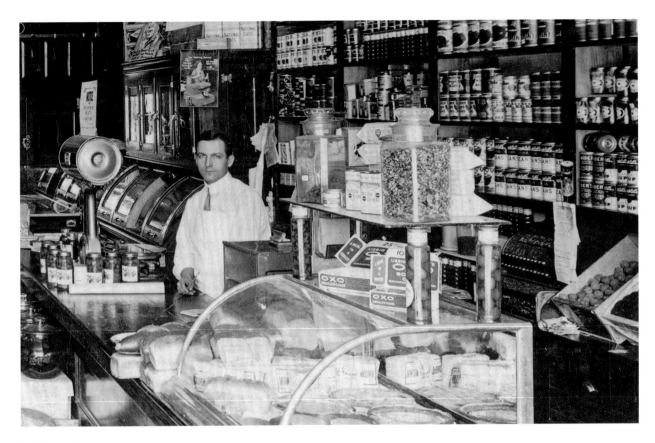

72 (DETAIL)

come to mean? How would they look six months from now? In which of them would she be dining? Which of these people whom she passed, now mere arrangements of hair and clothes, would turn into intimates, loved or dreaded, different from all the other people in the world?

As she came into the small business-section she inspected a broad-beamed grocer in an alpaca coat who was bending over the apples and celery on a slanted platform in front of his store. Would she ever talk to him? What would he say if she stopped and stated, "I am Mrs. Dr. Kennicott. Some day I hope to confide that a heap of extremely dubious pumpkins as a window-display doesn't exhilarate me much."

(The grocer was Mr. Frederick F. Ludelmeyer, whose market is at the corner of Main Street and Lincoln Avenue. In supposing that only she was observant Carol was ignorant, misled by the indifference of cities. She fancied that she was slipping through the streets invisible; but when she had passed, Mr. Ludelmeyer puffed into the store and coughed at his clerk, "I seen a young woman, she come along the side street. I bet she iss Doc Kennicott's new bride, good-looker, nice legs, but she wore a hell of a plain suit, no style, I wonder will she pay cash, I bet she goes to Howland & Gould's more as she does here, what you done with the poster for Fluffed Oats?")

II

When Carol had walked for thirty-two minutes she had completely covered the town, east and west, north and south; and she stood at the corner of Main Street and Washington Avenue and despaired.

Main Street with its two-story brick shops, its story-and-a-half wooden residences, its muddy expanse from concrete walk to walk, its huddle of Fords and lumber-wagons, was too small to absorb her. The broad, straight, unenticing gashes of the streets let in the grasping prairie on every side. She realized the vastness and the emptiness of the land. The skeleton iron windmill on the farm a few blocks away, at the north end of Main Street, was like the ribs of a dead cow. She thought of the coming of the Northern winter, when the unprotected houses would crouch together in terror of storms galloping out of that wild waste. They were so small and weak, the little brown houses. They were shelters for sparrows, not homes for warm laughing people.

She told herself that down the street the leaves were a splendor. The maples were orange; the oaks a solid tint of raspberry. And the lawns had been nursed with love. But the thought would not hold. At best the trees resembled a thinned woodlot. There was no park to rest the eyes. And since not Gopher Prairie but Wakamin was the county-seat, there was no court-house with its grounds.

She glanced through the fly-specked windows of the most pretentious building in sight, the one place which welcomed strangers and determined their opinion of the charm and luxury of Gopher Prairie — the Minniemashie House. It was a tall lean shabby structure, three stories of yellow-streaked wood, the corners covered with sanded pine slabs purporting to symbolize stone. In the hotel office she could see a stretch of bare unclean floor, a line of rickety chairs with brass cuspidors between, a writing-desk with advertisements in mother-of-pearl letters upon the glass-covered back. The dining-room beyond was a jungle of stained table-cloths and catsup bottles.

She looked no more at the Minniemashie House.

A man in cuffless shirt-sleeves with pink arm-garters, wearing a linen collar but no tie, yawned his way from Dyer's Drug Store across to the hotel. He leaned against the wall, scratched a while, sighed, and in a bored way gossiped with a man tilted back in a chair. A lumber-wagon, its long green box filled with large spools of barbed-wire fencing, creaked down the block. A Ford, in reverse, sounded as though it were shaking to pieces, then recovered and rattled away. In the Greek candy-store was the whine of a peanut-roaster, and the oily smell of nuts.

There was no other sound nor sign of life.

She wanted to run, fleeing from the encroaching prairie, demanding the security of a great city. Her dreams of creating a beautiful town were ludicrous. Oozing out from every drab wall, she felt a forbidding spirit which she could never conquer.

She trailed down the street on one side, back on the other, glancing into the cross streets. It was a private Seeing Main Street tour. She was within ten minutes beholding not only the heart of a place called Gopher Prairie, but ten thousand towns from Albany to San Diego:

Dyer's Drug Store, a corner building of regular and unreal blocks of artificial stone. Inside the store, a greasy marble soda-fountain with an electric lamp of red and green and curdled-yellow mosaic shade. Pawed-over heaps of tooth-brushes and combs and packages of shaving-soap. Shelves of soap-cartons, teething-rings, garden-seeds, and patent medicines in yellow "packages-nostrums" for

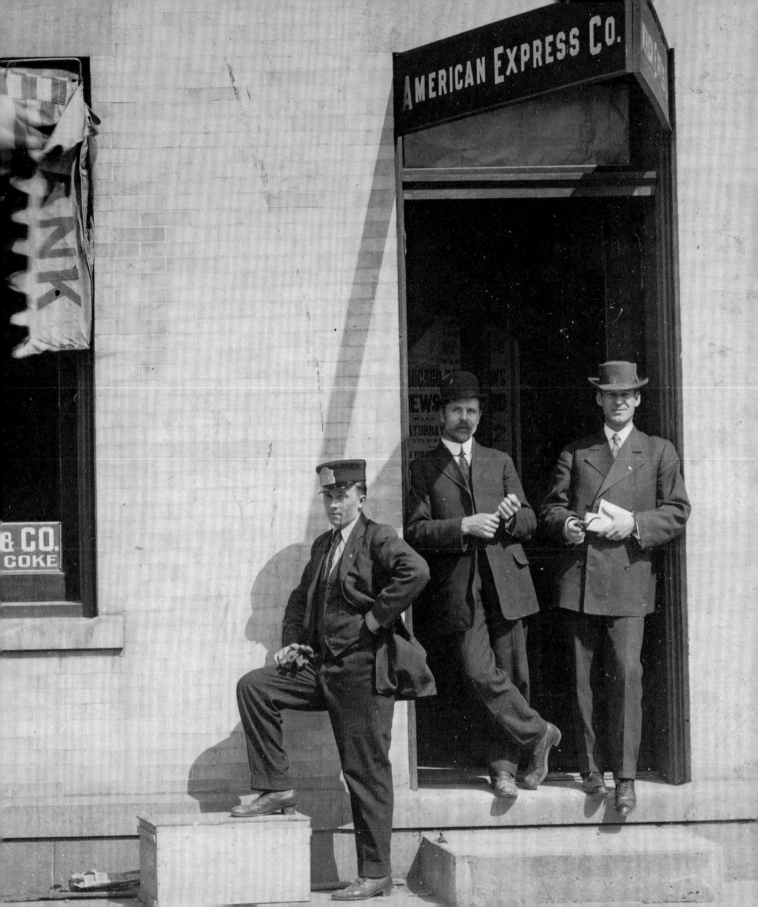

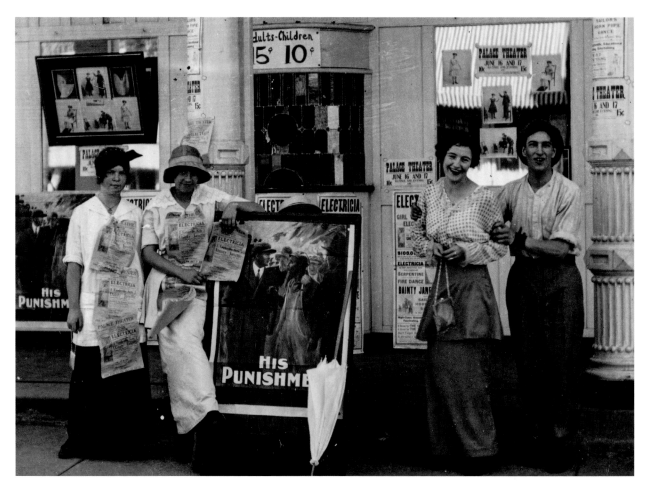

88 (DETAIL)

consumption, for "women's diseases"— notorious mixtures of opium and alcohol, in the very shop to which her husband sent patients for the filling of prescriptions.

From a second-story window the sign "W. P. Kennicott, Phys. & Surgeon," gilt on black sand.

A small wooden motion-picture theater called "The Rosebud Movie Palace." Lithographs announcing a film called "Fatty in Love."

Howland & Gould's Grocery. In the display window, black, overripe bananas and lettuce on which a cat was sleeping. Shelves lined with red crepe paper which was now faded and torn and concentrically spotted. Flat against the wall of the second story the signs of lodges — the Knights of Pythias, the Maccabees, the Woodmen, the Masons.

Dahl & Oleson's Meat Market — a reek of blood.

A jewelry shop with tinny-looking wrist-watches for women. In front of it, at the curb, a huge wooden clock which did not go.

A fly-buzzing saloon with a brilliant gold and enamel whisky sign across the front. Other saloons down the

block. From them a stink of stale beer, and thick voices bellowing pidgin German or trolling out dirty songs — vice gone feeble and unenterprising and dull — the delicacy of a mining-camp minus its vigor. In front of the saloons, farmwives sitting on the seats of wagons, waiting for their husbands to become drunk and ready to start home.

A tobacco shop called "The Smoke House," filled with young men shaking dice for cigarettes. Racks of magazines, and pictures of coy fat prostitutes in striped bathing-suits.

A clothing store with a display of "ox-blood-shade Oxfords with bull-dog toes." Suits which looked worn and glossless while they were still new, flabbily draped on dummies like corpses with painted cheeks.

The Bon Ton Store — Haydock & Simons' — the largest shop in town. The first-story front of clear glass, the plates cleverly bound at the edges with brass. The second story of pleasant tapestry brick. One window of excellent clothes for men, interspersed with collars of floral pique which showed mauve daisies on a saffron ground. Newness and an obvious notion of neatness and service. Haydock & Simons. Haydock. She had met a Haydock at the station; Harry Haydock; an active person of thirty-five. He seemed great to her, now, and very like a saint. His shop was clean!

Axel Egge's General Store, frequented by Scandinavian farmers. In the shallow dark window-space heaps of sleazy sateens, badly woven galateas, canvas shoes designed for women with bulging ankles, steel and red glass buttons upon cards with broken edges, a cottony blanket, a graniteware frying-pan reposing on a sun-faded crepe blouse.

Sam Clark's Hardware Store. An air of frankly metallic enterprise. Guns and churns and barrels of nails and beautiful shiny butcher knives.

Chester Dashaway's House Furnishing Emporium. A vista of heavy oak rockers with leather seats, asleep in a dismal row.

Billy's Lunch. Thick handleless cups on the wet oilcloth-covered counter. An odor of onions and the smoke of hot lard. In the doorway a young man audibly sucking a toothpick.

The warehouse of the buyer of cream and potatoes. The sour smell of a dairy.

The Ford Garage and the Buick Garage, competent one-story brick and cement buildings opposite each other. Old and new cars on grease-blackened concrete floors. Tire advertisements. The roaring of a tested motor; a racket which beat at the nerves. Surly young men in khaki union-overalls. The most energetic and vital places in town.

A large warehouse for agricultural implements. An impressive barricade of green and gold wheels, of shafts and sulky seats, belonging to machinery of which Carol knew nothing — potato-planters, manure-spreaders, silage-cutters, disk-harrows, breaking-plows.

A feed store, its windows opaque with the dust of bran, a patent medicine advertisement painted on its roof.

Ye Art Shoppe, Prop. Mrs. Mary Ellen Wilks, Christian Science Library open daily free. A touching fumble at beauty. A one-room shanty of boards recently covered with rough stucco. A show-window delicately rich in error: vases starting out to imitate tree-trunks but running off into blobs of gilt — an aluminum ash-tray labeled "Greetings from Gopher Prairie" — a Christian Science magazine — a stamped sofa-cushion portraying a large ribbon tied to a small poppy, the correct skeins of embroidery-silk lying on the pillow. Inside the shop, a glimpse of bad carbon prints of bad and famous pictures, shelves of phonograph records and camera films, wooden toys, and in the midst an anxious small woman sitting in a padded rocking chair.

A barber shop and pool room. A man in shirt sleeves, presumably Del Snafflin the proprietor, shaving a man who had a large Adam's apple.

Nat Hicks's Tailor Shop, on a side street off Main.

A one-story building. A fashion-plate showing human pitchforks in garments which looked as hard as steel plate.

On another side street a raw red-brick Catholic Church with a varnished yellow door.

The post-office — merely a partition of glass and brass shutting off the rear of a mildewed room which must once have been a shop. A tilted writing-shelf against a wall rubbed black and scattered with official notices and army recruiting-posters.

The damp, yellow-brick schoolbuilding in its cindery grounds.

The State Bank, stucco masking wood.

The Farmers' National Bank. An Ionic temple of marble. Pure, exquisite, solitary. A brass plate with "Ezra Stowbody, Pres't."

A score of similar shops and establishments.

Behind them and mixed with them, the houses, meek cottages or large, comfortable, soundly uninteresting symbols of prosperity.

In all the town not one building save the Ionic bank which gave pleasure to Carol's eyes; not a dozen buildings which suggested that, in the fifty years of Gopher Prairie's existence, the citizens had realized that it was either desirable or possible to make this, their common home, amusing or attractive.

It was not only the unsparing unapologetic ugliness and the rigid straightness which overwhelmed her. It was the planlessness, the flimsy temporariness of the buildings, their faded unpleasant colors. The street was cluttered with electric-light poles, telephone poles, gasoline pumps for motor cars, boxes of goods. Each man had built with the most valiant disregard of all the others. Between a large new "block" of two-story brick shops on one side, and the fire-brick Overland garage on the other side, was a one-story cottage turned into a millinery shop. The white temple of the Farmers' Bank was elbowed back by a grocery of glaring yellow brick. One store-building had a patchy galvanized iron cornice; the building beside it was crowned with battlements and pyramids of brick capped with blocks of red sandstone.

She escaped from Main Street, fled home.

She wouldn't have cared, she insisted, if the people had been comely. She had noted a young man loafing before a shop, one unwashed hand holding the cord of an awning; a middle-aged man who had a way of staring at women as though he had been married too long and too prosaically; an old farmer, solid, wholesome, but not clean — his face like a potato fresh from the earth. None of them had shaved for three days.

"If they can't build shrines, out here on the prairie, surely there's nothing to prevent their buying safety-razors!" she raged.

She fought herself: "I must be wrong. People do live here. It CAN'T be as ugly as — as I know it is! I must be wrong. But I can't do it. I can't go through with it."

She came home too seriously worried for hysteria; and when she found Kennicott waiting for her, and exulting, "Have a walk? Well, like the town? Great lawns and trees, eh?" she was able to say, with a self-protective maturity new to her, "It's very interesting."[1]

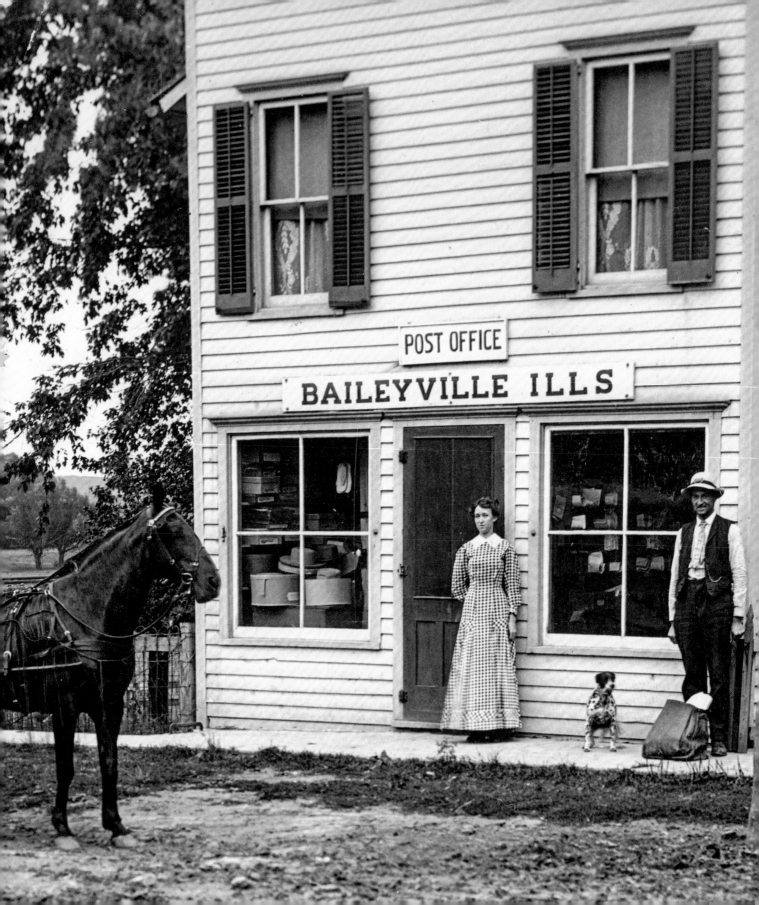

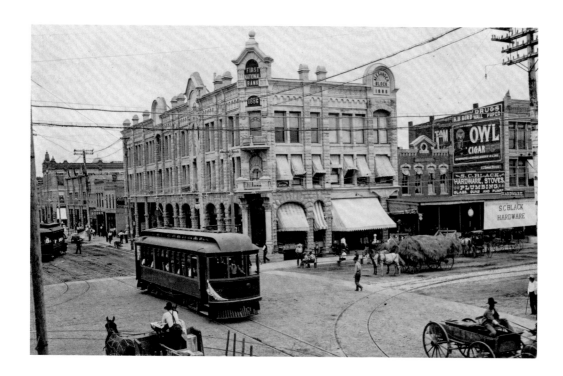

53
Ninth and Main, Winfield,
Kansas, 1909

54
Amish market,
Lancaster,
Pennsylvania, 1925

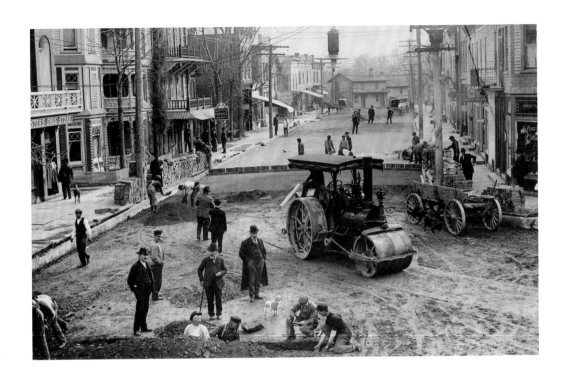

55
Street paving, Wyalusing,
Pennsylvania, 1907 or later

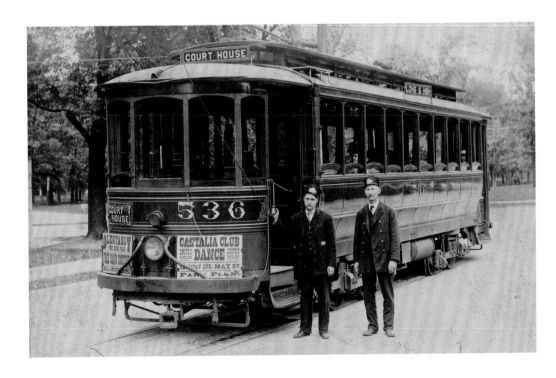

56
Streetcar, Columbus, Ohio,
1909 or later

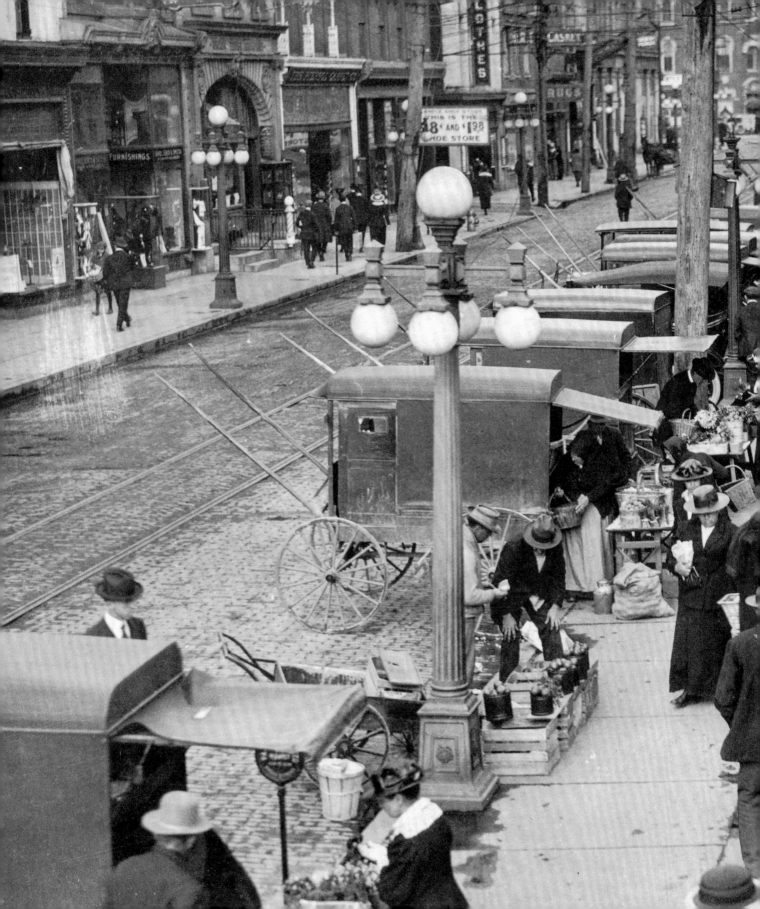

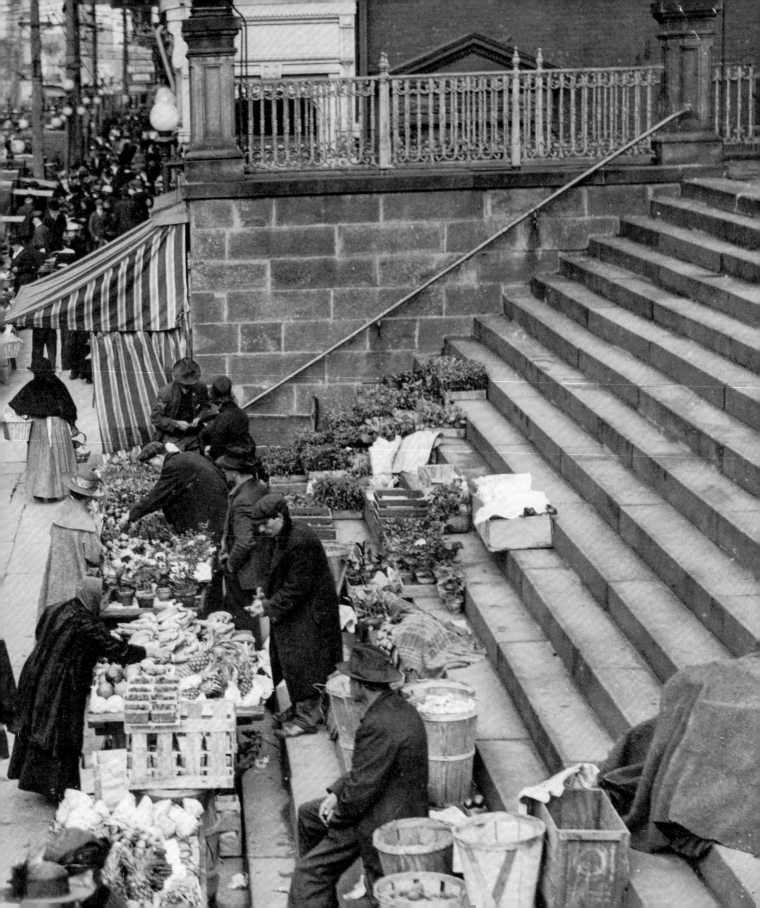

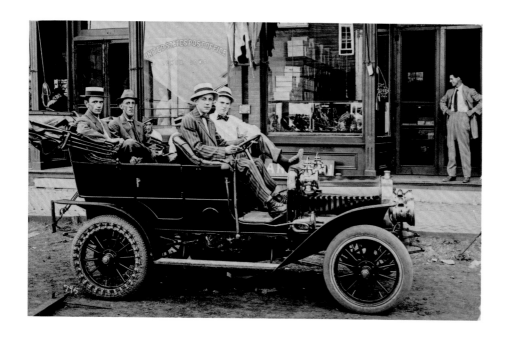

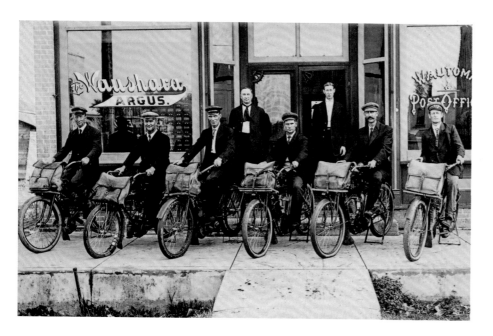

57

Outside the post office, Lenox,
Iowa, 1909 or later

58

Mail carriers, Wautoma, Wisconsin,
about 1914

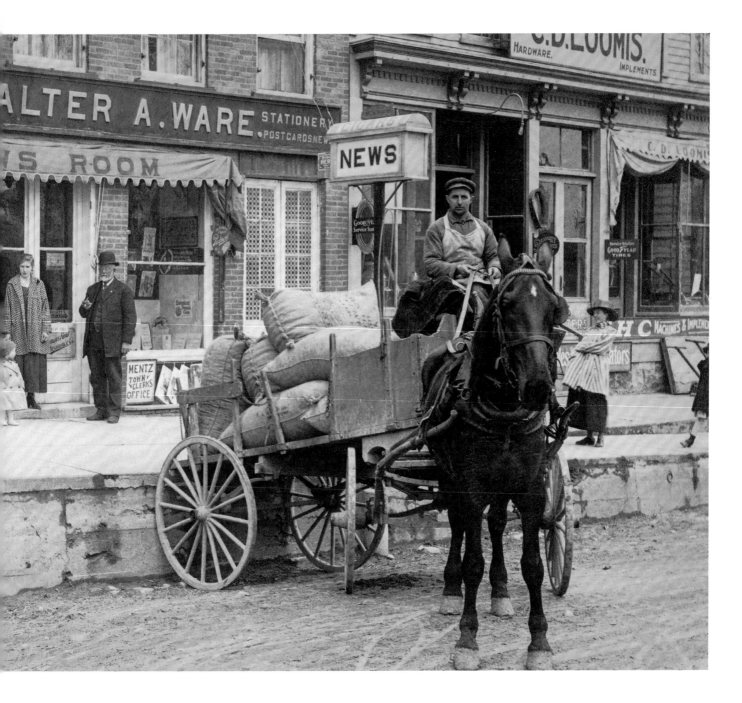

59

Walter A. Ware Stationers,
Mentz, New York, about 1914

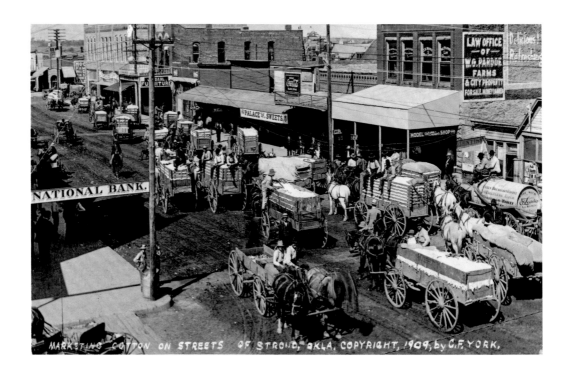

60

Marketing Cotton, 1909

C. F. YORK

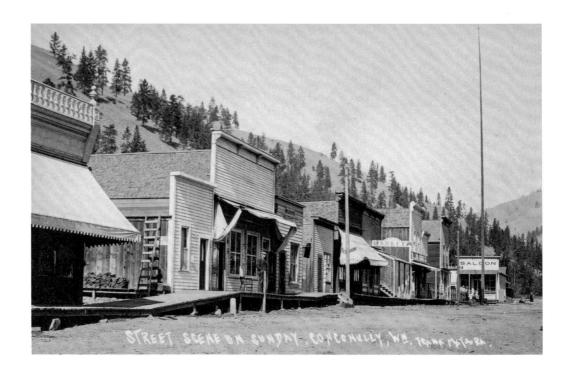

61

Street Scene on Sunday,
about 1914

FRANK MATSURA

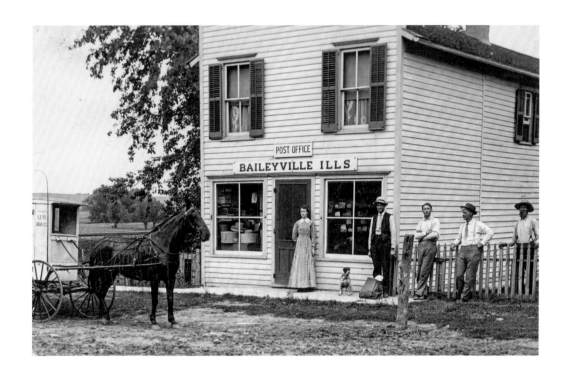

62

Post office, 1911

GEM PHOTO CO.

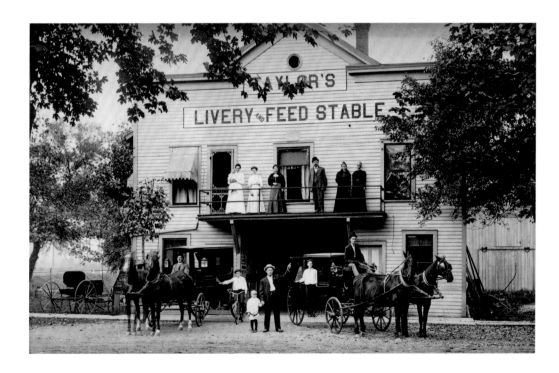

63

Taylor's Livery, Seville, Ohio, 1909 or later

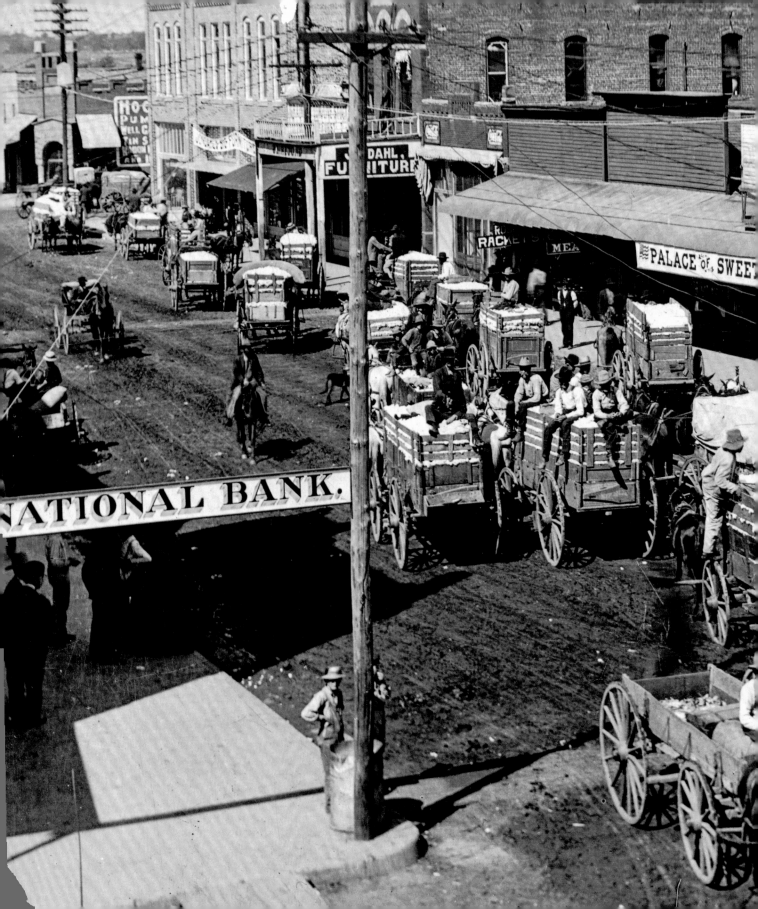

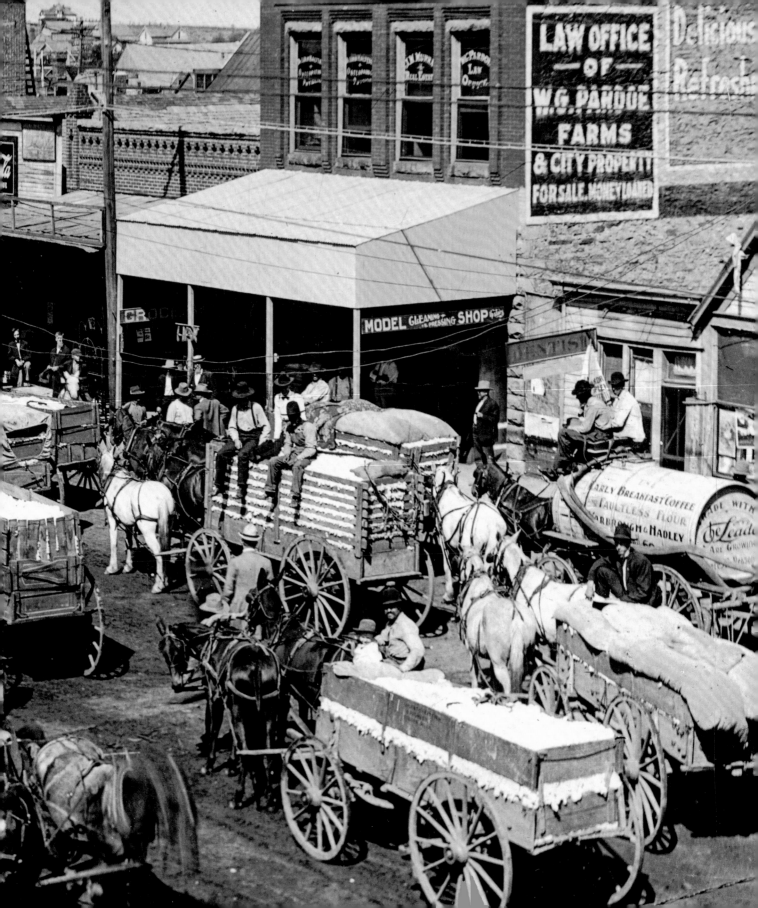

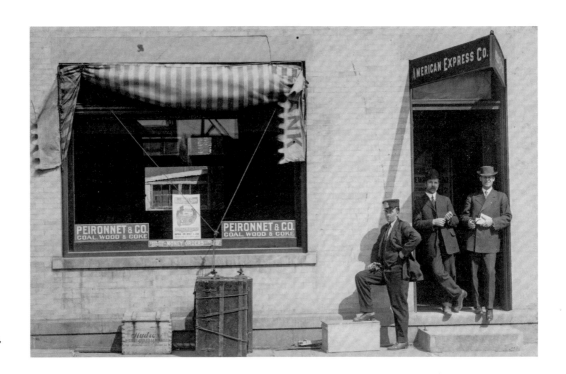

64
American Express, Chicago,
Illinois, about 1914

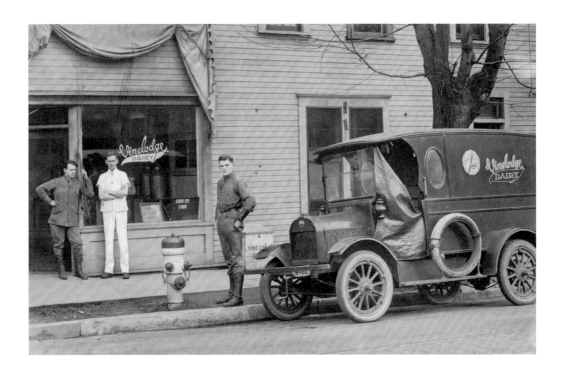

65
Vinelodge Dairy, Portland,
Oregon, 1915 or later

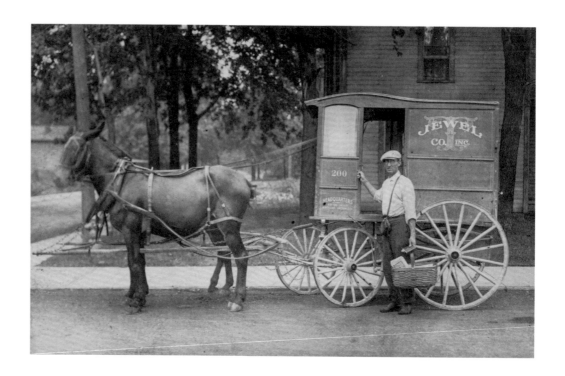

66
Jewel Company
Incorporated wagon,
1919

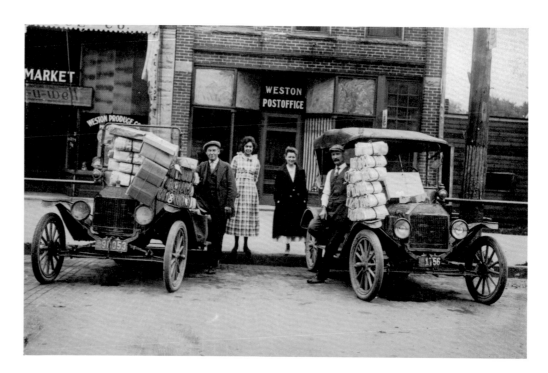

67
Post office, Weston, Ohio,
1917 or later

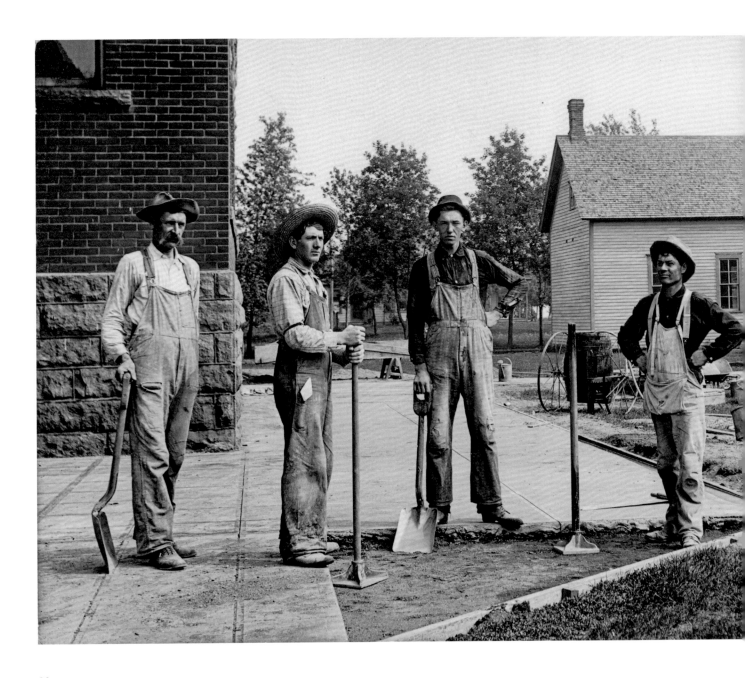

68
Cement workers, about 1914

69
State Road, Cuba, New York, 1910

H. F. WILCOX

70
Street laborers, Pratt, Kansas, about 1914

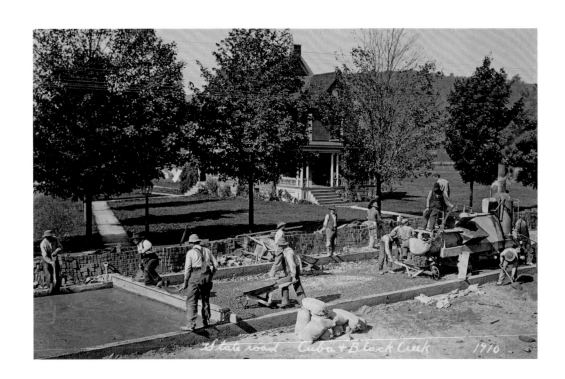

State road Cuba + Black Creek 1910

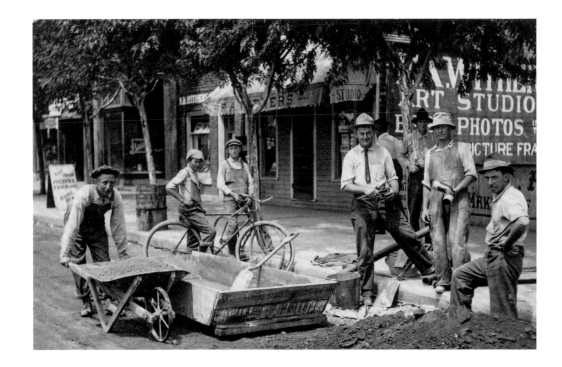

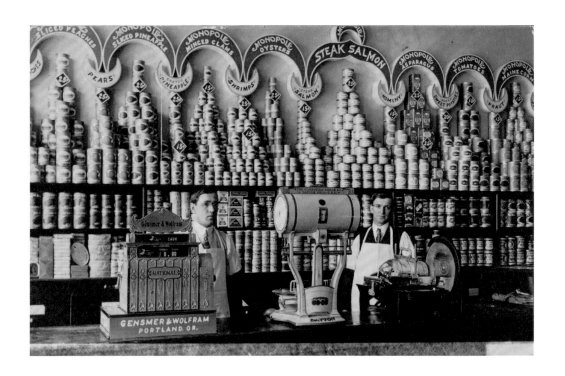

71
Gensmer & Wolfram
grocery, 1913

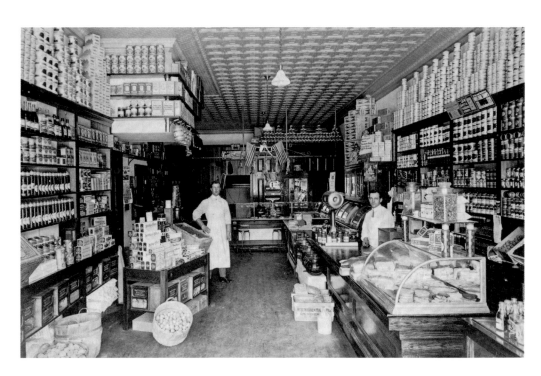

72
Grocers, 1913

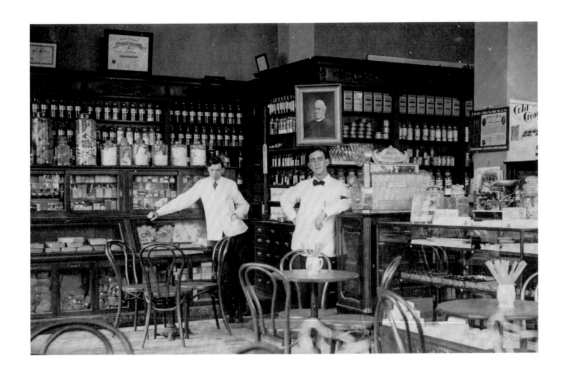

73
Pharmacists, 1907 or later

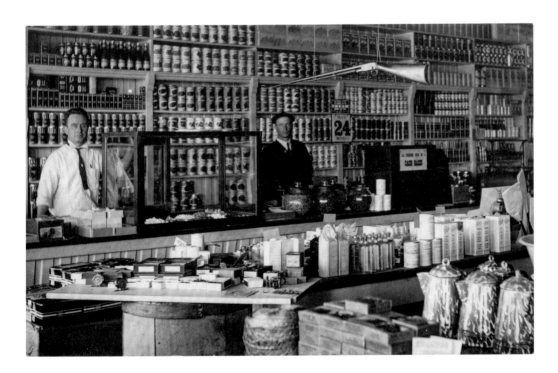

74
Hunting and fishing shop,
about 1914

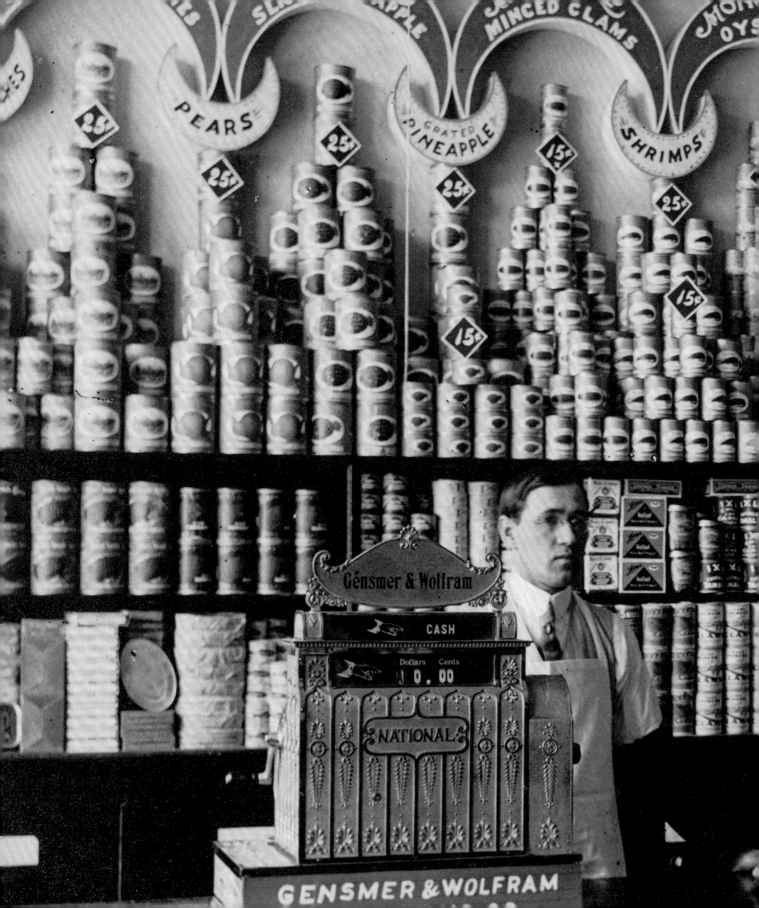

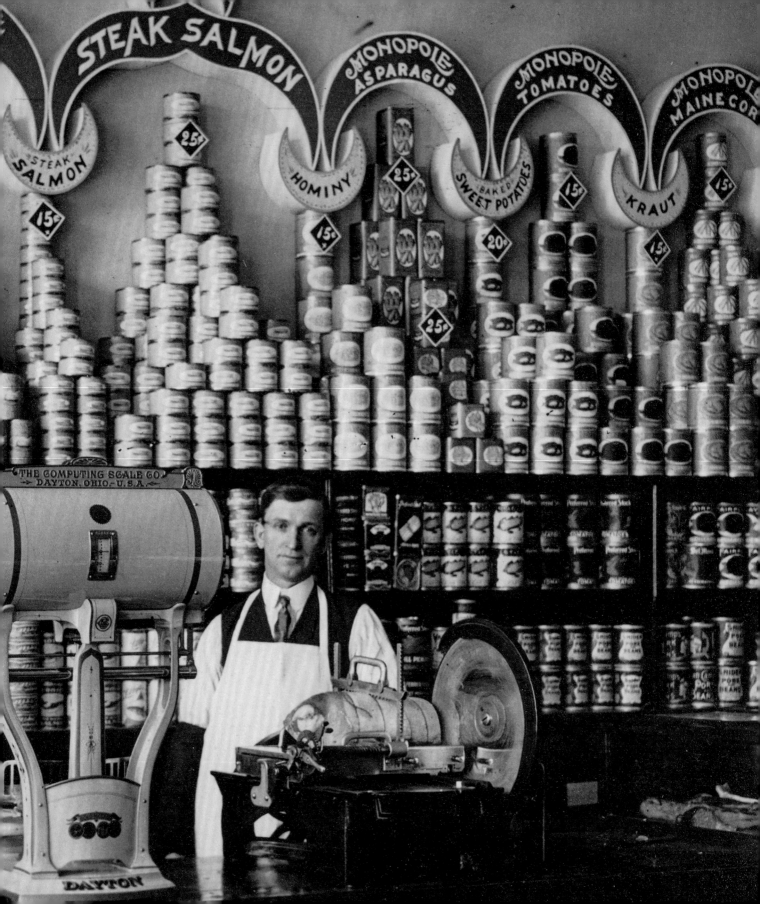

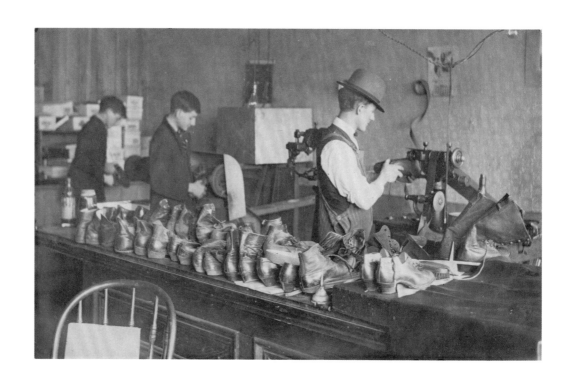

75
Cobblers, 1907 or later

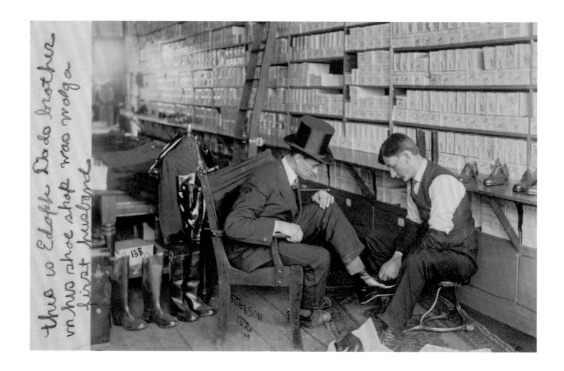

76
Shoe store, 1909
PETERSON PHOTO

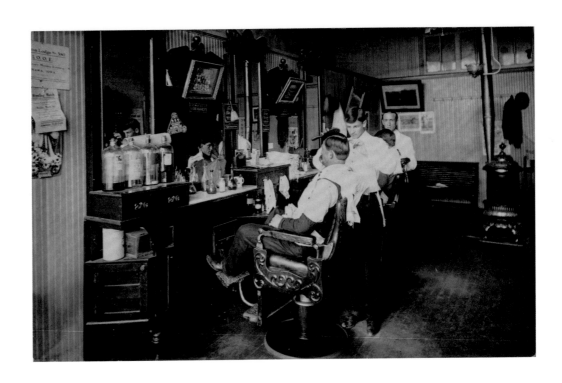

77
Barbershop, 1907 or later

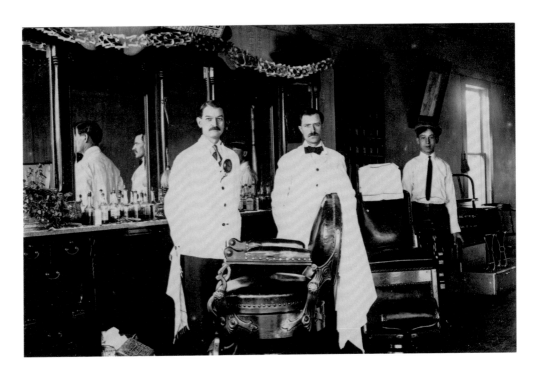

78
Barbers, 1911 or later

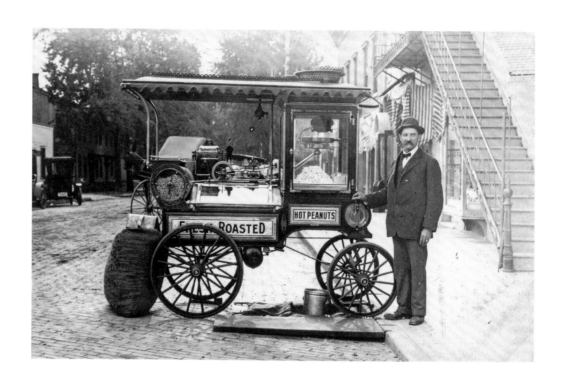

79
Roasted peanut cart, 1910
or later

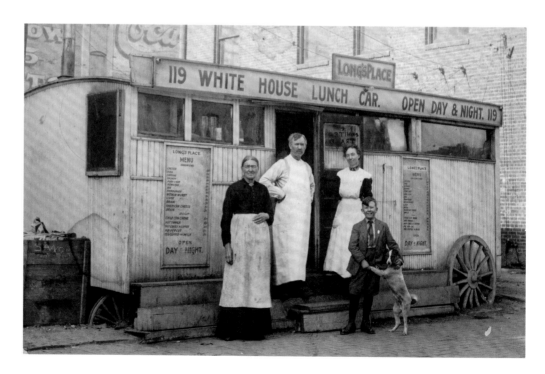

80
Long's Place lunch car,
about 1914

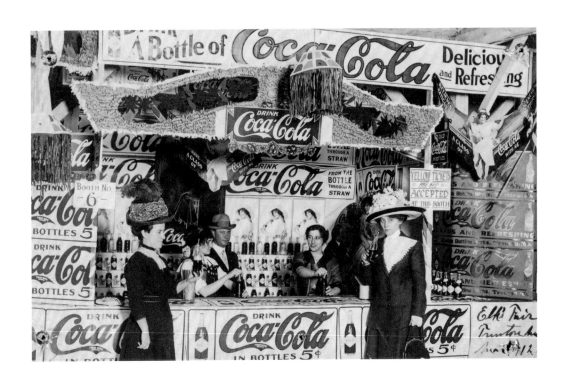

81
Coca-Cola stand, 1912

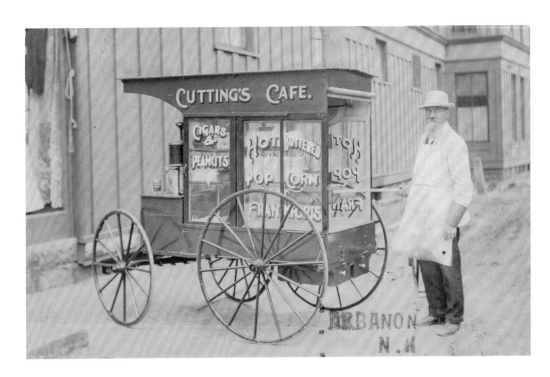

82
Cutting's Cafe, 1909

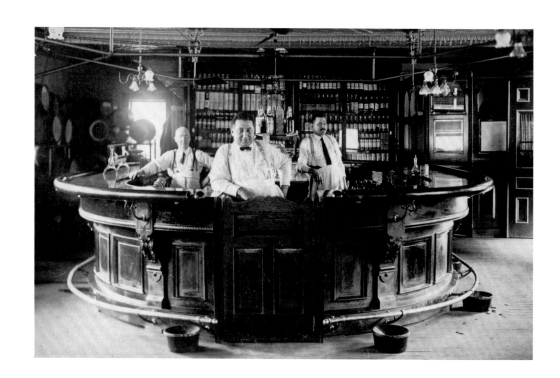

83
Bartenders, 1910 or later

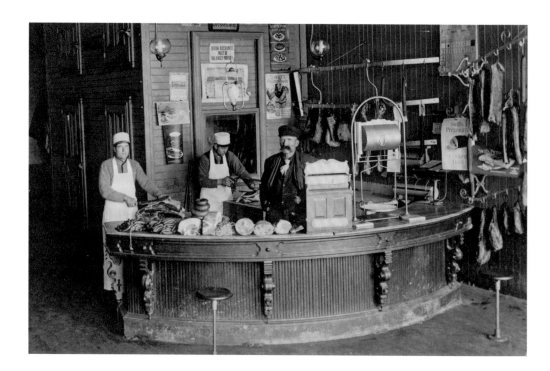

84
Butcher shop, Mabel,
Minnesota, 1909–10

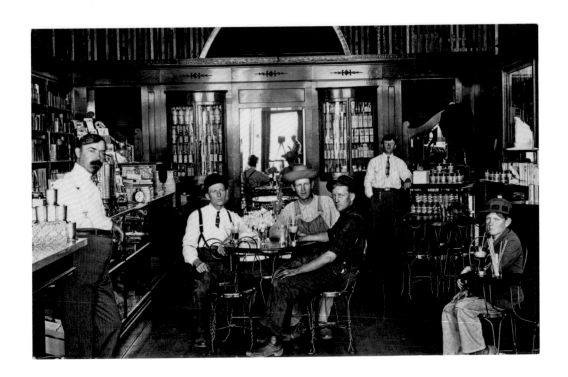

85
Men drinking, about 1914

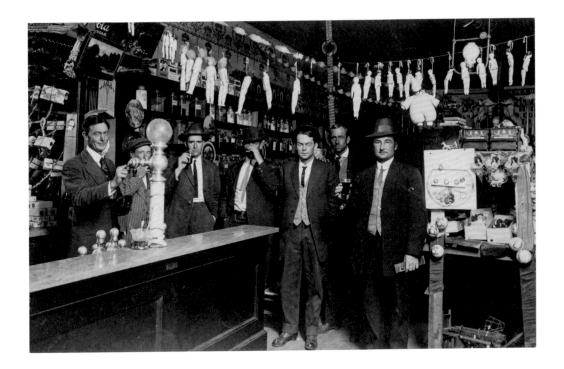

86
Men drinking, about 1914

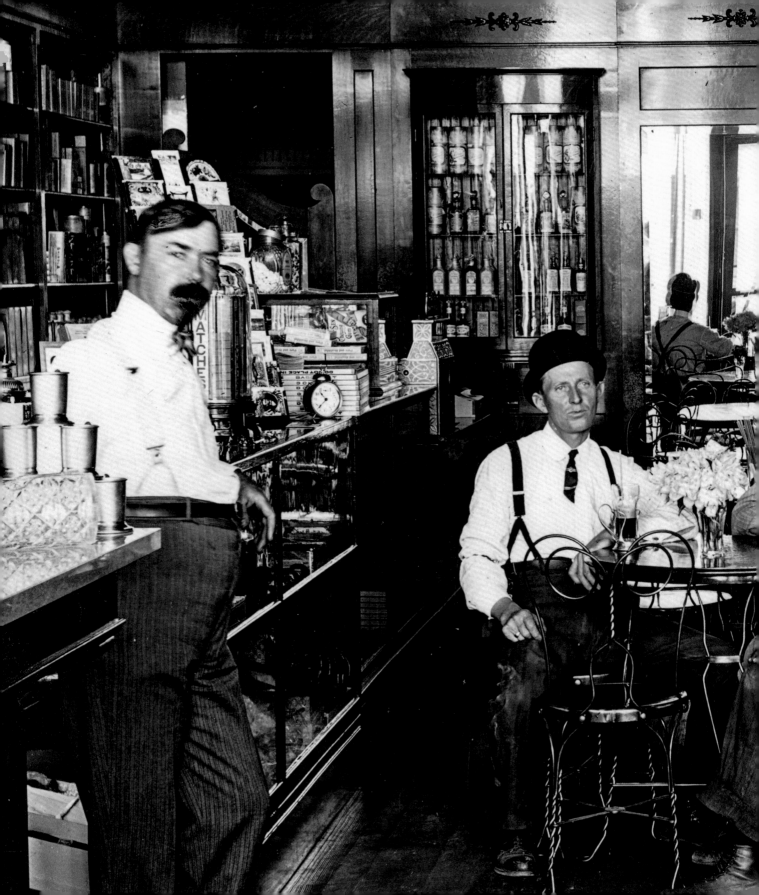

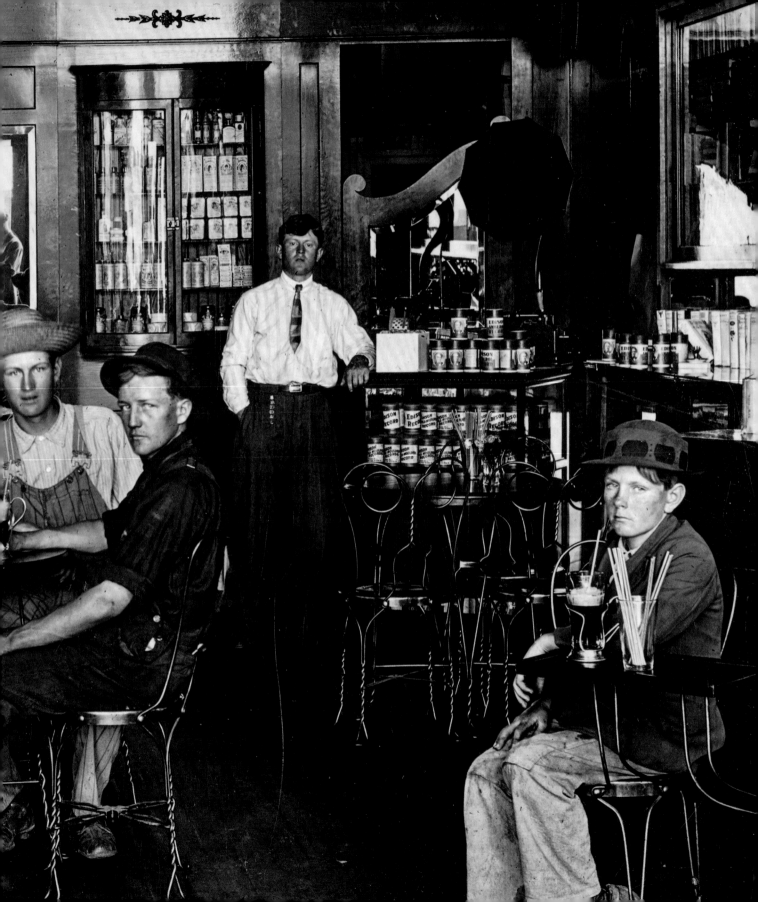

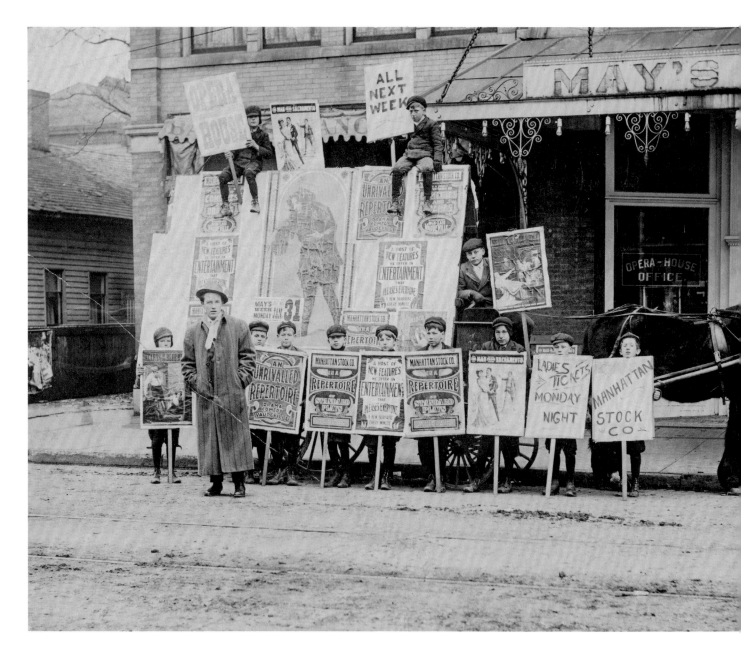

87
Advertising for the Manhattan
Stock Company, Piqua, Ohio, 1910

88
Electricia, the Woman Who Tames
Electricity, 1912

89
Dreamland Theatre, Kewanee,
Illinois, about 1910

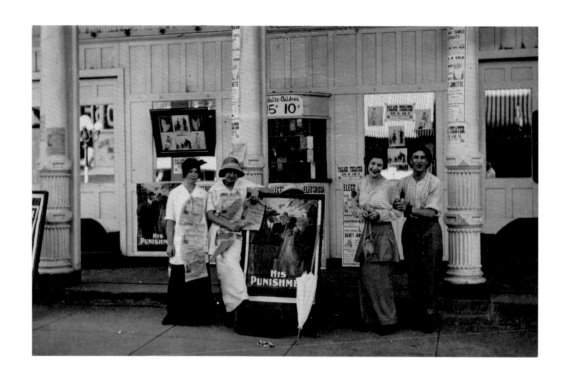

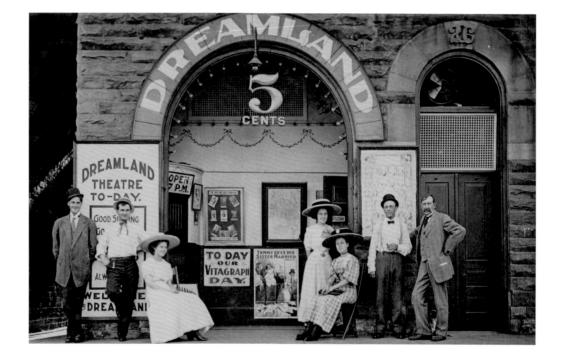

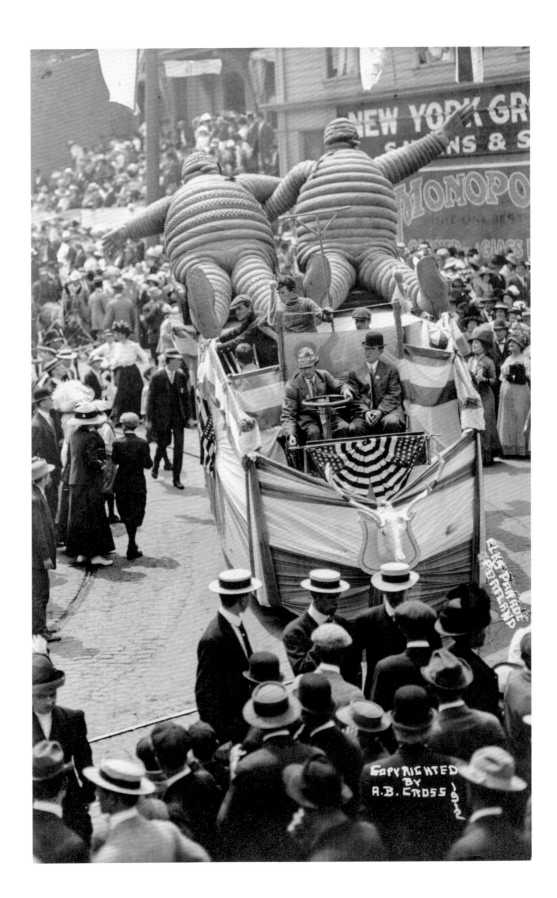

90
Elks Parade, Portland,
Oregon, 1912
ARTHUR B. CROSS

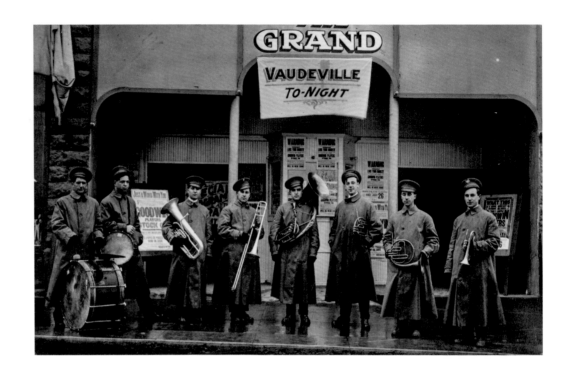

91
Grand Theater, Clarkston,
Washington, about 1923

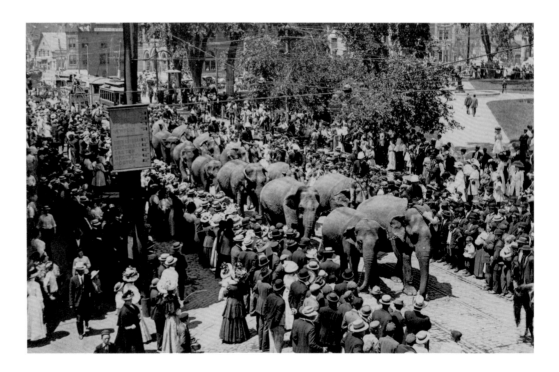

92
Forepaugh and Sells Circus,
Taunton, Massachusetts,
1907 or later

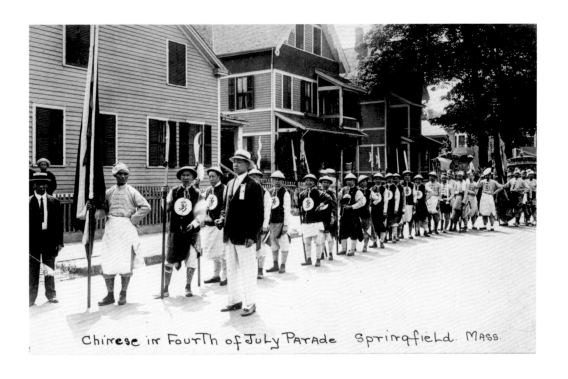

Chinese in Fourth of July Parade Springfield. Mass.

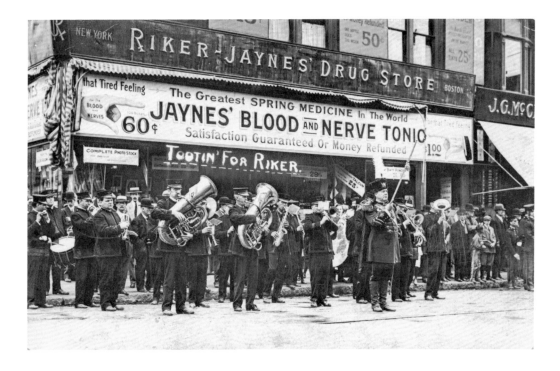

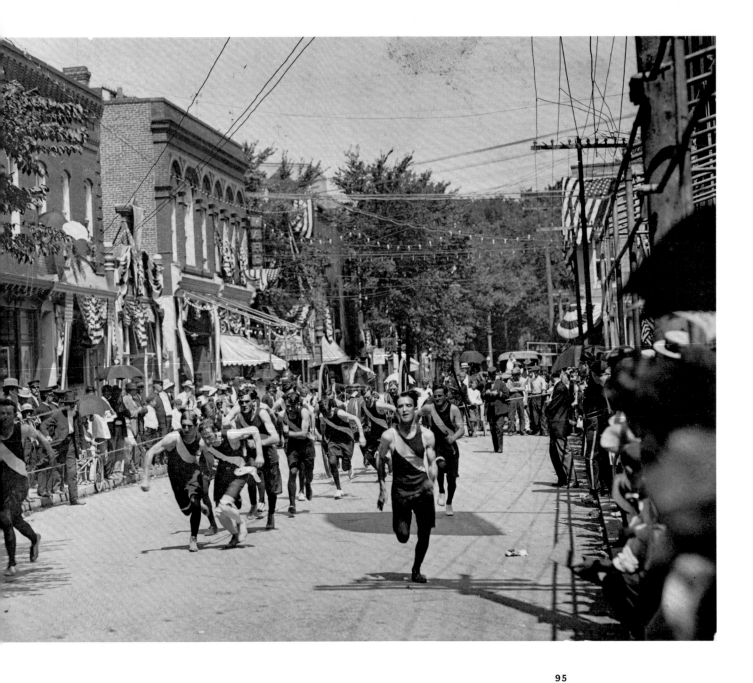

95
Foot race, 1909 or later

93
Chinese in Fourth of July Parade,
about 1914

94
Tootin' for Riker, Brockton,
Massachusetts, 1911

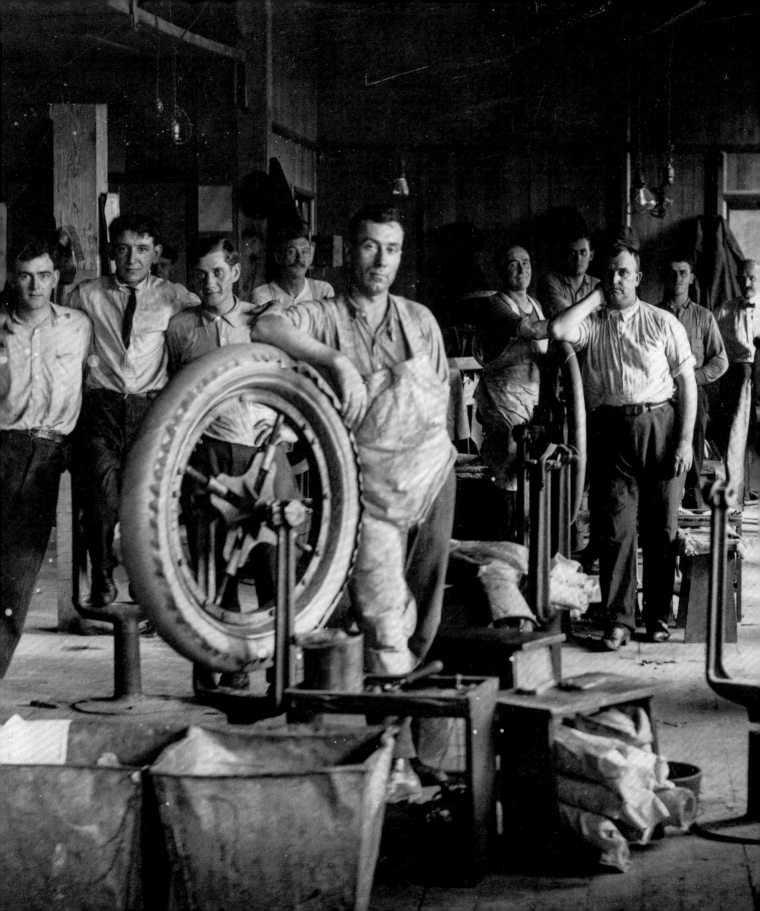

Democracy, at Work | JEFF L. ROSENHEIM

Soon after the Eastman Kodak Company and other American photography manufactures introduced specialty format postcard cameras and bespoke film sizes around 1903, the real photo postcard became omnipresent in small towns and large cities across the United States. Legions of mostly unidentified picture makers, professionals and amateurs alike, crisscrossed the country to work their trade inside classrooms of wary first-graders (see **13**); beside railroad tracks of folks heading to and from the depot (see **286**); and lakeside of proud anglers with their catch (**114**). Postcard photographers documented scenes worthy of Walt Whitman and seldom, if ever, recorded in other photographic formats: sturdy women quilting together in the shade (see **300**), farmers feeding their happy hens (see **8, 9**), trolley conductors in their cars awaiting passengers (**131**). They also recorded for posterity the era's social ills such as the harsh reality of unregulated child labor in factories and fields (see **12**). Such is the attraction, authenticity, and poignancy of photo postcards to historians and picture collectors. It is also what often distinguishes these miniature treasures overflowing with real-life stories from other types of photographs produced in the first two decades of the twentieth century.

A comparative study of postcards of workers at work in their place of employment (on the farm, in the factory, in small offices, on main street) and of workers at rest (posing inside photography studios wearing their occupational garments and pictured with their tools) — offers the viewer an opportunity to explore an America seldom seen. These often anonymous, but always intimate photographs record a nation at the precipice of great technological change and reveal how Americans viewed themselves, their occupations, and their place in society.

The vast majority of real photo postcards were made just about everywhere except within a photographer's studio, as earnest picture makers and ersatz entrepreneurs hit the road, leaving in the dust their brick-and-mortar studios to capture scenes in situ. In one example, seventeen laborers pause from their work assembling automobile tires inside a windowed garage (**96**). Each man is clearly illuminated, precisely arranged by the photographer to properly show their faces and respective body language. The photograph constructs a virtual assembly line of men, some in shirtsleeves, others in overalls, a few in neckties. Per the advertisement hanging on the wall, the location is Akron, Ohio, home of the American tire industry. Harvey Firestone established his business there in 1900 and two years later opened his first factory with twelve men. Might this be a view of that original business? Firestone's remarkable success and lucrative partnership with Henry Ford generated immediate wealth and healthy competition.

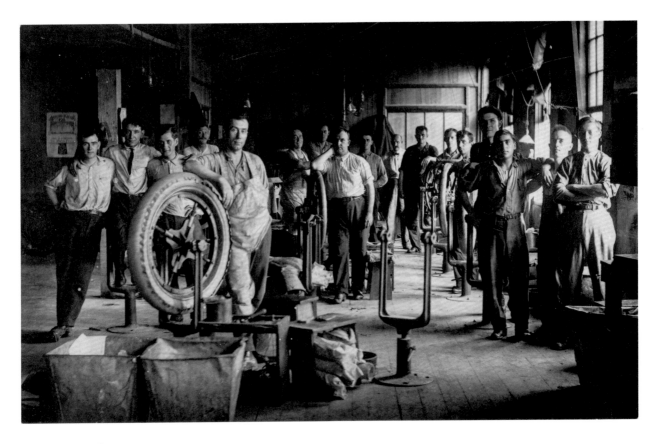

96 Tire factory, about 1914

Together with its archrivals, Goodyear and B.F. Goodrich, the companies imported so much rubber that Akron was soon dubbed "the Rubber Capital of the World."

In a purely symbolic way, the postcard presents a legion of soldiers in service to the United States of Ford; their heroic "General Washington" rests his arm on a tire and wears appropriate battledress: overalls. Despite its natural verisimilitude, it is not easy to determine what work the men in the postcard are actually doing, but perhaps they are affixing the outer skins of tires, or non-skid treads. What is certain is that the massive factories built in Ohio in the 1910s to cater to the nation's hunger for automobiles brought workers to the Midwest from all across the country, especially from rural communities. For better or worse, the Model T (introduced in 1908), and the human migration that built and consumed the vehicles, transformed America within a single generation. As Barry Byrne, an architect and disciple of Frank Lloyd Wright, succinctly expressed it: "The evil genius of our time is the car."[1]

Postcard photographers also ventured into more intimate interior spaces than factories, producing images of surprising rarity. Among the more interesting are those made in the often-cramped inner sancta of central telephone exchanges and small-town post offices. In both locations, the surviving real photo postcards provide culturally important source documentation that women

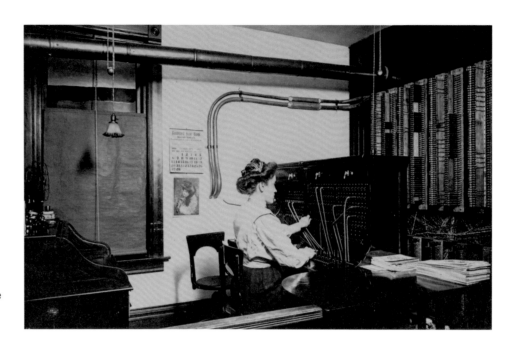

97 Rose Lekivetz, telephone operator, 1910
GEORGE L. SWENSON

found reliable employment in the 1900s–10s at the dawn of the era of respectable and safe women's work outside the home. Working women were often the heart of the nation's communication networks, manually connecting (by cable) callers to each other, and letters and postcards from their writers to their destinations and recipients. Their jobs — critical components of an early social network — offered economic independence and positive self-identity to a rapidly growing workforce of professional women.

Before the turn of the twentieth century, private telephone companies were fast at work stringing lines across the country and establishing a national telephone system, connecting rural residents to those in nearby communities, and to urban dwellers from coast to coast. The wires ran on poles along railroad tracks (following the previous routes used by the telegraph) and beside the nation's new roadways that connected locations not served by train. This offered good jobs at least temporarily for large teams of linemen (**132**), and even longer employment for women

working in the exchanges like Rose Lekivetz, one such telephone exchange operator in rural Rushford, Minnesota (**97**). Born Rose Kangel in 1886, she married John "Jack" Lekivetz on May 25, 1910, just three months after a local photographer, George L. Swenson, made this occupational portrait. The picture's date (February 1910) comes from the wall calendar behind Rose, Swenson's name and studio location are printed on the card's verso, and Rose's name is given in a family member's helpful inscription. Using these data points, her son's published ancestry narrative can be found, describing how "Mother Rose only went four grades in school, and learned to be a terrific plain writer and speller, teaching me the same of which I took small prizes at 'county fairs.'"[2] He also noted that his mother "was a hired girl and also a telephone operator at Minnesota." Rose gave birth to her son on May 12, 1911, left her position at the telephone exchange, raised a family, and died in 1966 in Riceton, Saskatchewan. Her son, Leonard, married, raised his own family, and lived with his

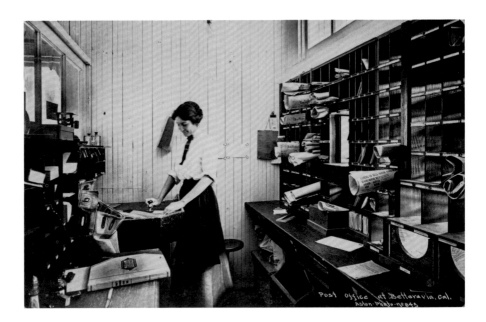

98 Post Office, Betteravia, California, 1911 or later
ASTON PHOTO

mother on the large family farm in Canada until 1953. All this rich history is gleaned from a seemingly ordinary real photo picture postcard.

Like the dramatic expansion of paved highways and improved steel bridges constructed to provide safer roadways for the expanding American driving public, the rapid increase of nationwide home mail delivery in the first decade of the twentieth century (often by automobile) was spurred by the enormous increase in postal business around 1900. This was likewise increased by mass migration across the country that in turn generated the mailing of penny postcards, both real photo postcards and, much more commonly, handsomely colored photolithographic cards.

It may be surprising to many that the vast majority of postal office workers in America in the first decades of the twentieth century were women. In her tidy shirtsleeves and tie, an anonymous clerk in a small post office serving just 350 residents cancels a piece of mail in Betteravia, California (**98**). The location was a planned company town in northern Santa Barbara County named for the French word for sugar beet roots. Established by the United Sugar Refining Company in 1897, the farm and community consisted of sixty-five cottages, a hotel, a church, a schoolhouse, an amusement hall, a general store, a gasoline station, a fire department, and yes, a post office. By 1908, the factory processed one thousand tons of beetroot per day harvested from some sixty-five hundred acres of sugar beets. The company and its successors thrived during the two world wars and during the Korean War as well, but in 1993, after the last major corporate owner of the factory, Sara Lee, abandoned its operations, Betteravia became a ghost town. While the business may not survive, this postcard offers an enduring image of what was in its day a thriving community.

Most of the postcards in the Lauder Archive are not stamped, addressed, or even annotated. This is equally the case in the majority of other similar collections and suggests that either the picture owners considered the cards too valuable or personally important to write on and post,

or they placed the cards in envelopes before letting them fly away. This provides an ongoing challenge for historians: what is to be gleaned about American industry or labor in these occupational photographs? Unfortunately, very little is known about why most of these cards were made, or for whom. In many cases, it may never be clear even where they were made, or whom they actually depict. Despite their seeming clarity, all photographs are tricky and their facticity is sometimes hard to interpret. As the renowned street photographer Garry Winogrand would repeatedly tell his students, "There is nothing as mysterious as a fact clearly described." Here, it is much easier to parse the postcards' graphic qualities, their no-nonsense, vernacular style, and how the picture makers took advantage of the customary drama of diverse work environments (factory floor, shop, and farm) to construct images that beguile the viewer even if he or she does not exactly know the difference between tire manufacturing and retreading; sewing and quilting; wheat from young corn. Despite the postcard's ubiquity, the actual period consumers of all these delightful scenes, and to whomever they may have been sent, remain, perhaps unsurprisingly, rather difficult to determine.

The clientele, however, for the large number of equally captivating postcards of workers posing inside portrait studios is much easier to establish: it was most certainly the sitters themselves and their extended family. For reasons of their own and not the photographers', a wide variety of enterprising women and men knocked on the proprietors' doors and requested their likenesses. These particular sitters chose to wear their work clothes, not their Sunday best. Perhaps more interestingly, they often brought with them the specific tools of their trades: pails of paint and miners' headlamps, rolling pins and rifles; ice tongs, mailbags, axes, and sewing machines (**99**).

The generally anonymous individuals posed themselves as they were, at ease and comfortable on their

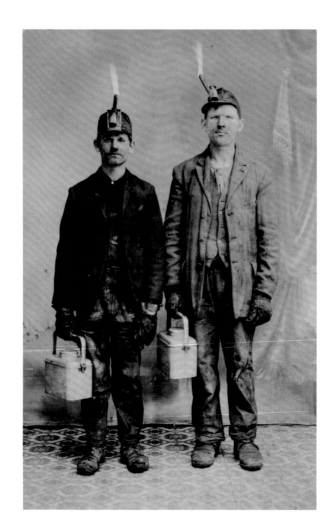

99 Coal miners, Scranton, Pennsylvania, 1910 or later

feet, contented to show off their paraphernalia and special garb. In contemporary terms, they owned their own experience before the camera and usually left the studio with a unique likeness about which little else may ever be known. These portraits were made exclusively for the subjects themselves and generally did not circulate in a marketplace controlled by the photographer or her/his agents.

Collectively, these postcards offer a rare view of modern America in the making — one constructed by the

people, for themselves. The era of the real photo postcard was fraught with great societal change: the mass exodus of Americans from farm communities to cities; the advance of technology from coast to coast in the form of the mass-produced automobile; and a brutal world war. The body politic was in flux and, for the first time in decades, many Americans did not know their immediate neighbors nor their fellow laborers in the workplace. As life became more fragmented and anonymous, society expressed itself in inexpensive portrait photographs. As the British psychologist Halla Bellof noted: "The more fragile our identity, the more we need to reinforce it. To show that we exist. To show that we can create something, in a photograph."[3]

In celebrating the lives and physical manners of workers, these humble photo postcards offer us an anatomy — perhaps even a connoisseurship — of the common man. A legion of dedicated studio portraitists used their skills to pose the figures and to carefully record their physiognomies and distinctive tools. As a graphic genre, these photographs update the centuries-old, primarily European printmaking tradition known interchangeably as small trades, street cries, and *petit métiers*. Here, the subjects are real, not idealized or stereotyped as seen in large numbers of popular seventeenth- and eighteenth-century engravings frequently released to the buying public with English, French, Italian, and Dutch captions.

While the occupational street and environmental portraits revel in their dynamic groupings of workers and architecturally dramatic settings — trains, factory floors, shops, and haberdasheries — the studio portraits tend to be more psychologically measured, focused primarily on individuals set against a neutral backdrop (**100**). As such, these particular worker portraits seem more closely linked to the medium's nineteenth-century beginnings — to daguerreotypes, ambrotypes, and tintypes sold with brass mats and pressed leather cases, featuring sitters in the studio with the tools of their trade. With characteristic daguerreian detail, an anonymous mason with his trowel and spirit level; a carpenter loaded up with his saw, plane, hatchet, caliper, and framing square; or a tinsmith with his red-hot soldering iron heater, for example, all evoke their immediate precedent of painted occupational portraits such as that of Paul Revere by John Singleton Copley. Taking all these portraits together one can easily hear Walt Whitman's glorious warble from his 1855 *Leaves of Grass*, the nation's finest elegy about the beauty of the American experience (and the poet's deep connection to it):

> *The pure contralto sings in the organ loft,*
> *The carpenter dresses his plank. . . .the tongue of*
> *his foreplane whistles its wild ascending lisp,*
> *The married and unmarried children ride home*
> *to their thanksgiving dinner,*
> *The pilot seizes the king-pin, he heaves down*
> *with a strong arm,*
> *The mate stands braced in the whaleboat,*
> *lance and harpoon are ready,*
> *The duck-shooter walks by silent and cautious*
> *stretches,*
> *Deacons are ordained with crossed hands at*
> *the altar,*
> *The spinning-girl retreats and advances to the*
> *hum of the big wheel,*
> *The farmer stops by the bars of a Sunday and*
> *looks at the oats and rye . . .*[4]

The real photo postcard studio portraits also look back to the era of the carte de visite in the years bracketing the U.S. Civil War. Unlike the cased objects and painting mentioned above, these highly collectible portable likenesses were mass marketed, produced on thick paper mounts, and sold unframed. After Queen Victoria began

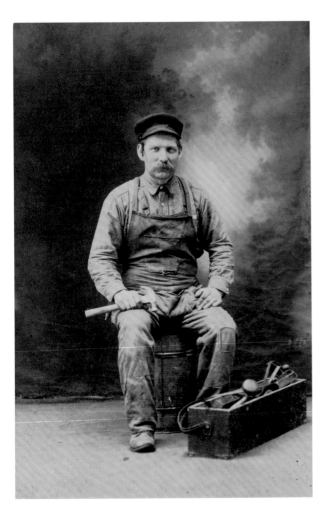

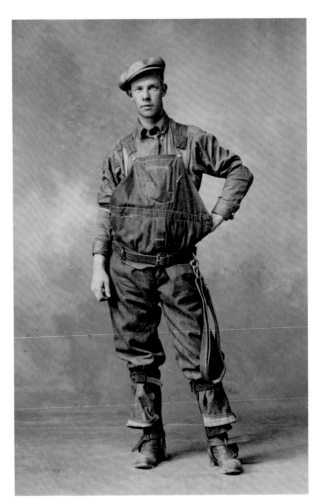

100 Man with toolbox, about 1923

101 Lineman, about 1918

actively collecting them, the international craze for this paper photography format (carteomania, it was named) was quickly exploited by photographers worldwide. The small size (4 by 2½ inches) and inexpensive price allowed most Americans the first opportunity to acquire high-quality portraits of their family and friends, world leaders, theatrical performers, and regional types. This large body of portraits, usually housed in small albums seamlessly blending private and public likenesses, marks the moment

in the nineteenth century when the western world (with the advent of steam power, the railroad, the camera, and the electric telegraph) slowly became interested in historic preservation and cultural memory.

One card shows a well-dressed, pole-climbing lineman from Aberdeen, South Dakota (**101**). His is a dangerous high-wire act, and the confident, rugged worker seems as ready to climb fifty feet and connect Aberdeen to Sioux Falls as he is to hook up with a Hollywood starlet in a King

Vidor silent film. The worker's bespoke outfit with its many leather belts and buckles, spiked climbing irons, and other tools is typical and used for climbing and safely strapping the lineman to wooden poles. The job is equal parts electrician, mechanic, aerialist, carpenter, and fireman. The personal protective equipment worn helps insulate the worker from both low-level voltage used for telephone transmission and high-level voltage used for electricity. The gear remains essentially unchanged since the age of the telegraph (1840s), the telephone (1870s), and nationwide access to electricity (1890s). It is worth noting that Aberdeen, only incorporated in 1882, was formed (like many other midwestern towns) when the area became the crossroads for numerous railroad systems at the turn of the twentieth century. It quadrupled in size between 1900 and 1920 and quickly became known as "the Hub City of the Dakotas." Aberdeen's most famous one-time resident, shopkeeper, and newspaper publisher was L. Frank Baum, the author of *The Wonderful Wizard of Oz* (1900), written and published after he departed the Dakotas for Chicago.

In another captivating studio portrait, a timeless young baker wearing a floppy white toque and a crisp, long white apron stands for the camera rather proud of his cake (**102**). Like a lineman's leg spikes, the classic toque remains a universal sign of a particular specialty and is still worn today in fine hotels and restaurants worldwide. In some larger kitchens with multiple cooks, the higher the hat, the more senior the chef — a quick and easy visual marker similar to chevrons on a soldier's sleeve. Here then, perhaps, is a chef-in-training suitably proud of having mastered his first kitchen test — a well-balanced and decorated cake — a genuine accomplishment certainly worthy of a visit to the local photo studio.

Just as revealing is a winning portrait of a fresh-faced brewer in high rubber waders who brought to the photographer's studio a glass of ale to toast his occupation and

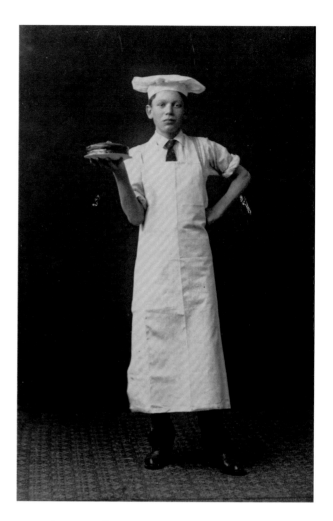

102 Baker, 1907 or later

complete his portrait (**103**). Is he the brewmaster or just a beer lover? Likely both. The subject's overalls and high boots suggest that the man is an expert quaffer who knows his way around noble hops and processed barley, wort and yeast, fermentation and barreling. Beer manufacturing has thrived in America from the day in 1632 when the Dutch West India Company built a brewery in Lower Manhattan on Brewers (later Stone) Street. It remains the most popular alcoholic beverage in the country. Interestingly,

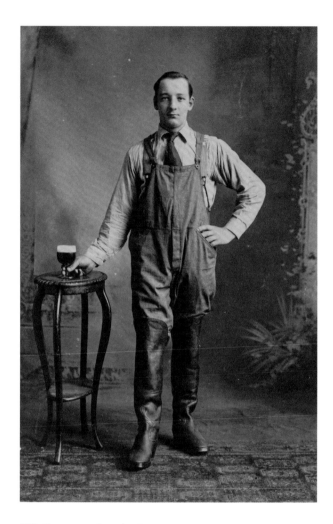

103 Brewery worker, about 1914

When the subjects of each of these portraits passed through the photo studio doors with their respective tools and in their working clothes, they also brought with them an aspect of the street; then, after the photographer printed the negative and produced the postcard, it lived another life. Outside the studio and back on the street, the photograph could be transported across the country and around the world, returning to wherever the worker was from — the next town up the road, or across the ocean. One wonders today, was their job temporary or for a lifetime? Can a bit of pride in their work be read in their faces and body language? And, if so, where does this reveal itself? In those subjects who look the camera right in the eye, or in those that look away?

As visual documents, it is possible that the postcards might even communicate more to contemporary viewers than they did to the subjects who commissioned them: they show in pure form what the portrayed knew inherently, the outer conditions of their world. They effortlessly present an aspect of reality — how a carpenter holds his square, a painter his brush and pail, a sharpshooter her rifle — something one would be hard-pressed to describe or mimic. For twenty-first century observers, culturally, these truths in their own way are as dramatic as the equally important postcard scenes of regional floods, tornados, and man-made disasters. They are quiet, democratic documents of individual human lives, the ordinary made extraordinary. Almost all the subjects here present themselves in an unpretentious way, at ease in their own bodies, with their tools, and before the camera (which they trust to reveal their essence). This seemingly unmediated realism recalls what James Agee noted in *Let Us Now Praise Famous Men* about the clothing worn by one of the impoverished but tireless Alabama tenant farmers in Walker Evans's photograph: his frayed work shirt and overalls were "a map of a working man."[5]

when the country was finally connected by transcontinental railroad on May 10, 1869, at Promontory Point, Utah, two teams of engineers and workmen — one from the west, one from the east — celebrated the occasion by breaking bottles of liquor on their opposite's locomotive prow as one might when launching an ocean-going vessel. The crew from California brought and then ceremoniously smashed a single bottle of champagne; the boys from New York exploded two bottles of beer.

In the early decades of the twentieth century, when American culture, with its gender and class traditions, was being challenged by women and the emerging middle class — at times quietly, sometimes loudly — and individuals demanded to be taken seriously, the camera was there to support them. Ideally suited to fulfill the needs of a changing era, photography's essential naturalism could and did reinforce the progressive idea that the life of each woman, man, and child was now valuable, to themselves and to the society at large. These splendid postcards are the proof. In these photographs, perhaps paradoxically, can be seen simultaneously: the worker and the person hiding behind the accoutrements of the occupation; the societal role performed by the individual, and the individual; the telephone operator and the daughter; the postman and the son who misses his family.

On an existential level, all of these portraits offer a direct confrontation with the self, and as such might best be read as assisted self-portraits. Leaving the workplace, but taking with them the attributes of their labor, the sitters let the external world and its vexing, inconvenient truths fall away. They meditate on themselves and their worldly path; even though they may be dressed for work, they are not in fact doing it; they are not performing the act and in that literal and psychic distance, that separation from toil for at least for a split second, their portraits hint at times to a connection to something deeper than work. At their finest, these simple photographs seem to reveal, to meditate on, to explore that which is locked inside each of us: how did we become the person we are? How are we different than our parents, different from our sisters and brothers? Who are we?

104 Tobacco workers, Branson, Missouri, 1917 or later

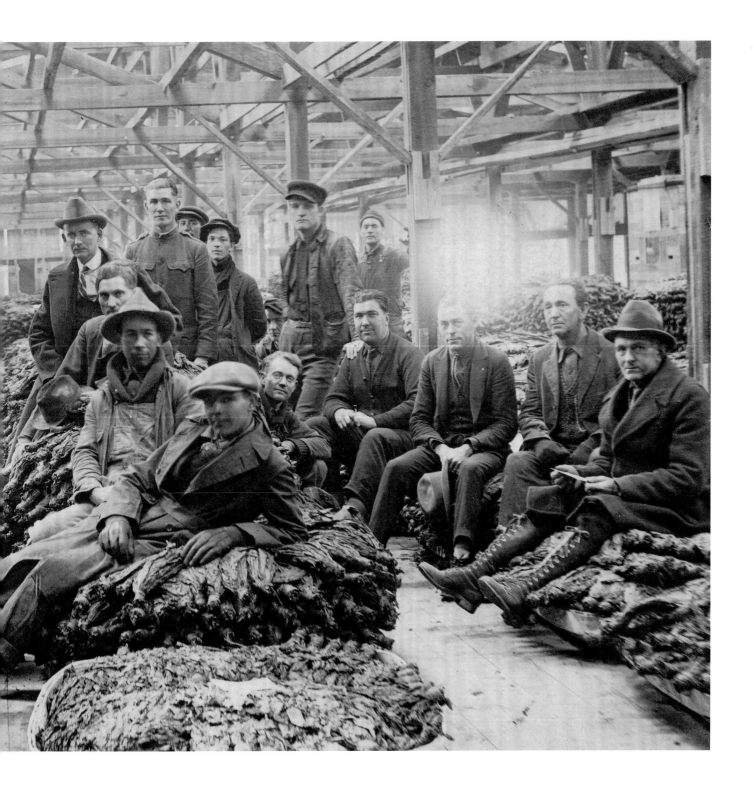

105
A Nice Man, about 1914

106
Sewing machine salesman, 1910 or later

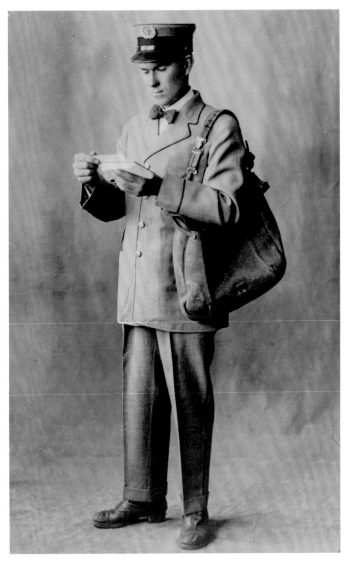

107
Two bakers, 1908

108
Mail carrier, 1917 or later

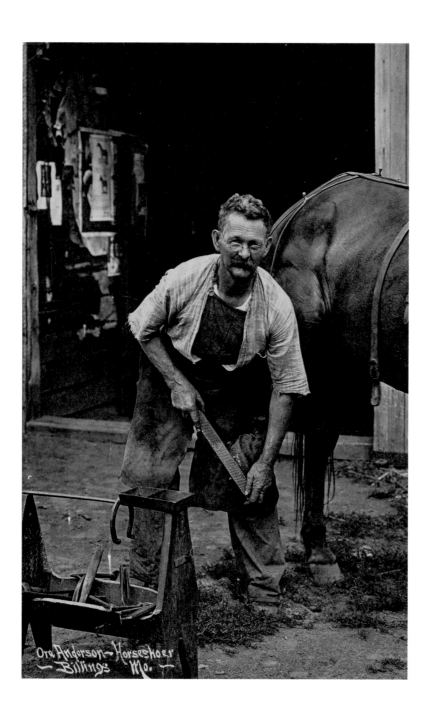

109
Ora Anderson, Horseshoer, about 1914

110
Harness shop, about 1914

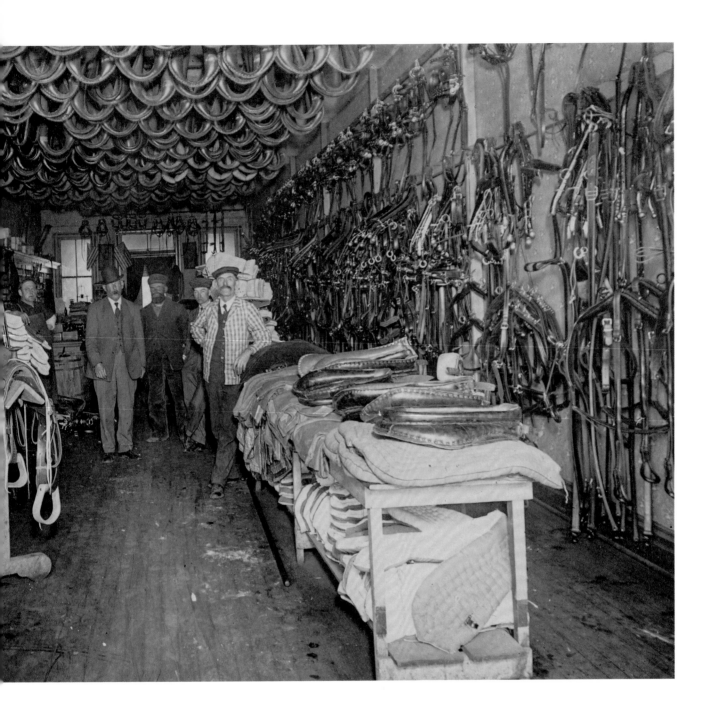

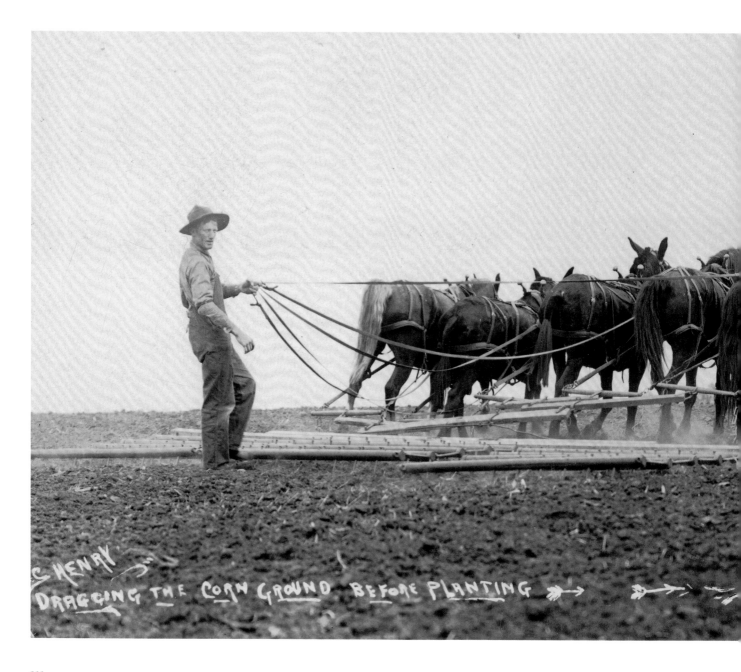

111
Dragging the Corn Ground Before
Planting, about 1914
C. HENRY

112
Russell and Henderson poultry
farmers, 1909 or later

113
Apple farmers, 1907
or later

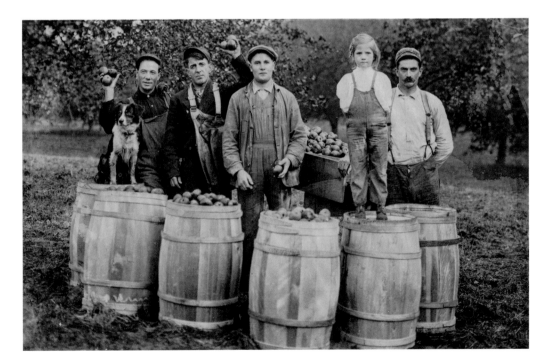

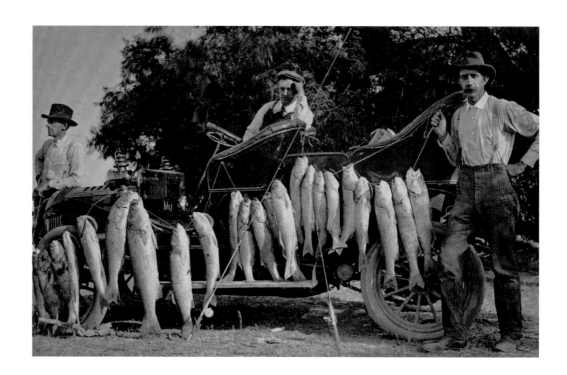

114
Sport fishermen, Stockton,
California, 1908

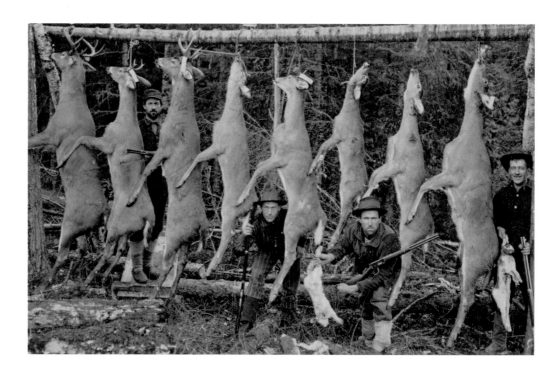

115
Deer hunters, 1907 or later

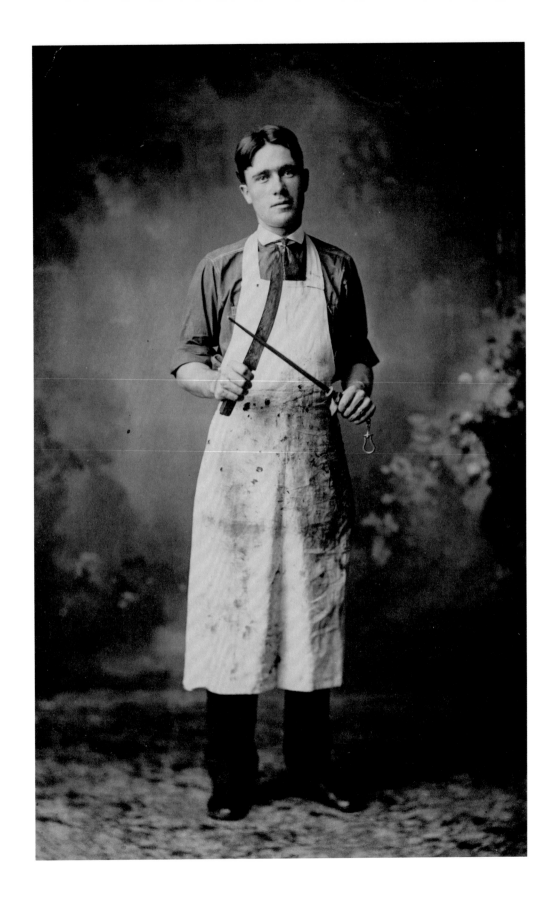

116
Butcher, about 1914

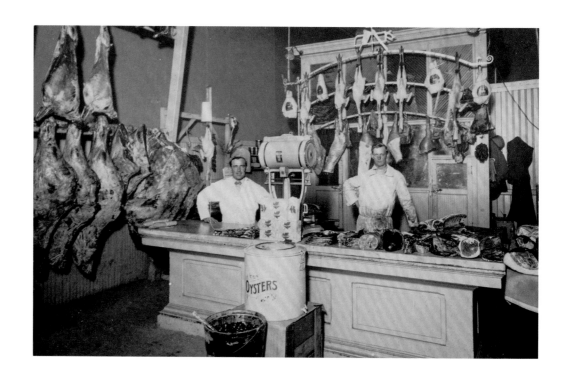

117
Butchers, about 1914

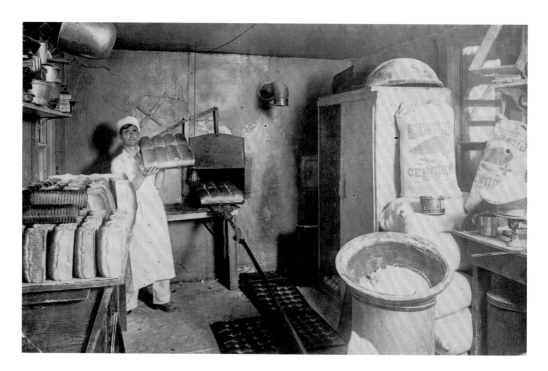

118
Baker, about 1914

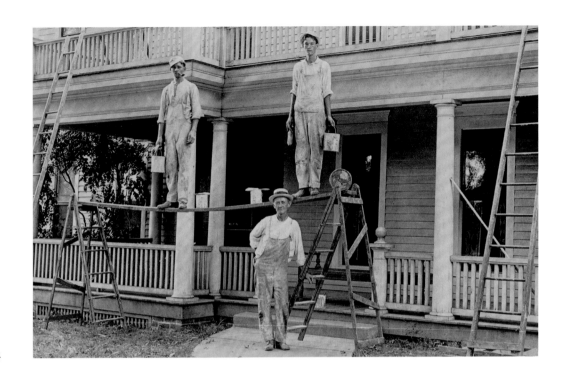

119
House painters, about 1914

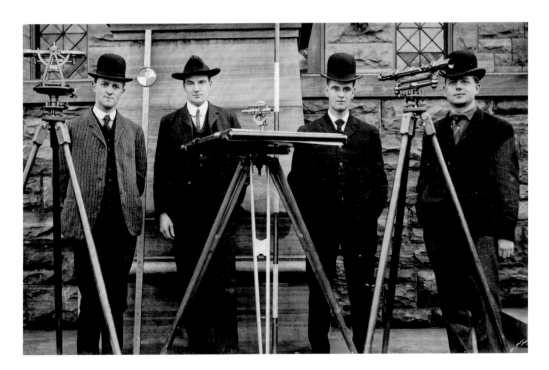

120
Surveyors, 1906

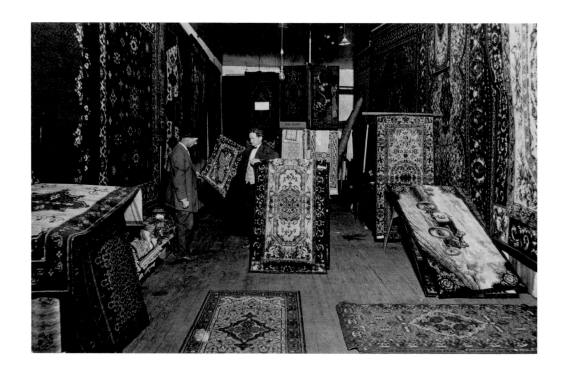

121
Rug shop, Longview, Texas,
about 1914

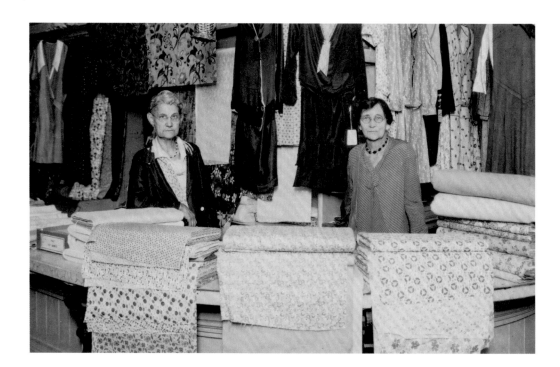

122
Mrs. B. C. Kenney and
friend, 1926 or later

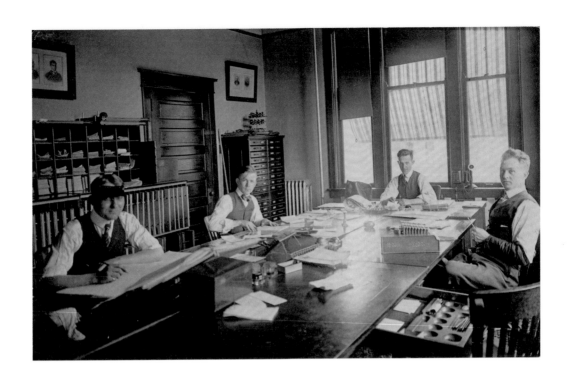

123
Accountants, about 1914

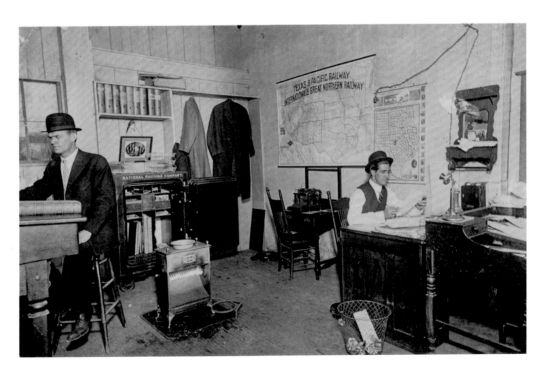

124
Office workers, Texas &
Pacific Railway, 1911

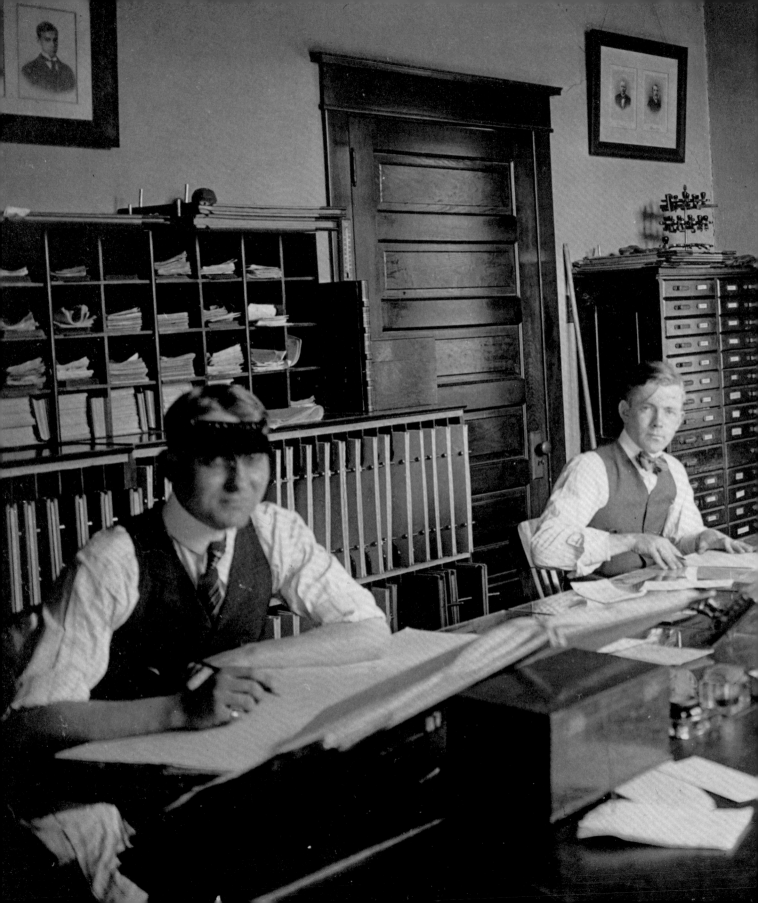

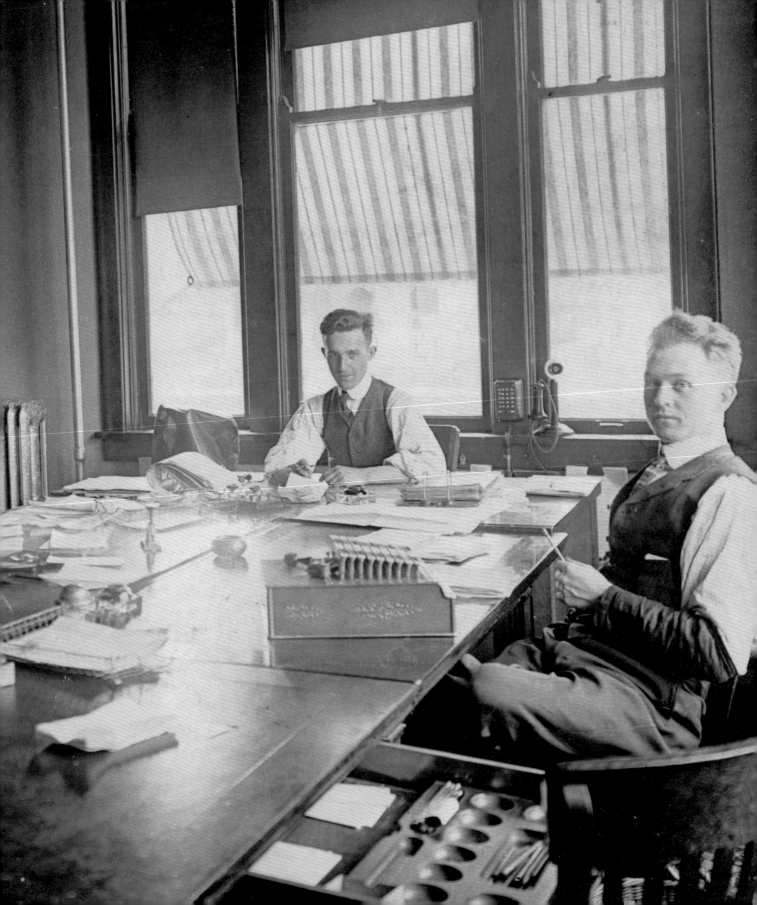

125
Bottlers, about 1914

126
American Olive Oil factory
workers, Los Angeles, 1907
or later

127
Shoemakers, 1908

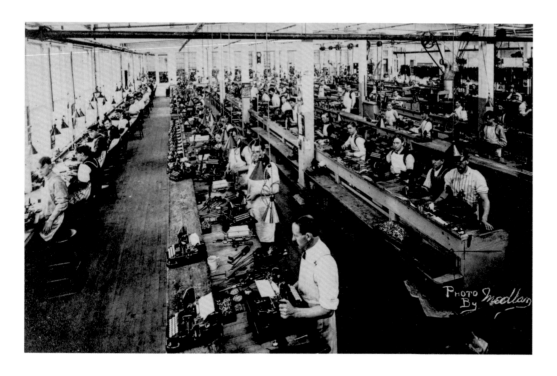

128
Typewriter factory,
1911 or later
MEDLAN

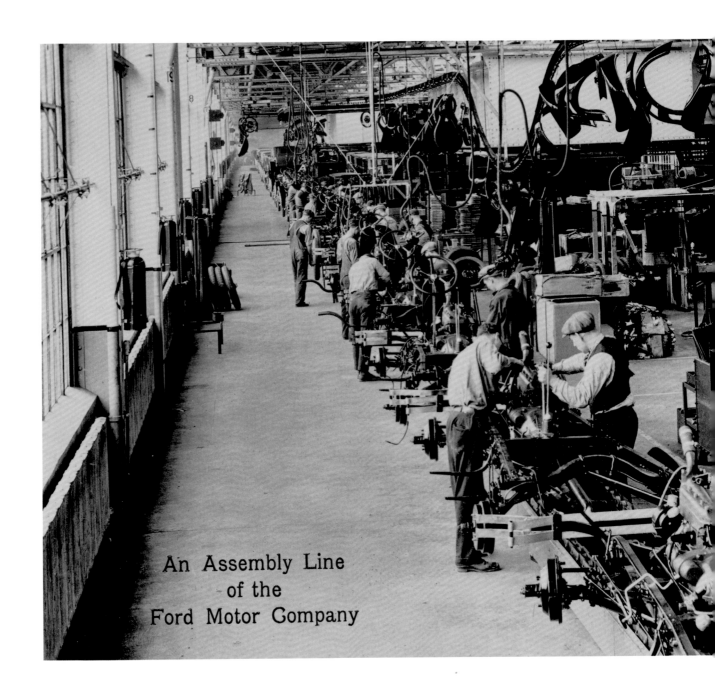

An Assembly Line
of the
Ford Motor Company

129

An Assembly Line of the Ford Motor Company,
mid-1920s

THE GARRAWAY COMPANY

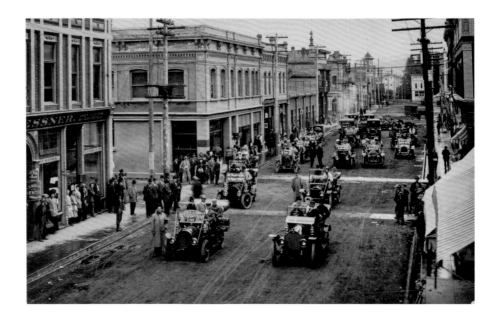

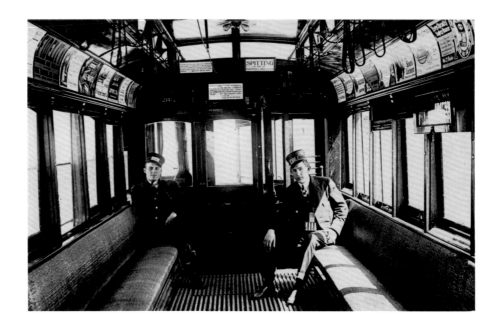

130
Auto parade to Eugene,
Oregon, 1910

131
Trolley conductors, Omaha, Nebraska,
about 1914

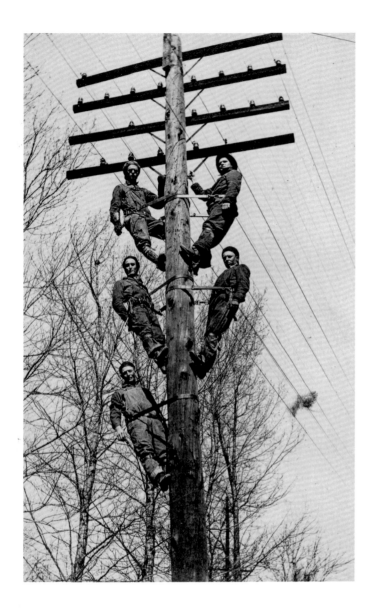

132
Linemen, Murray, Iowa, about 1914

133
Building a tank, about 1914

134
Laying railroad track,
about 1914

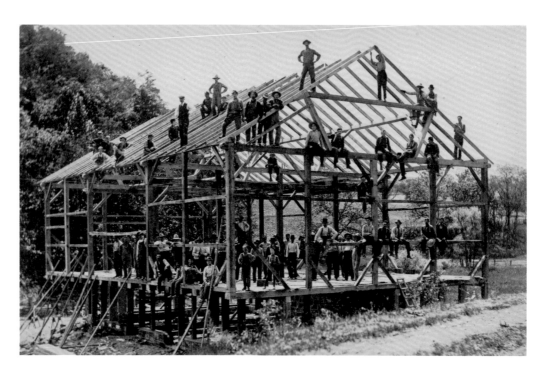

135
Framing a building, 1907
or later

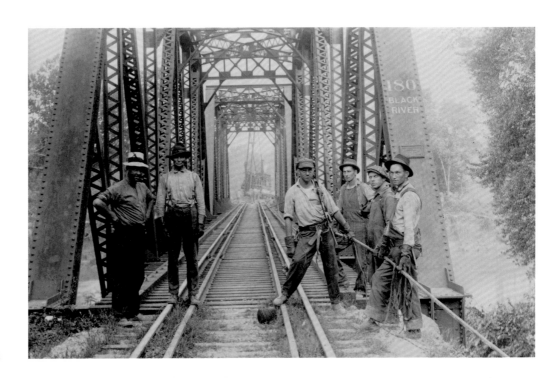

136
Railway workers, about 1923

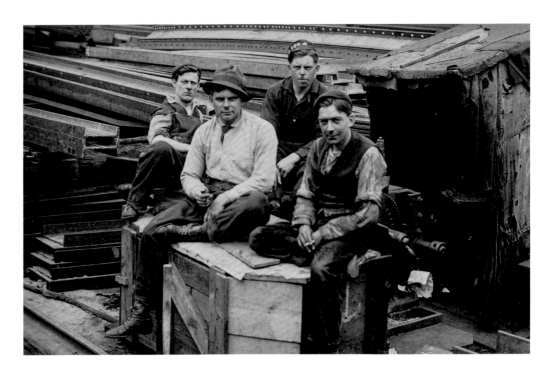

137
Steel workers, about 1914

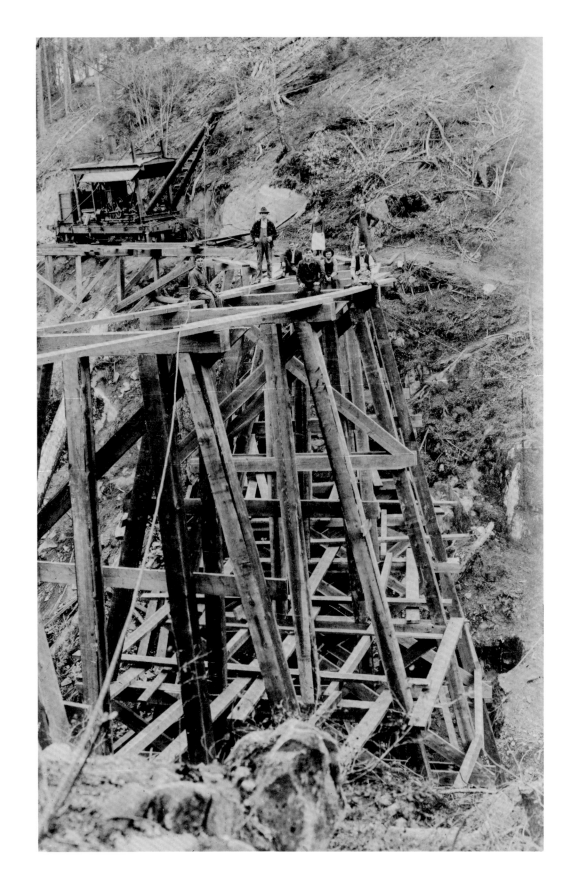

138
Building a railway trestle,
1907 or later

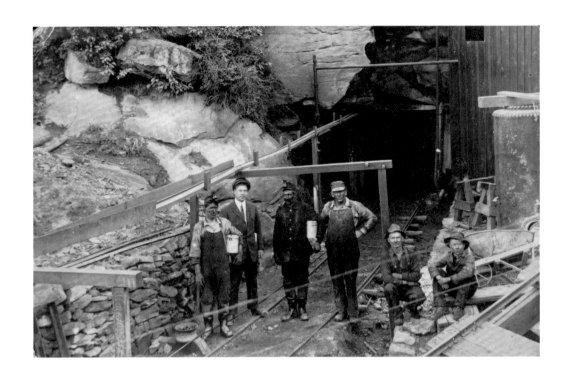

139
Coal miners, about 1914

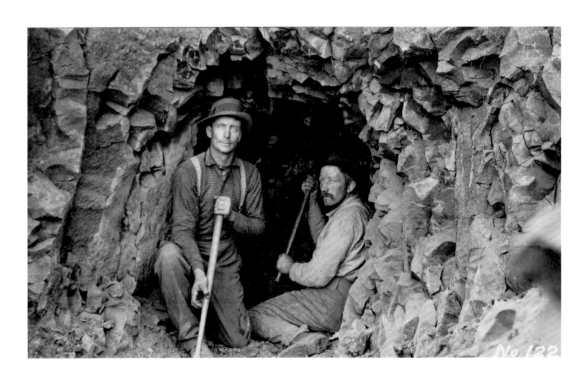

140
Coal miners, 1923 or later

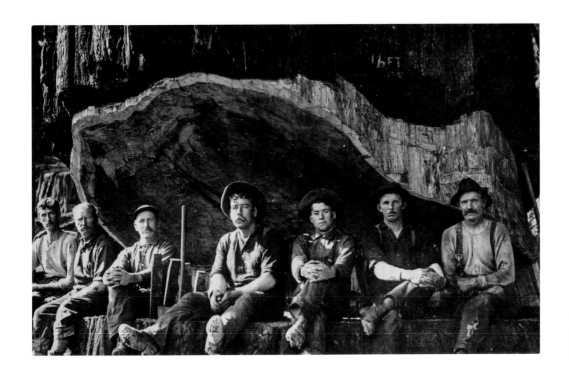

141
Lumberjacks, about 1914
DEL NORTE COMPANY

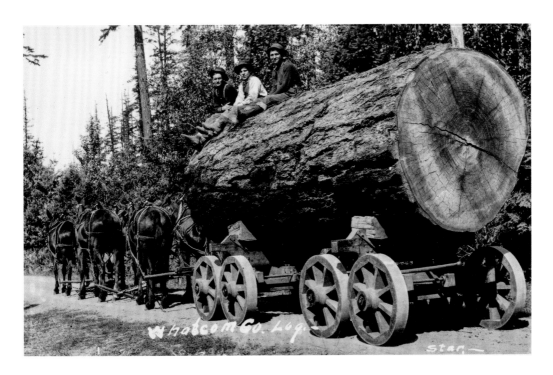

142
Whatcom County Log.,
1926 or later
STAR

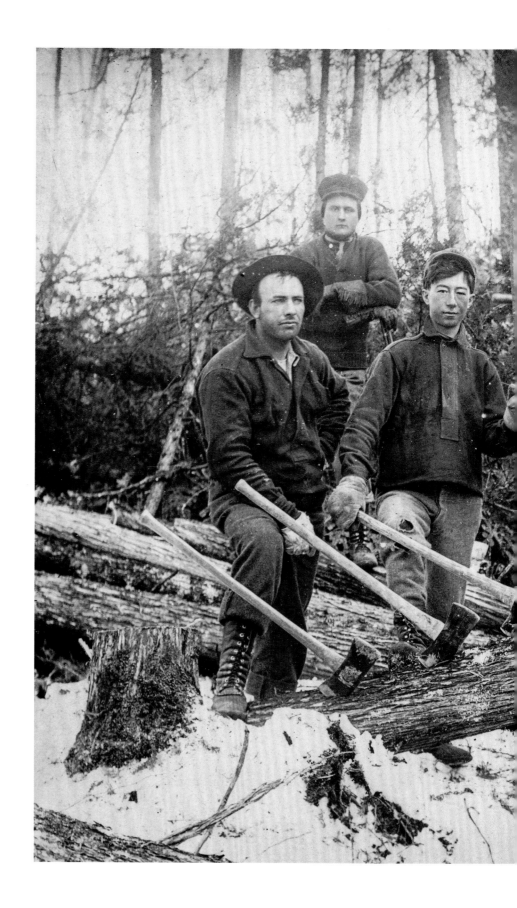

143
Lumberjacks, 1907 or later

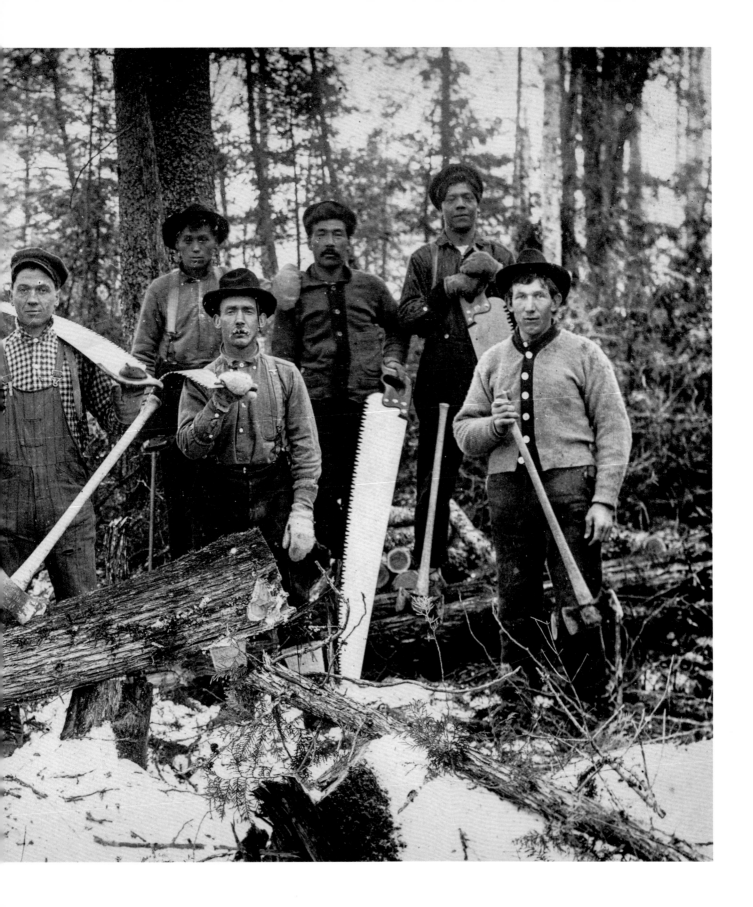

When You Look at This, Think of Me | CHRISTOPHER B. STEINER

Sometime in the early 1930s, a young Black woman posed for a portrait in what appears to be a makeshift photo studio, set up perhaps on the grounds of her high school campus (**144**). Affixed to the wall behind her is a cloth banner, its creases still visible from where it had been neatly pressed prior to being unfolded as a backdrop. Although the felt letters on the banner are mostly cut off from the image's frame, there are enough letters visible to make out that the photograph was taken at Downingtown Industrial and Agricultural School, a vocational high school established in 1905 to educate Black children in and around Chester County, Pennsylvania. The young woman is dressed in the uniform of her school team, and she is wearing a pair of Ball-Band high-top canvas rubber-soled sneakers, the latest innovation in competitive athletic footwear. She stands with one foot in front of the other, her left knee slightly bent, and she appears ready to throw a basketball while looking off somewhere into the distance. Although the photograph represents a unique likeness or portrait of this individual, the image closely follows the stylistic conventions of this period — photographing athletes in the artificial surroundings of a photo studio while presenting them as if caught in a frozen moment of action during a game or sporting event.

On the back of the postcard is written: "When you look at this, think of me. Keep this to remember me by. Love,
Alma Mae Bradley." Beyond the small clues presented in the brief handwritten text and in the image, virtually nothing else is known about this young woman — who she was, whom she was writing to, and how exactly she would want to be remembered.[1] Like so many other portraits on photo postcards produced in the early twentieth century, this one has been separated from its original context and from its intended recipient. What had started as a personal memento from a life being lived, is now a public document detached from individual experience and meaning.

In the early decades of the twentieth century, portraits on photo postcards were relatively inexpensive and affordable to people from all walks of life. Unlike earlier portrait photography, such as daguerreotypes and cabinet cards, which were almost exclusively commissioned by wealthy individuals, postcard portraits could be had by working class families and people of modest income.[2] They were made quickly and often without proper lighting or retouching. Frequently advertised as "made while you wait," the emphasis was almost always on cheapness and speed. "Photo postals," as they were sometimes known, were souvenirs captured in the carnival tent of an itinerant photographer or snapped in an urban photo studio. Many professional photographers considered them inferior in quality and aesthetic merits in comparison to true "artistic" studio portraiture. As one person commented in *The American Annual of Photography* in 1915, "few people who

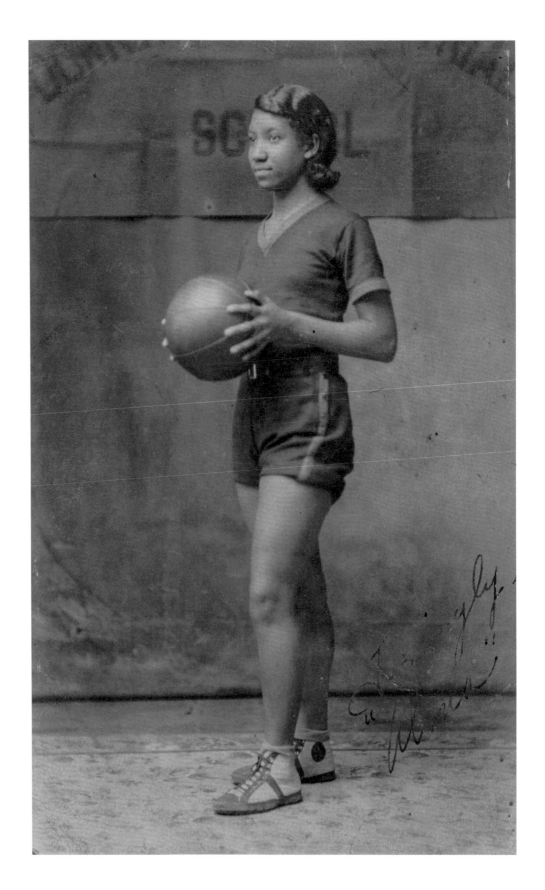

144 Alma Mae Bradley, 1926 or later

145 Corn farmer, 1911 or later

and their athletic abilities. They showed off a new hat, a new coat, a creative costume, or the good life afforded by a cold beer and the latest in phonograph technology.

A large category of postcard portraits was made up of workers posing with the tools of their trade — bakers, brewers, butchers, carpenters, circus performers, cobblers, firefighters, icemen, letter carriers, linemen, magicians, miners, nannies, painters, railroad workers and salesmen (**146**). Portraits of people exhibiting their professional tools and work clothes underscore the dignity of labor and the degree to which one's work was fundamental to individual identity and self-worth. Indeed, many of these occupational portraits appear to celebrate economic independence and small-scale skilled labor at a time when industrial capitalism and the factory system was encroaching more and more on the lives of trained workers whose professions had traditionally been passed from generation to generation. While the idea of an occupational portrait was not necessarily a new concept, having been available in the form of tintypes during the late nineteenth century for example, photo postcards allowed for a better-quality image as well as the ability to send that image out into the world.

Studio operators who offered portraits on postcards were motivated largely by money rather than artistic aspirations. Itinerant postcard photographers, it was reported in 1915, could earn four thousand dollars a year (roughly equivalent to one hundred and ten thousand dollars in 2021) on a carnival circuit.[4] The biography of Boris Pruss offers an interesting illustration of how a struggling young painter was forced to give up his artistic pursuits in order to make a living wage as a portrait studio photographer. Born in Russia in 1873, Pruss studied painting at Munich's Academy of Fine Arts, and was trained in portraiture by Franz von Lenbach, one of the German Empire's highest-paid portrait artists at the time. In 1899, Pruss immigrated

will pay good prices for their photographs ever seriously consider the three-for-twenty-five portraits. If they do order them, it is in much the same spirit in which they buy peanuts at a menagerie or a toy balloon on circus day."[3]

Studio portraits on postcards functioned as visual documents that could memorialize a meaningful event or special moment in time such as a religious rite of passage, a sporting victory, or a fruit or vegetable winning top prize at a fair (**145**). People displayed their musical instruments

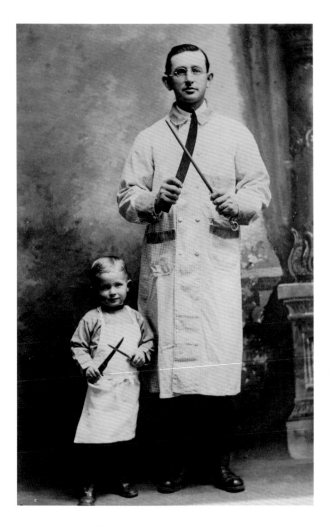

146 Butcher and his son, about 1914

photographic techniques from his mentorship with Lenbach, who encouraged the use of photographic studies in portrait painting, and likely trained his students in new camera technologies, including how to process dry-plate gelatin negatives.[5]

Not long after the conclusion of the exposition, Pruss opened his own photo studio in downtown St. Louis across from Union Station. He operated the Pruss Photo Postal Studio on Market Street for over two decades, offering photo portraits of all kinds, including those with elaborate painted backgrounds, prop trains and automobiles, and even novelty comic foregrounds. Through his success as the owner and operator of a lucrative photo studio, Pruss emerged as a prominent member of the St. Louis Jewish business community, and served for many years on the board of directors of the United Hebrew Temple. In 1926 Pruss sold the studio to his business partner Morris Rosenstroch, in order to start the first automobile taxicab service in St. Louis, an idea he conceived of "while watching the travelers leaving Union Station from his Market Street studio."[6] Boris Pruss thus made his fortune not by emulating his mentor to become a great fine art portrait painter, but rather through his entrepreneurial acumen. While owning a souvenir photo postal studio was not the artistic undertaking Pruss might have initially hoped for, it was a lucrative business venture.

In his book *The Presentation of Self in Everyday Life*, sociologist Erving Goffman argued that each person adopts two forms of self-representation: what he calls, on the one hand, "frontstage behavior" (the performance in front of others), and on the other, "backstage behavior" (the preparation work invisible to others, to display a good public image).[7] Having one's portrait made at a photo postal studio offered a rich opportunity to present for the camera one's "frontstage behavior," while simultaneously crafting a unique "backstage" environment in

to the United States, with hopes of becoming a successful portrait painter in New York City. He was elected in 1900 to the prestigious Salmagundi Sketch Club, where he exhibited his work alongside such renowned American artists as George Inness and Childe Hassam. Unable to find steady work as an artist in New York, Pruss relocated to St. Louis, Missouri, in 1904 to operate one of the photographic studio concessions at the Louisiana Purchase Exposition. Pruss would probably have been familiar with

which to perform and pose. Although a posture or facial expression may communicate something of one's identity, a photo portrait generally also conveys information about an individual's personality and aspirations via his or her choice of a particular painted background, costume, or studio prop.

Most photo studios, whether in cities, small towns, or even in carnival tents, were equipped with an array of painted backgrounds, typically representing either idealized pastoral landscapes — bucolic scenes abounding with trees, shrubbery, rivers and streams — or architectural subjects, such as ornately decorated interiors with heavy drapery, curving stairs, and floral bouquets, or building exteriors with manicured gardens, vine-entwined urns, and columned porticoes. In some cases, painted backgrounds were stretched on wooden frames that could be moved across the studio floor and put into position for a portrait sitting. In other cases, they were rolled onto specially designed mechanical frames that allowed the studio operator to change backdrops effortlessly between shoots. The ability to switch backgrounds suggests the sitter enjoyed some agency in the selection and construction of their portrait setting or studio environment. Whether a backdrop represented an interior or exterior scene, the emphasis was on underscoring a kind of nostalgic beauty focused on luxury and prosperity. Although the particular circumstances of many of the subjects in studio photos cannot be known for certain, detached as the cards often are from their original context, one can speculate that the elegant trappings of the painted backdrops offered people an opportunity to project "an upwardly-mobile remove to a genteel, book-cased parlor or a pillared formal garden."[8]

Some photographers commissioned their backgrounds from local artists and painters, but most were acquired from commercial manufacturers who advertised in trade journals and photography magazines. The market for these backdrops was competitive, and manufacturers would often copy one another's most popular and best-selling styles.[9] As commercial enterprises, studios were keen to regularly offer new backdrops and novel props as a way of luring back clients who may have already had their portrait taken.

New background styles could be prompted by the latest fads, current events, and world developments. During the First World War, for example, there was a surge in demand for studio portraits by U.S. soldiers and other service members, who wished to be photographed before they deployed overseas. The typical backdrops, with pastoral landscapes and opulent interiors, were not particularly well suited to this type of military portrait. Recognizing the potential for a new market, a number of background manufacturers took out advertisements in trade journals such as *Snap Shots*, a monthly magazine for practicing photographers, shortly after the United States declared war on Germany in 1917. The ads announced new designs for both an army background, depicting pyramidal tents and military camp surroundings, and a naval background, showing the deck of a gunship, a fort in the distance, a submarine in the near foreground, and an airplane in the sky. A small entry in the "Trade News and Notes" section of the magazine proclaims that the "progressive, up-to-date photographer should not be without one of each of these designs. They are moneymakers at this time."[10]

While some photo studio backdrops may have communicated a person's desire to elevate themselves to a higher social bracket or to establish their wartime role in a branch of military service, others literally transported people into the modern era or even onto the moon. In contrast to the "classic" painted backgrounds of parlors and gardens, which offered a nostalgic vision of Victorian aristocracy, most novelty or fantasy photos were forward looking, as they celebrated new technologies and new

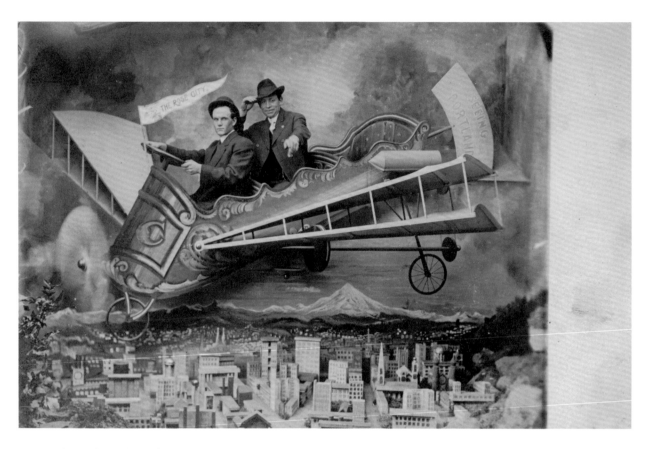

147 Men in a studio airplane, after 1906 CAL CALVERT

modes of transportation. Portraits could be taken while "driving" in a fake automobile or "flying" in a fake airplane or hot-air balloon. In 1906 Charles "Cal" Calvert opened his first commercial photo studio in Portland, Oregon. In Calvert's studio, patrons could pose in an elaborate "flying machine" set above a three-dimensional diorama of downtown Portland, complete with a painted background of a snow-covered Mount Hood. The thrill of flight was a novel and exciting development, as the Wright brothers had successfully flown the first powered airplane at Kitty Hawk in 1903. Though it is unlikely that either of the men in the card above had ever seen, let alone flown, an actual

airplane, in their portrait they fulfilled the illusion of flight with theatrical flair — holding onto a hat in an imaginary airstream, gazing down at the sights below, and piloting the "flying machine" with an oversized four-spoke steering wheel (**147**).

Little is known about how or why the crescent moon phenomenon started as a photo prop in America, but it reflects a general fascination with the moon and the cosmos at the turn of the twentieth century. Visitors to the 1901 Pan-American Exposition in Buffalo, New York, could "fly" to the moon in the Airship Luna, where they encountered costumed moon creatures on the attraction's

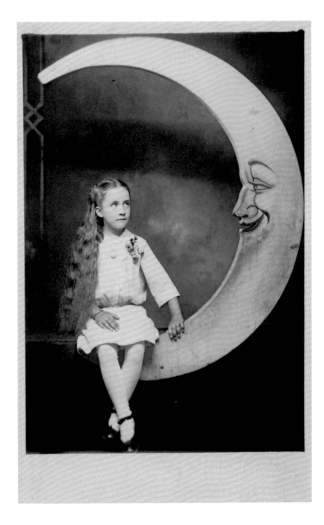

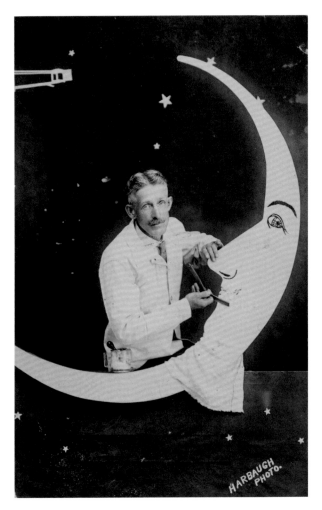

148 Portrait of a girl, 1907 or later

149 Portrait of a barber, about 1914 HARBAUGH PHOTO

cavernous paper-mâché lunar surface. The following year, Georges Méliès produced the silent film *A Trip to the Moon*, with an iconic image of the moon as a human face, as well as a scene featuring a woman floating in the night sky on a "croissant de lune."

Photo postal operators quickly grasped the potential profits that could be earned by offering people an opportunity to pose on novelty studio props, especially those in the shape of a crescent moon. These props were

generally constructed out of wood, painted white and sometimes embellished with the smiling face of the "man in the moon" (**148**). They were then positioned against a black background often decorated with stars, and sometimes including depictions of airships or hot-air balloons flying through the night sky. Clouds could be added in the foreground as wooden boards or as filters placed on top of the negative in the darkroom. Most people were photographed in the everyday attire they wore to the photo

studio or to the carnival fairgrounds. In some cases, customers posed in costumes or in the work attire of their trade, whether as a lineman or a barber (**149**).

While studio portraits of people posing in fake airplanes and automobiles celebrated the triumphs of modernity, playing the role of frontier characters offered people a different experience in the photo studio — an occasion to partake in a collective fantasy of American history and to embrace a fictionalized vision of American pioneers and the conquest of the West. In some instances, clients showed up at photo studios with their own attire — costumes worn for Halloween or birthday parties, outfits from Thanksgiving pageants, or even the uniforms of fraternal organizations like the Improved Order of the Red Men or the Degree of Pocahontas.[11] Those without costumes, however, could usually borrow one at the photo studio, where most photographers, eager to capitalize on the public's fantasy of the Old West, stocked a full wardrobe, including wooly chaps, leather wrist guards, holsters, prop guns, feather headdresses, buckskin shirts, and breechcloths.

Dressing up as cowboys and cowgirls may have offered members of new immigrant communities an opportunity to associate themselves with "authentic" American values and to participate in identities central to narratives of Americanness. Reenactments of frontier mythology also allowed working middle-class Americans, especially in urban centers, to recapture the spirit of individualist freedom as a reaction to industrial capitalism beginning to constrain self-determination within a society of rapid technological change.[12] For women, in particular, the appeal of outfitting oneself as a cowgirl may have been linked to reclaiming "a dying age in which women could balance both their essential feminine natures with the necessary tasks of masculine political and labor pursuits"[13] (**150**).

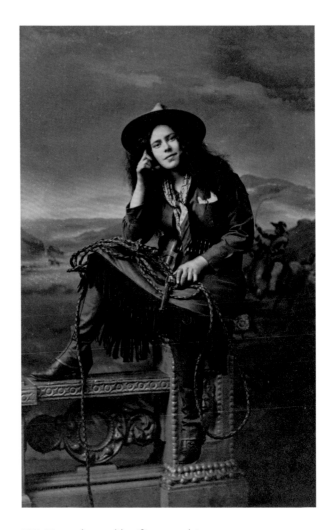

150 Woman in cowgirl outfit, 1907 or later HOHHOF STUDIO

In contrast to cowboy and cowgirl attire, dressing up as "Indian" tapped more directly into stereotypes of Native American populations who were identified with such generalized qualities as "independence, vigor, bravery, loyalty, spiritual power, and closeness to nature."[14] It is probably no coincidence that studio portraits of non-Native people dressing up as "Indians" during the peak of the photo postcard craze around 1910 coincides exactly with the formation of the Boy Scouts and Camp Fire Girls, for which

appropriation of Native American rituals and symbols was central to their mission. In both the photo portraits and the youth organizations, Native American identities were mimicked and espoused for their supposed connection to "intuitive" knowledge and "traditional" wisdom. "To reaffirm modern identity," writes Philip Deloria in his book *Playing Indian*, "Americans needed to experience that which was *not* modern. Just as one visited nature in order to be able to live in the city and enjoyed leisure in order to work more effectively, one turned to the past in order to understand the present and future. To be modern, one acted out a heuristic encounter with the primitive."[15]

Although most studio portraits were commissioned by individuals to share with a small circle of family and friends, certain cards, including those made of Native American subjects, were printed in larger quantities, intended for sale to tourists who often acquired postcards as souvenirs of their travel adventures in the early twentieth century.[16] These cards generally sought to represent ethnic types and stereotypes rather than a portrait of a specific person. Studio portraits of Native Americans that sold as souvenir postcards depicted men, women, and children in traditional attire, often posed in front of painted backgrounds of Victorian parlors and formal gardens (**151**). Because these images were staged in the artificial setting of a photo studio, they reveal little or nothing about the actual lived experiences of Native Americans at this time.[17] This was in fact a period of rapid change among Native American communities, who were suffering substantial economic, cultural, and physical hardship as a result of federal assimilation policies and forced removal from their land. However, witnessing this reality and the dire conditions of Native Americans was of no interest to tourists. Visitors to "Indian country" wanted to see "proud" and "authentic" indigenous people unspoiled by the scourge of poverty, displacement, and acculturation.

Because Native American studio portraits were so decontextualized from reality, they masked the real conditions of life outside the studio, and presented instead a "blank slate" onto which consumers of postcards could project their own fantasies and stereotypes of "primitive" civilizations.[18] This kind of sentimentality, which seeks to recover timeless cultures in the face of eradication and rapid change, was described by anthropologist Renato Rosaldo as "imperialist nostalgia"— a peculiar phenomenon in which agents of change "mourn the passing of what they themselves have transformed" through systematic eradication of indigenous cultures or the displacement of colonized people from their homeland. "Someone deliberately alters a form of life," Rosaldo writes, "and then regrets that things have not remained as they were prior to the intervention."[19]

In the summer of 1908, photographer Edward Bates moved from Iowa to Oklahoma in order to establish his own studio in the city of Lawton. Located just south of Fort Sill, where Native Americans from the Great Plains had been "resettled" during the latter part of the nineteenth century, Lawton was founded in 1901 just as the last of the Native American lands in the Oklahoma Territory was opened up to non-Indian settlement. Edward Bates, and later his widow Lenora Gillock Bates, operated a successful photo studio in Lawton's business district for over six decades. Like most other photo studios, the Bates Studio drew most of its business from local men and women seeking portraits of themselves and their children. In addition to family photos, Bates also produced multiple series of postcards for sale to tourists and local residents, including photographs of Native American subjects and local scenes documenting the rapid growth and development of Lawton during the first decade of its existence.

In just ten years, from 1901 to 1911, Lawton was transformed from a small tent-encampment to a burgeoning

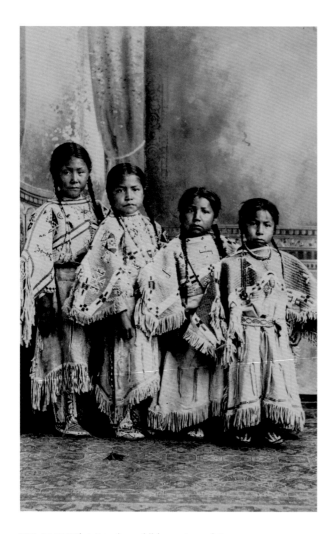

151 Four Native American children, 1917 or later

of commercial buildings were sold not only to tourists but also to city residents, who were encouraged by the local press to mail them out of town as "a fine way to create favorable impressions of Lawton."[21]

While Bates's postcards of modern buildings signaled the arrival of progress and prosperity, his postcards of Native Americans in traditional dress were meant instead to draw attention to the opposite end of an "evolutionary" ladder.[22] When juxtaposed, the image of "simple" indigenous people living on the outskirts of Lawton amplified the image of "modernity" in the postcard views of the city's new urban architecture. Although Bates produced some postcards of indigenous people engaged in outdoor activities, including at county fairs, parades, social dances, and cattle roundups, the majority of his most popular Native American postcards were portraits produced in his studio.

One popular example depicts a young Comanche mother in a long flowing Spanish fringe shawl, carrying her infant son in a traditional hide lattice cradle on her back (**152**). The caption, handwritten on the negative, reads "Nellie Sampitty & Child Comanches." The woman is, in fact, Elizabeth ("Nellie") Chibitty Saupitty. Because the postcard has no date, it is unclear whether the child is her eldest son Floyd Saupitty, born in 1917, or his younger brother, Larry Saupitty, born in 1922. Like so many other Native American children in southwest Oklahoma at this time, the Saupitty brothers were educated at Fort Sill Indian School. Under the misguided notion that preservation of Native American culture would impede their assimilation into white American society, children at Indian boarding schools were strictly forbidden from wearing traditional dress, practicing their customs and religion, or speaking their indigenous languages. During the Second World War, Larry Saupitty was recruited as one of the U.S. Army's Comanche Code Talkers. He was assigned to one of the D-Day landing infantry regiments, and on June 6, 1944, sent one of the first combat

urban center with "eight miles of street paving, fifty miles of cement sidewalks, a $100,000 high school, three magnificent ward schools, near $500,000 investment in waterworks and sewer systems, and business houses and residences to equal any city in the state."[20] Bates created a series of postcards, beginning in 1909, featuring some of the newly erected buildings in Lawton, such as the Midland Hotel, Lawton High School, the Federal Building and Post Office, and the First National Bank. These postcards

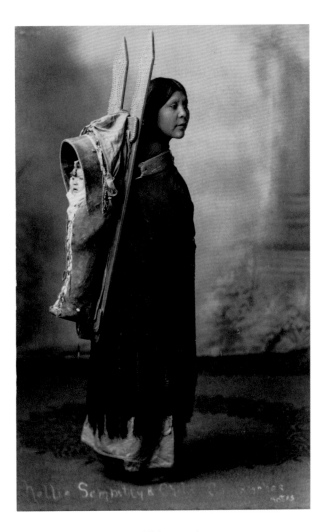

152 Elizabeth Saupitty and child, 1917 or later

The portrait of Nellie Saupitty and her child is one of several postcards Edward Bates produced of Comanche and Kiowa mothers posing in the studio with cradleboards on their backs. In each photograph, both the individuals and cradleboards are different, yet the pose in every one is almost identical. At the time they were being sold to tourists, postcards such as these were not purchased as portraits of well-known individuals but rather as clichés of a more generalized ideal of Native American motherhood.[25] These images of Native American women in traditional dress with children swaddled safely on their back would have appealed to an emerging nostalgia for rural womanhood at a time when urban Americans were growing increasingly anxious about the changing role of women in modern society. Photographs of strong traditional mothers — Madonna-like figures symbolizing fertility, domesticity, and traditional family values — evoked for urban white Americans the traditional responsibility of women as homemakers and nurturers of children.[26]

In 1915, Edward Bates took out an advertisement in one of Lawton's daily newspapers with the bold heading: "Get That Photograph Now." The copy below the heading reads, in part, "Years from now your children will cherish dearly that photo taken."[27] At the time the ad was written, Bates could not have fully appreciated that over a century later, photo postcards such as his portrait of Nellie Saupitty would in fact be dearly cherished not only by her direct descendants but by members of the Comanche Nation as a whole.[28] To her heirs, this postcard is a precious memory of a beloved ancestor which holds for them deep personal meaning. But to those outside her family, or unaffiliated with her ethnic heritage, the portrait is a "public document" whose private meaning may forever "remain locked to our view."[29]

Photo postcards reach across time and history to convey powerful stories about real people — the conditions of their lives, their talents and vocations, their dignity and

messages from Allied Forces on Utah Beach.[23] Ironically, as William Meadows notes in his book about the Comanche Code Talkers, "the United States military forces were actively seeking Native Americans to practice what they had been instructed not to do and punished for, for many years — speaking their native languages."[24] Ultimately it was the preservation, not eradication, of Native American languages and traditions which served to support America's victory in the Second World War.

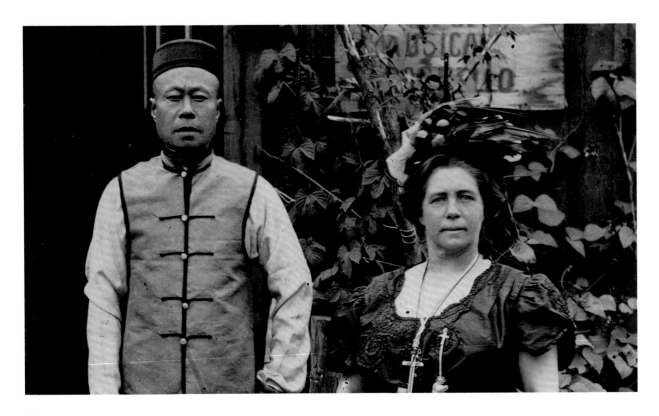

166 (DETAIL)

grace, their cultural identities, and the hopes and aspirations they may have held as they sat or stood in front of the camera to have their portrait made. Most studio portraits made on postcards circulated at the time of their creation within a close circle of family and friends; while others traveled more widely among tourists and curious outsiders. Today these same images continue to travel through flea markets, auction houses, postcard shows, and even eBay. Yet in so many instances the identity of those pictured has been separated from those who knew them or could tell us something about their personal story. Even when their names were recorded, like Alma Mae Bradley or Nellie Saupitty, their biographies are still difficult to reconstruct as most were neither famous nor well known.

In the absence of so much contextual information, it is still possible to read images through clues offered in the physical object of the postcard itself, such as a caption on the front or message on the back, the clothes or uniforms that were worn, an object that was held, a person's expression or body position, or the props and background chosen by the sitter to express a meaningful representation of themselves. As single images, portraits on postcards deliver an intimate viewing experience that connects us to another person's life and humanity. Taken as a whole, the universe of real photo postcards can form a living photographic archive — a kind of visual tapestry of the early twentieth century. Wherever they reside, these studio postcards invite us to consider the sitter, as Alma Mae Bradley expressed on the back of her basketball team portrait, "when you look at this, think of me."

153
Accordion player, 1917 or later

154
Woman with phonograph, 1911 or later

155
Saxophone player, 1926 or later

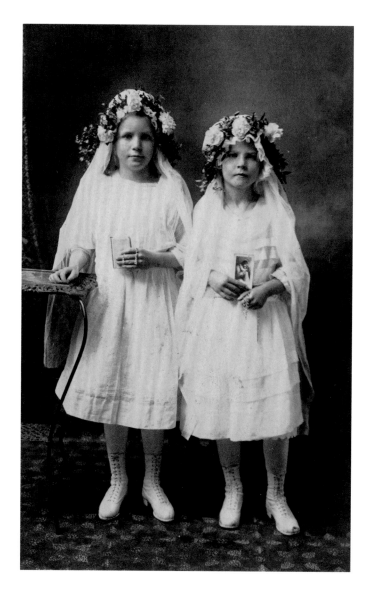

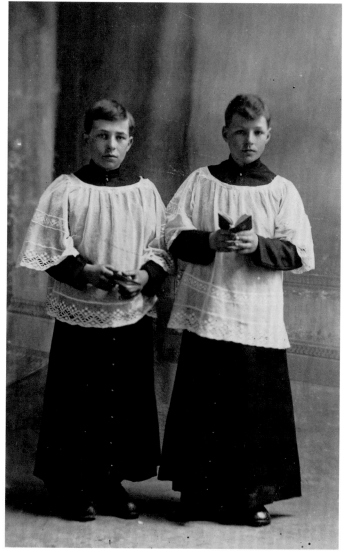

156
First Communion girls, 1917 or later

157
Altar boys, about 1914

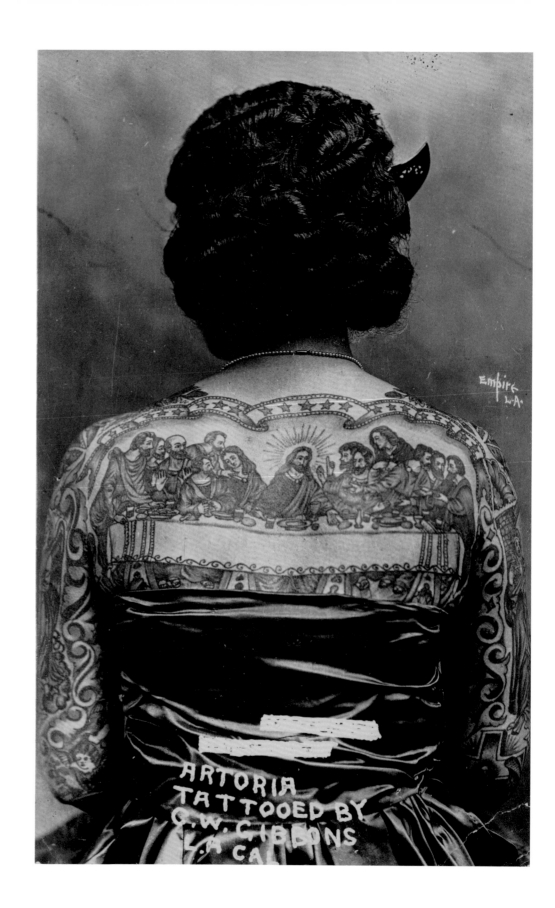

158
Artoria Tattooed by C. W. Gibbons,
1925 or later
EMPIRE

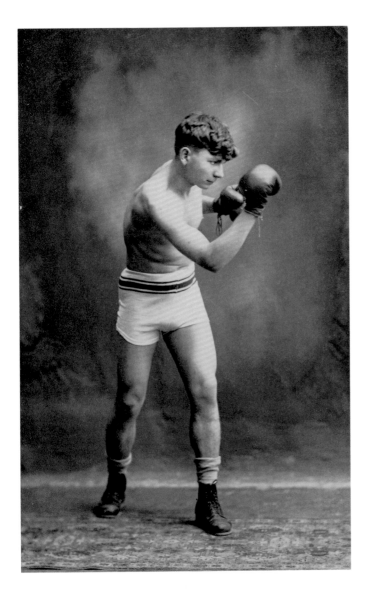

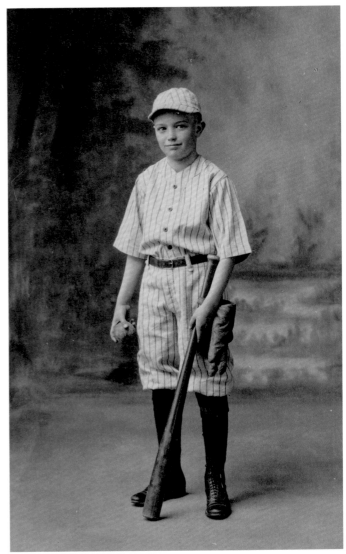

159
Boxer, 1912

160
Warren, age 10, 1917 or later

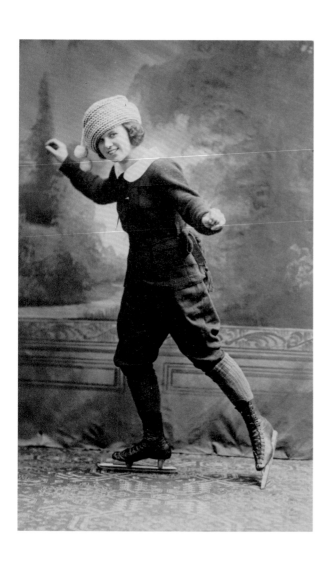

161
Ice skater, 1917 or later

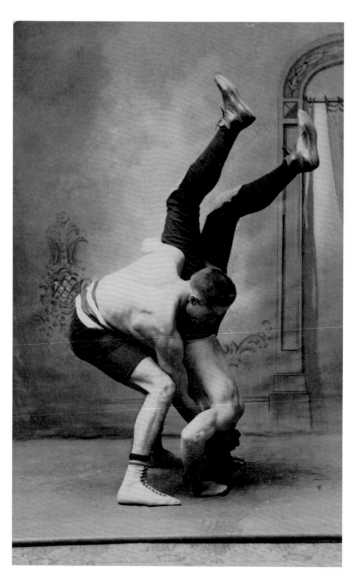

162
Wrestlers, about 1914
T. A. MORGAN

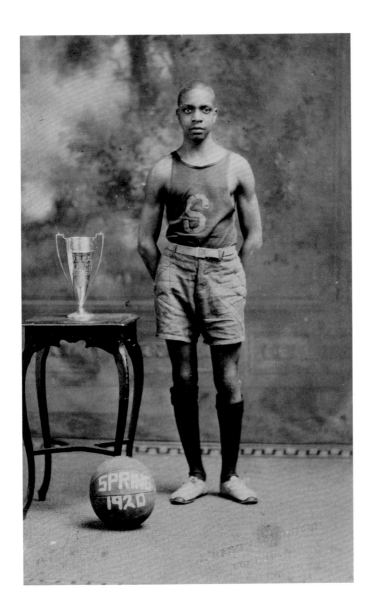

163
Basketball champion, Toledo,
Ohio, 1920
J. NASH LIVINGSTON

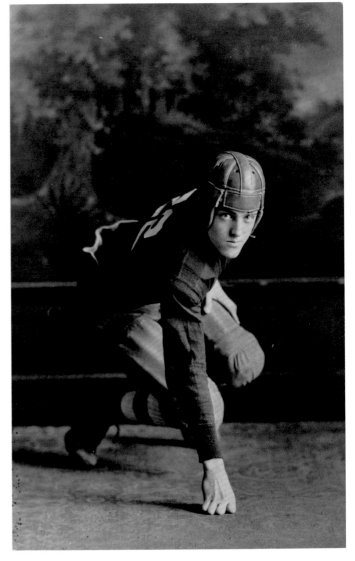

164
Earl de Vault, 1917 or later

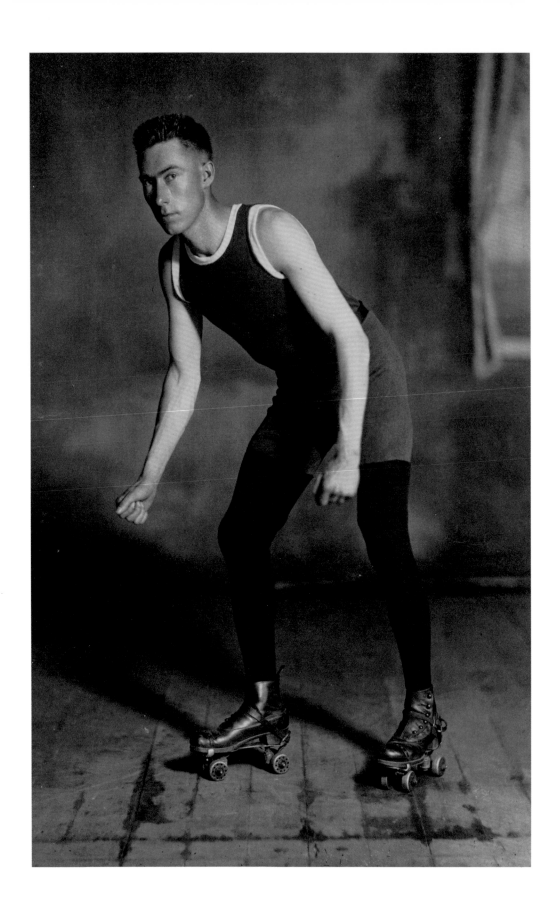

165
Roller skater, Frankfort,
Michigan, about 1914

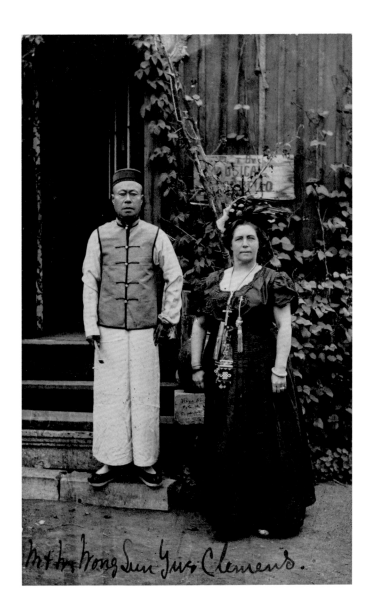

166
Mr. and Mrs. Wong Sun Yue Clemens,
San Francisco, California,
1909 or later

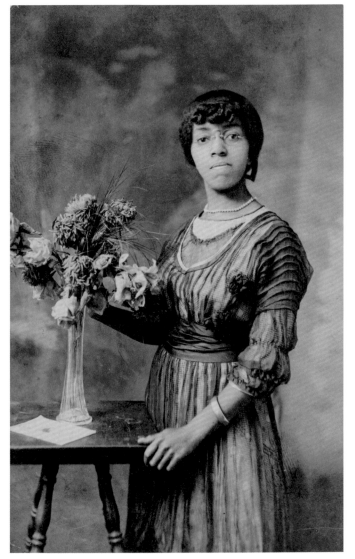

167
Woman with flowers, about 1914

168
Woman in finery, about 1914

169
Woman with a feathered hat, about 1914

170
Men with Stars and Stripes
beer, Lincoln, Nebraska, 1908
or later
KOZY STUDIO

171
Four workers, about 1914

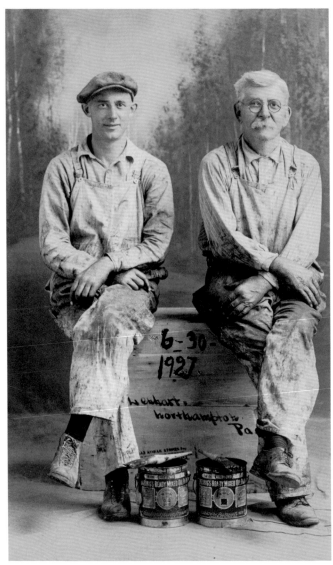

172
Two painters, 1927
LENHART STUDIOS

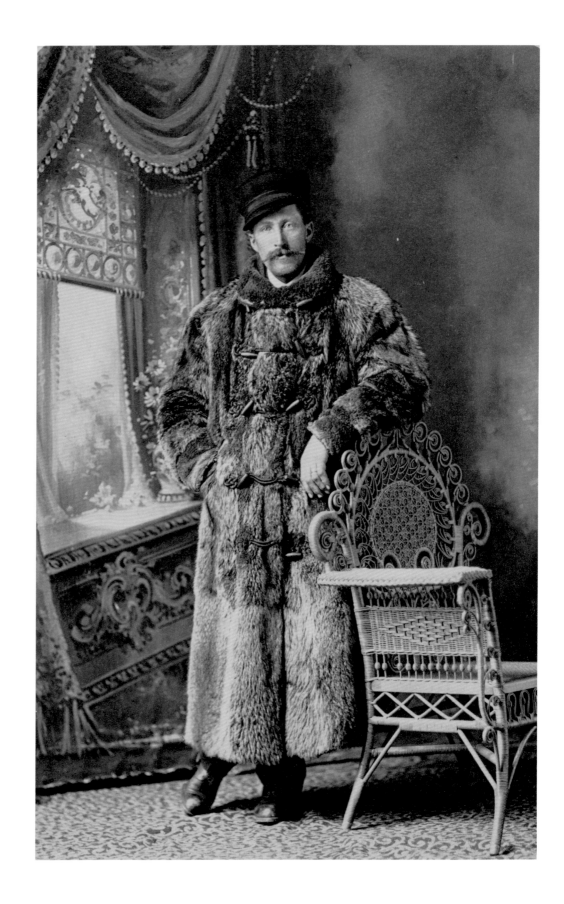

173
Man in a fur coat, 1910

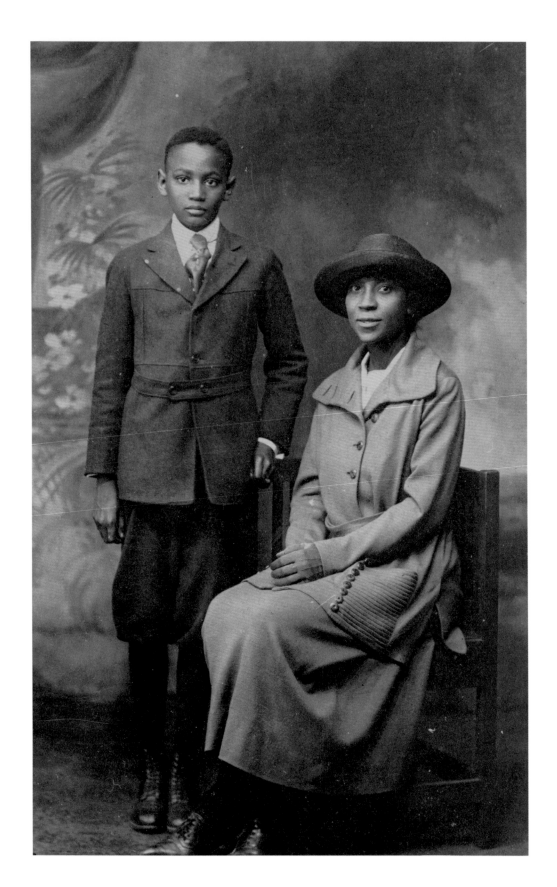

174
Woman and boy, 1917 or later

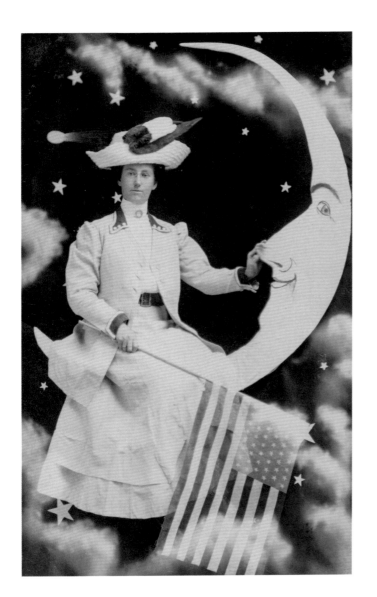

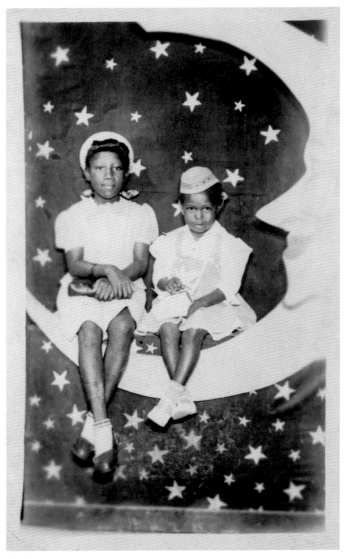

175
Portrait of Elise Welch, 1917
WILLIAM PINCH

176
Portrait of two girls, 1941 or later

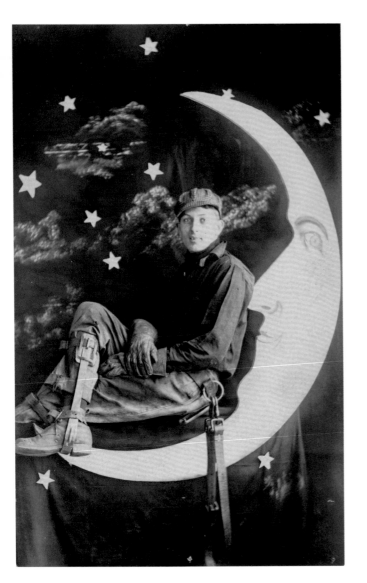

177

Portrait of a lineman, about 1914

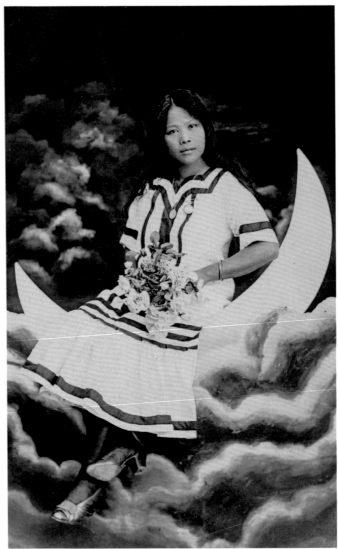

178

Portrait of a young woman, 1911 or later

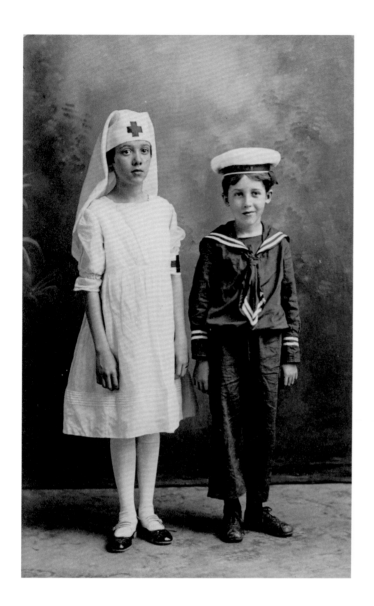

179
Girl in nurse costume and boy in sailor suit, 1917 or later

180
Boy in a suit, about 1914

181
Boy in cowboy costume, Altoona, Pennsylvania, 1916

182
Boy in Native American costume, about 1914

183
Woman in cowgirl outfit,
1907 or later

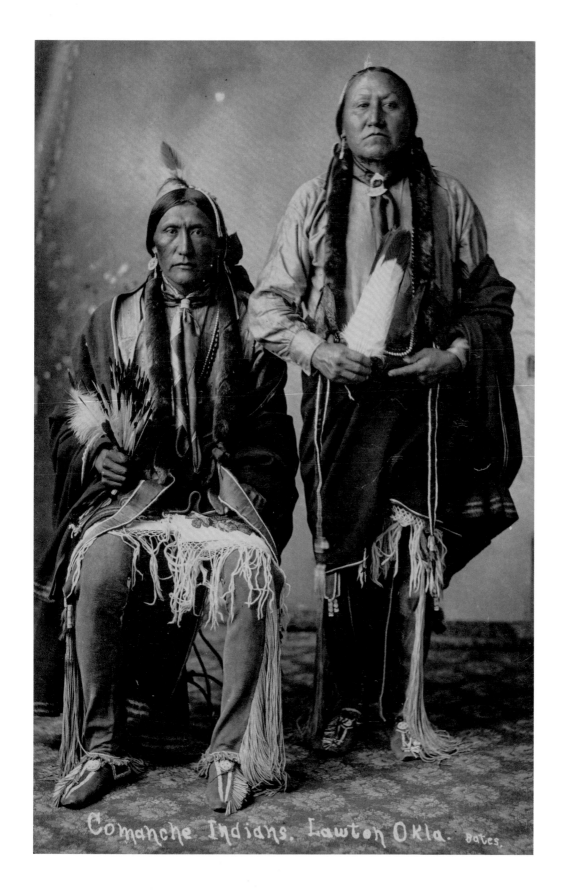

Comanche Indians. Lawton Okla. Bates.

184
Comanche Indians, 1909
or later
BATES STUDIO

Between Private and Public | ANNIE RUDD

Four young women pose for the camera, arms linked, kneeling together in an unkempt garden (**185**). Displayed before them is an object whose centrality within the scene hints at its meaningfulness: an album containing a collection of postcards. Like the women themselves, the postcard album is flanked by foliage — so much so that like the figures, it almost appears to be sprouting up from the earth. This image frames both its human subjects and the postcards that they give pride of place as the natural outgrowths of careful cultivation, and the mise-en-abyme that is achieved by printing this image of postcard enthusiasts on postcard stock suggests a degree of self-reflexiveness that observers looking at this image from the perspective of the 2020s might more readily associate with postmodern subjectivity than with Edwardian sensibilities.

The wry knowingness that colors this image and the deliberateness with which its subjects present their album to the camera encourage the viewer to take seriously the work of cultivation on which real photo postcards were predicated, and to consider what this work can illustrate about women's social position in the early decades of the twentieth century. Real photo postcards are especially rich sources of insight into the ways American women interacted with the culture that surrounded them as these cards allowed amateur photographers — a subset of the photographic community that, by the early twentieth century, was more dominated by women than ever before — to use a technology that was becoming widely associated with the depiction of domestic life in order to craft identities and engage in activities that were decidedly public.

In exploring the ways women used real photo postcards to negotiate between private and public realms and roles, it is fruitful to treat these postcards as media: as objects that moved between people, helping them to understand their place in the world, navigate that world, and relate to one another. Embracing postcards' mobility — and looking closely at the ways they circulated, and helped to connect those who used them — can aid in understanding their social meanings. Mediating interpersonal relations as well as broader political ones, these objects offered women multiple means of complicating the binary division between public and private existence. And while the real photo postcard was not unprecedented in the degree of public exposure or activity it afforded women, it nonetheless gave them significant new ways to imagine, enact, and represent feminine experiences that broke decisively with the mythos of separate spheres that had been central to Victorian ideals concerning gender — a mythos that was increasingly challenged in the Progressive Era. Occupying a space between conventionalized, public imagery and private, domestic imagery, the real photo postcard was

185 Four women with postcard album, 1908 or later

both a symbol of and a vehicle for the traversal of gendered boundaries.

It can be easy to imagine that the vogue for real photo postcards sprang fully formed from the 3A Folding Pocket Kodak, as the logical outcome of a new, accessible, and widely advertised commercial offering. Eastman Kodak began offering to print photographs made by this camera on postcard stock starting in 1906, and later suggested that photographs produced from other sizes of Kodak negatives could be repurposed as postcards, noting in a 1914 issue of *Kodakery* that a slightly smaller postcard made from the ubiquitous Brownie "reminds one of milady's dainty stationery."[1] Like many of Eastman Kodak's other consumer products, this "postcard camera" was widely available and marketed heavily to women. Even before the introduction of this camera, the popularity of snapshot photography and of the industrially produced picture postcard created a felicitous social context for the embrace of the real photo postcard.

With the rise of snapshot photography in the final years of the nineteenth century, the ranks of female photographers expanded dramatically, and photography became a feminized pursuit as never before. The designation of "amateur photographer" also became newly gendered. Traditionally associated with technically skilled photographers who undertook photography for the love of the craft, "amateur" was by the turn of the century being applied to snapshot photographers operating Kodaks and other hand cameras. Tellingly, as the term became increasingly pejorative, referring to a deskilled and commercialized set of practices, it also became more widely applied to women.

Eastman Kodak's aggressive marketing treated women as an untapped market of potential hobbyist photographers, with the belief that they could be encouraged — or perhaps pressured — to treat photographs as records of domestic life and chronicles of children's development. These advertisements often stressed the ease of use of the new box cameras, and emphasized the passage of time

and the value of photographs as records of the past. In this way, marketing efforts urging women to "keep a Kodak record of the family" frequently cast women as denizens of the domestic sphere and emphasized a time-honored understanding of photographs' value: their embalming function, their ability to preserve happy family memories and thus act as a kind of prophylaxis against the passage of time.

Kodak's marketing also assigned a specific temporal structure to the act of photographing: photography's proper object was presented as the chronicling of an ongoing, perpetually unfolding narrative, whether that narrative concerned the gradual maturation of one's children or the progression of a vacation. Gil Pasternak has characterized this new tendency as the establishment of "photographic biography," arguing that Eastman Kodak's marketing and pedagogical efforts, particularly through its in-house magazine, *Kodakery*, worked to establish a connection between taking photographs and constructing a "life story."[2] Women were hailed as the primary chroniclers of this narrative, with camera and film advertisements targeted to them in ways that addressed them as wives and mothers living a primarily domestic existence. In her study of Eastman Kodak's marketing, Nancy Martha West notes that the firm's advertisements stressed the capture of meaningful family moments, emphasizing above all else "the importance of home and the preservation of domestic memories."[3] One upshot of this marketing angle was the popularization of what Richard Chalfen has referred to as the "home mode" of photography, emphasizing family life and the goings-on of the private sphere.[4]

If snapshots that chronicled domestic life were a crucial precursor to the real photo postcard, so too was a medium that was highly public: the ubiquitous, mass-produced picture postcard, featuring colorized images of familiar attractions and printed in large quantities. By definition,

picture postcards were public media: they were, of course, intended to circulate widely, and a series of changes in postal regulations in the turn-of-the-century United States encouraged their mobility. In 1898, the U.S. Postal Service reduced the postage rate for postcards from two cents to one cent, making postcards significantly cheaper to send than sealed letters. That same year, the U.S.P.S. launched Rural Free Delivery, a service that made it possible for people living in remote areas to receive their mail once a day via delivery rather than traveling long distances to the closest post office. Previously home delivery had only been available in towns of ten thousand people or more.

But picture postcards were public in ways that superseded their individual trajectories from sender to recipient. They were omnipresent consumer goods, as one commentator wrote in 1905:

> *Wherever you go picture postcards stare you in the face. They are sold at cigar shops, libraries, chemists, and fruit stalls . . . they are at railway stations; they are hawked at the landing-stages of the steamers; the driver of diligence keeps a few in his hat; and I have not the slightest doubt that in every place frequented by tourists if you were to ask your way of a policeman he would tell you and then produce a little stick of picture postcards for your inspection.*[5]

In addition to constituting a ubiquitous part of the visual landscape in cities and towns, picture postcards were public images in that they tended to be constructed for the broadest appeal, favoring the most recognizable and legible views. A 1906 ad for prospective postcard photographers put it plainly: "Successful cards must appeal to large numbers of people, and therefore should aim at dealing with subjects in which large numbers of people are

186 Women sledding, about 1914

interested."[6] As picture postcards became a commodity of unprecedented popularity — in 1907, Americans mailed 799 million postcards — there was incentive to produce views that were highly conventionalized and idealized, free from any individual associations that would limit their desirability to consumers.[7] Contemporaries observed that it was difficult for postcards to offer an original view in this age when, as one commentator wrote in 1908, "topography is being rapidly used up. There are practically few subjects left to photograph which have not been done to death by the picture postcard, unless one can get well away from the beaten track."[8]

The snapshot and the picture postcard therefore represented opposites. Domestic snapshot photography as marketed by Eastman Kodak was firmly situated. While not necessarily hidden away from the wider world, snapshots mostly reaffirmed cultural conventions around what activities and affects deserved photographic documentation and hinged on the intimate, embedded depiction of familial life. Meanwhile, the views proffered by picture postcards tended to be disembodied and anonymized. They aimed for a view from above, laid out for the spectator's detached consumption, as a means of ensuring general appeal. In comparing the snapshot and the picture postcard, there is a broad gulf between imagery that was conceived of as "private" and that which was considered "public" — a gulf that real photo postcards would help to bridge.

In a vacation postcard mailed from New Hampshire to Mrs. R. S. Mason in Bradford, Massachusetts, eight women dressed in winter clothing climb a small, snowy hill with sleds and skis in tow (**186**). Pictured from the back, the women appear to be unaware of the camera's presence, engaged in conversation and absorbed by the effort of their ascent. This photograph presents its subjects' leisure activity in a manner that is decidedly less monumental and more intimate than what would be likely to appear on a mass-produced postcard; both literally and figuratively, what it depicts is off the beaten path. The sender, well acquainted enough with her recipient that no identification is necessary, implies that the card depicts her

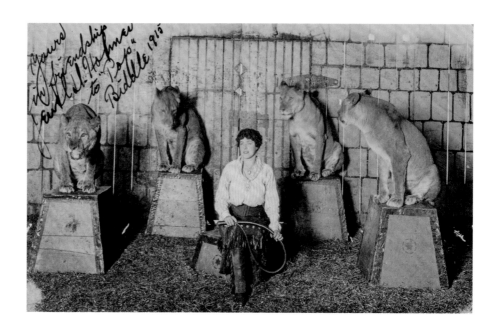

187 Holmes, lion tamer, 1915

own activities: she is either the picture's maker or one of its subjects. "We are having a very good time," she writes, adding, self-deprecatingly, "I haven't been very strenuous yet."

In allowing women to put themselves into publicly circulating pictures, real photo postcards afforded what contemporaries described as the personalization of a communications medium that was often anonymous and generic. Real photo postcards, produced for the photographer's own use or for small-scale distribution, presented a perspective and a set of subjects whose appeal was decidedly local and vernacular, and for many, this added to their appeal: "The amateur's post cards," wrote a commentator in *The Photo-Miniature* in 1908, "made to give pleasure to his friends or intimates, should be sharply differentiated from the commercial sorts by their personal associations or semi-intimate interest, shown in the choice of subjects and their treatment . . . It is the personal touch which makes the difference."[9] In addition to the perceived intimacy of these renderings, postcards

offered their users greater creative control, allowing amateur photographers to represent their lives and activities in a manner "enhanced by the individuality or personality of [their] maker."[10]

Real photo postcards thus allowed users to combine the agency of constructing their own images with the publicness of the circulating image. More so than earlier media forms, these postcards gave their makers the opportunity to write themselves into a visual narrative in a public way, and to allow their likenesses to move about in public space. While many of the strictures that disempowered women — such as the exclusion of most women from the public sphere and the denial to women of political agency via the franchise — were justified with the idea of separate spheres, postcards undermined the notion of a strict divide between public and private. Some of the critical functions of these postcards included representing women's activity in the working world, encouraging certain types of mediated public interaction, and supporting women's political action.

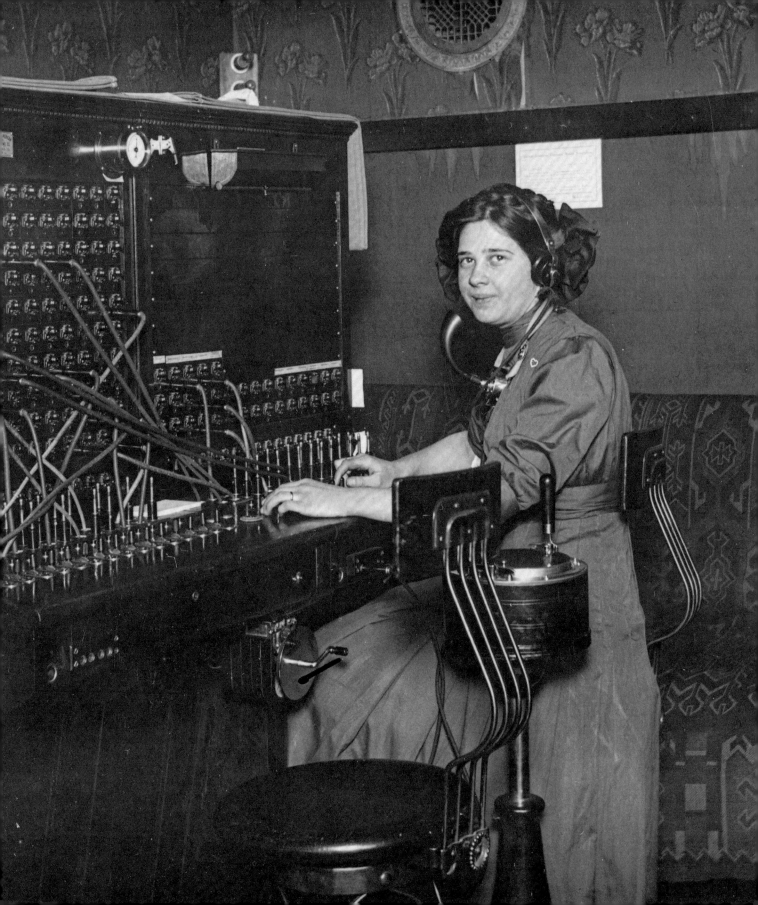

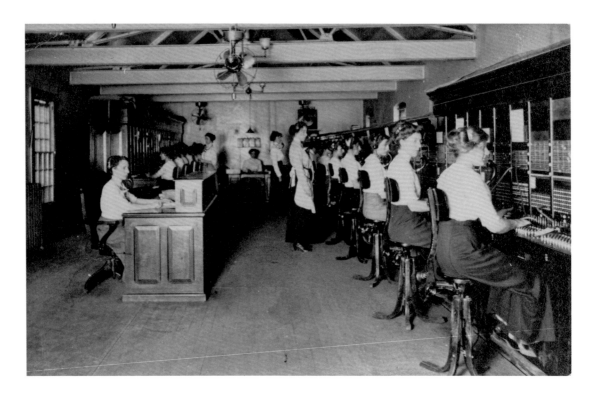

Through occupational portraits as well as workplace snapshots, real photo postcards served as means of visually representing women's work outside the home. Snapshot photography's aesthetic norms may have privileged domesticity, but the same cannot be said for real photo postcards, which illustrate a broad gamut of jobs that women undertook outside of the domestic realm. In this way, real photo postcards both captured women's participation in public life and, through the cards' subsequent distribution, visually reinforced it.

Women's work as shown in real photo postcards includes representations of both exceptional forms of labor and quotidian but underacknowledged ones. Some postcards illustrate the degree to which women were beginning to enter lines of work widely considered too hazardous for their participation. One card, for example, depicts a female lion tamer named Holmes, brandishing

a whip as she poses flanked by four lions who sit neatly on pedestals (**187**). Others show an early female truck driver, Luella Bates (**193**), and the race car driver Irene Dare (**194**).

In other fields of work outside the home, women constituted a more expected class of laborers. Postcards depicting telephone exchanges featured women operators, who quickly came to dominate this field of work, owing in part to employers' belief that they had better telephone manners than men, and in part to the fact that they could be paid considerably less than men.[11] On the back of one postcard (**188**), which depicts an Elmira, New York, roomful of telephone exchange operators clad in shirtwaists and skirts, the sender identifies herself as one of those pictured: "This is where I hold forth," she writes. Another operator (**195**), this one pictured solo at the switchboard as she offers a smile to the camera,

writes to her recipient, "Do I look natural?" As switchboard operators and as secretaries, large numbers of women were entering the workforce as white-collar employees in the early decades of the twentieth century, but they were doing so primarily in gender-segregated, supporting roles.

Another card shows a woman at a teacher's desk (**189**), presenting an image of the female educator that is rife with symbolism: her prominent flag and her presidential portraits demonstrate patriotism, drawings of bunnies and chicks on the blackboard signal gentleness, and the competing accessories on either side of her desk — a globe on one hand, a bouquet on the other — hint at a contest between the worldly and the feminine. Such accessories point to the competing priorities of her role as a teacher in this milieu, where women were gaining political ground but still widely expected to hew to the narrow strictures that governed feminine identity.

Significantly, postcard images also represented domestic labor as labor, making visible forms of work that tended to be overlooked because they took place in private settings. In one postcard (**190**) featuring a group portrait made in 1911 at a studio in Kinston, North Carolina, a Black woman poses with three young white children; her uniform, which includes a ruffled bonnet and an apron, suggests that she is the children's nursery maid or nurse. To fit into the frame among her diminutive charges, the woman kneels just behind them. Unlike in many postcard images of nuclear families, she is expected to position herself on the floor to accommodate the children, an arrangement that analogizes some of the power dynamics governing the work she performed.

In addition to capturing women in workplaces both public and domestic, these cards, through their collection and exchange, occasioned new mediated spaces in which

189 Teacher in the classroom, about 1914

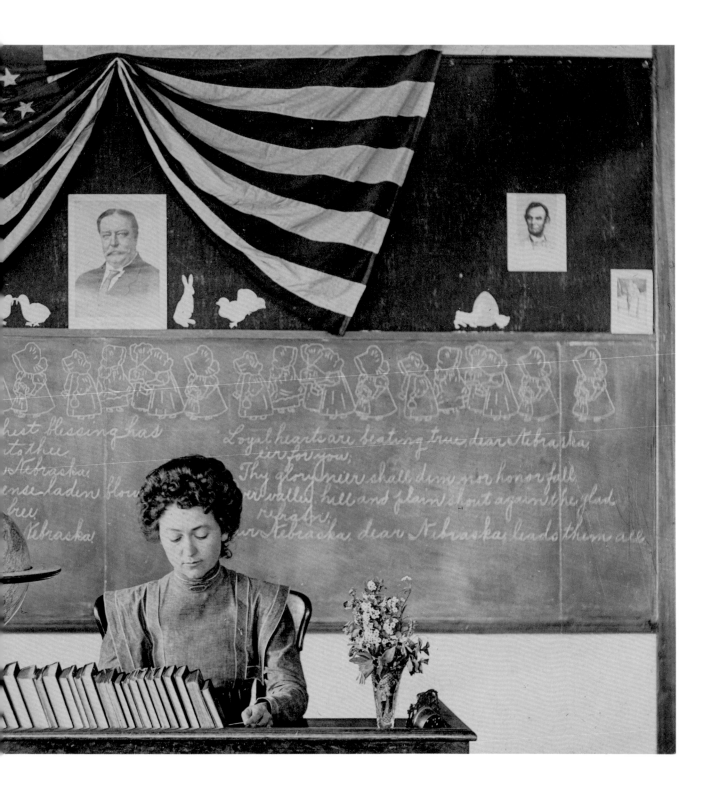

190 Woman with children, Kingston, North Carolina, 1911 or later GOBLE'S ART STUDIO

women could connect with one another. In particular, postcard exchange columns began to appear in numerous newspapers and magazines in about 1905. These columns functioned like classifieds sections in which readers could advertise their interest in trading postcards with others, often expressing preferences for particular kinds of cards, or cards from particular regions.

Postcard exchanges were not merely spaces for the dispassionate communication of consumer demand, they were also avenues for affective expression. In these exchanges, people — often young women — articulated aspects of their identities, expressed loneliness or enthusiasm or pride, and described their interests to others. One correspondent from Los Angeles described her postcard preferences, her needlework skills, and her interest in corresponding with "anyone desiring assistance, . . . especially the shut-ins." She described her own circumstances as solitary ones: "I am 24 years of age, and have been married three years I am a long distance away from any of my relatives, and am alone all the afternoon and all night, and so I often get lonely."[12] For those lacking the access to the lively experiences of vacationers and working women, postcards provided a pretext for mediated social interaction that would otherwise be absent. One young collector, writing in to the *New York Tribune* in 1906, lauded another reader's contribution to the column: "I think it is very nice of Olga Kolff to tell us about Rotterdam, and I think her description is very good. I, too, have been to Europe, and I expect to go again in a few years . . . when I go again I will tell you about it," she wrote to fellow readers, offering a chatty, convivial missive to the indiscriminate readership of this public-facing venue.[13]

These exchanges — a compendium of relatively unstructured and unforced messages about topics that would otherwise have been below the threshold of historical recording or newspaper reportage — offer an unexpected glimpse of the users and audiences of postcards. The closest equivalent with respect to content is personal correspondence, yet users of the postcard exchange were conscious of the fact that they were writing openly, to all potential readers of the newspaper, and they were in many cases providing their home address as well. This publicness was clearly not a source of consternation for those

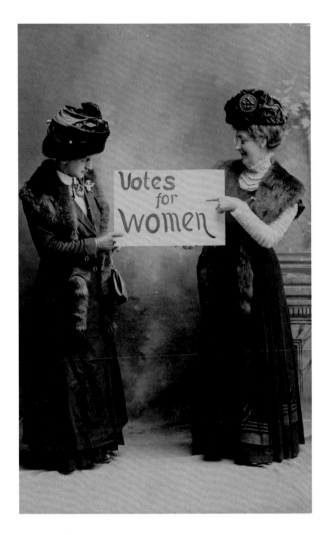

191 Votes for women, 1907 or later

about upcoming church sermons to "postcard showers," at which the person being celebrated was gifted with large volumes of postcards from friends. Examples like these make it clear that in the early twentieth century, much like today, the notion of a sharp divide between mediated communication and "real life" was mostly illusory.

Postcards also bridged this gap when it came to people's political practices, and here, one particular function stands out: postcards were used as a means of promoting and recording activities related to the women's suffrage movement. In this way, women exploited the visually compelling, timely, accessible, and public nature of postcards to promote concrete political change by demanding a role in the public sphere.

Women's magazines discussed photographic postcards as a way to participate in the production of suffragist media, to drum up support for the cause of suffrage, and to bring new supporters into the fold. "Get out your cameras," the Boston-based women's rights magazine *The Woman's Journal* implored its readers in 1909:

> *Why not prepare for the holiday season by arranging 'fetching' groups of children holding the suffrage flag, and photographing them for suffrage post cards? There is money and, what is better, useful propaganda work for the person or club that can evolve a really bewitching post card along this line . . . Charming childish material is abundant in suffrage homes. Let those of our readers who have cameras and artistic taste try it.*[14]

In another issue, the *Journal* noted, "The multiplication of woman suffrage postcards is one among many signs of the growth of interest in the question"[15] (**191**). Suffrage organizations organized postcard competitions, encouraging their members to design postcards that could be used to

postcard collectors who chose to write in. Instead, the women who sought exchange and companionship through these forums seemed to welcome the opportunity to address a broad and unpredictable public audience.

In addition to offering a pretext for communication at a distance through venues like the postcard exchange, real photo postcards served as impetuses for face-to-face interaction, from postcards reminding erstwhile parishioners

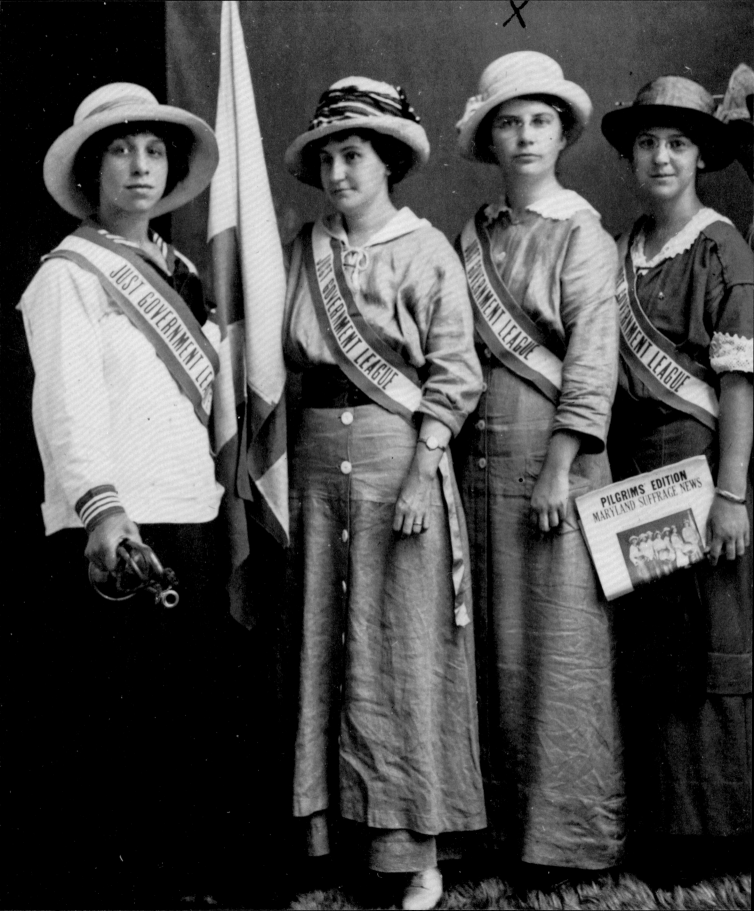

promote their cause, and "suffrage shops" sprang up in New York City and Atlantic City, among other locales, to sell postcards alongside suffragist literature and paraphernalia.[16]

Even when the images they featured were produced in a commercial studio rather than by amateurs, real photo postcards allowed women to exercise agency over the production of their likenesses, and to use those likenesses in the service of political gains. A postcard dating to June 1914 (**220**) shows a group of six women posed in the studio of T. W. Stewart of Oakland, Maryland. Standing in a row and gazing frankly at the camera, the women bear sashes that promote their organization, the Just Government League of Maryland, a women's suffrage association formed in 1909. The Just Government League's tactics included extended, multi-city hikes, during which members gave speeches promoting women's voting rights to audiences assembled along the route, and an inscription on the card's back reveals that this photograph was taken during one such march: "The Garrett County Hike in which we made 125 miles on foot making 2 to 3 speeches a day," it reads. The women pictured — led by Lola Carson Trax, third from left, donning a white hat — described their struggle using figurative language that aligned it with biblical and military errands: they frequently characterized themselves as "pilgrims" and a "suffrage army," and daily newspapers appropriated this language, with the *Baltimore Sun* calling them "Feminine Davids" poised to "attack the Democratic Goliath" and the *Washington Times* noting, "the route of the pilgrimage will carry the invaders into Garrett and Allegheny counties." Perhaps unsurprisingly, however, these articles also made note of the marchers' "filmy creations of summery frocks" and their sparkling eyes.[17] In these instances and innumerable others, press coverage of the suffragists treated them as a spectacle: not only were they described in terms of the political changes they sought and the tactics they employed, they were also portrayed as a sight to be observed.

This real photo postcard demonstrates an acute and canny consciousness of this fact, and a willingness to make the most of it. A spectator looking closely at the postcard might notice a small but arresting detail: one of its subjects displays the "Pilgrims Edition" of the *Maryland Suffrage News*, the official organ of the Just Government League, published to coincide with the march; the paper's front page bears a portrait of the same women who appear on this postcard, posed in a similar fashion. This picture-within-a-picture is suggestive of the self-awareness with which its subjects adopted and exercised their image as they undertook their fight for the vote: the Just Government League marchers are in possession of their own carefully controlled likeness, and they understand its value as a tool for drawing attention to their cause. To claim a place in the public sphere, this postcard suggests, women must wield power over their public images.

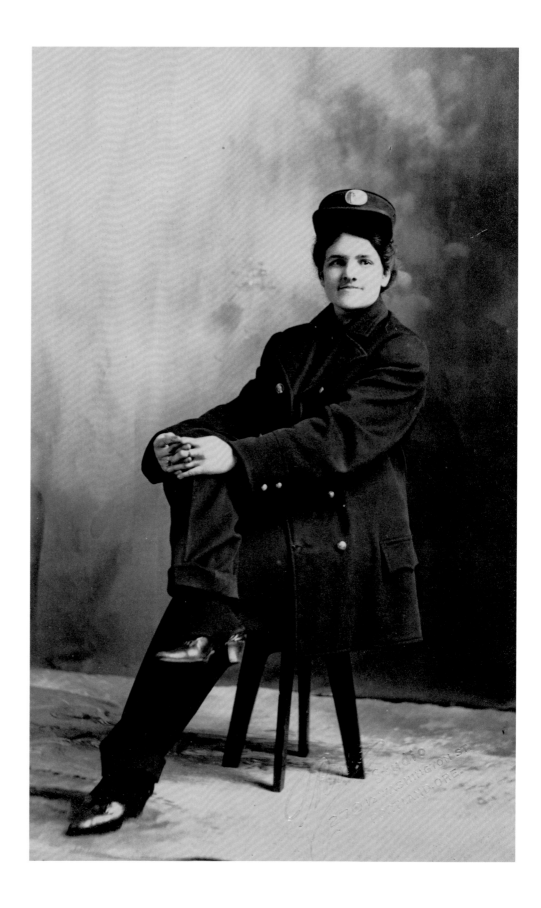

192
Railroad worker, Portland,
Oregon, 1911 or later
ROSE STUDIO

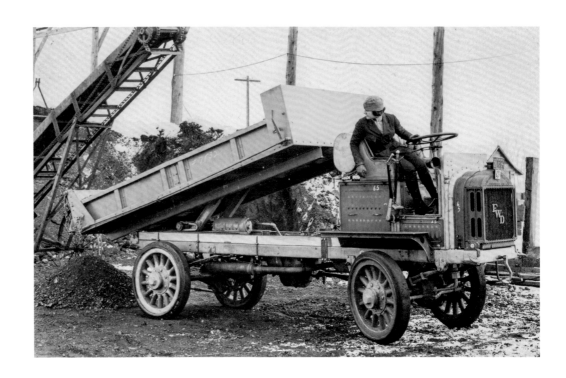

193
Luella Bates, first female
truck driver, 1917 or later

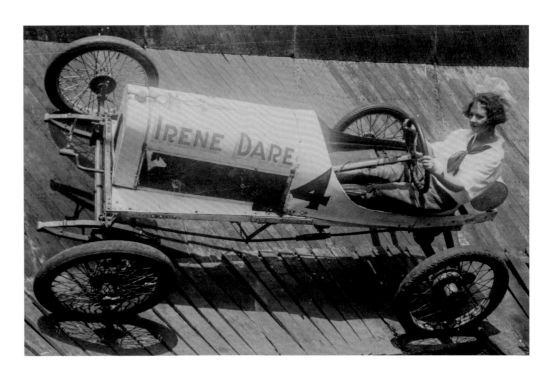

194
Irene Dare, about 1926–27

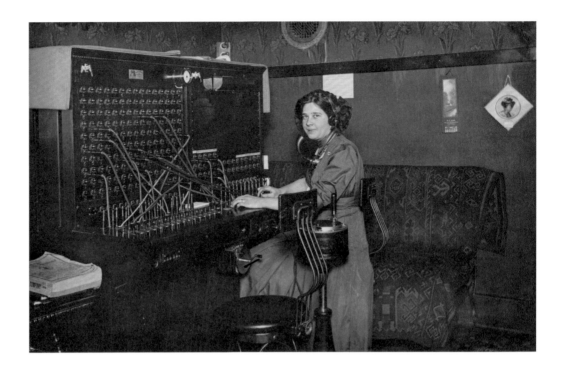

195
Telephone operator, 1907
or later
SXPC

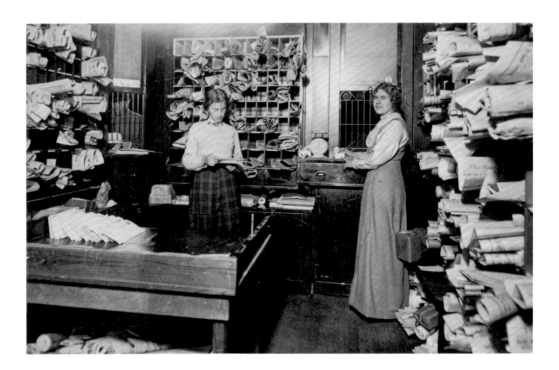

196
Mailroom clerks, about 1914

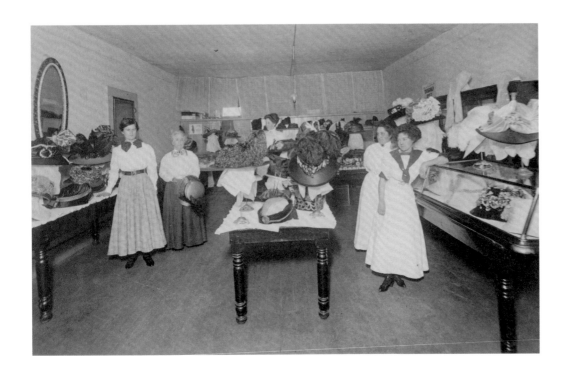

197
Hat shop, about 1914

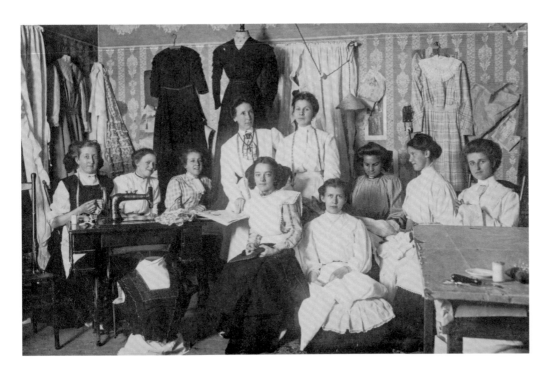

198
Seamstresses, about 1914

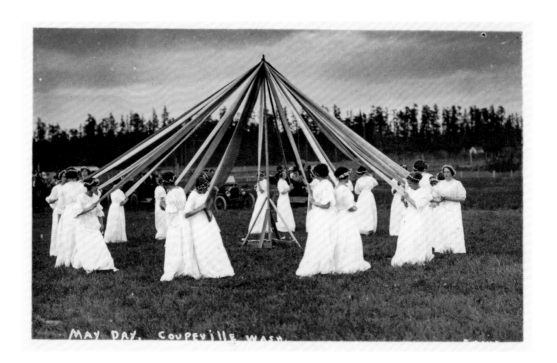

199
May Day, about 1914

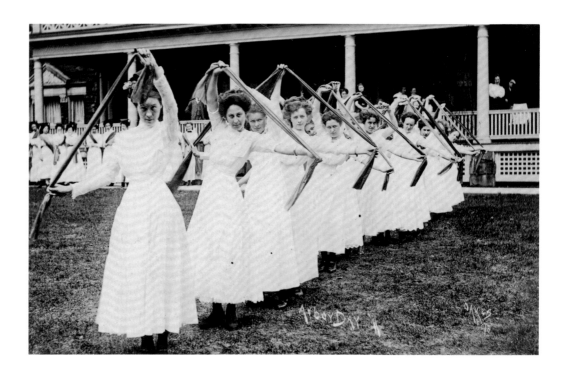

200
Arbor Day, 1911
OAKES FOTO

201
Mary Brockman, York,
Pennsylvania, about 1914
SIMON & MURNANE

202
Seven women, 1907 or later

203
Woman with dog, Lakefield, Michigan, about 1923
J. A. BELLINGER

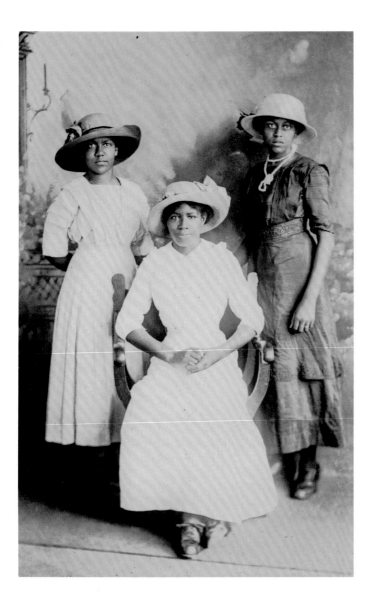

204
Three young women, about 1914

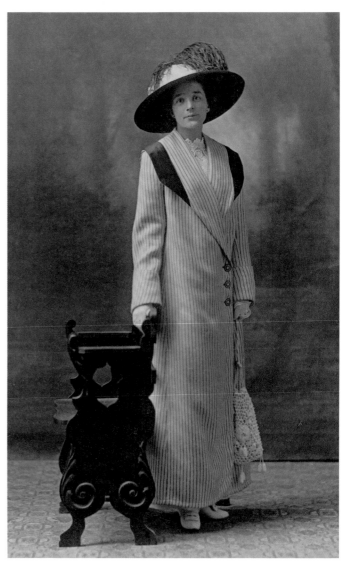

205
Woman in a hat, about 1914

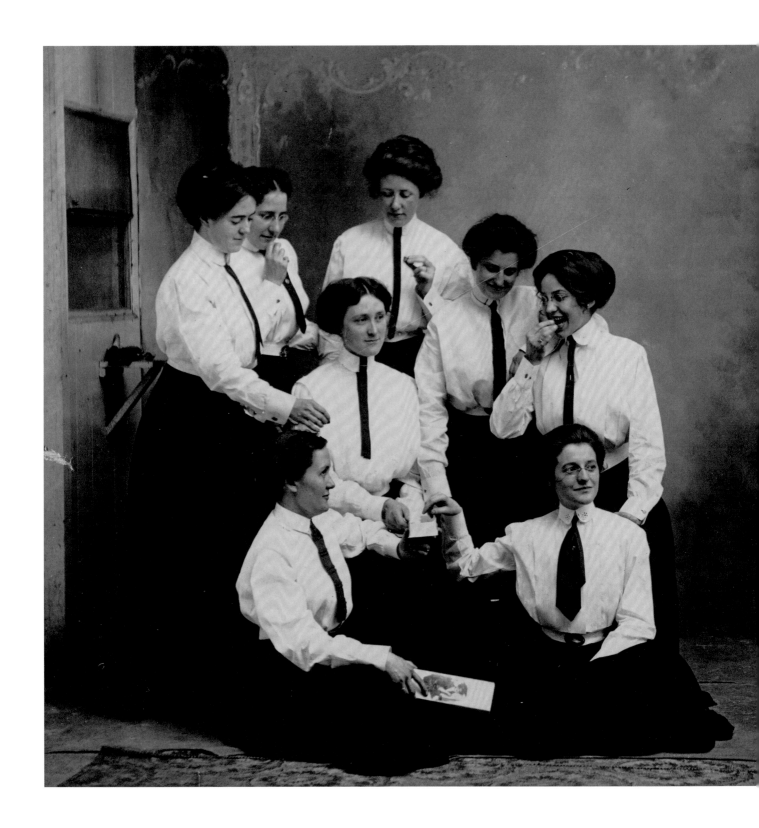

206
A group of women, Caldwell, Ohio,
about 1910

207
Woman in costume, 1917
or later

208
Prostitute, 1917 or later

209
Woman in costume, San
Antonio, Texas, about 1914
A. LEWISON

210

Women's baseball team,
1911 or later

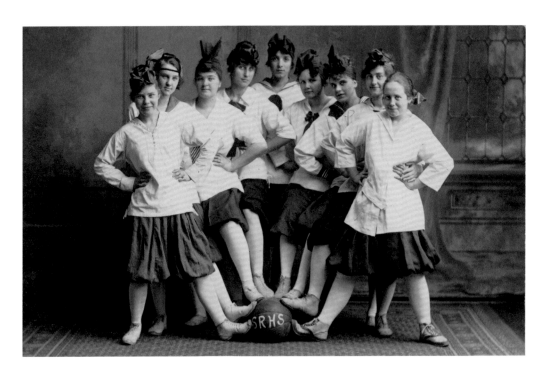

211

Women's high school
basketball team, 1915
or later

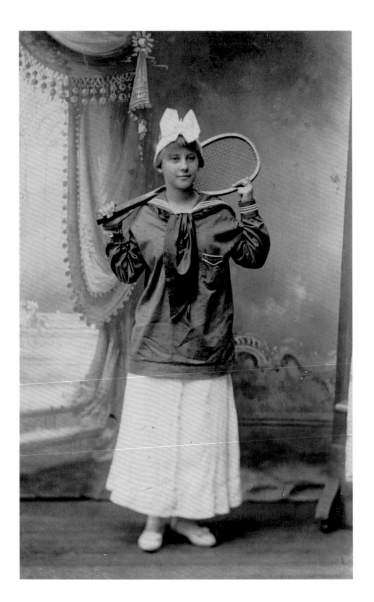

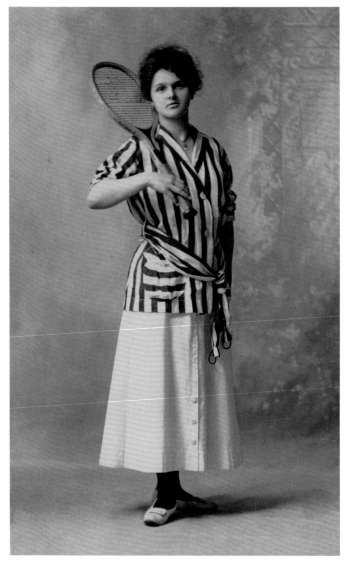

212
Tennis player, 1915 or later

213
Tennis player, about 1908
J. F. FASNACHT

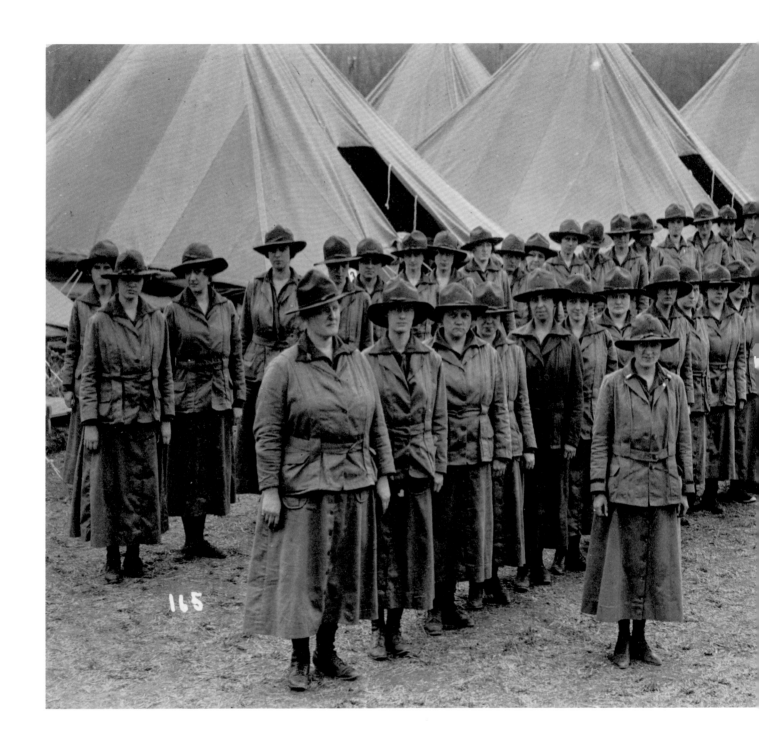

214
Women's camp, Chautauqua, New York, about 1914

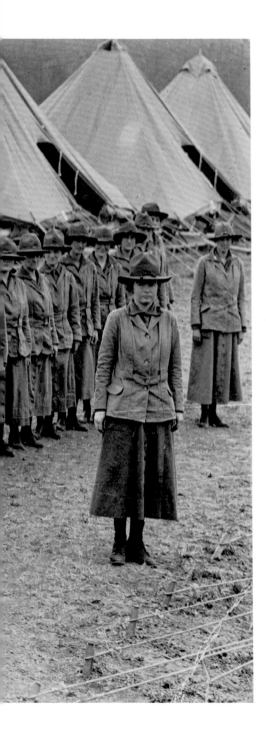

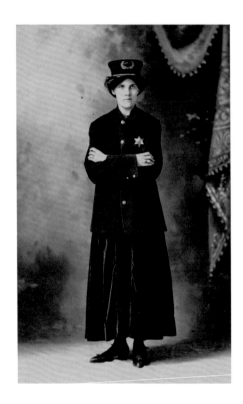

215
Lula Steele, religious worker,
Eureka, California, about 1914
HESS

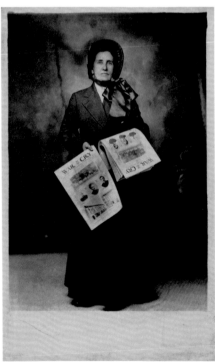

216
Mrs. A. I. Matteson, Salvation
Army worker, about 1914

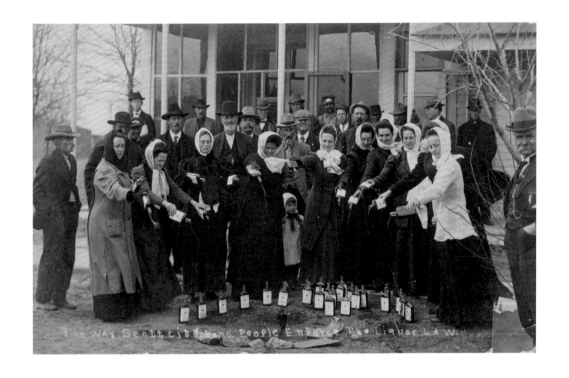

The Way Scott City Kans. People Enforce The Liquor LAW.

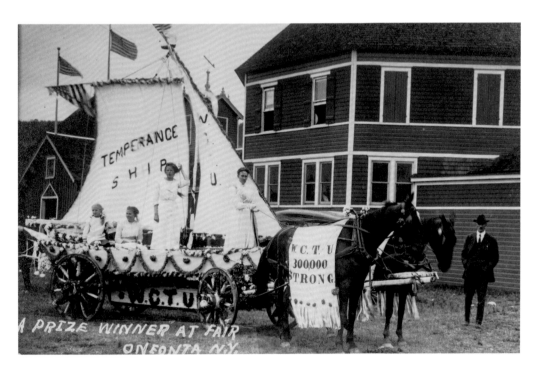

TEMPERANCE
SHIP

W.C.T.U

W.C.T.U
300000
STRONG

A PRIZE WINNER AT FAIR
ONEONTA N.Y.

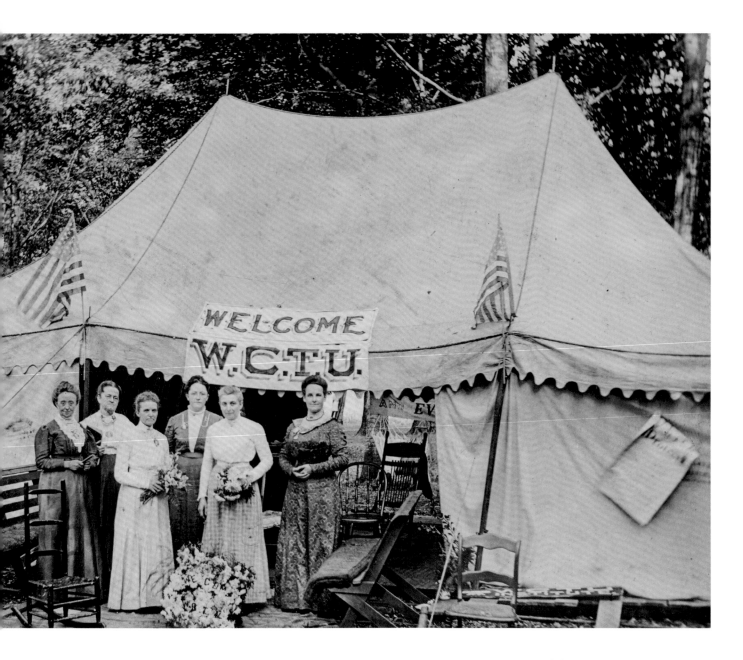

217
The Way Scott City, Kansas, People
Enforce the Liquor Law, 1910

218
A Prize Winner at Fair, 1911
or later

219
Women's Christian Temperance
Union tent, Honeoye Valley
Temperance Assembly, likely 1910

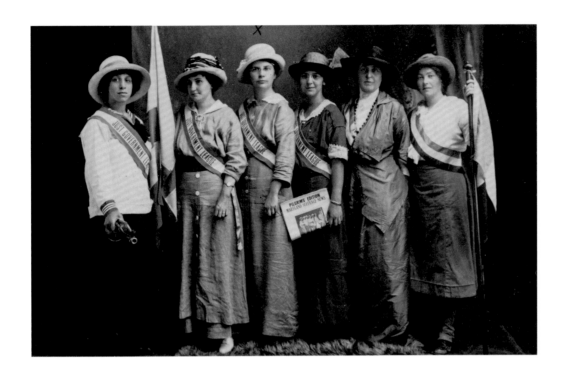

220
Members of the Just
Government League of
Maryland, 1914
T. W. STEWART

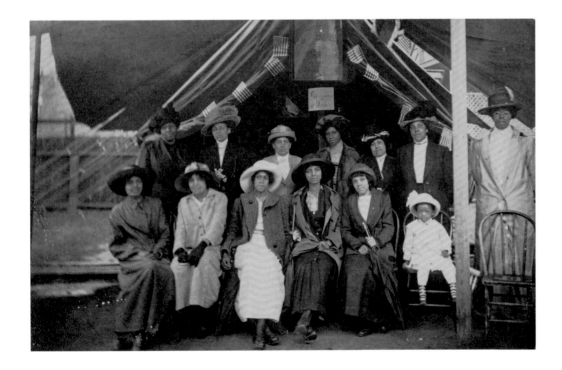

221
Suffragists, about 1912

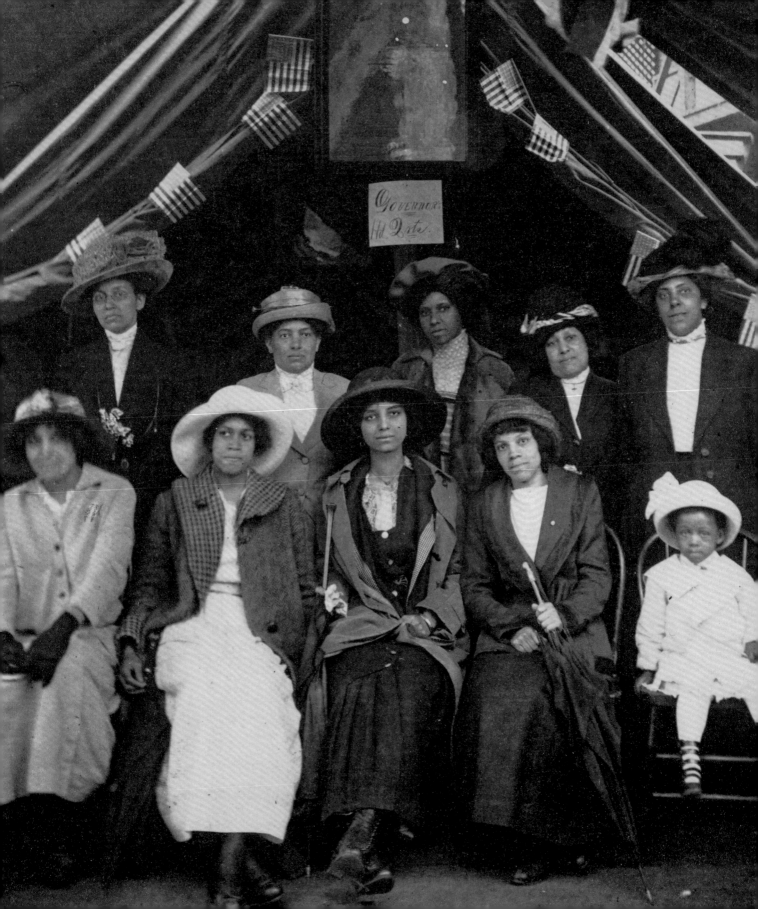

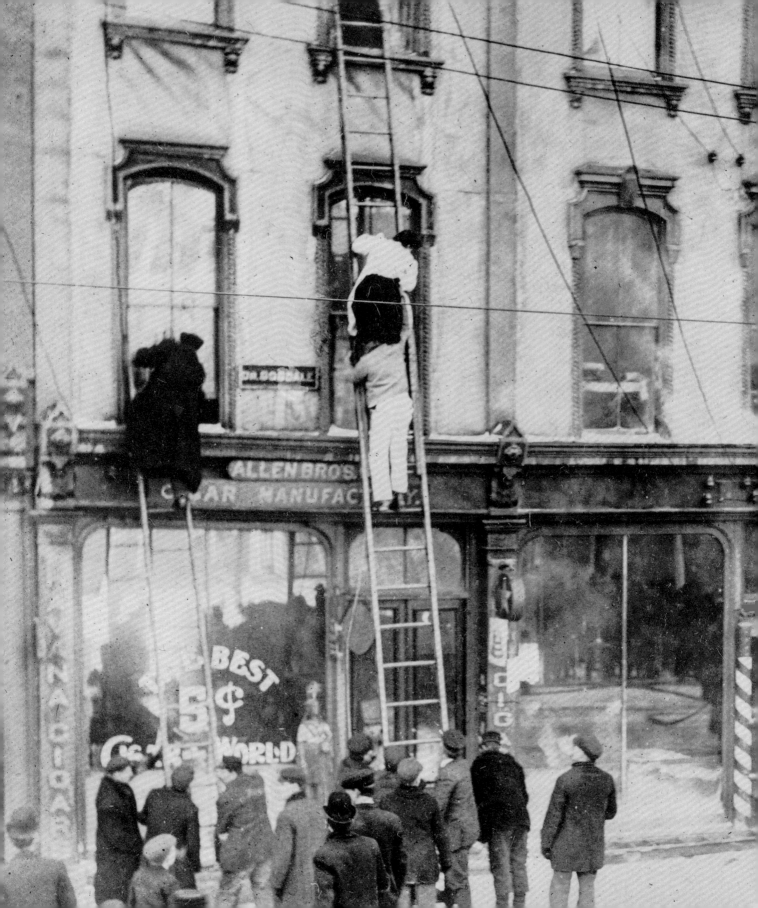

The News | ERIC MOSKOWITZ

On the afternoon of January 31, 1911, a Vermont milliner named Abbie Fraser set off on a trip to New Hampshire, asking a friend to tend her store in Montpelier while she was gone. Not yet forty, she had already known enough suffering for three lifetimes. Her first child, born prematurely, lived just fifteen minutes in 1900. Her second, born healthy in 1902, succumbed to pneumonia and meningitis on the cusp of her fourth birthday in 1906, the same year tuberculosis claimed Abbie's husband. In the wake of unknowable grief, she went to work in a local hat shop and purchased it in time, busying herself with broad brims and bright plumage.

The store occupied a second-floor suite in the handsome but rattletrap Rialto Block, all ironclad wood. Late on the frigid morning of February 1, Abbie's friend — the shop's previous owner — stopped by to warm the store, lighting the wood stove and adjusting the dampers, before returning to open for customers.[1]

Neither woman would ever see the inside of Fraser's Millinery again. A fabric screen near the stove caught fire, and the blaze spread quickly through the shop. A picture framer down the hall smelled smoke; a lawyer across the street sprinted to a corner alarm box. In the time it took Montpelier's volunteer firefighters to muster — scattering paperwork, shoving aside noontime plates and cutlery,

scrambling to secure horse-drawn engines — the building became engulfed, smoke filling the interior stairs and flames lapping the windows.

Three people were trapped: housekeeper Stella Morse and her ten-year-old daughter Mabel in a third-floor apartment, and Dr. William L. Goodale in a second-floor medical office. After rescuing all three by ladder, firefighters worked chiefly to contain the blaze from spreading to neighboring buildings downtown. They knew the Rialto, which spanned the south side of a bridge over a branch of the Winooski River, would eventually collapse onto the ice below.

It took just ninety minutes before the expanse — iron cladding bulging, roof sagging, trusses groaning — crashed down upon that frozen river, taking with it two millinery parlors, two medical offices, and two apartments, as well as that frame shop, a cigar factory, a cigar store, and a barber shop, the domain of an aging Civil War veteran-turned-tonsorialist named Oughtney Jangraw. The top-floor tenement dwellers lost nearly everything. Stella Morse and her children were left without a stick of furniture; neighbor Frank Wise's beloved organ shattered into kindling on the pile.

Photographers with pocket cameras responded as quickly as the firefighters, buzzing about all afternoon. Though they found the light especially favorable from the riverbank, one of them on the State Street bridge managed

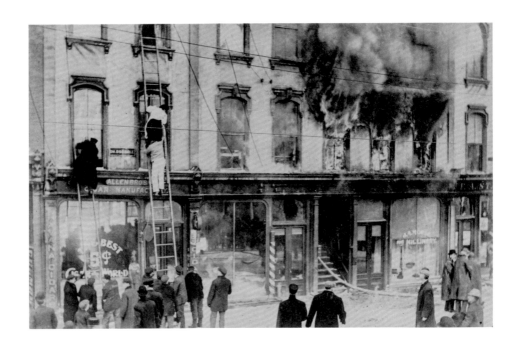

222 Rialto Block fire, 1911

to catch the side-by-side descent of Dr. Goodale in his black cloak and Mrs. Morse in her apron, while flames and smoke billowed from the windows of Fraser's Millinery to their right (**222**). There were so many "camera fiends" snapping pictures that they earned a full paragraph in the *Montpelier Morning Journal*'s coverage of the fire.[2] By the following day, a variety of postcard "views of the Rialto block fire were on sale . . . and found many purchasers."[3]

Today, that might seem surprising, even unseemly or gratuitous. "It's interesting to me that this would be made into postcards. I mean, who would want to send these kinds of postcards?" Mabel Morse's granddaughter, Carol Willey, mused 110 years after the fire — though she answered her own question a beat later: "Except it's a way to capture a piece of history and hang onto it."[4]

Real photo cards like this were just as likely to be saved as posted, capturing for posterity a fire that drew throngs of onlookers — many coming seven miles from Barre by streetcar — well into the evening, for the very same

reasons: to watch the action; to assess the damage; to keep faith with the memory of a favorite barbershop, a reliable cigar store, a charming millinery parlor, a whole block snuffed out where it had stood so solidly. To the extent such cards were mailed, they served as silver-gelatin siblings to the more fragile news clippings a friend or relative might send from an out-of-town paper in those analog days — and as direct forebear to the citizen journalism of the digital age, captured by ubiquitous smartphones and disseminated through social media.

Though this particular one was unsent, the Vermont Historical Society has a copy of the same card posted while the embers on the ice were still smoldering, to a thirty-four-year-old woman in Wisconsin — Mrs. C. E. Whelpley, the former Alice Bagley — who'd left her native Vermont in 1908 after her husband got a job managing a stone-polishing mill beyond Green Bay. The nearly thousand-mile distance must have seemed achingly far in a time of pay-per-word telegrams and pricy, patchwork phone

service, but the fast-traveling penny postcard returned her to State Street for a moment. The sender (a woman named Hattie, likely her sister-in-law) pointed out Dr. Goodale and Mrs. Morse — not Jennie Morse the first-floor milliner, but the unrelated Stella Morse living upstairs — while sending "love to all."[5]

Now as then, these images fill gaps in the photojournalism landscape, whether a result of today's shrinking newsrooms — pummeled by lost ad revenue in the digital age, squeezed by private equity and out-of-town ownership — or the dearth of pictures in local media a century ago, before small-town papers could easily reproduce photos. Sometimes the cards supplemented the work of staff photographers, running in print in major dailies; more often they were à la carte offerings at the intersection of entrepreneurship and freelance journalism, served up for a nickel or dime at the drug store, the newsstand, and the stationer's.

Consider the ink-on-newsprint coverage of that Montpelier fire. For all the drama and destruction, no one died, so the papers down in Boston either ignored the news or buried it as a brief. In Burlington, Vermont's largest city, the fire merited four hundred words; in Barre, closer to the source, seven hundred. In Montpelier, where it was the most dramatic fire of the year, the news commanded five thousand words across five pages and thirteen columns of the February 1 *Evening Argus* and February 2 *Morning Journal*, plus a slew of follow-ups.[6]

Yet not a single photograph accompanied any of these newsprint accounts. The leading Boston papers already employed halftone images, sprinkling their daily pages with occasional breaking-news photos — taken nearby or rushed by auto or train, before the 1935 debut of the AP's Wirephoto transmission service — as well as headshots and prearranged stills, while bundling more photos for special weekend pictorials. Vermont's newspapers remained text-heavy affairs, with just a smattering of thumbnail portraits.

To look at this Montpelier view, with its abundant detail and frame-filling action against so many picture-free pages of newsprint, is to feel a certain sympathy for the reporters who churned out all that deadline copy, laboring to describe what a camera could capture in one tidy shot.

If that calls to mind a certain cliché, it was just eight weeks after this fire that newsman and orator Arthur Brisbane, self-styled father of "yellow journalism" and the top editor at William Randolph Hearst's flagship *Evening Journal*, wowed the Syracuse Advertising Men's Club's "Newspaper Night" with a series of witticisms on the value of clarity, brevity, and punch. One particular Brisbane bon mot would live on as a bromide: "Use a picture. It's worth a thousand words," he told the four hundred plus ad men, journalists, and business leaders gathered at the opulent Onandaga Hotel. Then he rattled off Macbeth's "sound and fury" soliloquy — "If you can write like that, your name is Shakespeare. That's all I'll say. Good night" — and caught the overnight train back to New York City.[7]

That Brisbane's truism about the storytelling power of pictures would coincide with the apex of the real photo postcard is telling. Though photography itself was three-quarters of a century old, the technological breakthroughs that allowed images to be captured nimbly in the field and disseminated quickly were fresh: small, lightweight cameras; faster exposure times; flexible celluloid film; halftone and soon rotogravure processes for commercial printing; the rise of postcards coupled with the marriage of photo paper and postcard stock, in the case of real photo postcards.

For all the tourist views and affordable portraits served up on those photo postcards, they quickly emerged as an important way to record and share local news. In the

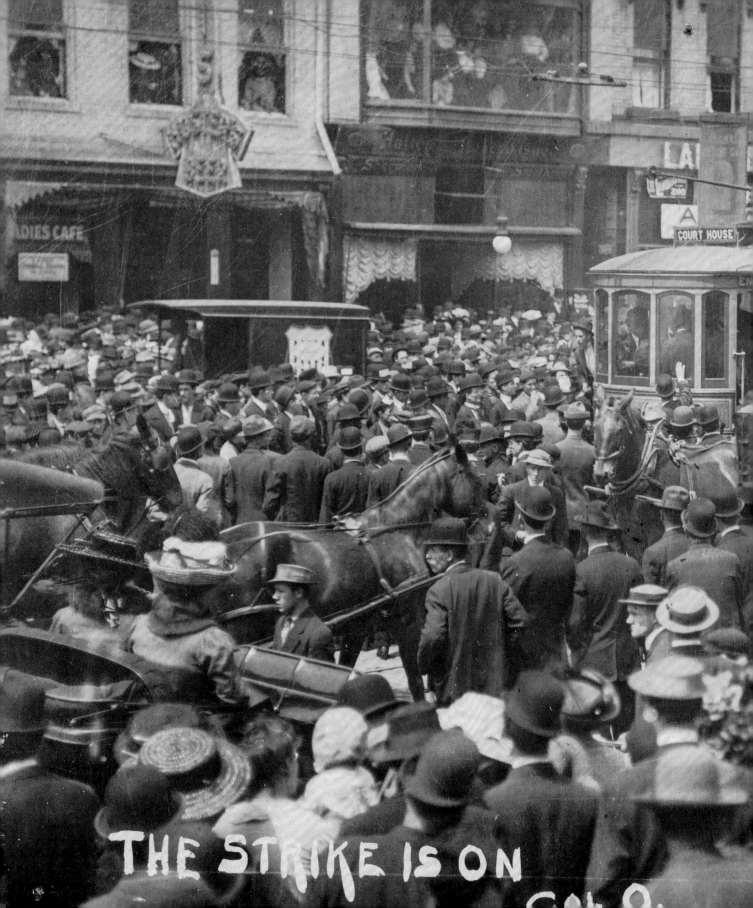

THE STRIKE IS ON

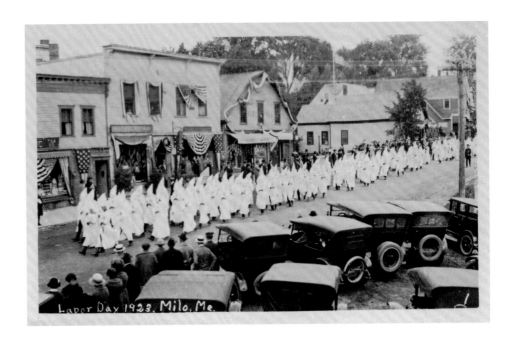

223 Labor Day, 1923

man-bites-dog annals of journalism, the photographers bypassed the everyday for the memorable, noteworthy, or momentous — and sellable — recording a variety of breaking news, spot news, and feature photos, the visual language of print journalism for decades to come. In some cases, the cards survive as a visual record of significant moments or currents in history, like the bloody clashes between management and labor amid the late Gilded Age fight for workers' rights, or the ugly, anti-immigrant ascent of the Ku Klux Klan across the North in the 1920s (**228, 223**). Just as often, the cards captured a granular moment with meaning and news value unique to a particular place and time.

Disasters and their aftermath were a staple, as with the Montpelier fire or the July 4, 1908, head-on collision between a passenger and freight train near Boonville, New York — which killed six people and injured fourteen more — or the pre-dawn bursting of a pair of million-gallon water tanks sitting side by side on a hilltop in Parkersburg, West

Virginia, March 19, 1909, which killed a sleeping newly-wed couple, injured several other people, and destroyed a swath of buildings (**238, 224**).[8] That June, *Popular Mechanics* ran six photographs — real photo postcards, perhaps — from Parkersburg, noting "these illustrations tell far more graphically than words the result of the bursting of two great water tanks."[9] Stripped of context, cards like these might evoke disaster porn, but they documented for personal posterity the myriad tragedies that lead local newspapers for a day or two, earn brief national notice, and recede from wider view — even as they indelibly alter the lives of victims and survivors, rippling through future generations.

The photographers who took disaster pictures — responding to a landscape-rattling boom or word of a catastrophe — presaged the future newshounds with their ear to the emergency-radio scanner, chasing breaking news. Still, in chronicling local life, red-letter days provided more predictable fare for postcard photographers,

228 (DETAIL)

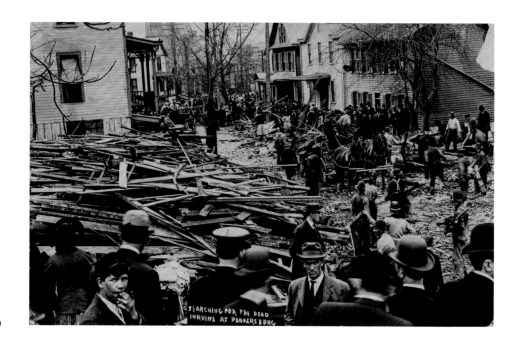

224 Searching for the Dead in Ruins at Parkersburg, 1909

with parades, rallies, and political stump speeches all frequent subjects. The national figure passing through town was a particular favorite, at a moment when whistle-stop tours were still fresh, drawing huge crowds both for their novelty and because they were the only way to hear a candidate directly, before radio and TV.

No politician of that era was as beloved by the postcard photographer as Theodore Roosevelt, whose riveting attempt to reclaim the White House in 1912 — vying to unseat erstwhile friend and chosen successor William Howard Taft — played out around the real photo postcard peak. With his patrician-populist charisma, Colonel Roosevelt (as the ex-president liked to be called) conveyed a crackling energy that comes through in card after card — in contrast to Taft, about whom one Republican observer said in 1909, "I knew he was good natured but I never dreamed he was so dull."[10]

A card with a steamer in the background catches Roosevelt in Sandusky, Ohio, on May 15, 1912 — waving his Rough Rider hat from a flag-draped stage in front of Lake Erie — giving one of seventy-five speeches during a closing sprint across Ohio, Taft's home state, before its Republican primary (**225**). Roosevelt would beat the incumbent there, while winning nine of the final ten primaries.[11] Still, Taft would claim the nomination at the June convention, prompting Roosevelt to break away on a new Progressive Party ticket, dubbed the "Bull Moose Party" after Roosevelt declared himself "strong as a bull moose," that cleaved social-reform Republicans from Taft's more conservative wing.

Three Vermont cards in the Lauder Archive capture Roosevelt on the other side of that schism, barreling around the Green Mountain State over Labor Day weekend by train and automobile — driven mainly by Dr. Horatio Nelson Jackson, the Burlington physician who completed the first successful coast-to-coast automobile trip in 1903 — to make sixteen speeches and a flurry of impromptu appearances, urging Vermonters to vote the Bull Moose

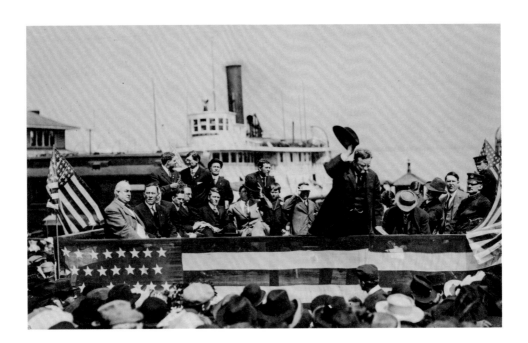

225 Theodore Roosevelt, 1912

ticket in September's state election, a litmus test for the November national contest. The view showing Roosevelt cocked to his right, clutching a bunting-wrapped support post and leaning over the stage, was shot the first day on a Bennington baseball field, and evokes Roosevelt's famous "man in the arena" address of 1910 (**234**). Speaking to an estimated five thousand people on a gusty morning, Roosevelt's voice projected even without amplification, as he covered an array of campaign matters before ending with a winking announcement of "national significance"— that Bennington's semi-pro nine would play Pittsfield on the diamond immediately after.[12] The up-close framing has the feel of a present-day news photo; postcard views more often captured the sweep of the crowd, for reasons of access and focal length — as well as the sales potential of detail-rich cards packed with locals. A series of companion views in the Bennington Museum's collection do not even show Roosevelt, instead looking back across the crowd from near the stage, showing men standing in the

infield and women, children, and seniors beyond them in the covered grandstand.

In Barre, where granite laborers yielded a rich vein of Progressive Party support, Roosevelt can be seen on the last day of his Vermont dash addressing an estimated eight thousand — "probably the largest audience ever gathered together in Barre," that evening's *Barre Daily Times* said — shoehorned into the triangular City Park, with the Beaux Arts–inflected Barre Opera House visible in the background (**226**).[13] This card is rare for being captioned and signed by the photographer, in this case Jedd Beckley, a farmer-turned-stonecutter who also operated one of Barre's half-dozen photo studios for seven years.

In his photography prime, Beckley advertised all manner of work — studio portraits, house calls, "flash-light" pictures of indoor events, portrait postcards at twelve for one dollar with the occasional seventy-five-cent special, and processing and printing services for amateurs — but here, he navigated the scene like a true photojournalist,

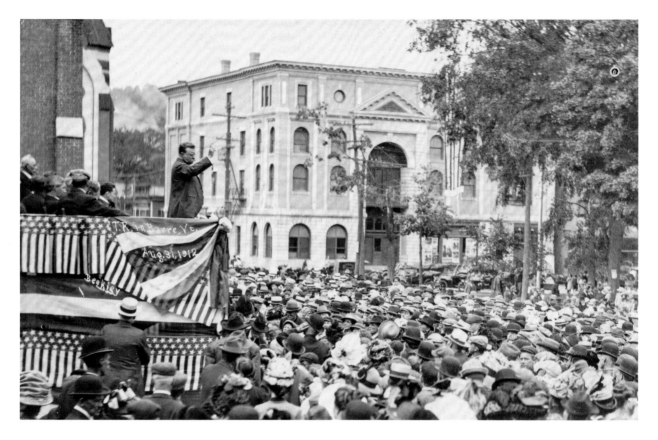

226 Theodore Roosevelt, 1912 JEDD BECKLEY

rising above the crowd for a better vantage and hustling after different angles. Despite what appears to be an impassable thicket of people, Beckley managed to catch Roosevelt from both sides. The Vermont Historical Society owns a mirror-image view taken from Roosevelt's far left, looking out from near the Opera House. That particular card was sent by Edith Dodge, wife of a local jeweler, to a friend fifty miles west, much as one now would text a photo and quick note. Edith pointed out herself and her seven-year-old son, propped above the crowd.

For the photographer, inscribing an image was notable at a time when newspapers rarely printed reporter bylines or photographer credits, even as it reflects advertising savvy and the natural desire to be recognized for one's work. For the viewer today, it's a reminder that this card isn't simply a window onto the past but a glimpse through an actual person's viewfinder. To hold the card is to stand where they stood, if just for a moment; to see what—and how—they saw.

The inscription on one card, "Birger and His Gang," vaults the viewer from quietly eyeing a band of outlaws to considering what photographer Mitchell—Alvis Michael Mitchell of Harrisburg, Illinois—might have felt as he steadied his camera before all that brandished firepower, with at least three Tommy Guns, a dozen rifles, and a sneakily high number of pistols present in the frame (**227**).

Though Mitchell suggested to a reporter years later that he had arranged the photo, family lore has it the other way: Birger's gang enlisted the reluctant photographer, knocking on the door and spooking his wife; Mitchell was at the Lion's Club, probably drinking. He was twenty-seven then, with an infant daughter and a nine-year-old nephew he was helping to raise. Knowing Birger liked kids, Mitchell brought the boy along as an insurance policy for returning safely.[14] It makes sense then that Mitchell, returning to the studio unharmed, would not only have taken the steps to ink his name on the negative but to secure the copyright, especially rare among small-town photographers and real photo postcards. The hand-circled "c" insignia is bona fide; the federal *Catalogue of Copyright Entries* shows Mitchell copyrighted twelve Birger-related images in 1927 and '28, starting with three from this session at the gang's compound, known as Shady Rest.[15]

Though little remembered beyond Southern Illinois, Charlie Birger — born Shachna Itzik Birger in Eastern Europe in the early 1880s, before his parents fled the pogroms and wound up in St. Louis, via New York — was as notorious as any gangster anywhere from 1926 to 1928. One wire story during the period referred to an ascendant Al Capone as "the Charlie Birger of Cook County."[16] The St. Louis papers alone wrote hundreds of stories about the Birger gang, which controlled bootlegging and "adult entertainment" across the coal-mining country of Southern Illinois, where rumrunners from Florida passed through on the way to St. Louis and Chicago.

Birger, sitting sidesaddle on the porch rail at back right in a bulletproof vest, first came to national attention through a bloody attack on the Ku Klux Klan in April 1926, alongside a St. Louis outfit known as the Shelton Gang, before tension between those two gangs erupted into a war that terrified the region for months. Image conscious and media savvy, Birger did a stint in the army as a horse breaker, styled himself after Hollywood cowboy Tom Mix, kept a monkey as a pet, and cultivated a Robin Hood air, tossing coins at the schoolyard and helping immigrant families, according to local historian Jon Musgrave. At one point, Birger bailed out a widow at risk of losing her farm; with the note paid off in cash, his gang then robbed the loan officer on his way back from making the collection.[17]

Despite the 1927 notation on the card, the photo's date can be narrowed down to within a few days in October 1926, based on the movements, arrests, and deaths of the pictured gang members, all of whom Musgrave can identify. Mitchell did not copyright and distribute the images until after Birger and others who might pose a threat were locked up or dead the following spring. Initially, just one picture from that shoot circulated, at Birger's insistence, showing the arsenal propped against the gang's gleaming Hupmobile but no people, only a muscular dog resting on the car's roof. Mitchell took at least five photos that day, selling one to the *Chicago Tribune* and another to the *St. Louis Post-Dispatch*, distributing the others himself as postcards and movie-theater lantern slides.[18] Birger was sufficiently pleased that he invited Mitchell back to Shady Rest, and to document other episodes, including asking Mitchell to be the official photographer at Birger's own gallows; convicted of orchestrating the murder of a small-town mayor allied with the Sheltons, Birger became the last man publicly hanged in Illinois, on April 19, 1928.

To this day, Alvis Mitchell's Birger photos endure. One of Mitchell's nephews, Mike, had a set of the pictures growing up and relished the thrill of showing them to boyhood friends in the 1950s. The gallows images in particular had the power to shock. "It's like a car wreck and you don't want to look, but you have to look."[19] Musgrave over the years has seen the Birger Gang photographs displayed in local restaurants and social studies classrooms, as well as the sheriff's department and state attorney's office. With

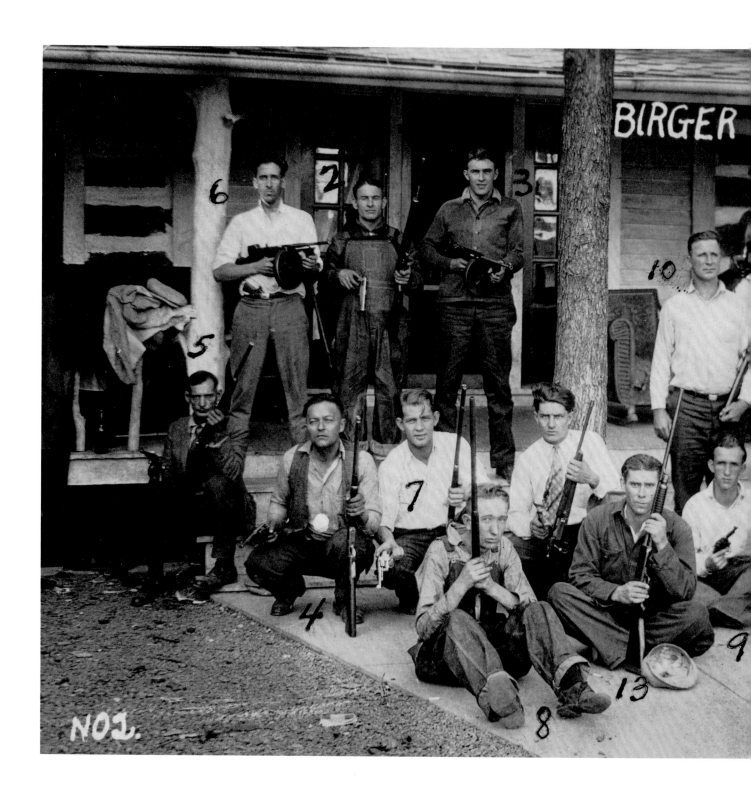

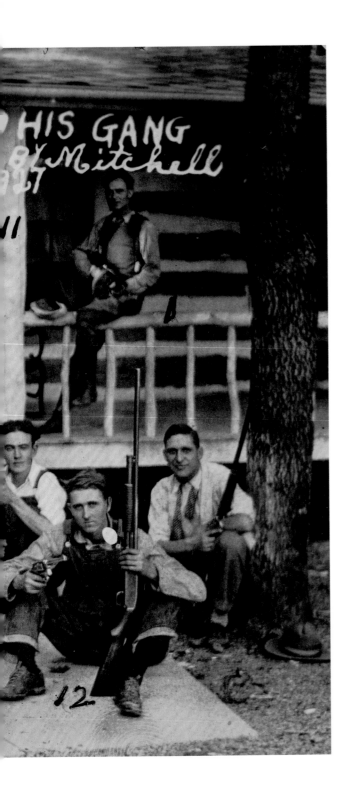

HIS GANG
& Mitchell

the copyright now expired, the image can be purchased in a variety of formats — canvas prints, jigsaw puzzles, tote bags, throw pillows — through websites that profit from public-domain images, summoned by generic search terms like "Prohibition," "vigilante," and "gunfighter." Decoupled from its news value, the photo still makes money one print at a time, if no longer for Alvis Mitchell.

In each of these cases, the picture packs its own story, even as it raises unanswered questions. The right prose — a news clipping, a message on the back, a passed-down memory — can enhance a card's narrative power, unlocking its mysteries. Still, much can remain unknown.

The photo of Roosevelt in Sandusky is nearly identical to one that ran in Cleveland's *Plain Dealer* the next day, the newspaper caption yielding the date and location as well as the name of the sidewheel ferry in the background, the Arrow, and the mayor of Sandusky at far left, though the other faces on stage are lost to history. Returning to Montpelier, the engulfed facade shows three clearly visible names, pinpointing it as the Rialto — though that only hints at the nine other businesses and apartments that occupied 34–42 State Street or the lives entwined, in and out of the frame. Freed from peril on the third floor, ten-year-old Mabel Morse may be just beyond view, watching a rescuer lead her mother down the ladder, or she may already be warming at a nearby drugstore, where her mother would soon be carried after fainting upon reaching the ground. Though Mabel would live nearly to ninety, she sealed away the memory of the fire, never mentioning it to her granddaughter in all their time together. And yet, she directed donations at her death to her local rescue squad in Vermont.

227 Birger and His Gang, 1927 ALVIS MICHAEL MITCHELL

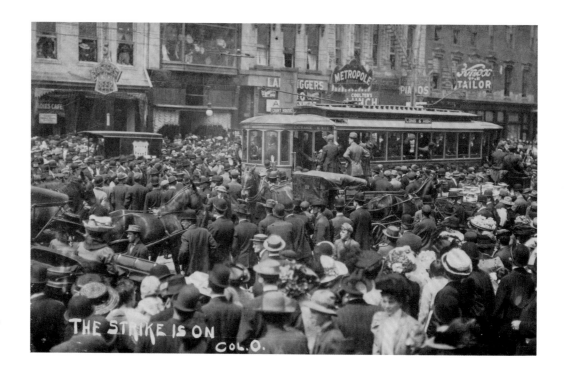

228
The Strike Is On, Columbus,
Ohio, 1910
MEYERS PHOTO CO.

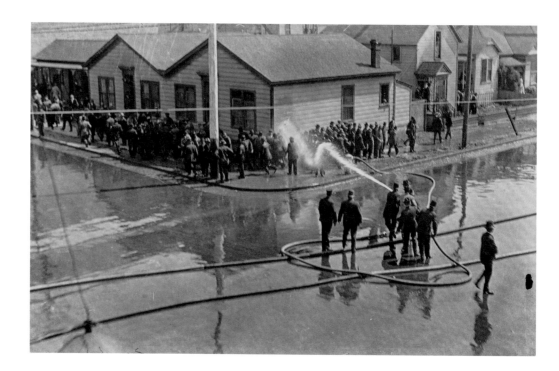

229
Police hosing labor
unionists, San Diego,
California, 1912

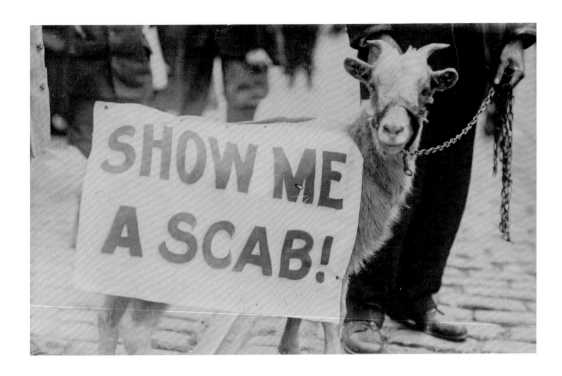

230
Show Me a Scab!,
probably 1910

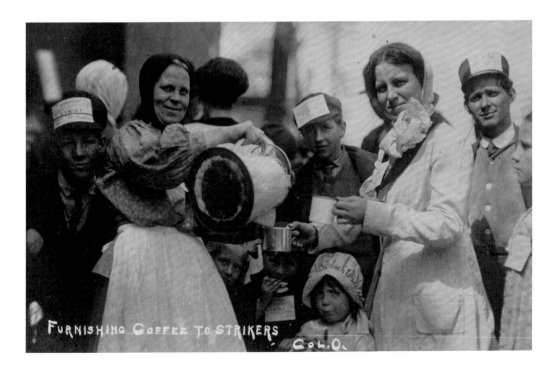

231
Furnishing Coffee to
Strikers, Columbus,
Ohio, 1910
MEYERS PHOTO CO.

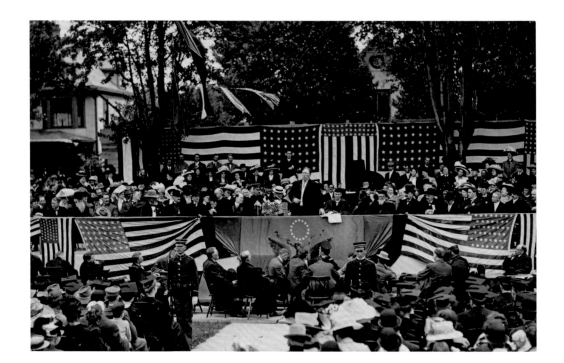

232
William Howard Taft
speaking at the Ohio
Northern University
Commencement, 1910

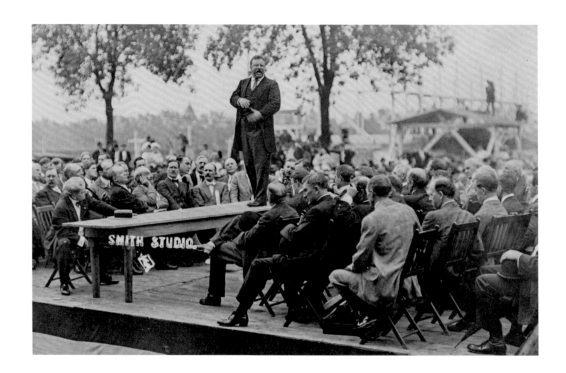

233
Theodore Roosevelt,
Freeport, Illinois, probably
1910
SMITH STUDIO

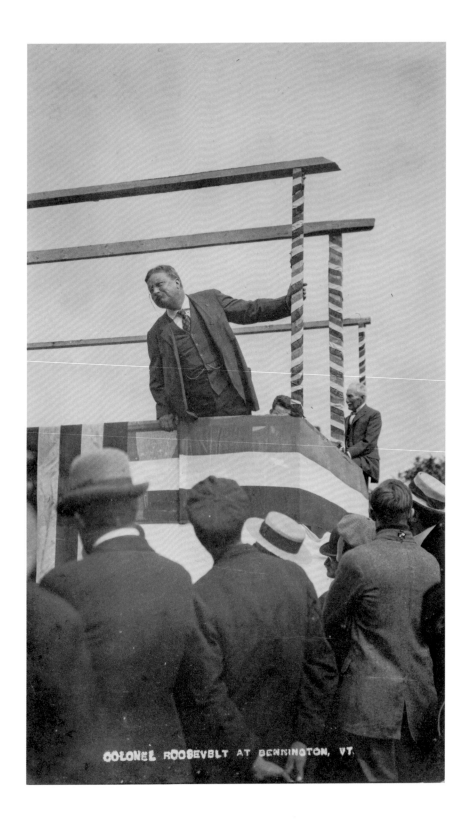

234
Colonel Roosevelt, 1912

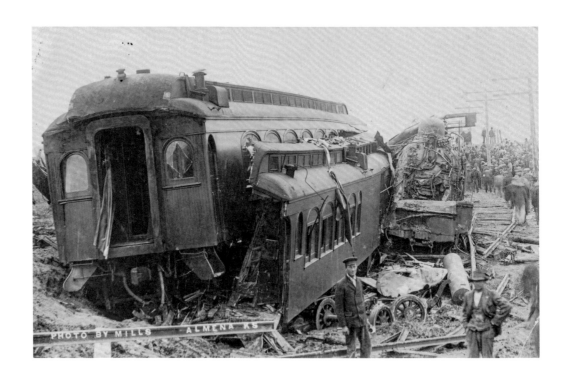

235
Rock Island Line wreck,
1910
A. K. MILLS

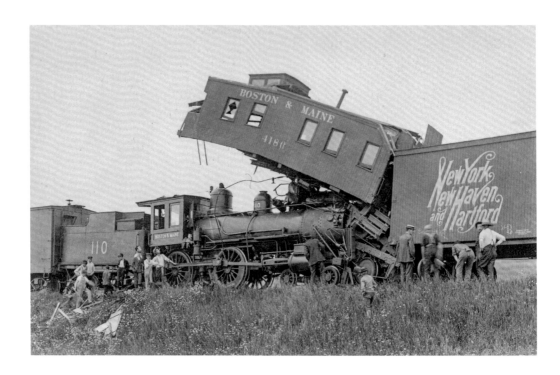

236
Boston & Maine train
wreck, possibly 1907

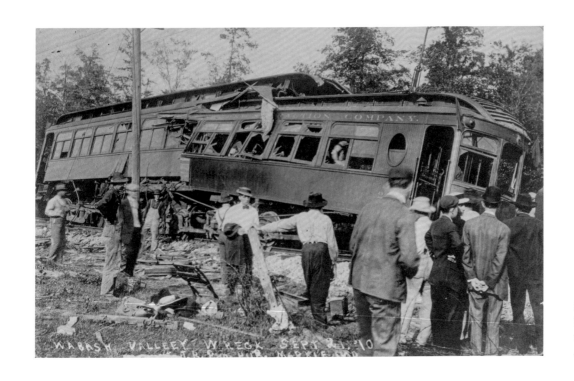

237
Wabash Valleey Wreck,
1910
J. B. PHOTOGRAPHERS

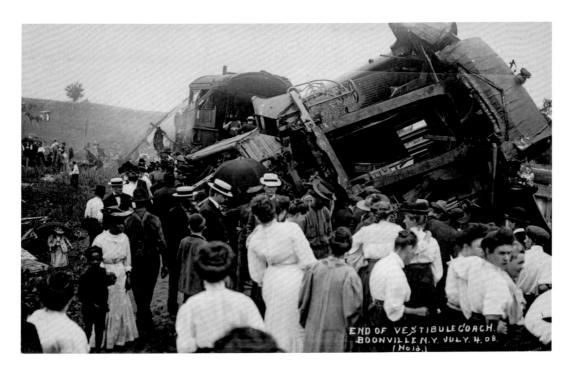

238
End of Vestibule Coach,
1908
HENRY M. BEACH

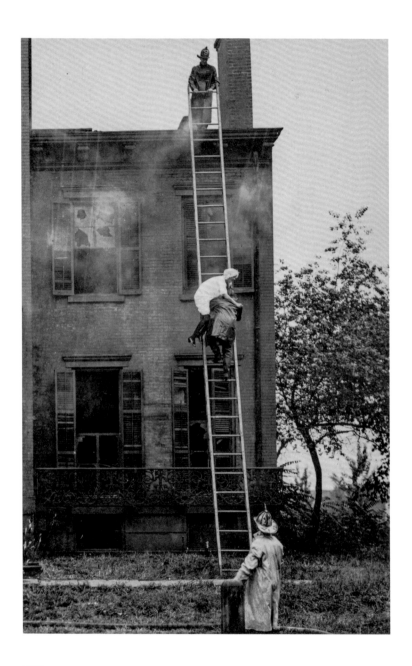

239
Fire rescue, about 1923

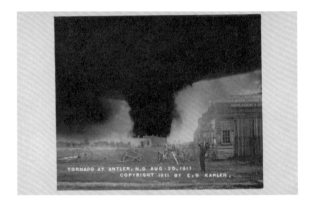

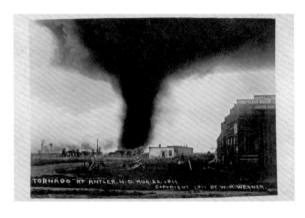

240, 241
Tornado at Antler,
North Dakota, 1911

E. S. KARLEN

242
Tornado at Antler,
North Dakota, 1911

W. H. WEGNER

243

Gipsy Oil Company
55,000 barrel tank on fire,
Drumwright, Oklahoma,
1914

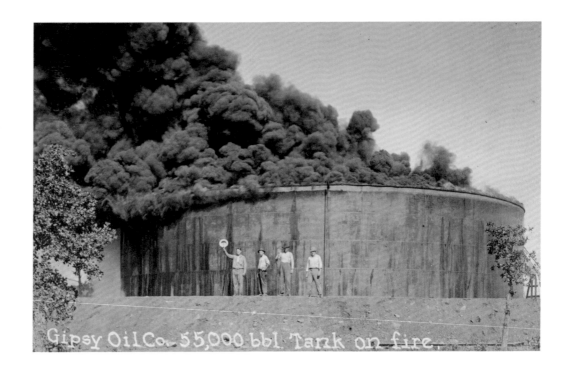

244

Burning of Gulf View Hotel,
1916

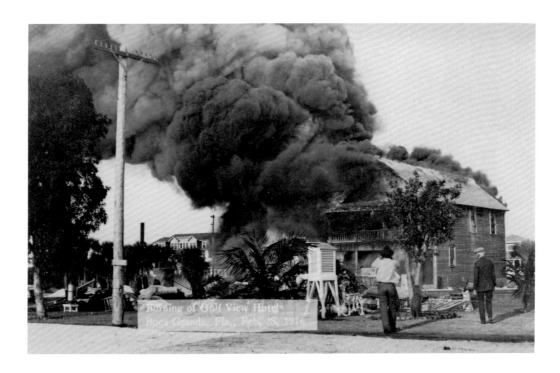

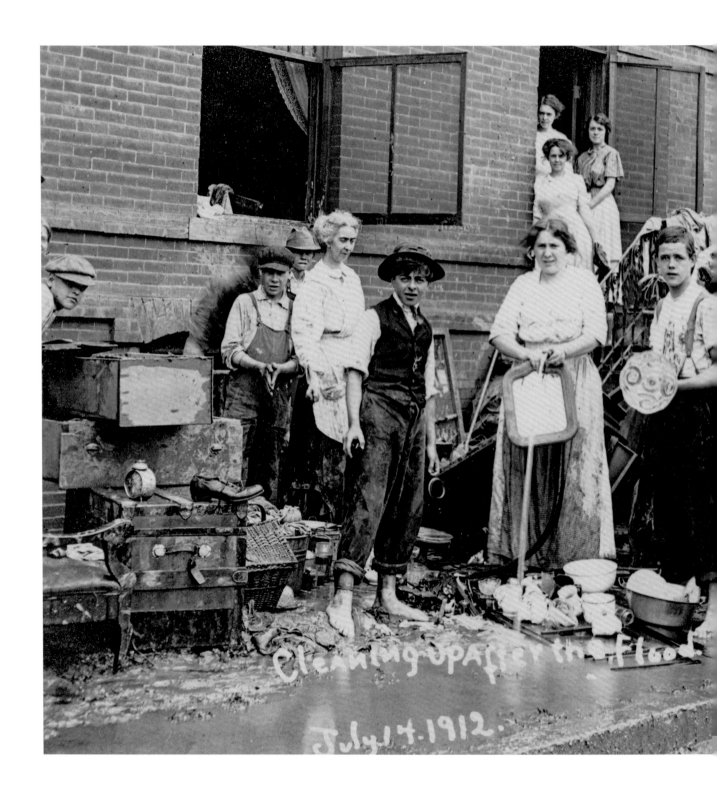

Cleaning up after the flood.
July 14, 1912.

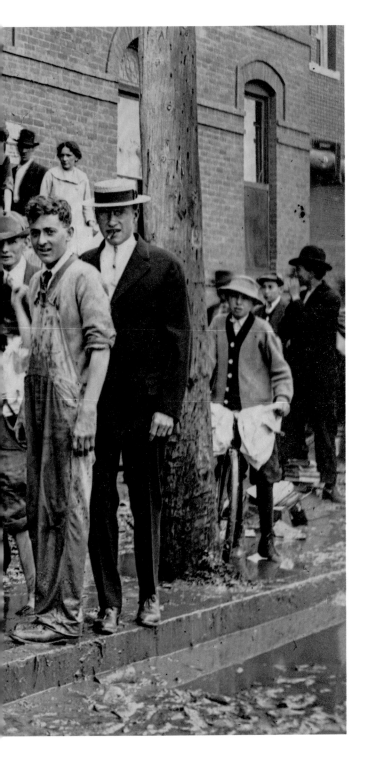

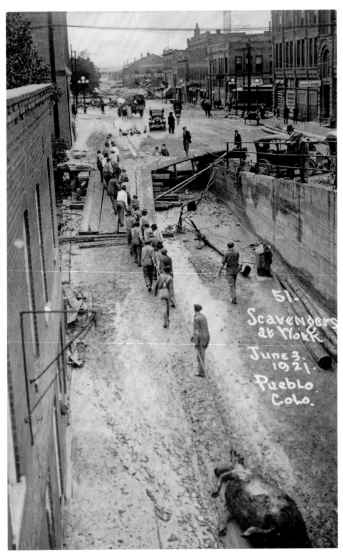

246
Scavengers at Work, 1921

245
Cleaning up after the flood,
Denver, Colorado, 1912

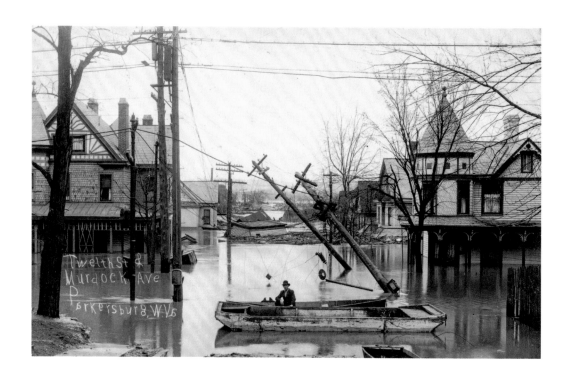

247
Twelfth Street & Murdock
Avenue, 1913

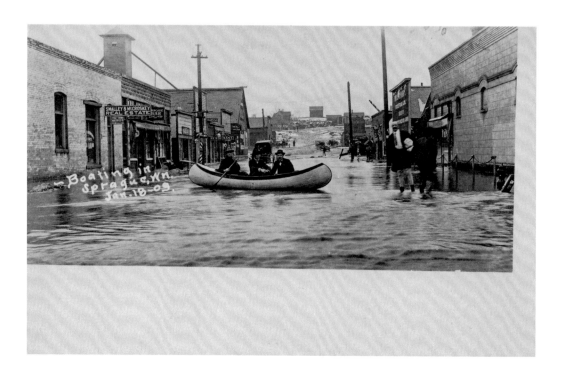

248
Boating in Sprague, 1909

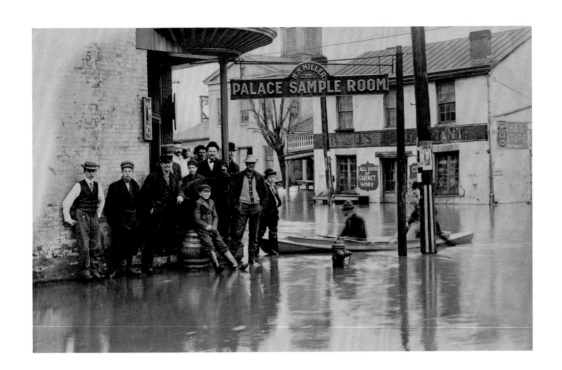

249
Flood at H. H. Miller,
Galena, Illinois, 1911

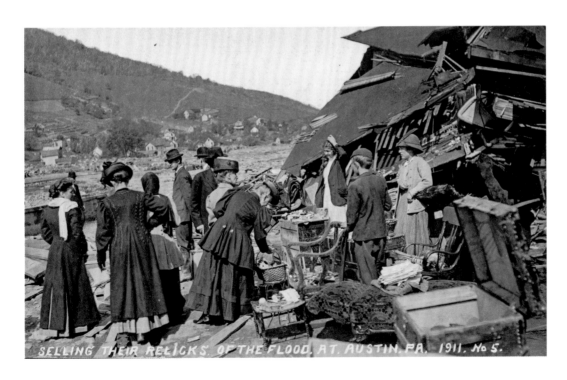

SELLING THEIR RELICKS OF THE FLOOD, AT AUSTIN, PA. 1911. No 5.

250
Selling Their Relicks of
the Flood, 1911
HENRY M. BEACH

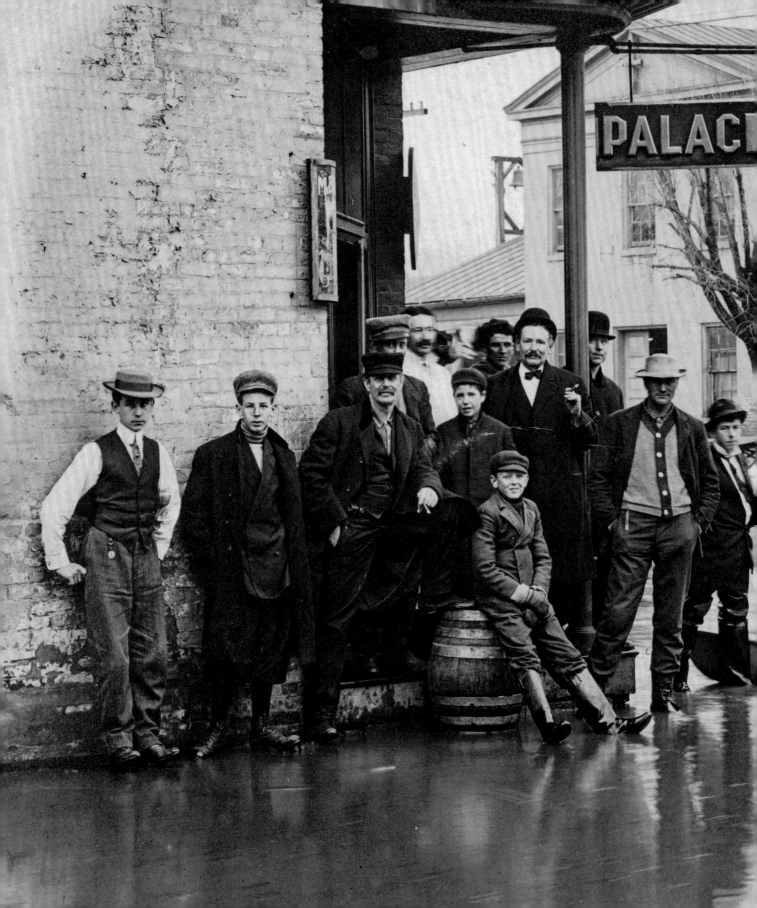

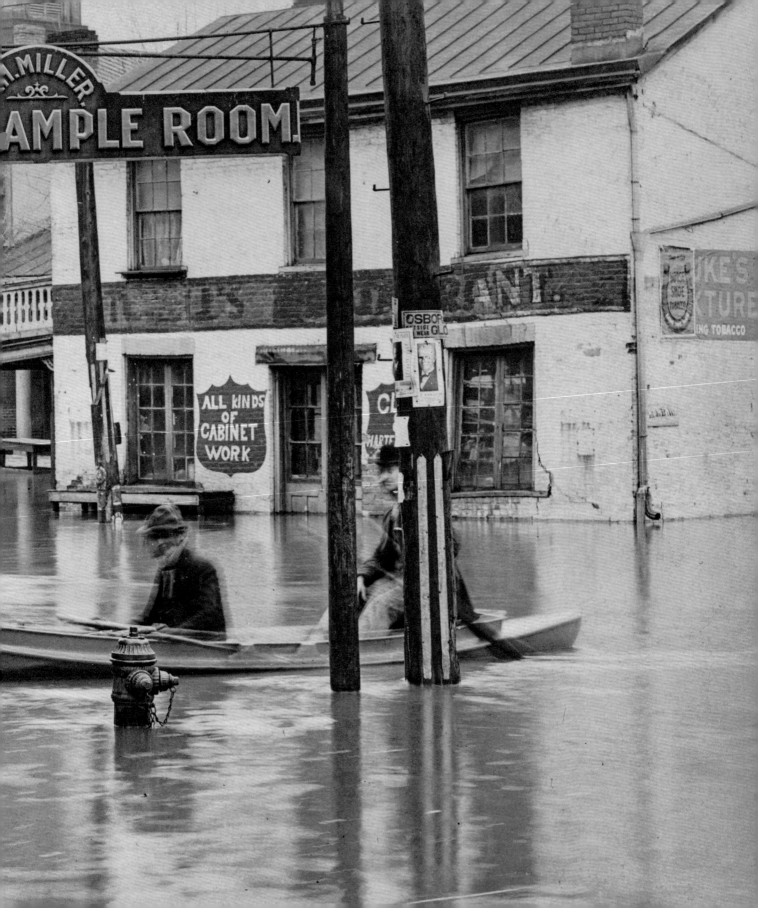

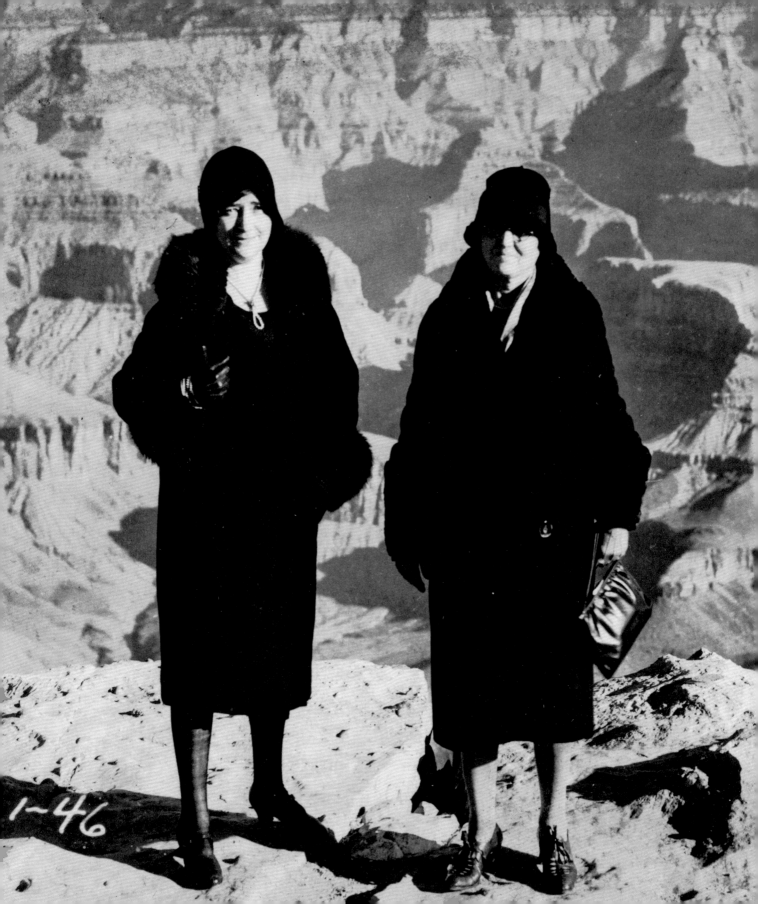

Postcards and Road Trips | LYNDA KLICH

On January 14, 1929, two elegantly dressed women stood in front of an expansive view of the Grand Canyon, posing somewhat formally for a photographer who snapped their picture and printed it on postcard stock (**251**). One of the women, presumably, wrote the date on the back, and also noted: "Background is over ten miles away." The women stand before what is today a hackneyed tourist view, found in countless photo rolls on smartphones and repeated on numerous Instagram feeds, but what was then remarkable, a novelty. Their heeled shoes and clutches indicate that they did not rough it to get there, but were neatly dropped, likely by a driver, in a predetermined location designed to ensure that they could procure a photograph that would communicate, in effect, that they had "been there, done that." For a modern viewer, the card's sepia tone and handcrafted nature perhaps evoke a feeling of nostalgia, but in its day, these characteristics signaled modernity. Technological developments in photography and the invention of automobiles allowed people to replace the traditional painted studio backdrop with the natural wonders of the United States, creating an enduring domestic tourist landscape. In the first few decades of the twentieth century, postcards, cars, and tourism became emblems of a youthful, growing, and changing United States. As the Grand Canyon postcard

shows, a class-based, racially segregated framing of tourist vistas formed this national image and is perhaps at odds with the "realism" of the real postcard. Nonetheless, it reflects a mobility and sense of place that remain at the heart of the country's self-image.

From the start, the histories, uses, and popularity of the postcard in general were tied to travel and movement. As a communications technology, the postcard depended upon new mail and transportation networks. Other contemporary phenomena of modernity, such as the World's Fair and the transatlantic liner, ensured the postcard's status as both souvenir and collectible, fueling a nearly fanatical global "postcarditis" that began in the mid-1890s and lasted for more than two decades. By far, the lithographically reproduced "view" card — of the largest cities to smallest villages — greatly outnumbered all other types of cards during height of the postcard's popularity (amounting to upward of 90 percent of published cards). The sites depicted on printed, mass-produced postcards became the "must sees," determining the itineraries of many a tourist. Sending a postcard from the road became a requisite of travel — it simultaneously served as proof of the journey and marked the sender as modern citizen.[1]

In the early 1900s, the real photo postcard joined the printed postcard and other photographic innovations, such as lightweight and relatively inexpensive hand-held

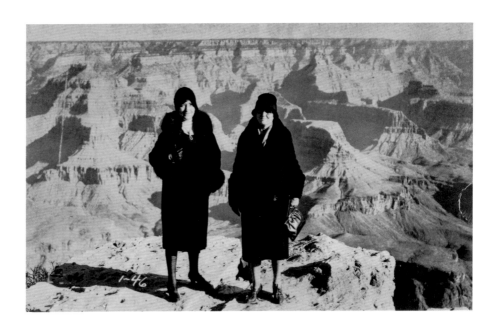

251 Two women at the Grand Canyon, 1929

cameras (operated by the press of a button), roll film, and mail-in processing, that made photography more familiar and affordable to the everyday person. Kodak's Brownie camera cost one dollar in 1900 — equivalent to just over thirty dollars today. Printed on stiff and sturdy stock, real photo postcards were inexpensive and were designed to travel throughout one's personal network. For a wide populace, they became an essential means for registering personal memories that could be shared and forever revisited.

Also in the decades around the turn of the twentieth century, changes in U.S. workplaces, such as weekends off and paid holidays, introduced leisure time and vacations to middle- and working-class lifestyles and brought travel within reach for a larger group (though some workers got only Saturday afternoons and Sundays off at best, resulting in new forms of local entertainment and leisure).[2] Whether a day at the park, a local junket, or longer distance travel, leisure became something for many to consume, especially through the photograph, and an ever-evolving tourism industry ensured countless opportunities to do so. Being occasionally off the clock made travel essential to a balanced and modern lifestyle.[3] As an increasing array of tourist locales became accessible, documenting touring through photographs became intrinsic to the experience of excursions. And, the materialization of leisure and place through photography became a key way to demonstrate the growing political and commercial muscle of the United States.

Advances in several transportation technologies and the expansion of networks such as railroads and transatlantic liners encouraged the pursuit of travel by multiple means, but none fed into the sense of U.S. identity more so than the private motor car. Just as Kodak democratized photography and ensured its entry into more and more homes, so did Ford's Model T, bringing a previously out-of-reach technology into middle-class and sometimes working-class homes. Recreation was a principal use among early private auto owners. Freedom from timetables and set routes, associations with wanderlust and speed, the lure of the open road and little-explored

territories, plus improvements to the National Park system put a distinctly "American" stamp on travel by car.

The spirit of independence and adventure inherent in automobile culture is embodied in the figure of the pathfinders — pioneering automobile travelers who set out along uncharted roadways, some of them previously Native American foot trails — to inspect, map, and plot what later became the national highway system. Civil engineer and veteran pathfinder Anton L. Westgard, dubbed the "Daniel Boone of the Gasoline Age," recorded his adventures in a picturesque, and at times patriarchal, memoir, recounting perilous expeditions on eighteen transcontinental road trips that laid the groundwork for now famous motorways such as the Pacific Coast Highway, Route 66, and the Lincoln Highway, all created to promote national tourism. In venturing where no car had gone before, pathfinders faced numerous obstacles, whether natural, such as snowstorms, floods, sandstorms, clouds of mosquitoes, or technological, such as broken axles, gasoline scarcity, and flat tires. (**252**).

The pathfinders' work not only transformed the country's landscape, but also allowed them to mold the changing face of the nation (often at the expense of federal nature reserves and Native American lands and thanks to the lobbying of the auto industry). The serendipity of road travel allowed Westgard, for example, to attend unexpected events of all kinds, from a Mormon dance to a Mexican wedding, "right here in the United States, not in a remote corner of some foreign country." And it brought him in touch with what he called "Americans all," from Apache and Hopi people to enlisted Filipino men to new Eastern and Southern European immigrants who quickly had become the "sinews of the nation." Westgard's recollections of visits to the Grand Canyon detail the rapid growth of car culture. First rebuffed by a hotel manager who disdainfully insisted that "there would not be many

252 70-Foot Cut at the New Mindoro Road, about 1908

motorists braving the wilds of Arizona," Westgard returned two years later to find enormous garages and a highway leading right up to the Grand Canyon to accommodate the "swarms of motor tourists" headed that way.[4] The adventures of Westgard and his pathfinder comrades, which made it into newspapers across the country, resulted in millions of miles of hospitable roads that came to symbolize national glory. They also illuminate why, in the first quarter of the twentieth century, the automobile industry

253 Kodak advertisement, 1912 or later

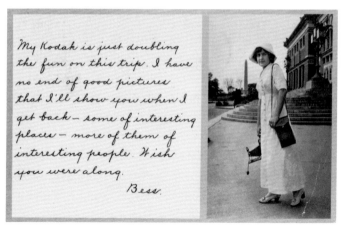

254 Kodak advertisement, 1912 or later

was among the most important in the U.S. and why the car became more distinctly connected to national identity here than in any other country in the world.

Westgard, of course, carried a camera with him for official business, and filled his memoir with snapshots of adventures and misadventures alike. The car and camera together marked mobility and leisure, independence and exploration, all signs of burgeoning modernity in the U.S. These two most modern of machines also encouraged a consumption of the landscape as the car took people to new places and the camera allowed them to capture the sites and views that came to define the nation.[5]

In its advertising campaigns, Kodak began aggressively promoting the new flexibility and speed of picture making and equating good pictures with travel, enshrining photography as de rigueur among travelers. The company drove the point home with slogans such as: "Take a Kodak with You," "Vacation Fun Doubles When You Have a Brownie Camera," "Vacation Days Are Kodak Days," "The World Is Mine — I Own a Kodak," and "Kodak as You Go." One campaign even declared "A vacation without a Kodak is a vacation wasted." The company made special use out

of the new culture developing around cars, and planted thousands of roadside signboards to alert car tourists to upcoming scenic vistas, perfect for a photograph.[6] Kodak came up with gadgets to make taking photographs on the road easier, including the "Optipod" that clamped the camera to the windshield and, coupled with the self-timer, allowed the photographer to place herself in the picture.[7] Kodak even linked the camera to automobile technology in *Kodakery* (its magazine aimed at educating amateurs) by comparing the power of certain developing agents to twenty- and one-hundred-horsepower engines, respectively, and by likening challenges during the developing process, such as the effects of cold and bromide, to the hills and wind faced on the road.[8]

Kodak recognized that, as a key component of travel, the real photo postcard opened up new ways for packaging one's travel experience by creating a personalized visual diary. For example, to advertise its prepackaged postcard photo blanks, Kodak created a line of sampler postcards — personalized by fictional senders — some of which touted the real photo's suitability for documenting vacations. In one, a skier named Peg dangled the postcard

255 Olive Hill, Kentucky, 1917
C. E. SCARLETT

as "evidence" of the "photographic fun" she was having on a ski trip, meant to make its recipient envious. In another, a pioneering single female sightseer named Bess promised her correspondent (on the card's verso) that "friends at home will be glad of personal Velox postals (like this one)" (**253, 254**). An advertorial in *Kodakery,* ostensibly written by a boy at camp and directed to his father at home, highlighted the flexibility and immediacy of the real photo postcard for documenting the travel experience: "Since I wrote to you last, I have been making my prints on Velox postal cards. The boys wanted to send pictures of the camp home to their folks, and the cards are just the thing . . . Bob's father sent him a watch for his birthday and he wanted his dad to know he liked it, and so I made a picture of him looking at the watch. Then I made a print on a post card and Bob sent it home."[9] Another article in the same issue drove the point home: "A post card bearing a picture printed from a negative made by the sender is doubly welcome, for it has the individuality

of companionship — a personal touch that is lacking in the cards we buy."[10]

While Kodak and other manufacturers marketed their products to tourist amateurs, the conjunction of the real photo, automobile, and tourism transformed professional postcard production as well. The car allowed countless enterprising photographers to take to the road, no longer entrenched in their studios and encumbered by heavy cameras, lenses, glass plates, developing equipment, and chemicals. Professionals traveled with mobile darkrooms (**255**) or set up at specific sites to take photographs of tourists, like the Grand Canyon visitors. Some photographers expanded their market by hitting the road to make signature views of scenic attractions (capturing local sites and small-town life along the way), which they added to their studio inventory and sold at the new roadside businesses that developed around tourism, such as motels, resorts, recreational areas, campsites, restaurants, souvenir shops, and gas stations, as well as

256 Shuey's Pretzel Stand,
1927 or later

at the sites themselves. Some spent years on the road, creating vast catalogues and selling millions of postcards that depicted everyone from the Native Americans who had long inhabited the lands to the new brand of auto-tourists passing through, and everything from vistas and local flora and fauna to the intrusive elements of rising car culture, like roadside signage and hospitality establishments and entertainment parks (**256**).[11] Attractions old and new, natural or man-made, provided endless subject matter for mobile postcard photographers. A marketing card made toward the end of the real photo era by Bill Shipler, member of a family with four generations of photographers who operated in Salt Lake City for nearly a century, demonstrates the symbiotic relationship between photography and tourism (**257**). Shipler's card promotes visits to the sites represented in his catalogue as much as it does his services.

Whether taken by a professional photographer or an amateur, the real photo postcard made the subjectivity of representation widely accessible. Travelers had long found ways to preserve and display their journeys, often with scrapbooks and albums full of brochures, tickets, printed postcards, purchased photographs, and other mementos, found elements that typically adhere to an experience prepackaged by the tourist industry. With the real photo postcard, tourists could now render the precise vista that they saw and situate themselves within it.[12] Even a traveler who did not own a camera could leave a site with a real photo postcard that lent authority to their documentation. Only a real photo postcard — designed for the mails — could travel like its sender, traversing the country and delivering the customized landscape, often including a depiction of the traveler, to the recipients. And it did so with the immediacy and materiality of a photograph taken on the spot. The real photo postcard's reverse, often used to record or transmit observations, reinforced the direct and tactile experience embodied by these unique photographic objects.[13] Though identical

257 See Scenic Utah This Year, 1936 or later
BILL SHIPLER PHOTOS

trip, are discarded and forgotten."[14] The tourist industry encouraged and fed this new impetus for the self-determined tourist landscape and the need for display. Alongside advertisements for maps and guidebooks, *The Travel Magazine* routinely ran listings for the stereopticon and the "postcard lantern," machines that could amplify and project photographs and postcards to up to ten feet, allowing one to give "delightfully illustrated travel talks" to church or school groups, or "personally conducted tours at your fireside, an entertaining and instructive pastime for winter evenings."[15]

Real photo postcards also allowed tourists to participate in the construction of a national identity, as the country experienced domestic economic and social growth, and an amplified international presence. Largely based in the natural landscape, this tourist identity was mostly available to the white, middle-class population who exhibited a proprietary sense of the nation's territories, like modern-day settlers. The resulting national identity conveyed a sense of privilege and liberty in the face of the spreading urbanization and industrialization of the country, and, arguably, its changing racial makeup and social hierarchies.[16] While the country democratized, upward mobility remained available to circumscribed groups, who performed their class status through travel and photography, among other ways. Real photo subjects claimed the nation by activating its tourist landscape and inserting themselves within it.

Certain landscapes seemed to emphasize awe-inspiring tourist adventures more so than others. Unusual rock formations were especially popular, whether expansive and sublime like the Grand Canyon, Twin Rocks Castle Garden in Kansas, Caroline Natural Bridge in Utah, Glacier Point in California, or decidedly more modest like Balance Rock in Vermont and one by the same name in Colorado. As one figure noted on the back of her picture of South

in form to the commercially printed card, the real photo postcard — with the clarity of detail and crispness lacking in printed photographs — spoke to firsthand experience, and enabled a sense of authenticity, giving each card the potential to both individualize and share the experience of travel. One contemporary opined that real photo cards "will be kept and valued by our friends, the stay-at-homes, long after the commercial postcards, which marked the

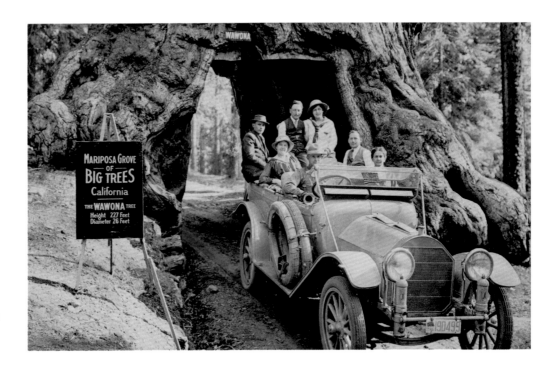

258
Tourists at Mariposa
Grove of Big Trees,
about 1914

Dakota's Badlands, there are "just miles of dirt," reflecting the awe generated by the country's seeming endlessness. Among the most depicted formations was Umbrella Rock on Lookout Mountain in Chattanooga, that city's first tourist destination, visited since the mid-nineteenth century by tourists including both Roosevelt presidents. They were preceded by Civil War soldiers who fought bitterly nearby at the Battle of Wauhatchie, an episode recounted on the tourist plaque next to the rock (**261**). One visitor proclaimed "What a wonderful sight" to his recipient; another pointed out that the site provided breathtaking views of the Tennessee River, both the distant Blue Ridge and nearby Missionary Ridge, the Signal and Raccoon Mountains, Cameron Hill, and Chattanooga. While the messages on travel postcards typically identify the subjects depicted, numbers of miles traveled, or commented on the weather, those from Umbrella Rock tend to emphasize the daring required to sit on the precariously

balanced rocks. Noting the sixteen-hundred-foot drop, one postcard sender wrote, "we could not put on our pleasantest smile."

Cards depicting Umbrella Rock and other spots reveal a certain amount of repetition, indicating that there were prescribed locations and shots, a consequence of the commercial packaging and marketing of the nation, and confirmation of the ritualistic aspect of tourist consumption.[17] Big tree postcards, often peppered with stats listing astounding heights and diameters, illustrate this idea of the tourist trophy, and confirm the way in which the automobile not only made out-of-the-way sites accessible, but also helped facilitate a type of assembly line consumption of these sites.[18] In Mariposa Grove, California, for example, it seems a photographer stood at the ready to snap photos of chauffered cars passing through the Wawona Tree, a sequoia that boasted a twenty-six-foot diameter in August of 1910 and had a tunnel cut by the park service specifically

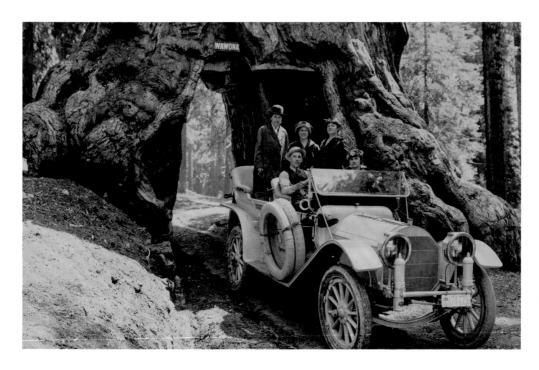

to spur automobile tourism (**258, 259**). Such cards encapsulate the lure of the real photo tourist postcard: it simultaneously conveys a sense of homogeneity and individuation, and, given its indexicality, provides "truthful" documentation of visits to these defining national sites.

Despite the formulaic scenarios depicted on some of the cards, their aesthetic often reflected innovations in photography. In some cards, as with the two women at the Grand Canyon, the poses of tourists recall the stiff formality of the studio portrait; at other times the figures have a naturalism and sense of spontaneity that suggest the emerging snapshot. For example, photographs taken at Saltair, a popular turn-of-the-century resort on the banks of the Great Salt Lake in Utah, regularly feature groups of bathers posed in casual camaraderie (**260**). The Saltair resort seems to have promoted the photography of swimming tourists, a trope that had become requisite for any seaside visitor by the end of the nineteenth century.

Saltair provided various places for photo-ops of bathers wearing swimsuits bearing the name of the resort, such as a rope stretching across the shallow water or a floating raft emblazoned with the phrase "Saltair, try to sink" touting the lake's renowned buoyancy; rail carts carried swimmers around the sprawling site, stopping at photo-ready canopies labeled "Souvenir, Saltair Beach" or in front of the resort's signature large dance halls. Bathers, "just drifting along like sea gulls," as one visitor wrote on the back of a card sent home, gave the cards a freshness and relaxed nature that likely provided excellent advertising for Saltair. More importantly, these postcards seem in step with a more casual aesthetic likely attributed to the rise of the amateur photographer thanks to Kodak's cheaper cameras.[19] While clearly part of the same tourist ecosystem as the rock formation and big tree photographs, these lively postcards signal a youthful, active, and growing body politic.

Other postcards represented the modern infrastructure that developed around tourism, such as the Mt. Manitou incline railway. The tram, just over one mile long, was first constructed in 1907 to haul materials for a mountaintop hydroelectric plant before being converted to a tourist attraction that enabled the easy ascension of the nine-thousand-foot Rocky Mountain in a mere sixteen minutes. Once reaching this astounding height, quite easily, tourists could look at the vista through coin-operated binoculars, have a snack at the snack bar, or buy a memento at the souvenir shop. Such funiculars became emblems of modernity that symbolized international supremacy. Postcards taken at this site, named for its base at Manitou Springs, Colorado, boasted on their versos that this steam-powered railway was "the longest and highest incline on the globe." Enterprising photographers captured shots of each car at the summit, hoping to sell souvenir photographs to some of the dozens of passengers that made each breathtaking and daring trip (a ploy that remains familiar) (**268**). Rather than preserve the West as natural wonder, such cards flaunted the technologized conveniences of the tourist landscape.

A closer look at the Manitou card speaks to the unpleasant realities underlying the exuberant image of the U.S. conveyed on these postcards. The inclined railroad ran segregated cars, with Black travelers assigned to the front, and ostensibly more frightening, seats. The Saltair resort, as well, faced negative publicity over refusing to allow a Black man to enjoy its offerings.[20] Compare these circumstances to those of the women at the Grand Canyon. Their attire — cloche hats, fur collars and cuffs, stockinged legs, scarfs, and jewelry — suggests a certain disposable income. Perhaps the two women debated over

260 Swimmers at Saltair, 1918 LEVENE

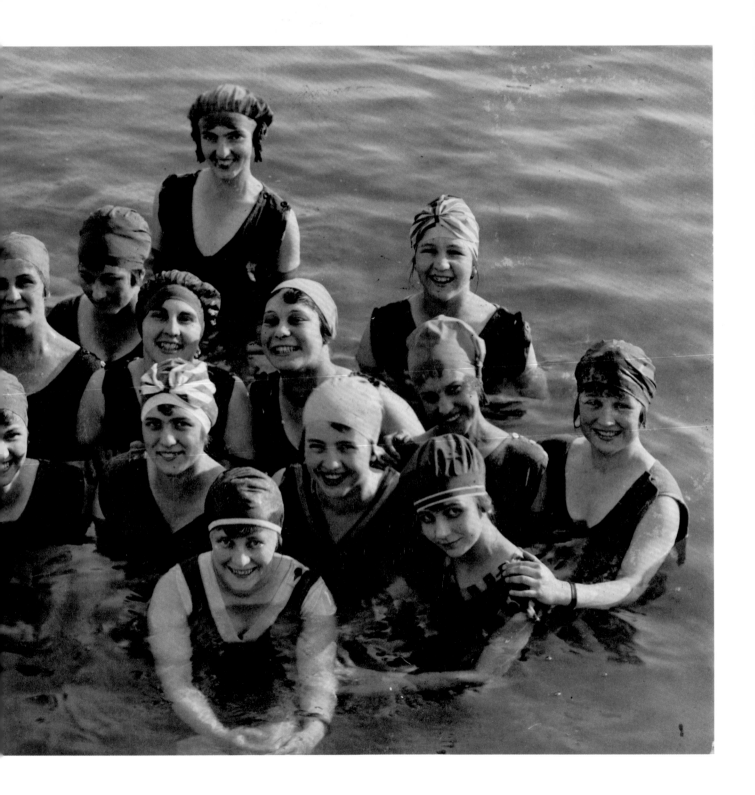

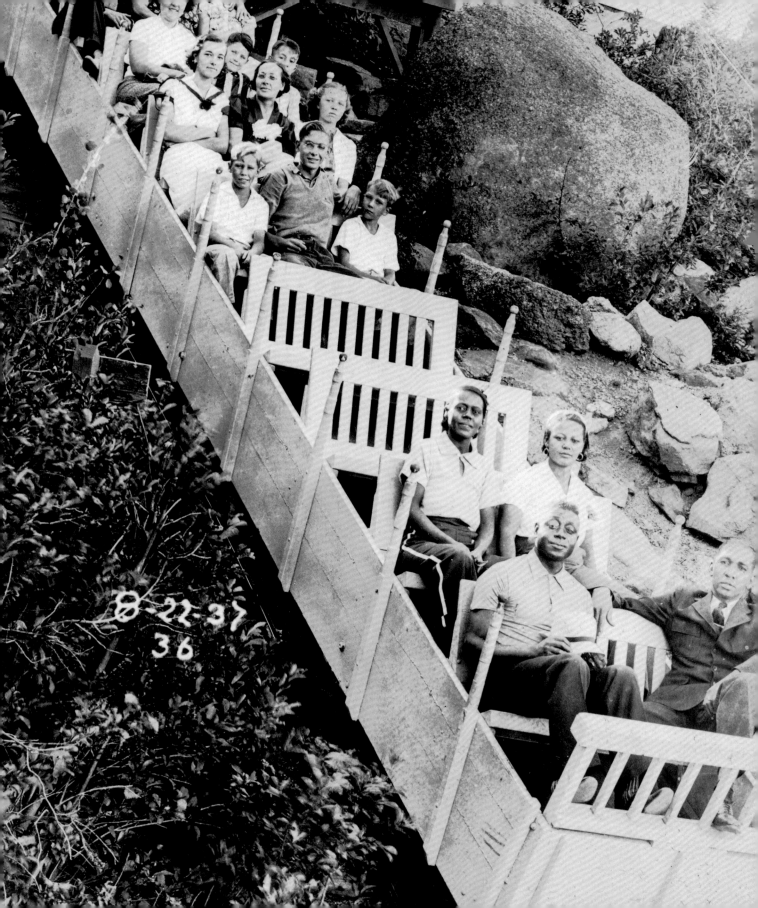

8-22-37
36

which photo location on the Canyon's South Rim to patronize: Kolb Studio, founded in 1904, or the Fred Harvey Lookout Studio, which opened nearby a decade later — either one would be open to them as white women. The women's class signifiers and race suggest a degree of freedom of choice and movement. Ease of travel and door-to-door service were not available to all.

These factors and the incidents at Manitou and Saltair serve as reminders that the national myth of the American West remained elusive to many. It proved less of a draw to Black tourists, whose less-than-favorable associations with the country's land remained mired in the history of enslaved labor, sharecropping, and the Jim Crow obstacles still faced on the modern excursion.[21] Black private motorists, whose economic circumstances did allow them to avoid the official segregation of public transport, would still have needed to research which sites remained off limits to them, and which few welcomed them for overnight stays and meals or were willing to repair their vehicles.[22] For hourly, sustenance-level earners who toiled in factories and sweatshops, whether longtime residents of city slums, new immigrants just joining the urban workforce, or Blacks participating in the Great Migration, faraway travel by private car remained a fantasy, and they instead took advantage of local leisure excursions accessible by streetcar such as amusement parks, arcades, and dance halls. Postcard photographers obliged such tourist fantasies, allowing day-trippers to wave goodbye on pasteboard props such as cars, trains, boats, and even planes (**266, 269**; see **147**). The seen and unseen in tourist postcards of this era remind the viewer that new technologies and

social conveniences were only available to certain people and in different ways. As products of a certain moment in time, they also reflect that "See America First," a propagandistic travel campaign initiated in 1906 geared toward white middle- and upper-class citizens, had its roots in anxieties over the changing constitution of national identity that still reverberate today.[23]

Regardless of the circumscribed nature of tourism at this time, the real photo postcards that emerged from the newly mobile and modern nation reinforce the individualized yet curiously mass experience of the tourist landscape. Envisioning the tourist as the new pioneer in a nation hurtling toward change while clinging to long-standing myths, they allowed U.S. citizens to claim their country and to participate actively in constituting its visual image. The very figure of the tourist situated in the landscape thanks to an actual photograph, whether that card was sent through the mails, projected in a slide show, or placed in an album with other elements picked up along the way, suggested an authenticated experience. More than mere records of a trip, real photo postcards heralded a new era of mobility and modernity, with citizens (of a certain sort) free to roam, and possess, the nation's newly accessible natural landscape. Only the timely invention of the real photo postcard, with its affordable nature, ease of use, and ubiquity, made possible the community building of place. Far from packaging nostalgia, these little rectangles embodied change — in how photography was employed, how it circulated and was received, how people recorded themselves, how they got places, and, ultimately what the idea of "nation" was.

BAD LANDS
NEAR MILES CITY MONT.

263
Devil's Den, 1909

261
Family at Umbrella Rock, Tennessee,
1926 or later

262
Badlands, about 1914

264
Children diving, about 1914

265
Swimmers at Saltair, 1929

266
Drinking tourists, 1926
or later

267
Curio Shop, Tarpon Springs,
Florida, 1917 or later

268
Mount Manitou, possibly 1937

269
Three tourists, 1917 or later

270
Start for Pike's Peak, 1912
PAUL GOERKE & SON

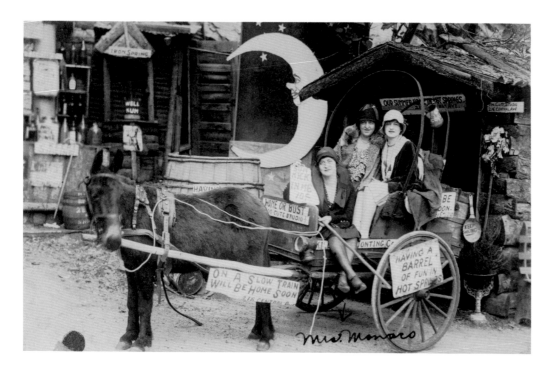

271
Women touring Hot
Springs, Arkansas, 1926
or later
TOO CUTE STUDIO

272
Tourists photographing,
about 1914

273
Bathers, 1905 or later (?)
GEORGE BISHOP

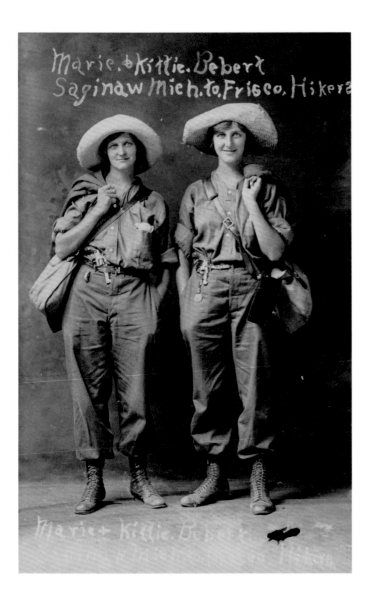

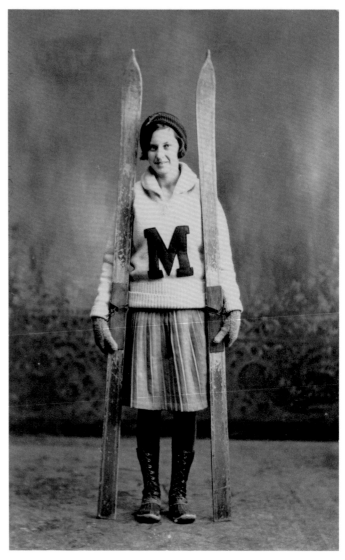

274
Marie and Kittie Bebert,
about 1918

275
Skier, 1926 or later

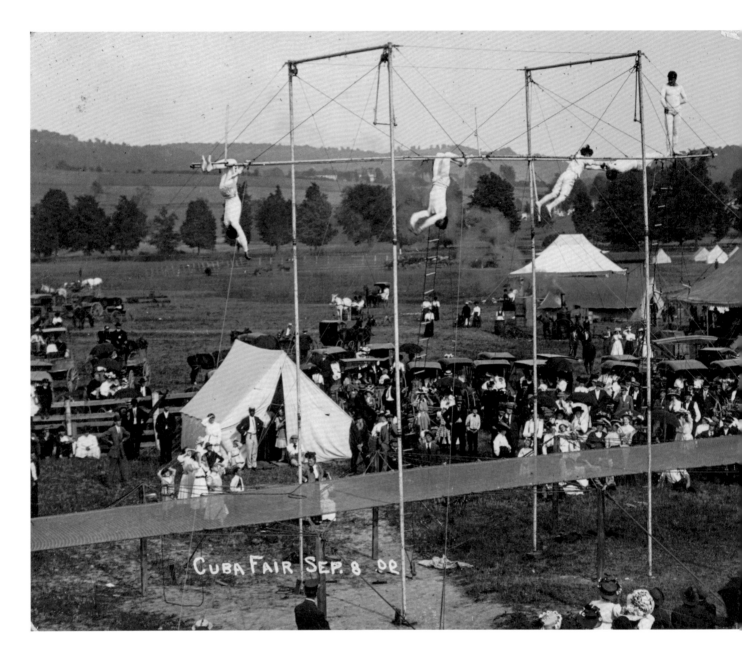

276
Cuba Fair, New York, 1909
H. F. WILCOX

277
Big Novelty Exhibition, about 1914

278
Circus, about 1914

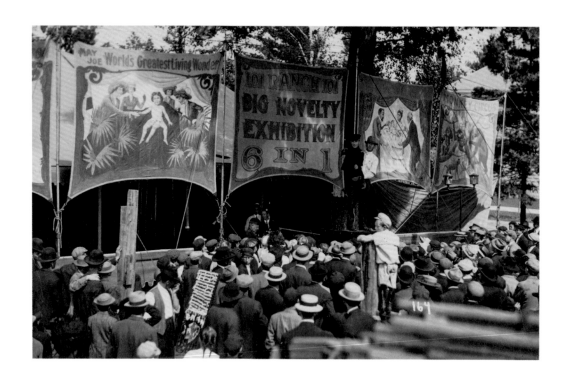

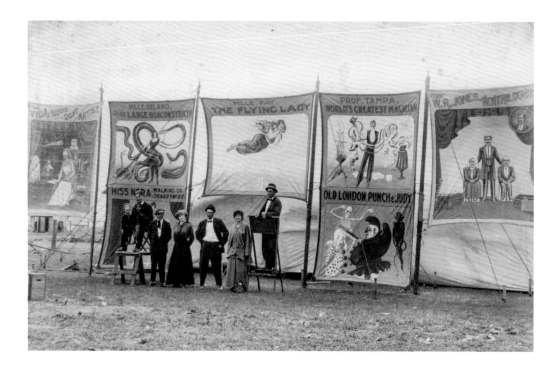

279

Man and woman in an
automobile, 1918

280

Men and women in an
automobile, 1912 or later

281
Thrasher the Photographer,
1917 or after

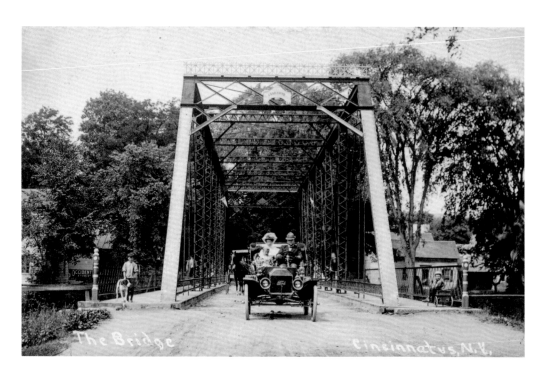

282
The Bridge, 1914
HERBERT A. MYER & CO.

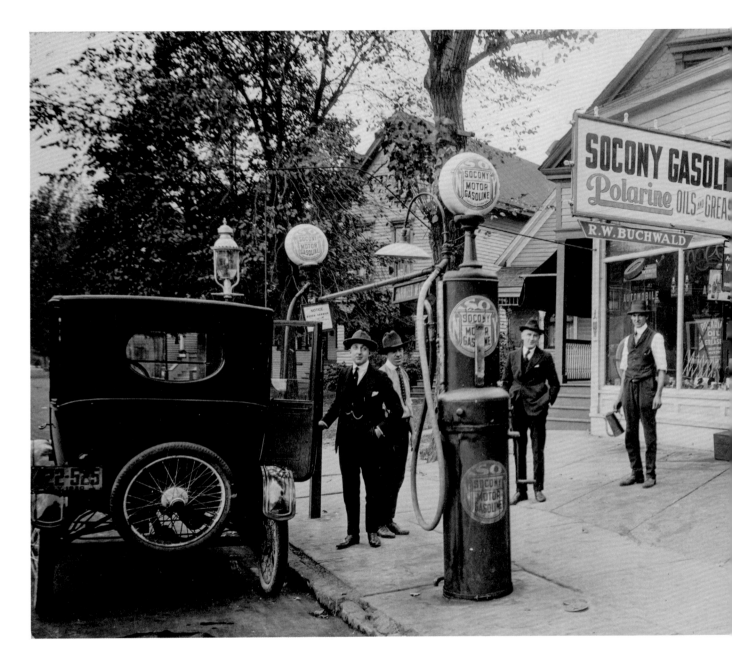

283
Socony gas station, 1920

284
Man in front of a Chrysler dealership, 1926 or later
HAROLD B. WOLFE

285
Standard Oil Company gas station, 1917 or later

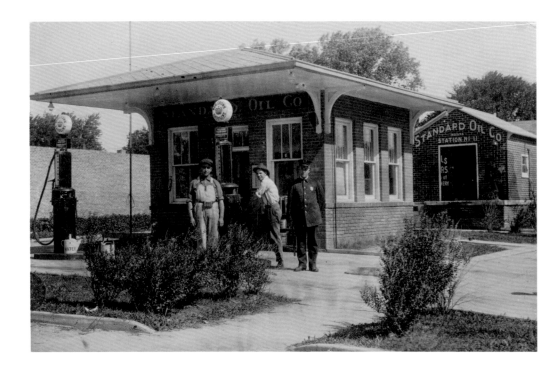

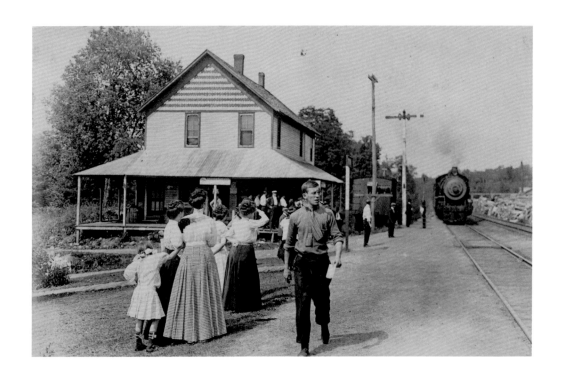

286
Depot, Otter Lake,
New York, 1909

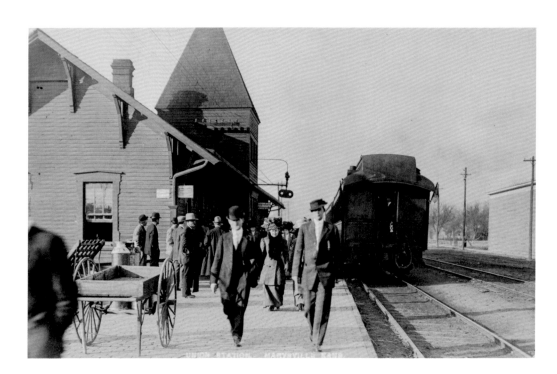

287
Union Station, Marysville,
Kansas, 1911

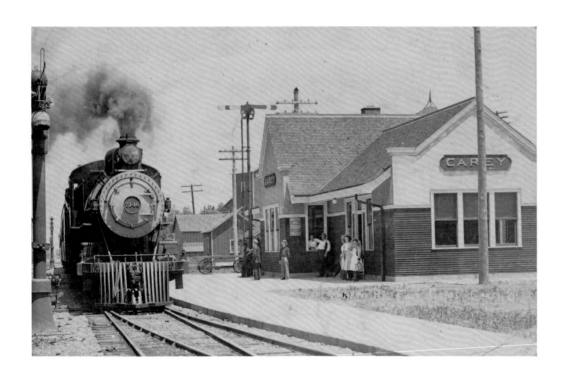

288
New Big Four Depot, Carey,
Ohio, 1909

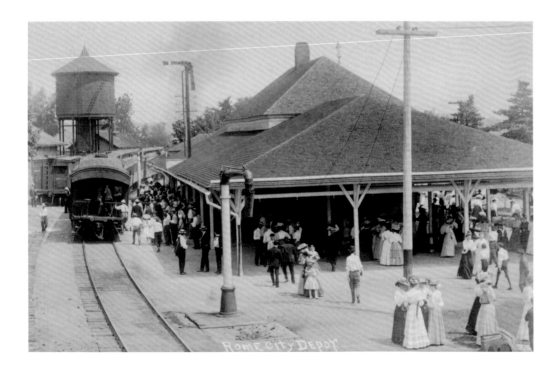

289
Rome City depot, Indiana,
1907

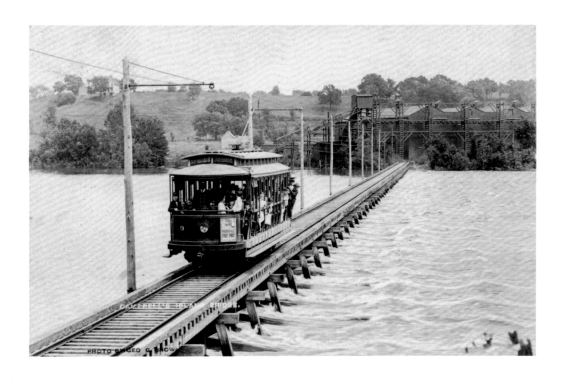

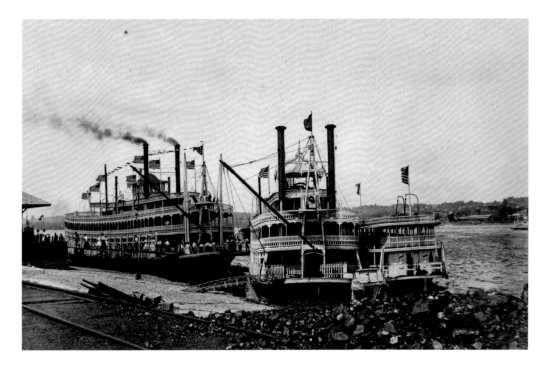

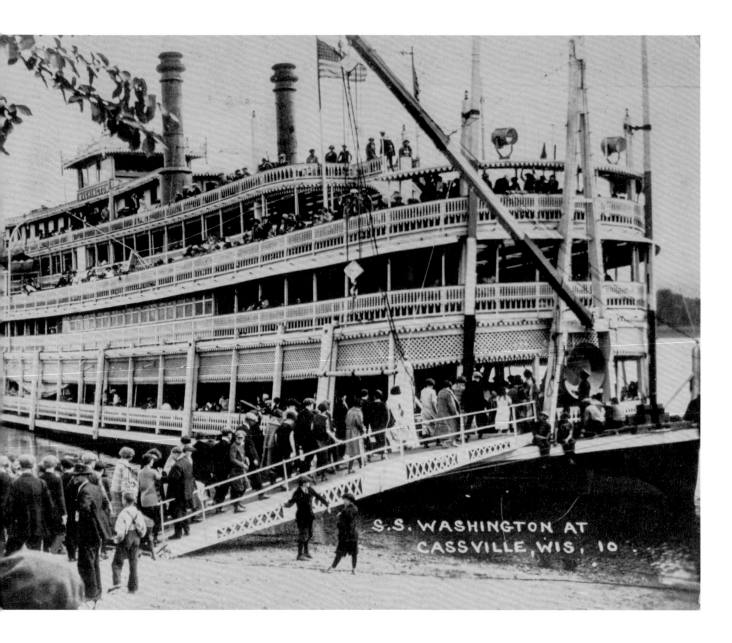

292

S. S. Washington, 1917 or later

290

Campbell's Island Bridge, East Moline,
Illinois, about 1907

GEORGE BROWN

291

Steamboats, 1907 or later

293
H. N. Atwood, about 1914
H. F. DUTCHER

294
Airplane, after 1910
W. H. BENEDICT

295
Getting Ready for a Flight, 1910

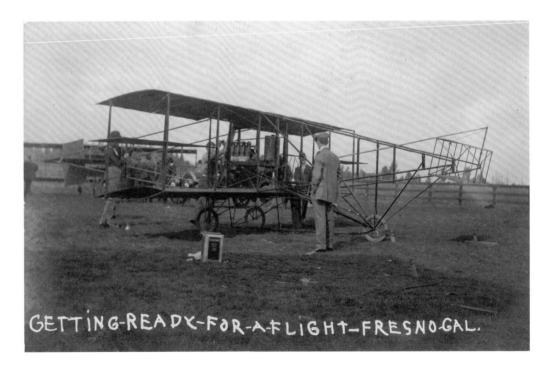

GETTING-READY-FOR-A-FLIGHT-FRESNO-GAL.

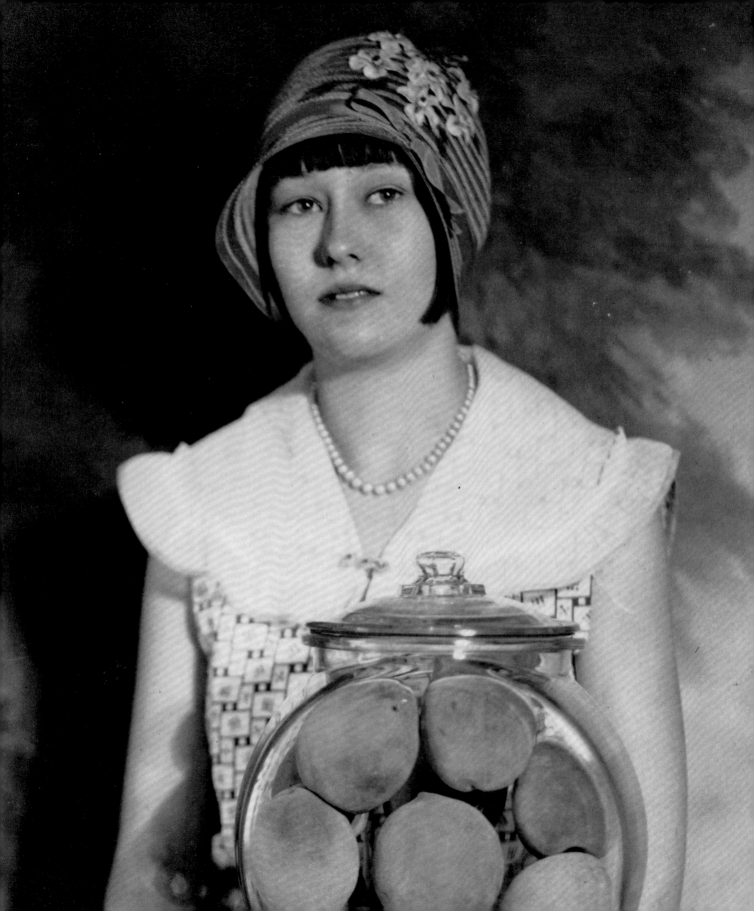

Simpler Times? | BENJAMIN WEISS

Nostalgia is a powerful drug, but it needs to be to do its job. At every moment of our lives, we live with the past and with our memories — memories of pleasures and opportunities, disappointments and excitements. Year by year, they accumulate, piling up and competing for our attention. To experience all of those sensations and emotions at full strength, and in their full complexity, at the same time would be overwhelming. We would — all of us — be paralyzed.

So we edit. We invent. We tell stories about our lives, repeating them and tweaking them until they please us and are easy to tell. We create heroes and villains, and satisfying endings to unsatisfying tales. And, in the process, we distort our memories, sometimes with devious or deceitful intent, but just as often with no intent at all. Whether we are conscious of it or not, nostalgia is the act of searching for and finding a past we would prefer to have had, rather than the one that existed.

Miserable jobs improve as they drift down the years. Difficult relationships lose their drama and trauma. The processing of memory into nostalgia works like a glacier, slowly grinding off the sharp peaks and smoothing the rugged edges of our emotional landscapes. The intensity and specificity of the moment undergo a slow dilution, which, in turn, allows space for new experiences and emotions. In that smoothing process, though, we often lose the precision and clarity of true memory. The sometimes rosy-hued results are not without an element of truth, but they are carefully packaged and shaped for easier consumption.

The same process happens at the larger scale of historical memory. Records are lost, details are hidden, and uncomfortable events are buffed up for ease of public consumption. All historical periods undergo smoothing and distillation as they recede; and, just like individuals, societies lose the ability to understand their pasts with the nuance and complexity that was available to those who were there at the time.

It is difficult to imagine a historical source better suited to the phenomenon of elided memory and nostalgia than the real photo postcard. Everything conspires to make us look at the images on these cards through a protective haze: the many decades that have passed, the old clothes, and the quaint technology. Even the fact that the photos are in black and white reinforces the sense that they are from a safer and, we hope, simpler, place and time.

Indeed, the temptation is built into the cards' very subjects. Photographers, as we have seen throughout this book, often selected the good bits of life to enshrine on their cards. Postcards were commercial products after all, and, just like Renaissance portraits, photo postcards were meant to please a patron. The images were carefully

312 (DETAIL)

selected and shaped for that purpose. The challenge to us, many decades later, is to ensure that we are not tricked by the postcards, for in most cases they present their best selves and hide their darker secrets.

The positive stories the cards show aren't necessarily wrong or untrue, but they aren't the whole picture either. So think hard when looking through a box of cards, and don't shy away from the ugly parts. It is the duty of the present to remember the past as it was, not as we want it to be. We honor the humanity of the people of the past by recognizing them as people, flawed though their humanity inevitably was, not as archetypes or heroes.

Uglier stories do come through in the cards — nativism, poverty, child labor, the KKK — sometimes in ways that shock us. This book contains no postcards that show lynchings, for example, but there are many thousands of such cards. And it is important, always, to remember that nearly all those cards were meant to celebrate, not condemn, the act of murder. Similarly, cards that show

the KKK on the march are, mostly, propaganda for the organization rather than resistance to it. But at the same time, it is vital to remember that images can escape their creators. A postcard that shows a hooded army marching en masse down Pennsylvania Avenue, the Capitol in the background, could be a call to action for antiracist forces just as much as it is for supporters of the organization.

Whether the stories the cards convey are good or bad; idyllic or dramatic or just everyday; the real power of these objects, as documents not just of history but of lived human experience, is the spur they provide for a fuller appreciation of historical complexity. The cards' remarkable intimacy is an invitation and challenge to the imagination — an opportunity to consider the past in a detailed and nuanced way. When a postcard shows a clothesline full of freshly washed sheets, don't just admire the white linen or think about the beautiful smell of laundry dried in the wind; make sure that you also think of the labor of washing clothes by hand in a tub equipped with only a mechanical mangle, and of the weight of that wet laundry on the way to the line. When presented with an idyllic Fourth of July picnic, arrayed on a blanket spread out on lush grass, give a thought to the child who might find that blissful meal a boring, buggy nightmare. Consider the ways fancy-dress costumes can be uncomfortable and ill-fitting, or the sense of feeling odd and out of place at a civic ceremonial. We've all been there.

Real photo postcards are a magnificent window into the past. Allow yourself to look through that window with your eyes and your imagination wide open, because the lessons that the cards teach — about the stresses and strains, successes and failures of a country — are as valuable to the way we look at ourselves today as they are in understanding the past. And the past is, ultimately, the source of who we are.

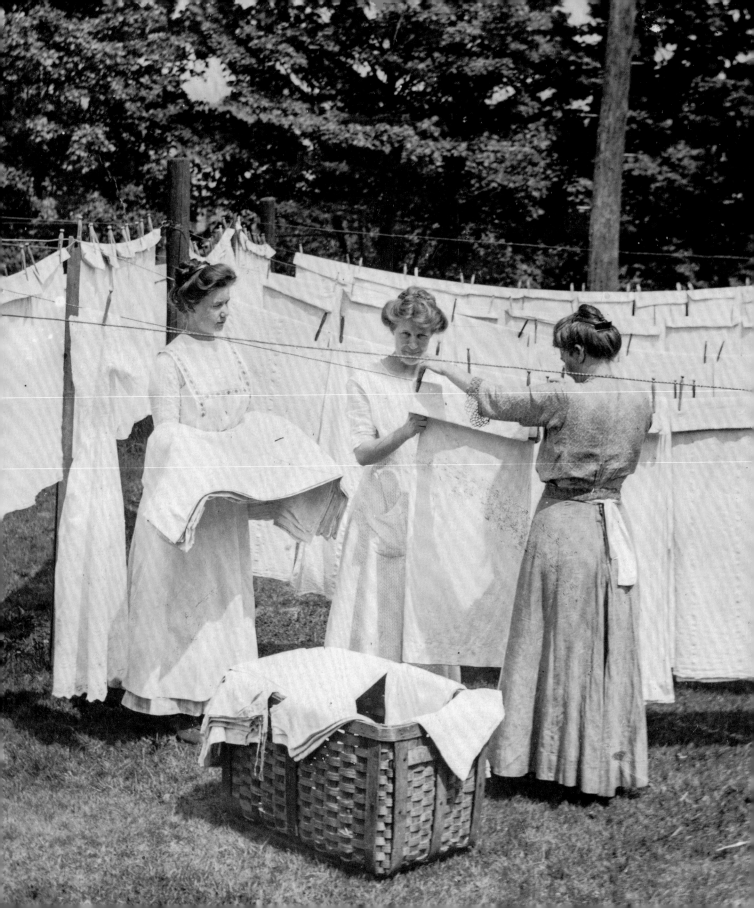

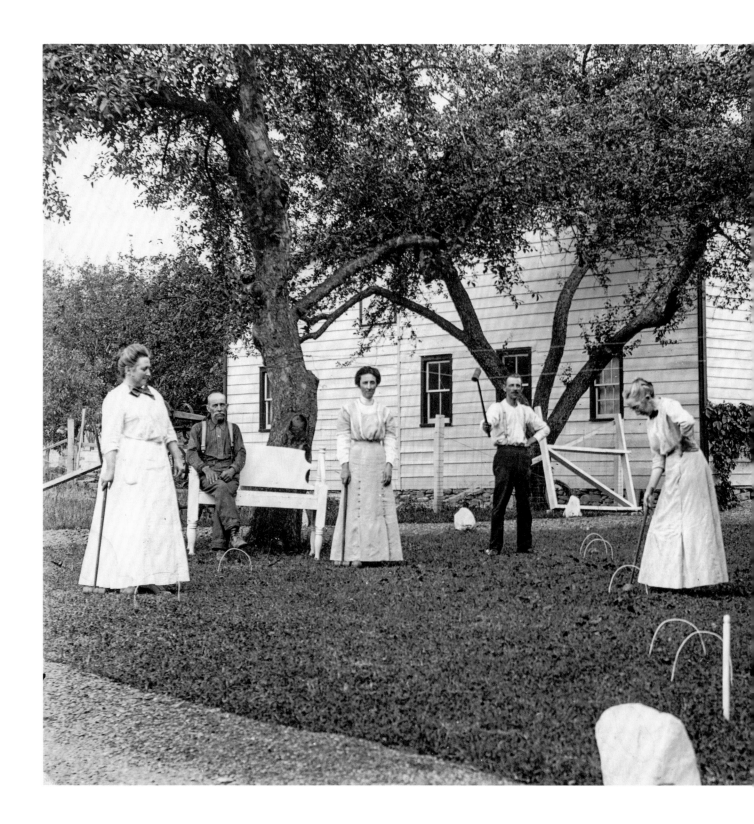

297
Doris with peaches, Littlefield,
Texas, 1926 or later

296
Playing croquet, about 1914

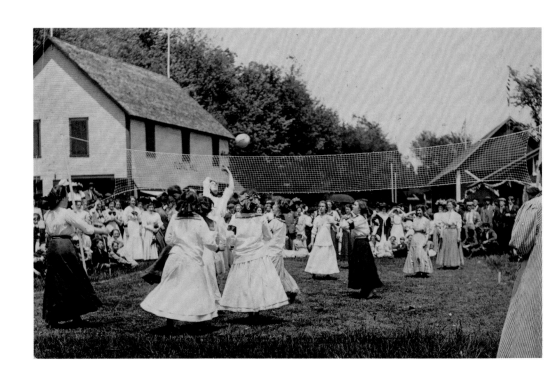

298
Field day, Springfield,
Vermont, 1910

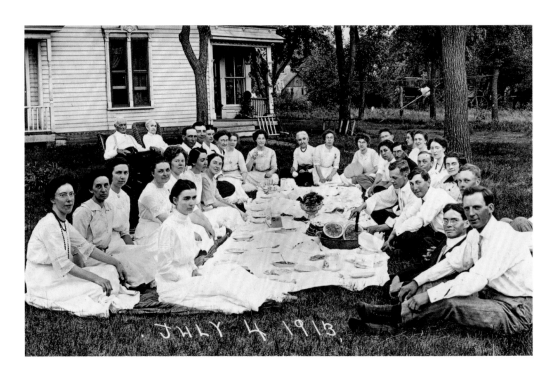

299
July 4, 1913

300
Aunt Dinah's quilting party,
Rutherford, New Jersey,
1912

301
Washerwomen, 1913

302
East Brady Bottling Company float,
Pennsylvania, 1907 or later

303
S. W. S. Annual Clambake, 1915

304
Seen in Chinatown, 1912 or later
R. & H. PHOTO

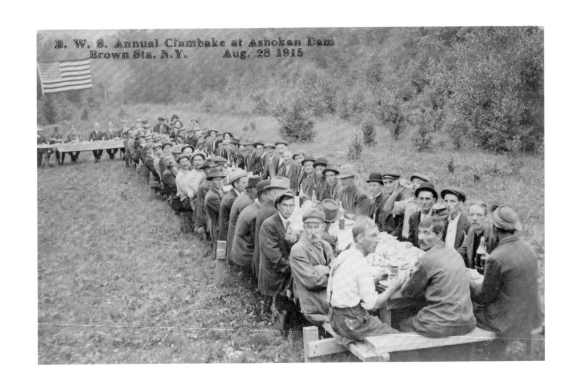

B. W. S. Annual Clambake at Ashokan Dam
Brown Sta. N. Y. Aug. 28 1915

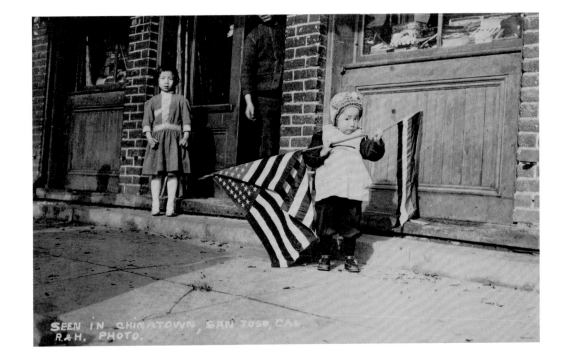

SEEN IN CHINATOWN, SAN JOSE, CAL.
R.&H. PHOTO.

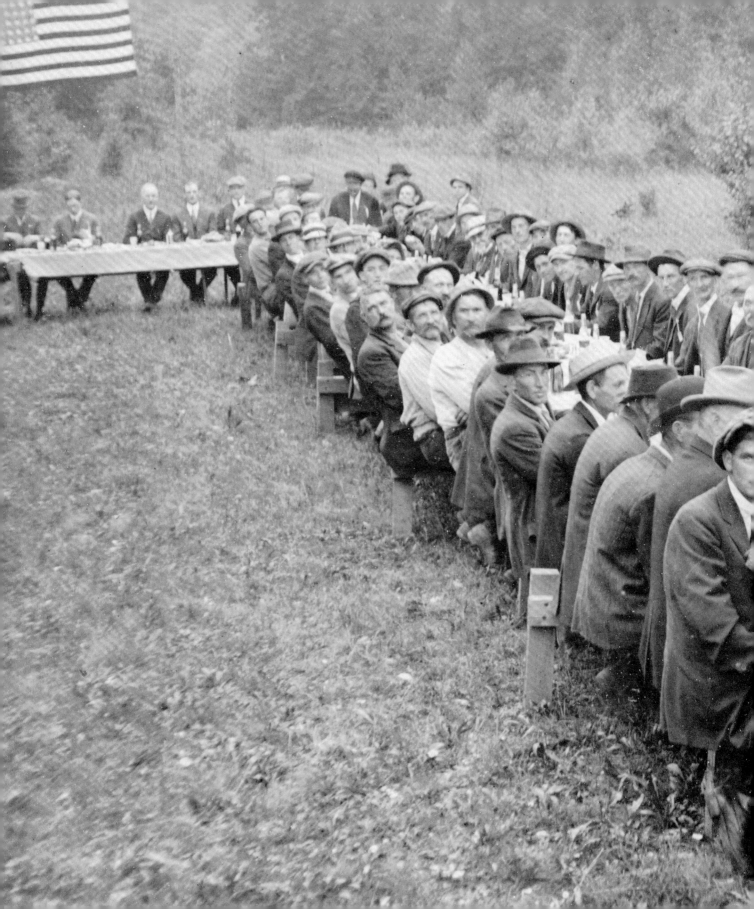

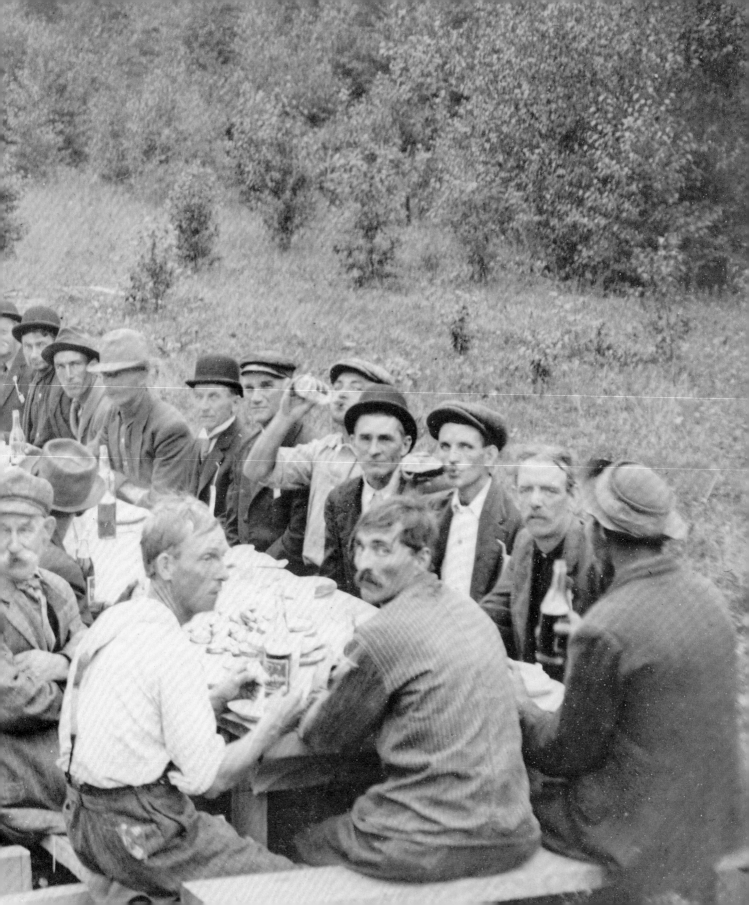

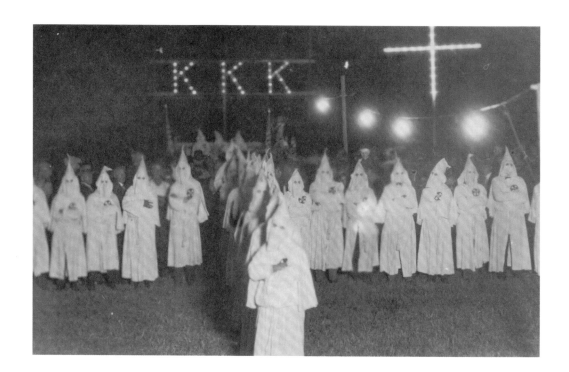

305
Ku Klux Klan rally, 1917
or later

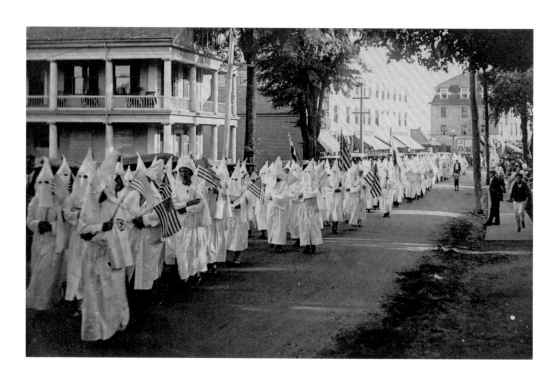

306
Ku Klux Klan parade, Kittery,
Maine, 1924 or 1925

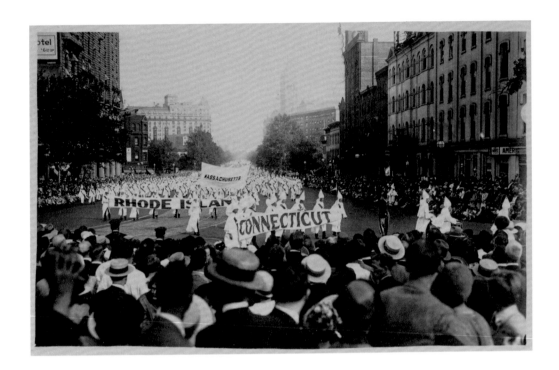

307
Ku Klux Klan march on
Washington, D.C., 1925

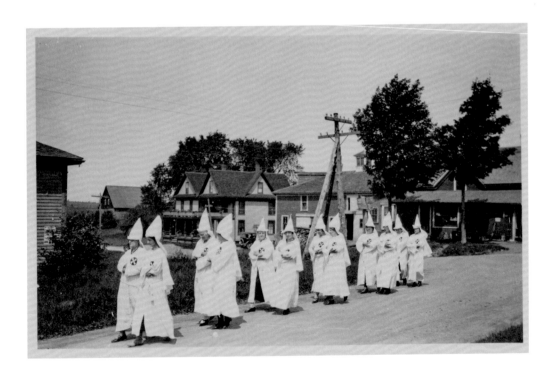

308
Ku Klux Klan women
marching, Enfield, Maine,
1925

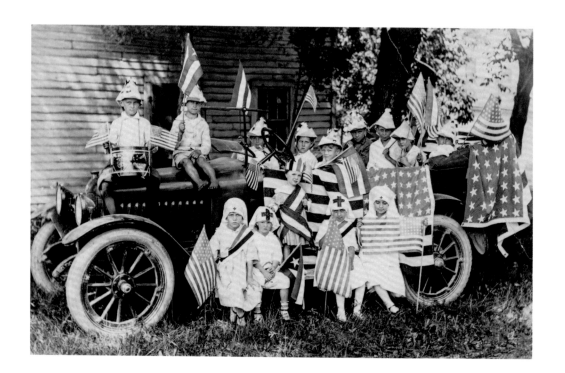

309

Children wearing patriotic garb, 1917 or later

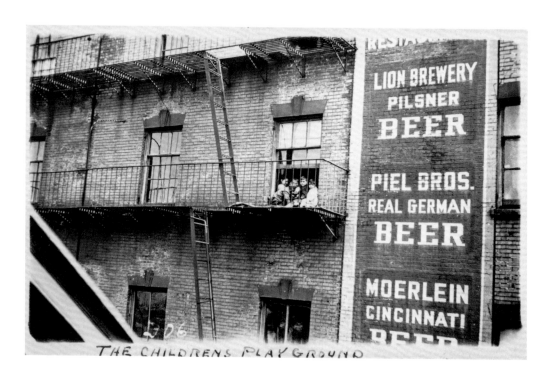

310

The Children's Playground, about 1914

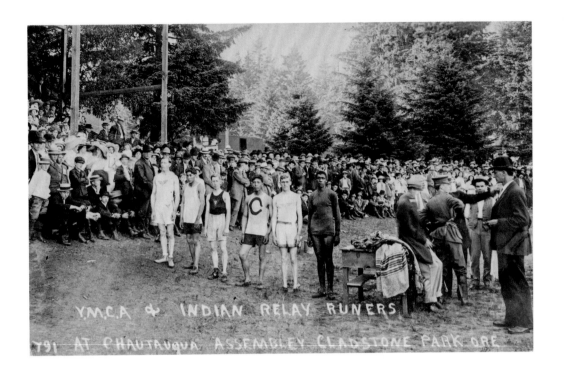

311

Y.M.C.A. & Indian Relay
Runners, Chautauqua
Assembly, about 1914

312

Boy wearing patriotic garb,
about 1914

Y.M.C.A. & INDIAN

LAY RUNERS

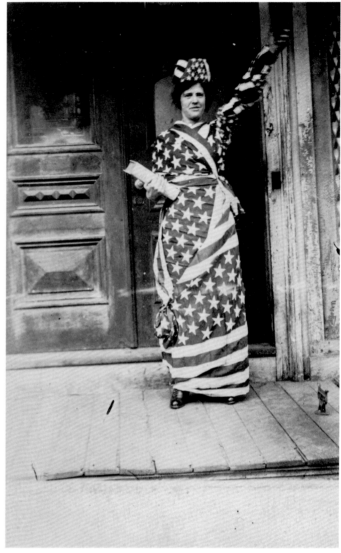

313
Man in Uncle Sam costume, 1908
CHAPMAN BROS., PHOTOGRAPHERS

314
Woman wearing patriotic garb,
1910 or later

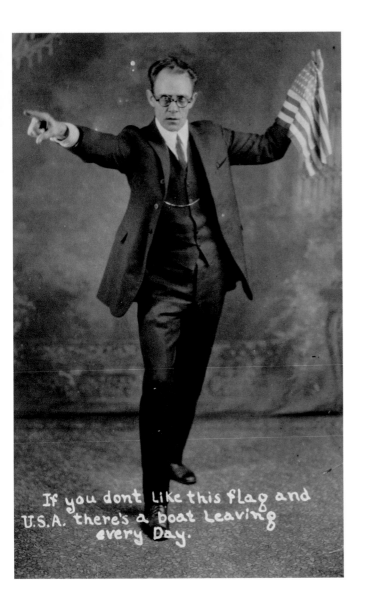

If you dont like this flag and U.S.A. there's a boat Leaving every Day.

315
Anti-immigrant flag waver,
1925 or later

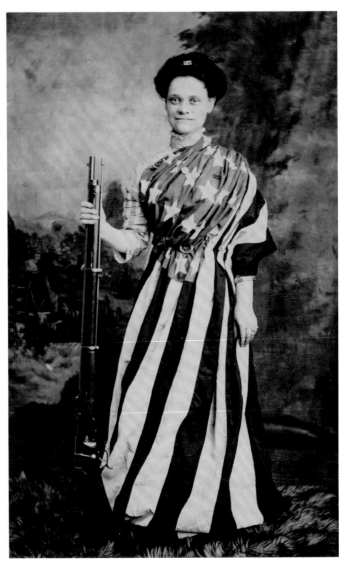

316
Woman in American flag costume,
1910 or later

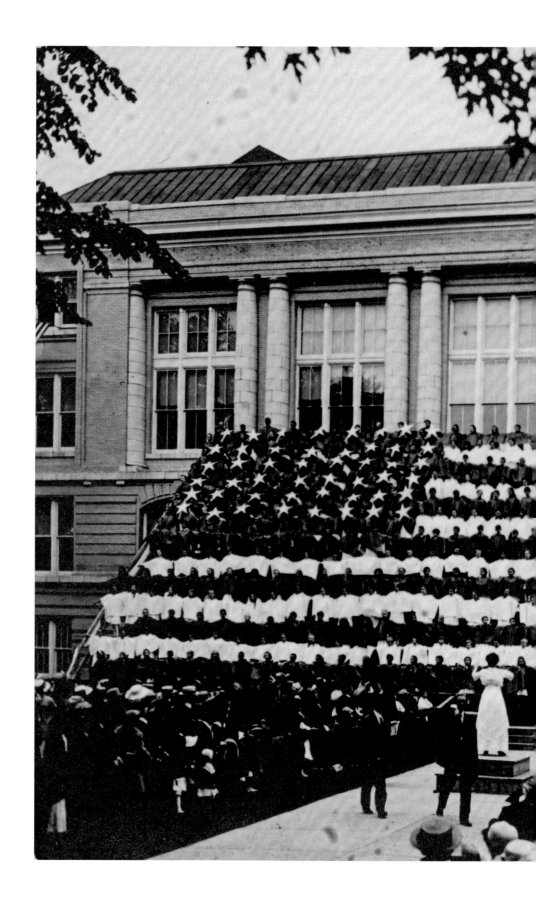

317
Living American flag,
Gloversville High School,
New York, about 1914

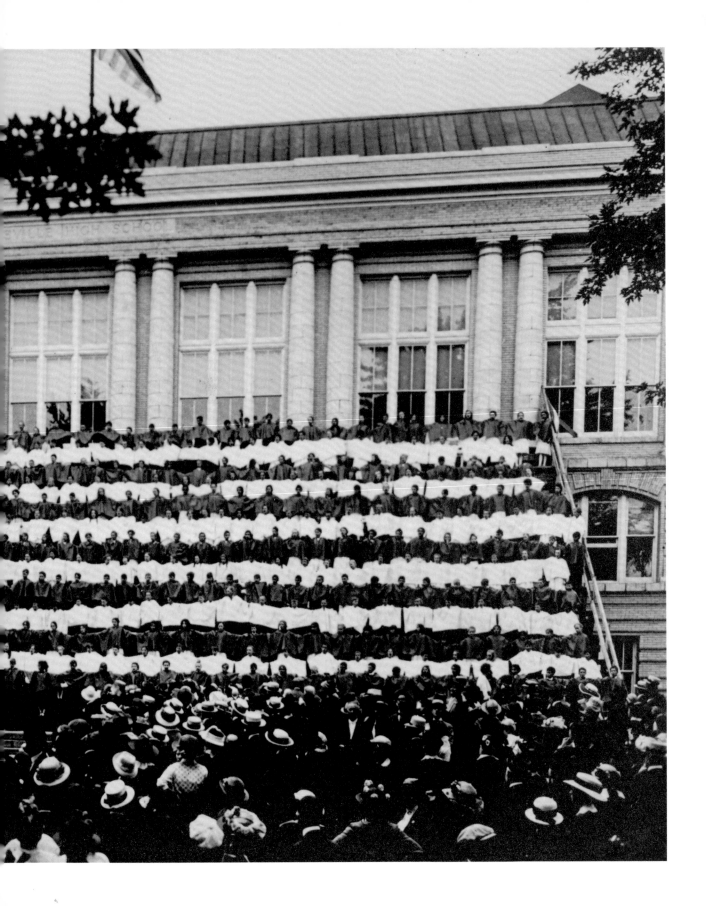

Notes

IN AND OUT OF FOCUS

1. Steve Harmon, "Throwback Thursday," *The Hutchinson News*, posted August 1, 2019.
2. Cattle auction advertisement, *The Hutchinson News*, April 4, 1914, 7; "Gee, Gene's Car's Gone," *The Hutchinson News*, November 26, 1917, 11; "His Hobby is Finding Bells," *The Hutchinson News*, August 6, 1931, 5; "Hutchonians Recall Gene, *The Hutchinson News*, June 28, 1961, 31.

MAKING POSTCARDS AND (SOMETIMES) MAKING MONEY

1. "Photographic Post-Cards," *The Photo-Miniature* 8, no. 94 (October 1908): 425.
2. "Photographic Postal Cards," *The Photographic Times* 33, no. 5 (May 1901): 235.
3. For a detailed chronology, see Robert Bogdan and Todd Weseloh, *Real Photo Postcard Guide: The People's Photography* (Syracuse: Syracuse University Press, 2006), 14–20.
4. *Photographic Printing Complete. Complete Self-instructing Library of Practical Photography*. Volume 4. Edited by James Boniface Schriever and Thomas Harrison Cummings (Scranton: American School of Art and Photography, 1908): 303.

5. Jessie Robinson Bisbee, "The Problem of Postal Portraits," *The Association News* 3, no. 11 (December 1916): 460.
6. C. H. Claudy, "The Re-Sitting Policy Again," *Bulletin of Photography* 29, no. 738 (September 28, 1921): 394.
7. "Average Prices," *Abel's Photographic Weekly* 8, no. 197 (October 7, 1911): 334–36.
8. "The Much Berated Postcard," *Studio Light, Incorporating The Aristo Eagle, The Artura Bulletin* 4, no. 7 (September 1912): 18–19.
9. Edward R. Trabold, "A Reply to Mr. Ogilvie," *Camera Craft* 21, no. 11 (November 1914): 530.
10. *The Professional and Amateur Photographer* 13, no. 11 (November 1908): 482–83.
11. J. Peat Millar, "The Professional Photographer and Picture Postcards," *The Professional and Amateur Photographer, A Journal of Practical Photography* 13, no. 10 (October 1908): 422–23.
12. Paul Glenn Holt, *Fifty Dollars a Week with Car and Camera* (Boston: R. Snyder, 1926), 16.
13. "Postcard Studio," *American Photography* 9, no. 4 (April 1915): 250.
14. R. Willis Yeaton, "Economical Production of Postcards," *American Photography* 7, no. 4 (May 1913): 206.
15. F. M. White, "The Postcard Business," *American Photography* 7, no. 5 (May 1913): 281.
16. Charles R. Ogilvie, "The Demonstrator Talks," *Camera Craft* 21, no. 9 (September 1914): 442.

17. D. E. Jakot, "The Portrait Postcard Studio," *American Photography* 7, no. 8 (August 1913): 460–62.
18. James Everton, "Postcards for Profits," *Snap Shots* 23, no. 1 (January 1912): 6.
19. "Postcards for the Professional," *Wilson's Photographic Magazine* 46, no. 627 (March 1909): 130.
20. R. Willis Yeaton, "Economical Production of Postcards," *American Photography* 7, no. 4 (May 1913): 210.
21. Frederick Visick, "A Method of Titling Postcards," *Snap-Shots* 24, no. 9 (September 1913): 161.
22. James Everton, "Postcards for Profits," *Snap Shots* 23, no. 1 (January 1912): 6.
23. R. Willis Yeaton, "Economical Production of Postcards," *American Photography* 7, no. 4 (May 1913): 210.
24. "Centennial Celebration of the M. W. Prince Hall Grand Lodge," *Alexander's Magazine* 6, no. 6 (October 15, 1908): 263.

MAIN STREET

1. Sinclair Lewis, *Main Street* (New York: P. F. Collier & Son, 1920).

DEMOCRACY, AT WORK

1. Studs Terkel, *Working* (New York: Avon Books, 1975), xxvi.
2. "The Jack and Rose Lekivetz Story," in *The Ties That Bind: Estlin Gray Riceon*

Bechard (Riceton, Saskatchewan: Bechard, Riceton, Gray and Estlin History, 1984), 914–15.

3. Halla Bellof, *Camera Culture* (Oxford: Basil Blackwell Inc., 1985), 22.

4. Walt Whitman, *Leaves of Grass — Facsimile Edition* (New York: The Eakins Press, 1966), 21.

5. James Agee, *Let Us Now Praise Famous Men* (Boston: Houghton Mifflin, 1941), 266.

WHEN YOU LOOK AT THIS, THINK OF ME

My thanks to the following individuals who helped with various aspects of my research for this essay: Deborah Anna Baroff, Aslaku Berhanu, Jaime Ellyn Bourassa, Terry Ellen Ferl, Rachel Mosman, Carney C. Saupitty, Jr., Elizabeth Semmelhack, Patricia Marie Todd. I am also extremely grateful to Robert E. Jackson and Rebecca Steiner for their invaluable comments and editorial suggestions on earlier drafts

1. Alma Mae Bradley appears on a list of the seventeen graduating seniors from Downingtown Industrial and Agricultural School on June 13, 1935, published in Baltimore's *The Afro-American* on June 15, 1935. She is also pictured in a 1931 women's basketball team photograph taken outdoors in front of one of the campus houses.

2. Robert Bogdan and Todd Weseloh, *Real Photo Postcard Guide: The People's Photography* (Syracuse: Syracuse University Press, 2006), 24.

3. Jessie Robinson Bisbee, "Postal Portraits — Why?," *The American Annual of Photography*, 1915, 52.

4. Bisbee, "Postal Portraits — Why?," 52.

5. Carola Muysers (2002), "Physiology and Photography: The Evolution of Franz von Lenbach's Portraiture," *Nineteenth-Century Art Worldwide* 1, no. 2: 88.

6. Obituary of Boris Pruss. *St. Louis Globe-Democrat*, May 4, 1940, 2.

7. Erving Goffman, *The Presentation of Self in Everyday Life* (New York: Doubleday, 1959).

8. Lucy R. Lippard, "Frames of Mind," *Afterimage* (March/April 1997): 8.

9. Krista Keller, "'A Great Variety of New and Fine Designs': Advertisements for Painted Backgrounds, 1856–1903." Unpublished MA thesis, Program of Photographic Preservation and Collections Management, Ryerson University and George Eastman International Museum of Film and Photography, 2013.

10. *Snap Shots*, November 1917, 83.

11. Philip J. Deloria, *Playing Indian* (New Haven: Yale University Press, 1998), 59–65.

12. Shari M. Huhndorf, *Going Native: Indians in the American Cultural Imagination* (Ithaca: Cornell University Press, 2001), 19–78.

13. Rebecca Elena Scofield, "Riding Bareback: Rodeo Communities and the Construction of American Gender, Sexuality, and Race in the Twentieth Century" (Ph.D. dissertation, Harvard University, 2015), 32.

14. Pauline Turner Strong, "Cultural Appropriation and the Crafting of Racialized Selves in American Youth Organizations," *Cultural Studies* 20, no. 10 (2008): 6.

15. Deloria, *Playing Indian*, 105.

16. Michelle Stokely, "Picturing the People: Kiowa, Comanche, and Plains Apache Postcards," *Plains Anthropologist* 69, no. 234 (2015): 102.

17. Arjun Appadurai, "The Colonial Backdrop," *Afterimage* 24, no. 5 (1997).

18. Patricia C. Albers, "Symbols, Souvenirs, and Sentiments: Postcard Imagery of Plains Indians, 1898–1918." In *Delivering Views: Distant Cultures in Early Postcards*, edited by Christraud M. Geary and Virginia-Lee Webb (Washington, D.C.: Smithsonian Institution, 1998), 67.

19. Renato Rosaldo, "Imperialist Nostalgia." In *Culture and Truth: The Remaking of Social Analysis* (Boston: Beacon Press, 1989), 69–70.

20. *The Lawton Constitution*, May 3, 1909, 2.

21. *Daily News-Republican* (Lawton, Oklahoma), June 9, 1909, 1.

22. Stokely, "Picturing the People," 109.

23. William C. Meadows, *The Comanche Code Talkers of World War II* (Austin: University of Texas Press, 2003), 141.

24. Meadows, *The Comanche Code Talkers of World War II*, 91.

25. Cynthia Culver, "Prescott, Representing the Ideal American Family: Avard Fairbanks and the Transformation of the Western Pioneer Monument," *Pacific Historical Review* 85, no. 1 (2016): 112–114.

26. Barbara A. Hail, "A House for the Beginning of Life." In Barbara A. Hail, ed. *Gifts of Pride and Love: Kiowa and Comanche Cradles* (Providence, RI: Haffenrefer Museum of Anthropology, Brown University, 1999), 33.

27. *The Lawton News* (Lawton, Oklahoma), October 14, 1915, 6.

28. Carney C. Saupitty, Jr., Comanche National Museum and Cultural Center. Personal communication, June 23, 2021.

29. Luc Sante, *Folk Photography: The American Real-Photo Postcard 1905–1930* (Portland: YETI Books, 2009), 36.

BETWEEN PRIVATE AND PUBLIC

1. "A Little Cousin of the Post Card," *Kodakery* II, no. 1 (1914): 21.

2. Gil Pasternak, "Taking Snapshots, Living the Picture: The Kodak Company's Making of Photographic Biography," *Life Writing* 12, no. 4 (2015): 431–46.

3. Nancy Martha West, *Kodak and the Lens of Nostalgia* (Charlottesville: University of Virginia Press, 2000), 13.

4. Richard Chalfen, *Snapshot Versions of Life* (Bowling Green, Ohio: Bowling Green State University Popular Press, 1987), 8–9.

5. Frederic T. Corkett, "The Production and Collection of the Pictorial Postcard," *Journal of the Society of Arts*, November 17, 1905, 625.

6. E. J. Wall and H. Snowden Ward, *The Photographic Picture Post-Card: For*

Personal Use and for Profit (London: Dawbarn and Ward, Ltd., 1906), 78.

7. "The Ubiquitous Postcard," *The Amateur Photographer and Photographic News*, August 25, 1908, 174.

8. "En Passant," *The Amateur Photographer and Photographic News*, December 1, 1908, 512.

9. "Photographic Post-Cards," *The Photo-Miniature* VIII, no. 94 (October, 1908): 424–25.

10. "Photographic Post-Cards," 425.

11. Lana Rakow, *Gender on the Line: Women, the Telephone, and Community Life* (Urbana and Chicago: University of Illinois Press, 1992), 207–25.

12. "Correspondence and Postcard Exchange," *Los Angeles Times*, July 28, 1907, V114.

13. "Postcard Exchange," *New-York Tribune*, August 5, 1906, B5.

14. "Get Out Your Cameras," *The Woman's Journal*, September 25, 1909, 153.

15. "More Suffrage Post Cards," *The Woman's Journal*, February 13, 1909, 28.

16. "Suffrage in New York City," *The Woman's Journal*, August 27, 1910, 141.

17. "Feminine Davids from Baltimore Attack the Democratic Goliath," *The Baltimore Sun*, October 18, 1914, 7; "Suffragists Begin Maryland Invasion," *The Washington Times*, June 13, 1914, 14.

THE NEWS

1. "Fire Loss Close To $30,000," *The Montpelier Evening Argus*, February 2, 1911, 5. (Newspapers.com, accessed June 28, 2021.)

2. "Rialto Block Burns and Goes into River," *Montpelier Morning Journal*, February 2, 1911, 1, 3, 4.

3. "News Notes About Town," *Montpelier Morning Journal*, February 3, 1911, 8.

4. Phone interview with Carol Willey, May 27, 2021.

5. Email from librarian Paul Carnahan, Vermont Historical Society, June 21, 2021; Ancestry.com vital records for Alice

(Bagley) Whelpley, accessed June 22, 2021.

6. Newspaper coverage from the February 1, 1911, *Burlington Daily News*, *Barre Daily Times*, and *Montpelier Evening Argus* and the February 2, 1911, *Boston Globe* and *Montpelier Morning Journal* accessed May 11, 2021, at Newspapers.com. Other Boston papers reviewed at Newspaperarchive.com and Genealogybank.com, June 28, 2021.

7. "Notable Addresses and Amusing Stunts Feature Newspaper Night of the Syracuse 'Ad' Mens Club," *The Post-Standard*, March 28, 1911, 6, 18. (Newspaperarchive.com, accessed May 27, 2021.)

8. "Train Accidents in July," *Railroad Age Gazette*, August 21, 1908, 754. (Google Books, accessed July 1, 2021.)

9. "Two Great Water Tanks Burst Destroying Property," *Popular Mechanics* (June 1909): 494–95. (Google Books, accessed June 24, 2021.)

10. Paolo E. Coletta, *The Presidency of William Howard Taft* (Lawrence, KS: University Press of Kansas, 1973), 74. (Internet Archive, accessed June 28, 2021.)

11. "President Scorns Peace as Teddy's Blows Fall," *Cleveland Plain Dealer*, May 16, 1912, 1, 2. (Genealogybank.com, accessed June 25, 2021.)

12. "Col. Roosevelt in Bennington this Morning," *Bennington Evening Banner*, August 29, 1912, 1. (Newspapers.com, accessed May 20, 2021.)

13. "Throng of 8,000 Saw Roosevelt in Barre Today," *The Barre Daily Times*, August 31, 1912, 1. (Newspapers.com, accessed May 19, 2021.)

14. Phone interviews with Michael Beykirch and Suzanne O'Toole, May 18, 2021.

15. *Catalogue of Copyright Entries, Part 4: Works of Art; Reproductions of a Work of Art; Drawings or Plastic Works of a Scientific or Technical Character; Photographs; Prints and Pictorial Illustrations*, 1927, New Series, Volume 22, No. 1, 283–84, and *Catalog of*

Copyright Entries, Part 4, New Series, Volume 23, For the Year 1928, Nos. 1–4, Library of Congress, Copyright Office, 215. (HathiTrust Digital Library, accessed July 1, 2021.)

16. "Gang Warfare Plot is Nipped," *The Mansfield News*, November 12, 1927, 12. (Newspapers.com, accessed July 1, 2021.)

17. Phone interviews with Jon Musgrave, May 18 and 19, 2021.

18. Interviews with Musgrave.

19. Phone interview with Mike Mitchell, May 20, 2021.

POSTCARDS AND ROAD TRIPS

1. Monica Cure concisely describes the broader intersection of postcards and travel in *Picturing the Postcard: A New Media Crisis at the Turn of the Century* (Minneapolis and London: University of Minnesota Press, 2018), 40–45.

2. Nancy Martha West, "'Vacation Days are Kodak Days': Modern Leisure and the New Amateur Photographer in Advertising," in *Kodak and the Lens of Nostalgia* (Charlottesville and London: University Press of Virginia, 2000), 38–40.

3. John Urry, "The 'Consumption' of Tourism," *Sociology* 24, no. 1 (February 1990): 23.

4. A[nton] L. Westgard, *Tales of a Pathfinder*, self-published, New York, 1920, 173–74.

5. West, "'Vacation Days are Kodak Days,'" 67.

6. These campaigns are mentioned in Rachel Snow, "Tourism and American Identity: Kodak's Conspicuous Consumers Abroad," *The Journal of American Culture* 31, no. 1 (2008): 10–11; Annie Rudd, "Creating the Kodaker: Hand Cameras, Snapshots, and Amateur Photography, 1880–1914." (Paper presented at the International Communication Association Annual Meeting, San Juan, PR, May 2015), 15–16; West, "'Vacation Days are Kodak Days,'" 65; and Claudia Bell and John Lyall, *Accelerated Sublime: Landscape,*

Tourism, and Identity (Westport, CT, and London: Praeger, 2002), 116.

7. "Capable Kodak Conveniences" advertisement, Kodakery 9, no. 12 (August 1922): 30.

8. Dr. C.E.K. Mees, "The Fundamentals of Photography. Chapter VI — The Developing Solution," Kodakery 6, no. 1 (September 1918): 22.

9. "Jimmy Prepares to Leave Camp," Kodakery 2, no. 1 (September 1914): 22–23.

10. "A Little Cousin of the Post Card," Kodakery 2, no. 1 (September 1914): 20.

11. For studies of mobile postcard photographers see: Robert Bogdan, Exposing the Wilderness: Early-Twentieth-Century Adirondack Postcard Photographers (Syracuse: Syracuse University Press, 1999) and Jeremy Rowe, "Have Camera, Will Travel: Arizona Roadside Images by Burton Frasher," The Journal of Arizona History 51, no. 4 (Winter 2010): 339–49.

12. For more on travel albums, see Marguerite S. Shaffer, See America First: Tourism and National Identity, 1880–1940 (Washington and London: Smithsonian Institution Press, 2001), 261–301; and Rachel Snow, "Snapshots by the Way: Individuality and Convention in Tourists' Photographs from the United States, 1880–1940," Annals of Tourism Research 39, no. 4 (2012), 2013–50.

13. Rachel Snow, "Correspondence Here: Real Photo Postcards and the Snapshot Aesthetic," in David Prochaska and Jordana Mendelson, eds. Postcards: Ephemeral Histories of Modernity (University Park: The Pennsylvania State University Press, 2010), 51.

14. "Photographic Post-cards," The Photo-Miniature 8, no. 94 (October 1908): 426.

15. Advertisements for the Prescott-Stereopticon, The Travel Magazine, May 1910, 407, and for the Practical Lantern Company's Postcard Lantern, The Travel Magazine, October 1909, 4.

16. Shaffer, See America First, 233–34.

17. For more on the formulaic aspect of tourism and tourist consumption, see Shaffer, See America First, 308; Snow, "Snapshots by the Way," 2028; and Rachel Snow, "Tourism and American Identity: Kodak's Conspicuous Consumers Abroad," The Journal of American Culture 31, no. 1 (2008): 17.

18. Snow, "Tourism and American Identity," 17.

19. Rudd, "Creating the Kodaker," 1.

20. John D. C. Gadd, "Saltair Great Salt Lake's Most Famous Resort," Utah Historical Quarterly 36, no. 3 (Summer 1968): 209.

21. Melanie Shellenbarger, High Country Summers: The Early Second Homes of Colorado, 1880–1940 (Tucson: University of Arizona Press, 2012), 22–26.

22. Prior to the 1936 publication of The Negro Motorist Green Book, the first Black travel guide, motorists likely relied on advertisements in Black magazines and newspapers for information. On the difficulties that Black travelers faced see: Mark S. Foster, "In the Face of 'Jim Crow': Prosperous Blacks and Vacations, Travel and Outdoor Leisure, 1890–1945," The Journal of Negro History 84, no. 2 (Spring 1999): 135–43; and Myra B. Young Armstead "Revisiting Hotels and Other Lodgings: American Tourist Spaces through the Lens of Black Pleasure-Travelers, 1880–1950," The Journal of Decorative and Propaganda Arts 25 (2005): 139–41.

23. Shaffer, See America First, 233–34.

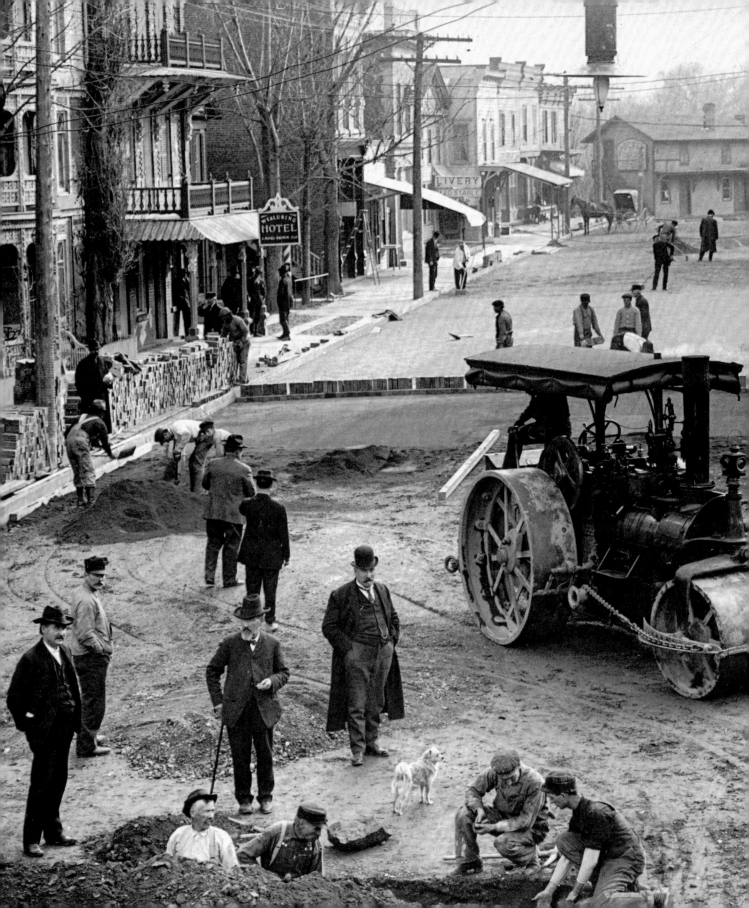

List of Illustrations

ANNA TOME, WITH LYNDA KLICH, ERIC MOSKOWITZ, AND BENJAMIN WEISS

While many real photo postcards document specific events, such as a withering tornado that scourged the town of Antler, North Dakota, in 1911, or the Ku Klux Klan's 1925 March on Washington, many more have unidentified subjects that float more freely in time and space. In studying these undated images, it is the backs of the cards that reveal their place in history. The back of a card — its design, manufacturer's logos, custom typefaces, and unique stamp boxes — holds a wealth of information that can help determine the date of a card (see detail on page 309). In addition to the photo paper's expiration date, which was typically two years after manufacture, the stamps, cancellation marks, and inscriptions can all point to when and where the photograph on the front was taken. Turning the cards over to decode their clues imparts numerous histories, not just of the specific card, but also of the burgeoning field of amateur photography in the early decades of the twentieth century.

Over 80 percent of the cards in this book are in mint condition and bear no inscriptions, dates, or cancellation marks, so we relied on comprehensive research by Robert Bogdan, Professor Emeritus of Education and Sociology at Syracuse University, and the postcard collector Todd Weseloh to estimate their dates. In their 2006 book, *Real Photo Postcard Guide: The People's Photography*, Bogdan and Weseloh examined five thousand cards collected for their backs and thirty thousand additional postcards. Building on the scholarship included in Hal Morgan and Andreas Brown's 1981 book *Prairie Fires and Paper Moons*, Bogdan and Weseloh matched subtle changes in printing, including logos and typefaces, to cancellation marks and inscriptions, to establish the earliest known dates of every logo and variation of typeface for the most popular brands in circulation between 1900 and 1950.

Modifications, which happened every few years, could be as subtle as changes in the serif on the words "Post Card." More obvious adjustments included shifts in the label for the inscription side of the divided back from "This space for message" to "Correspondence here," or simply "Message," along with distinctive changes to stamp box designs and logos. In some cases, the clue is an absence of stamp box and logo altogether. Using Bogdan and Weseloh's earliest known dates for each design variation, we were able to suggest a date for most cards in this book, as well as observe patterns and trends in manufacturing and photo technology.

Since the backs of the cards bear brand-specific logos and design variations, we deduced which types of photo paper were used based on each manufacturer's history. From roughly 1907 to the 1930s, ten brands

Reverse of card 290

accounted for 80 percent of the real photo postcard market (which comprised over 450 manufacturers) and sold both types of photo paper used at the time: printing-out papers and developing-out papers. Printing-out papers, which by the 1890s had begun to replace the time-consuming and fussy wet-plate printing of the nineteenth century, were coated with a light-sensitive emulsion and contact printed against a negative of the same size. "P.O.P.s," as they were known colloqui-ally, were only moderately light sensitive and generally exposed outdoors under sunlight, as opposed to in a sealed, dark room. Newer to photographers were the faster but more involved developing-out papers. Coated in a much more light-sensitive silver bromide emulsion, they required a darkroom sealed against outside light, as well as chemical developer and toning baths, to render an image. Given its more sophisticated process, developing-out paper was not adopted by most photographers until the end of the 1920s. Capable of extremely fast, precise images, developing-out papers remain the primary medium used today.

The Eastman Kodak Company was constantly introducing more advanced and user-friendly products ahead of its competi-tors, cementing market dominance and controlling 69 percent of the photo paper market by 1908. Approximately 60 percent of the postcards in this book were printed on paper by Azo, one of Kodak's subsidiary brands. Kodak also owned Velox, which accounts for another 4 percent of the cards here. Competing brands, including Defender, Cyko, and Kruxo, constitute the other 36 percent.

Besides attesting to Kodak's market domi-nance, the prominence of Azo postcards also reveals how photographers were adopting new technology. Azo made Kodak's version of so-called "gaslight papers," a far less light-sensitive derivative of developing-out papers, first invented in the 1890s and named for its ability to be contact printed indoors under lamplight. A March 1919 article titled "The Fundamentals of Photography" in the amateur photography magazine-cum-advertisement

Kodakery advised that photographers use one of their gaslight papers, as they "can be handled safely in any subdued light" — meaning, they did not require a light-sealed darkroom — and printed "from about 5 seconds to a minute," significantly faster than printing-out papers. "The old troubles," *Kodakery* advertised, "of judging the extent of printing, and the difficulties with toning baths [are] entirely absent with this simple and convenient printing medium." Indeed, the proliferation of Azo postcards testifies to Kodak's successful market integration of new mediums: while many still sent their negatives out for developing, gaslight papers allowed consumers to make expedited, detailed contact prints at home, turning amateurs into photographers and photographers into Kodak customers. This is but one story imparted by the backs of real photo postcards.

In cataloging the hundreds of cards for this publication and the exhibition it accompanies, we discovered a smattering of discrepancies where a card was hand-dated or a stamp cancelled after or before Bogdan's exhaus-tively researched timeframes. Such discords of data are part of the maturation of a field. Long a novelty pastime, albeit one defined by connoisseurship and historical expertise, the study of postcards has only recently been institutionalized. The meticulous process of indexing and archiving these implements of rapid communication a century later is to some extent like mapping a tornado after the dust has settled. Future study will no doubt lead to more discoveries — by those who remember to turn the cards over. — AT

Unless stated otherwise, postcards are from the Leonard A. Lauder Postcard Archive, a promised gift to the Museum of Fine Arts, Boston; their medium is gelatin-silver print on card stock; their size is 3½ by 5½ inches with some variation; and their format is divided back.

CITIZEN PHOTOGRAPHERS

1
Parade with forty-six-star United States flag, 1916
Kruxo 11

IN AND OUT OF FOCUS

2
Eugene McInturff's hamburger stand, about 1914
Hutchinson, Kansas
Marion W. Bailey
Azo 4

3
Hamburger vendor, 1907 or later
Kruxo 7 (?)

4
Woman with book, 1911
St. Louis, Missouri
Maxwell
Kruxo 8 (?)

Maxwell's studio was located at 1407 Market Street in St. Louis, Missouri. The studio's dates of operation are unknown, but in 1907 and 1908 they ran numerous ads in the *St. Louis Palladium*, one of the city's leading Black newspapers.

5
Man reading a newspaper, 1922 or later
Sun Studio
Artura 6

6
Bar mitzvah boy, 1917 or later
Azo 6

7
Trumpet player, 1926 or later
Azo 8

8
Feeding Chickens, 1907 or later
Azo 4

9
Mary F. Mitchell feeding chickens, about 1912
Wichita, Kansas
Azo 5

10
By the Sand Road, 1914
South Pines, North Carolina
Ellsworth Curtis Eddy (1882–1969)
Azo 5

Born in Hollis, New Hampshire, Eddy began
working in North Carolina with the photogra-
pher Edmond L. Merrow in 1907, and moved
there permanently in 1912. Perhaps best
known for images of poor Black North Carolin-
ians, Eddy produced a wide range of cards,
including portraits and local sights.

11
Children with pumpkins, about 1914
Azo 5

12
Children harvesting strawberries, about 1914
Azo 5

Children under 16 made up nearly one-fifth
of the work force in 1900, as businesses took
advantage of their cheap labor, inability to
unionize, and the lack of government regula-
tion. Child labor was especially prevalent in
agriculture.

13
East Ward first grade class, about 1914
Wymore, Nebraska
Azo 5

14
Irving School, about 1914
Azo 5

In the 1910s, most schools in the United States
were segregated by race; this is an unusual
example of an integrated classroom from
the period

15
Balloon Race, 1909
North Adams, Massachusetts
Defender 4 (?)

1909 was the second year of an annual "point-
to-point" balloon race that started in North
Adams, Massachusetts, and ended thirty
miles north of the city. The goal was to land as
close as possible to a predetermined location.

16
Hot-air balloon ascension, 1910
Polk, Nebraska
Artura 5

Polk, Nebraska, was barely four years
old at the time of this fair. Photographs
taken moments after this image show the
rather bedraggled (but unmanned) balloon
exploding in mid-air.

17
Circus at Union City Bi-County Fair, 1917
or later
Union City, Indiana
Azo 6

18
Floral Hall at Valley Fair, 1910 or later
Brattleboro, Vermont
Cyko

The Valley Fair was established in 1886 as
an alcohol-free family event for farmers to
present their livestock and crops for awards.
The fair was immediately popular and
attendance reached 25,000 by the turn of
the century. Changing tastes and financial
mismanagement forced the fair association
to disband and sell the grounds in 1931.

19
Union Dental Company advertisements, 1907
or later
Salt Lake City, Utah
Azo 4

This is not an advertisement for the dentist,
but for the signs, which were painted by
George Jacob Maack (1867–1936).

20
G. R. Gaines Transfer and Storage wagon, 1913
or later
Shelbyville, Indiana
Kruxo 11

21
National Woolen Mills, about 1914
Wheeling, West Virginia
Azo 5

22
Poster hangers, about 1914
Portland, Oregon
Azo 5

23
Child laundry workers, about 1923
Cyko 5

24
Flour mill workers, about 1914
Azo 5

25
A family, postmarked 1913
Griffin, Georgia
Azo 5 (?)

The card bears the typewritten note:
"this Bunch came in from the Farm and is
A Saturday after noon Sight to be seam [sic]
in Dear Old Griffin, Ga."

26
Women painting, after 1917
Boothbay, Maine
Azo 6

This class is possibly from the Commonwealth
Art Colony, a summer art school established
at Boothbay Harbor, Maine, in 1907.

MAKING POSTCARDS AND (SOMETIMES) MAKING MONEY

27
Squirrel in Harvard Yard, 1905
Cambridge, Massachusetts
Collection of Benjamin Weiss

28
Kodak advertisement, postmarked 1914
Customized for Ford Optical, Co., Denver, Colorado
Velox 15

This card has a "handwritten" (though printed) message on the back, inviting customers to send their photos to Ford Optical to be printed as postcards, so you can "recall the places you visit and the friends you make."

29
A. H. Cummings in his Photocar 2, post-marked 1908
Bonaparte, Iowa
A. H. Cummings
Azo 4 (?)

Cummings sent this card to Ellen Schisler, of Astoria, Illinois: "Here I am in Iowa this is my place of business."

30
"KKK Tonic" salesmen, postmarked 1909
Defender 4 (?)

Based in Keokuk, Iowa, the K. K. K. Medicine Company (the three K's derive from the spelling of the city's name), was in business from around 1900 to the 1940s, manufac-turing a variety of tonics, balms, and salves, mostly distributed by traveling salesmen.

31
Photographer in the field, 1907 or later
Azo 4

32
Leeland Art Co.'s studio, 1914 or later
Mitchell, South Dakota
Kruxo 10

Leeland Art Studio most likely opened around 1914, at 318 North Main Street, in Mitchell.

33
Pontius Studio, 1907 or later
Sycamore, Ohio
David Riley Pontius (1855–1910)
Azo 4

34
Photographer and sitter with dog, 1907 or later
Cyko 5

35
Posing for a portrait, postmarked 1907
Cyko 5, variation C

36
American Film Company employee, about 1913
Evanston, Illinois
Azo 5

The American Film Manufacturing Company operated from 1913–1920 in Evanston, Illinois. The card bears a message, in Spanish, from D. R. F. to an L. H. Weld, of Ithaca, New York.

37
Kodak advertisement, 1910
A. R. Kinnaman, Photographer
York, Nebraska
Azo 5

Kinnaman sent this card to Gertie Collingham, of Fairmont, Nebraska: "Dear Cousin Gertie, Here is an advertisement card. What do you think of it? . . . Answer soon."

38
Photography studio, 1911 or later
Nebraska
Kruxo 10

39
Kodak Amateur Finishing Department print envelope, date unknown
Hamberg, North Dakota
Olsen's Studio
Lithograph and letterpress on paper

Return-mail envelopes like these were essen-tial to the home-made postcard business, providing amateurs access to Kodak's devel-oping and printing laboratories.

40
Kerr's Studio, 1908
Azo 4 (?)

41
Mobile photography studio, postmarked 1912
Sweetser, Indiana
Cyko 5

This card was sent to Emma Martin, North Manchester, Indiana: "Hello Mrs. M., Came over here Monday. Think I will like it here but I am easily suited. Business started good but quiet to-day. We are ten miles from Lafon-taine. Love from Mrs. W."

42
Farmer Fred's photography studio, 1917 or later
Pleasant Lake, Indiana
Azo 6

43
Let the Harley-Davidson photographer take the picture, postmarked 1915
Goodell, Iowa
H. R. Allabem

44
Cambridge High School 1918 Foot Ball Team, 1918
Madison, Wisconsin
Pearson, Reierson Studio
Azo 6

Cards like these were sold on their own, but also served as advertisements for the

individual images, which the studio could produce on demand.

45
Photographer in the field, about 1914
Azo 5

46
Photographer in the field, about 1914
Azo 5

47
George A. Hale, Photo Supply Dealer, about 1918
Claremont, New Hampshire
Noko

48
A Suggestion for Displaying Post Cards, 1907 or later
Tyndall, South Dakota
Bruhn & Zehnpfennig's Department Store — Scotland, South Dakota

49
Postcard rack in the Oneonta Department Store, 1907 or later
Oneonta, New York
Cyko 5, variation B (?)

50
Shop with postcards, 1910 or later
Cyko 5

51
Advertisement for the Clyde Banks photography studio, 1914
Bellingham, Washington
Clyde Banks (died 1977)
Cyko 5, variation C

The reverse has a notation identifying the figures as Coalba Von Soust and the Vermullen children, who were friends of Banks's.

52
Pricing for prints and enlargements, 1926 or later
Otto Conrath, Fort Winfield Scott, San Francisco, California

This is a sample for postcards Conrath offered as souvenirs for trainees at the Civilian Military Training Camp, at Fort Winfield Scott in San Francisco.

MAIN STREET

53
Ninth Avenue and Main Street, 1909
Winfield, Kansas
Azo 4 (?)

54
Amish market, 1925
Lancaster, Pennsylvania
Azo 6 (?)

55
Street paving outside the Wyalusing Hotel, 1907 or later
Wyalusing, Pennsylvania
Azo 4

56
Streetcar, 1909 or later
Columbus, Ohio
Azo 4

57
Outside the post office, 1909 or later
Lenox, Iowa
Azo 5

58
Mail carriers, about 1914
Wautoma, Wisconsin
Azo 5

"This shows myself, Assistant and 6 rural carriers, which composes the post office force of Wautoma. The fleshy one standing in the door is yours truly. W. H. Berray."

59
Walter A. Ware Stationers, about 1914
Mentz, New York
Azo 5

Walter Allen Ware (1888–1967) ran a news agent and stationery store in New York's Finger Lakes region; though much altered, the buildings remain.

60
Marketing Cotton on Streets of Stroud, Okla., 1909 (postmarked 1912)
Stroud, Oklahoma
Clyde F. York (born 1881)
Cyko 5 (?)

61
Street Scene on Sunday, about 1914
Conconully, Washington
Frank Matsura (1874–1913)
Azo 5

Frank Matsura immigrated to Okanogan, Washington, from Japan in 1903. Already a skilled photographer, he started his business in 1907, specializing in views of small-town life in the Pacific Northwest.

62
Post office, postmarked 1911
Baileyville, Illinois
Gem Photo Co. of Freeport, Illinois
Azo 5

The United States Postal Service established Rural Free Delivery in 1896, increasing postal access for small communities such as Baileyville. Horse-drawn postal wagons would still have been a common sight through the 1920s.

63
Taylor's Livery and Feed Stable, 1909 or later
Seville, Ohio
Azo 5

64
American Express Company, about 1914
Chicago, Illinois
Azo 5

65
Vinelodge Dairy, 1915 or later
Portland, Oregon
Cyko 6

As of 1917, the Vinelodge Dairy storefront was located at 475 Jefferson Street.

66
Jewel Company Incorporated proprietor with wagon, 1919
Azo 6

The back is inscribed, "W.J.B. as he looks when at work. Picture taken July 1919."

67
Weston Post Office and delivery automobiles, 1917 or later
Weston, Ohio
Azo 6

68
Cement workers, about 1914
Azo 5

69
State road, Cuba + Black Creek, 1910
Cuba, New York
H. F. Wilcox, Commercial Photographer
Azo 5

70
Street laborers, about 1914
Pratt, Kansas
Azo 5

These men are working on the street outside F. A. Withers Art Studio; Withers opened the studio on East Kansas Avenue on July 1, 1910. According to the *Medicine Lodge Cresset*: "Mr. Withers himself has been in the business for years and knows it from end to end."

71
Gensmer & Wolfram grocery, postmarked 1913
Portland, Oregon
Azo 5

Gensmer & Wolfram was located at 739 Union Avenue North. The grocery was most likely owned by Sarah P. A. Wolfram and Theodore Ferdinand Gensmer, who were married in Winona, Minnesota, in 1908.

72
Grocers, 1913
Probably Detroit, Michigan
Cyko 5

73
Pharmacists, 1907 or later
Cyko 5

74
Hunting and fishing shop, about 1914
Azo 5

75
Cobblers, 1907 or later
Azo 5

76
Shoe store, 1909
Peterson Photo
Azo 4

77
Barbershop, 1907 or later
Azo 4

78
Barbers, 1911 or later
Possibly Chester, Nebraska
Artura

According to the sign above the mirror, and the message (in German) on the card, a haircut was 6 cents and a shampoo 25 cents.

79
Roasted peanut cart, 1910 or later
Cyko 5

80
Long's Place lunch car, about 1914
Azo 5

81
Coca-Cola stand, postmarked 1912
Azo 4 (?)

By the time this postcard was sent, the Coca-Cola Company was spending the astronomical sum of one million dollars annually on advertising, including sponsorships at local fairs that would result in booths like this one.

82
Cutting's Cafe, postmarked 1909
Lebanon, New Hampshire
Azo 4

83
Bartenders, 1910 or later
Cyko 5

Before Prohibition, saloons, sample rooms, and taverns, although largely places for men, were crucial to the social life of a city and the transmission of working class and immigrant cultural values. By 1900, Chicago had as many saloons as dry-goods stores.

84
Butcher shop, 1909–10
Mabel, Minnesota
Kruxo 9

The inscription on the back of this card tells us that it shows Milo Rasmus (about 1887/89–1965), most likely on the left, who was married to Alvina Fardall (1895–1950) and lived in Mabel, Minnesota for most of his life. Lawrence H. Lawson (1868–1950) is possibly to his right, and the figure on the far right may be Lawrence's father, Hadley Lawson.

85
Men drinking, about 1914
Azo 5

86
Men drinking, about 1914
Azo 5

87
Advertising for the Manhattan Stock Company,
1910
Piqua, Ohio
Azo 5

May's Opera House was the preeminent
theater in Piqua and featured "two picture
machines — continuous shows and no stop
to change reels," as well as traveling acts
and stage plays from New York and else-
where. Among the many posters for the
Manhattan Stock Company is one for Thomas
Edison's *Frankenstein* — released March 18,
1910, it was the first film adaptation of Mary
Shelley's book.

88
Electricia, the Woman Who Tames
Electricity, 1912
Azo 5

89
Dreamland Theatre, about 1910
Azo 5

The Dreamland Theatre was established in
1907 at 205 North Main Street as one of the
first movie houses in Kewanee, Illinois. The
photo includes a poster for the 1910 film
Tommy Gets his Sister Married.

90
Elks Parade, copyrighted 1912
Portland, Oregon
Arthur B. Cross (1872–1935)
Azo 5

Fraternal organizations like the Benevolent
and Protective Order of Elks were hugely
popular in the early twentieth century and
would often participate in large public
parades. This float was sponsored by Michelin,
whose mascot even then was the animated
stack of tires known as Bibendum, or the
Michelin Man.

91
The Grand Theater, about 1923
Clarkston, Washington
Cyko 5

The people here are possibly the Goodwin
Players, a popular vaudeville and theater act
heralded as "first class entertainment if you
want to forget your troubles," according to
the *La Farge Enterprise* of La Farge, Wisconsin
in 1914. On the back, the group has written:
"Believe me, we sure make 'noise'"

92
Forepaugh and Sells Circus, 1907 or later
Taunton, Massachusetts
Kruxo 7

93
Chinese in Fourth of July Parade, about 1914
Springfield, Massachusetts
Azo 5

An influx of Chinese immigrants facilitated the
railroad boom of the mid-nineteenth century,
but as the twentieth century approached,
racism and economic tensions fueled anti-
Chinese sentiments. The Chinese Exclusion
Act of 1882 largely suspended immigration
from China, and mandated that Chinese-
Americans to carry a certificate of identity.
This early-twentieth-century image of Chinese
immigrants participating in an Independence
Day parade captures the resilient yet fraught
status of assimilation in a conflicted notion.

94
Tootin' for Riker, postmarked 1911
Brockton, Massachusetts
Azo 5

In an age of quack medicine sold by traveling
salesmen, safety and reliability was always a
concern. Riker-Jayne, one of the largest drug-
store chains of the era, played on their aura
of solidity in their advertising: "You Are Safe
When You Buy At Riker-Jayne."

95
Foot race, 1909 or later
Azo 5

DEMOCRACY, AT WORK

96
Tire factory, about 1914
Azo 5

97
Rose Lekivetz, telephone operator, 1910
Rushford, Minnesota
George L. Swenson
Kruxo 9

In the days before direct dialing, callers relied
on telephone operators to operate the switch-
boards and relay calls to other subscribers.
At first, many operators were young boys, but
soon women came to dominate the profes-
sion. The role of operator began to disappear
in the 1930s as new technologies enabled
callers to reach one another directly.

98
Post Office, 1911 or later
Betteravia, California
Aston Photo
Kruxo 10

Frank C. Aston (1871–1966) worked in San Luis
Obispo, California, from about 1906 through
the 1940s. Originally from Ohio, he moved
to Bakersfield, California, to assist another
photographer and opened Aston Studio at 957
Montgomery Street, San Luis Obispo, in 1906.

99
Coal Miners, 1910 or later
Scranton, Pennsylvania,
Cyko 5, variation B

100
Man with toolbox, about 1923
Cyko 5, variation C

101
Lineman, about 1918
Possibly Aberdeen, South Dakota
Noko

102
Baker, 1907 or later
Artura 3

103
Brewery worker, about 1914
Azo 5

The beer industry was heavily influenced by
German immigrants. This card, addressed to
a Frank J. Rothbauer has an inscription, in
German, that reads "From your brother: Carl."

104
Tobacco workers, 1917 or later
Branson, Missouri
Azo 6

105
A Nice Man, about 1914
Azo 5

This punning card (A Nice Man = An Ice Man),
celebrated the ice trade, an essential service
before electric refrigeration. In winter, natural
ice was cut from ponds and lakes, stored in
underground, sawdust-lined warehouses, and
then distributed in summer to a thirsty nation.

106
Sewing machine salesman, 1910 or later
Cyko 5, variation B

Sewing machines were a booming business in
the late nineteenth and early twentieth centu-
ries, available through mail-order catalogues
but also from door-to-door salesmen.

107
Two bakers, 1908
Kruxo 8

108
Mail carrier, 1917 or later
Azo 6

109
Ora Anderson, Horseshoer, about 1914
Billings, Montana
Azo 5

Ora Anderson (1850–1931) was a farrier based
in Billings, Missouri. He appears on a number
of postcards, usually posed as if hard at work.

110
Harness shop, about 1914
Azo 5

111
Dragging the Corn Ground Before Planting,
about 1914
C. Henry
Azo 5

112
Railcar for Russell and Henderson poultry
farmers, 1909 or later
Kruxo 9

113
Apple farmers, 1907 or later
Kruxo 7

114
J. C. Warner and Friends with Striped Bass,
1908
Stockton, California
Azo 4

115
Deer hunters, 1907 or later
Azo 4

116
Butcher, about 1914
Azo 5

117
Butchers, about 1914
Azo 5

118
Baker, about 1914
Near Nelson, Nebraska (?)
Azo 5

The sack of Jensen and Sons Mills flour
suggests that this bakery was possibly located
near Nelson, Nebraska, where that mill was
established in 1904.

119
House painters, about 1914
Azo 5

120
Surveyors, postmarked 1906
Possibly Potsdam, New York
Cyko 4 (?)

121
Rug shop, about 1914
Longview, Texas
Azo 5

122
Mrs. B. C. Kenney and friend, 1926 or later
Azo 8

123
Accountants, about 1914
Azo 5

124
Office workers, Texas & Pacific Railway, 1911
Possibly Marshall, Texas
Azo 5

The postmark from Marshall, Texas, and
the Texas & Pacific Railway map on the wall
suggest that this is an office for the Texas &
Pacific Railway, which ran from Marshall to
Sierra Blanca. The card is addressed to Ms.
J. H. Wilson, of Columbus, Ohio, and reads:
"Dear Bro & Sis & Dorothy & Baby . . . Have you
ever seen this fellow before to the right in this
picture . . . Bro L. M. W."

125
Bottlers, about 1914
Azo 5

126
American Olive Oil factory workers, 1907
or later
Los Angeles, California
Azo 4

127
Shoemakers, 1908
Azo 4

128
Typewriter factory, 1911 or later
Possibly Chicago, Illinois
Medlan
Artura 5

129
An Assembly Line of the Ford Motor Company,
mid-1920s
Dearborn, Michigan
The Garraway Company, Rutherford,
New Jersey

130
Auto parade to Eugene, Oregon, 1910
McMinville, Oregon
Azo 5

Automobile parades epitomized the popularity of the motor car in the early twentieth century. They were held all over the country, beginning as early as 1899, when the Automobile Club of America organized one in New York City, immortalized in a Thomas Edison film. The parade represented on this card was quite long — nearly ninety miles on poor roads.

131
Trolley conductors, about 1914
Omaha, Nebraska
Eagle Post Card House; Judson David Barratt
(about 1870–1952), Proprietor
Azo 5

132
Linemen, about 1914
Murray, Iowa
Azo 5

133
Building a tank, about 1914
Azo 5

134
Laying railroad track, about 1914
Azo 5

135
Framing a building, 1907 or later
Kruxo 7

136
Railway workers, about 1923
Possibly Poplar Bluff, Missouri
Cyko 5, variation C

This card appears to show the Union Pacific railway bridge over the Black River, in Poplar Bluff, Missouri. The bridge was constructed by the American Bridge Company in 1903.

137
Steel workers, about 1914
Azo 5

138
Building a railway trestle, 1907 or later
Kruxo 7

139
Coal miners, about 1914
Azo 5

140
Coal miners, 1923 or later
Kruxo 13

141
Lumberjacks, about 1914
Del Norte Company
Azo 5

142
Whatcom County Log., 1926 or later
Star. —
Azo 8

In the early twentieth century, Whatcom County, Washington — on the Canadian border — was a major logging center. Big trees like the one in this card are now mostly gone or protected, and today the region is dominated by raspberry farms.

143
Lumberjacks, 1907 or later

**WHEN YOU LOOK AT THIS,
THINK OF ME**

144
Alma Mae Bradley, 1926 or later
Chester County, Pennsylvania
Azo 8

145
Corn farmer, 1911 or later
Artura 5

146
Butcher and his son, about 1914
Azo 5

147
Men in a studio airplane, after 1906
Portland, Oregon
Cal Calvert
Cyko

148
Paper moon portrait of a girl, 1907 or later
Pittsburg, Kansas
Azo 4

149
Paper moon portrait of a barber, about 1914
Harbaugh Photo
Azo 5

150
Woman in cowgirl outfit, 1907 or later
Chicago, Illinois
Hohhof Studio
Kruxo (?)

151
Four Native American children, 1917 or later
Azo 6

152
Eizabeth "Nellie" Saupitty and child, 1917
or later
Azo 6

153
Accordion player, 1917 or later
Azo 6

154
Woman with phonograph, 1911 or later
Artura 5

155
Saxophone player, 1926 or later
Azo 8

156
First Communion girls, 1917 or later
Azo 6

157
Altar boys, about 1914
Azo 5

158
Artoria Tattooed by C. W. Gibbons, 1925 or later
Los Angeles, California
Empire
Azo 7

Artoria Gibbons was one of the best-known tattooed women of the period, and performed in numerous circus sideshows, including those of Barnum and Bailey and the Ringling Brothers. Artoria's husband, Red Gibbons, tattooed over 80 percent of her body, and her circus appearances brought fame to them both. She was born Anna Mae Burlington in 1893 to Norwegian immigrants in Linwood, Wisconsin, but went by the stage name Mrs. C. W. Gibbons. This photograph captures Red's version of Leonardo da Vinci's *Last Supper*, one of many Renaissance paintings he tattooed on his wife. Empire Studio was located at 427 Main Street in Los Angeles, California, near several tattoo shops owned and operated by Red.

159
Boxer, 1912
Cyko 5

160
Warren, age 10, 1917 or later
Azo 6

161
Ice skater, 1917 or later
Azo 6

162
Wrestlers, about 1914
Morgantown, West Virginia
T. A. Morgan
Azo 5

163
Y.M.C.A. Basketball champion, 1920
Toledo, Ohio
J. Nash Livingston
Azo 6

164
Earl de Vault, 1917 or later
Azo 6

165
Roller skater, about 1914
Frankfort, Michigan
Azo 5

166
Mr. and Mrs. Wong Sun Yue Clemens, 1909 or later
San Francisco, California
Azo 5

Wong Sun Yue and Ella Mae Clemens ran a teahouse and shop in Chinatown, San Francisco, where they sold "relics dug from the ruins" of the 1906 San Francisco earthquake and postcards of themselves. The couple met while helping Chinese earthquake survivors. Their shop was located at 897 Sacramento Street and later at 535 Grant Avenue.

167
Woman with flowers, about 1914
Azo 5

168
Woman in front of an illuminated tower backdrop, or woman in finery, about 1914
Azo 5

169
Woman with a feathered hat, about 1914
Azo 5

170
Men with bottles of Stars and Stripes beer, 1908 or later
Kozy Studio
Lincoln, Nebraska
Cyko 5

Stars and Stripes beer was the subject of a major United States Supreme Court decision in 1907 (Halter vs Nebraska), which decided that a Nebraska law banning the use of the U.S. flag in advertising was constitutional. These men pose with bottles that bear a later version of the beer's label. The Kozy Studio was located at 1034 O. Street, Lincoln, Nebraska. Local newspaper ads indicate the studio had been in operation since at least 1908, and changed its name to W. L. Prewitt in 1922.

171
Four workers, about 1914
Azo 5

These men pose with lunch pails and lanterns of a sort that suggest they work either in mines or on the railroad.

172
Two painters, 1927
Northampton, Pennsylvania
Lenhart Studios
Azo 8

173
Man in a fur coat, postmarked 1910
Artura 5 (?)

Bearing a message in Norwegian, this card, addressed to Ole Flatland, of Canby, Minnesota, is testimony to the large and vibrant Scandinavian community in the upper Midwest.

174
Woman and boy, 1917 or later
Azo 6

175
Paper moon portrait of Elise Welch, 1917
Cleveland, Ohio
William Pinch
Azo 5

176
Paper moon portrait of two girls, 1941 or later
Kodak 1

177
Paper moon portrait of a lineman, about 1914
Azo 5

178
Paper moon portrait of a young woman, 1911
or later
Artura 5

179
Girl in nurse costume and boy in sailor suit,
1917 or later
Azo 6

180
Boy in a suit, about 1914
Azo 5

181
Five-year-old boy in cowboy costume, 1916
Altoona, Pennsylvania
Azo

182
Boy in Native American costume, about 1914
Azo 5

183
Woman in cowgirl outfit, 1907 or later
Velox 12

184
Comanche Indians, 1909 or later
Lawton, Oklahoma
Bates Studio
Kruxo 9

Edward Bates (1858–1941), whose studio was
at 423–425 D Avenue in Lawton, Oklahoma,
was best known for images of Native Ameri-
cans. Lawton is the center of the present-day
Comanche Nation, and is also very close to
Fort Sill, where many Native Americans were
held as political prisoners during the late
nineteenth century.

BETWEEN PUBLIC AND PRIVATE

185
Four women with postcard album, 1908 or
later

186
Women sledding, about 1914
New Hampshire
Azo 5 or Solio 2 (?)

187
Holmes, lion tamer, 1915
Azo 5

188
Telephone operators, 1907 or later
SXPC

Telephone companies preferred women
operators, known as "hello girls," because
they were considered more polite. Though
pioneers in the labor force, these women
were subjected to strict rules governing their
behavior.

189
Teacher in the classroom, about 1914
Azo 5

190
Woman with children, 1911 or later
Kingston, North Carolina
Goble's Art Studio
Artura 5

191
Votes for women, 1907 or later
Kruxo 7

This studio portrait of suffragists was likely
taken before the 19th Amendment was rati-
fied on August 26, 1920. The two smartly
dressed, middle- or upper-middle-class white
women are indicative of the movement's core
demographic.

192
Railroad worker, 1911 or later
Portland, Oregon
Rose Studio
Artura 5

Beginning in the 1890s it was not unusual to
find women working as railroad telegraphers
and station or ticket agents. Rose Studio was
located at 270 ½ Washington Street, Portland,
Oregon in 1908.

193
Luella Bates, first female truck driver, 1917
or later
Azo 6, Kodak

Luella Bates, the first licensed female truck
driver, sits behind the wheel of a Ford four-
wheel-drive Model B. An accomplished driver
and mechanic, Bates toured the country as an
advertisement promoting — however prob-
lematically — a truck so easy to maneuver that
even a woman could do it.

194
Irene Dare, about 1926–27
Azo 8

Ruth Codling performed as the driver "Irene
Dare" in her husband Joe's sideshow act,
"Dobish's Wall of Death." Her acts involved
driving horizontally along cylindrical amphi-
theater walls while the audience watched
from above. Her car changed design in 1928,
possibly dating this photograph to either 1926
or 1927. Codling was replaced by Joe's second
wife, Pearl Dobish, sometime in the 1930s.

195
Telephone operator, 1907 or later
SXPC

196
Mailroom clerks, about 1914
Azo 5

Despite being mainstays of the postal service since the Civil War, women were discriminated against with lower wages and prohibitions against becoming carriers. Instead most worked as clerks in the dead letter office, dealing with undeliverable mail.

197
Hat shop, about 1914
Azo 5

198
Seamstresses, about 1914
Azo 5

199
May Day, Coupeville, Washington, about 1914
Azo 5

May 1, a holiday known as International Workers' Day, is also an ancient celebration marking the beginning of summer; maypoles derive from medieval celebrations and became popular at U.S. colleges at the end of the nineteenth century.

200
Arbor Day, postmarked 1911
Pennsylvania
Oakes Foto
Azo 5

Arbor Day, begun in Nebraska by J. Sterling Morton on April 10, 1872, with the planting of one million trees, was observed in schools throughout the 1880s. Today, it is usually celebrated on the last Friday in April.

201
Mary Brockman, about 1914
York, Pennsylvania
Simon & Murnane
Azo 5

Simon and Murname, a York, Pennsylvania, photography studio located at 227 W. Market Street, specialized in "photos taken at night." The sitter is most likely Mary H. Brockman, who was born in York on April 24 1880, and lived with her husband, Frank C. Brockman, on North Duke Street.

202
Seven women, 1907 or later
Azo 4

203
Woman with dog, about 1923
Lakefield, Michigan
J. A. Bellinger
Cyko 5

204
Three young women, about 1914
Azo 5

205
Woman in a hat, about 1914
Azo 5

Hats were big business — enormous in size and adorned with a superabundance of fabric and flourish — before the outbreak of WWI. Real photo postcards captured both the women who worked in the industry and their proud customers during the height of flamboyant hat craze of the 1910s.

206
A group of women, postmarked 1910
Caldwell, Ohio

Alice, one of the women in this picture, likely a group portrait of co-workers, sent this postcard to her niece, Grace Weatherby, in West Mansfield, Ohio.

207
Woman in costume, 1917 or later
Azo 6

208
Prostitute, 1917 or later
Azo 6

The bared breast and cigar suggest that the figure in this card is a sex worker.

209
Woman in costume, about 1914
San Antonio, Texas
A. Lewison
Azo 5

210
Women's baseball team, 1911 or later
Artura 5

Starting as early as 1866 with a team at Vassar College, women's baseball saw public blowback in the late 1870s, and, as a result, many programs shut down. Nonetheless, by the 1890s "Bloomer Girls," as they were called for the puffy pants they played in, forged their way into professionalized teams like the one pictured here.

211
Women's high school basketball team, 1915 or later
Cyko 6

This photograph was taken when women's basketball was still a relatively new sport. The first woman to play was Senda Berenson at Smith College in 1893; its popularity grew rapidly on college campuses soon after.

212
Tennis player, 1915 or later
Cyko 6

213
Tennis player, about 1908
Harrisburg, Pennsylvania
J. F. Fasnacht
Noko

214
Women's camp, about 1914
Chautauqua, New York
Azo 5

In 1874 the Methodist bishop John Vincent started an annual meeting in Chautauqua County, New York, that soon evolved into the Chautauqua Movement, an educational and spiritual program with branches all over

the country. Part religious community, part community center, and part multi-disciplinary school, the Gladstone Chautauqua was the most successful expression of Vincent's program, offering a social and spiritual outlet for the surrounding community until its closure in 1928.

215
Lula Steele, religious worker, about 1914
Eureka, California
Hess
Azo 5

216
Mrs. A. I. Matteson, Salvation Army worker, about 1914
Azo 5

The Salvation Army was established in the UK in 1865 as a religious charitable organization patterned after the military. This sitter holds the *War Cry*, the organization's newspaper.

217
The Way Scott City, Kansas People Enforce the Liquor Law, 1910
Azo 5

These Women's Christian Temperance Union members in Scott City, Kansas, pour out the stash of a local bootlegger in early March 1910. The town was founded as a temperance community in 1885 by Chicago native Maria DeGeer.

218
A Prize Winner at Fair, 1911 or later
Oneonta, New York
Kruxo 10

Founded in Cleveland, Ohio, in November 1874, the Women's Christian Temperance Union advocated prison reform, suffrage, labor protections, and, as seen on this parade float, prohibition.

219
Women's Christian Temperance Union tent, Honeoye Valley Temperance Assembly, likely 1910
Shinglehouse, Pennsylvania
Azo 5

An Inscription on the back of this card notes that "Mama Ellen H. Clark is Center 4th from left. Mrs. Walter T. Palmer is last on right."

220
Members of the Just Government League of Maryland, 1914
Oakland, Maryland
T. W. Stewart
Noko

Established in 1909, following a defeat of the suffrage amendment in the Maryland General Assembly, and headed by Edith Houghton Hooker, the Just Government League was the largest women's rights organization in Maryland. By 1919 membership totaled 17,000, and literature was distributed to approximately 114,000 people in 1913 alone.

221
Suffragists, about 1912
Azo 5

The sign above these women reads Governor's Headquarters, suggesting they are organized to support a candidate. The women may be affiliated with the Alpha Suffrage Club, founded by Ida B. Wells in Chicago in 1913 (the year women were granted the right to vote in Illinois). Wells's husband, Ferdinand Lee Barnett, had been appointed by Charles S. Deneen as Illinois's first Black assistant state's attorney. Deneen served as Illinois governor from 1905–1913, but was not re-elected in 1912, the campaign possibly pictured here.

THE NEWS

222
Rialto Block fire, 1911
Montpelier, Vermont
Kruxo 7

223
Labor Day, 1923
Milo, Maine
Azo 6

Labor Day in 1923 saw a series of daytime parades of the Ku Klux Klan, which was very active in Maine starting in the early 1920s. Charismatic leader Eugene Farnsworth capitalized on anti-immigrant and anti-Catholic sentiments in Maine, and built a robust following that peaked around 1925, when the Klan had more than 150 members in the state. The Maine Klan largely faded by the early 1930s.

224
Searching for the Dead in Ruins at Parkersburg, 1909
Cyko 5, variation A

This card shows the aftermath of the March 19, 1909, flood in Parkersburg, West Virginia. A two-million-gallon hilltop water tank burst in the early morning of March 19; shrapnel from the tank pierced a second tank, sending a deadly cascade of water through the town.

225
Theodore Roosevelt campaigning, 1912
Sandusky, Ohio
Azo 5

This card shows Roosevelt campaigning in Sandusky, Ohio, on May 15, 1912. A similar photo appeared in the May 16 issue of the *Cleveland Plain Dealer*.

226
Theodore Roosevelt, 1912
Barre, Vermont
Jedd Beckley
Azo 5

Roosevelt campaigned in Barre, Vermont, on August 31, 1912. Though Roosevelt won more of the popular vote than his Republican rival, incumbent William Howard Taft, both lost the election to Democrat Woodrow Wilson. This photograph was taken two days after Roosevelt's Bennington appearance, in card 234.

227

Birger and His Gang, copyrighted 1927
Alvis Michael Mitchell, Harrisburg, Pennsylvania
Azo 8

228

The Strike Is On, 1910
Columbus, Ohio
Meyers Photo Co.
Azo 5

The 1910 Columbus Streetcar Strike was one of the most dramatic uprisings in Ohio history. Facing sixty- to sixty-five-hour work weeks, no vacation time, and wages of just nineteen to twenty cents per hour, workers went on strike beginning July 24. The strike was violent from the beginning, with strikers bombing and throwing acid into cars operated by strikebreakers, who were paid thirty dollars a week, more than double the usual rate. The five hundred and seventy striking workers suspended the strike in defeat on October 18, with many leaving town for employment elsewhere.

229

Police officers hosing labor unionists, 1912
San Diego, California
Azo 5

Though this card is not labeled, nearly identical images suggest that this shows an incident during the San Diego Free Speech Fight of 1912, when the city government tried to outlaw socialist soapbox speakers in a certain neighborhood. The hope was to curb the influence of the International Workers of the World, known as the "Wobblies." Major clashes ensued between the Wobblies, police, and vigilantes.

230

Show Me a Scab!, probably 1910
Probably Seattle, Washington
Azo 5

This card likely shows the Seattle Labor Day parade of 1910. *The Seattle Daily Times* noted that the hit of that year's parade was a goat with a large sign that read "Show me a scab." The goat led the machinists' delegation.

231

Furnishing Coffee to Strikers, 1910
Columbus, Ohio
Meyers Photo Co.
Azo 5

232

William Howard Taft speaking at the Ohio Northern University Commencement, 1910
Ada, Ohio
Azo 5 (?)

President Taft's speech at Ohio Northern University's fortieth annual commencement drew a crowd of eight thousand. In addition to life and career advice, Taft also denounced "muck raking" journalism, suggesting that this "unjust" phase of news was to pass. Future president Warren G. Harding received an honorary degree at the same commencement.

233

Theodore Roosevelt, probably 1910
Freeport, Illinois
Smith Studio
Azo 5

In 1910, Roosevelt undertook a transcontinental trip that passed through Illinois, stopping in Freeport, Belvedere, and Chicago. The events in Freeport were planned for September 8th, 1910.

234

Colonel Roosevelt, 1912
Bennington, Vermont
Cyko

235

Rock Island Line wreck, 1910
Near Clayton, Kansas
A. K. Mills
Azo 5

This card shows a washout wreck that occurred on the Rock Island Line near Clayton, Kansas, on September 23, 1910, killing at least sixteen people. A flash storm swept away a steel bridge over a normally dry creek bed, and the train plunged into the gap at full speed. The accident occurred at about 2 a.m. between the towns of Clayton and Dellvale.

A. K. Mills ran the Mills Photo Gallery in Almena, Kansas, where he also sold pianos. Mills gave up the photo studio in 1907, but continued to place ads for photos for hire in subsequent years, as evidenced by this card.

236

Boston & Maine train wreck, possibly June 29, 1907
Possibly Dover, New Hampshire
Velox 10

237

Wabash Valley Wreck, 1910
Fort Wayne, Indiana
J. B. Pho. Pub. MARKLE
Azo 5 (?)

This card shows the aftermath of a horrific crash between two interurbans on September 21, 1910. Interurbans were streetcars that traveled from one city to another, like a single-car train. Two cars on Bluffton line of the Fort Wayne and Wabash Valley Traction Company collided head on between Fort Wayne and Bluffton. The crash killed forty-one people, thirty-nine on impact, and two more later.

238
End of Vestibule Coach, 1908
Booneville, New York
Henry M. Beach (1863–1943)

On July 4, 1908, a northbound passenger train on the Rome, Watertown, and Ogdensburg Railroad collided head-on with a southbound freight train at Boonesville, New York. The accident caused six deaths and fourteen injuries.

239
Fire rescue, about 1923
Possibly Newark, New Jersey
Cyko 5

240, 241
Tornado at Antler, N.D., 1911
Antler, North Dakota
E. S. Karlen
Azo 5

On August 20, 1911, a tornado razed the town of Antler, North Dakota. This tornado, which appears to have been the strongest of six that came through rural Bottineau County that day, killed four people and injured thirty others.

242
Tornado at Antler, N.D., Aug 20, 1911
Antler, North Dakota
W. H. Wegner
Cyko 5, variation B

Very often, more than one photographer saw opportunity in a news story or natural disaster. E. S. Karlen and W. H. Wegner both documented the August 1911 tornadoes that devasted Antler, North Dakota, capturing different moments in the progress of the funnel cloud.

243
Gipsy [sic] Oil Co. 55,000 bbl. Tank on Fire, 1914
Drumwright, Oklahoma
Azo 5

This card documents the Gypsy Oil Tank Fire that raged in Drumwright, Oklahoma, on August 27, 1914. The massive oil-field fire destroyed tanks owned by the Prairie Oil and Gas Company and the Gypsy Oil Company. The town spurted up from the ground during an oil boom, drawing thousands of workers between 1912 and 1920, but later emptied out during the Great Depression.

244
Burning of Gulf View Hotel, February 28, 1916
Boca Grande, Florida
Azo 5

245
Cleaning up after the flood, 1912
Denver, Colorado
Noko

This card shows the aftermath of the Cherry Creek flood in Denver on July 14, 1912. Though Cherry Creek was an "ordinarily tame and insipid, uninteresting and dirty little stream," according to the *Denver Post*'s coverage, intense rainfall caused it to overflow, killing at least two people, injuring several more, and causing hundreds of thousands of dollars in damage.

246
Scavengers at Work, 1921
Pueblo, Colorado
Azo 6

On June 3, 1921, the Arkansas River overflowed after a dramatic rainstorm, leaving much of downtown Pueblo under ten feet of water. The flood killed hundreds in a 300-square-mile area of the river valley. Here, scavengers remove one of thirty-two horse carcasses from a barn.

247
Twelfth Street and Murdock Avenue, 1913
Parkersburg, West Virginia
Azo 5

248
Boating in Sprague, 1909
Sprague, Washington
Cyko 5, variation A

249
Flood at H. H. Miller's Palace Sample Room, 1911
Galena, Illinois
Azo 5

Galena, Illinois, faced flooding every spring, but the Valentine's Day flood of 1911 was particularly bad. H. H. Miller, the proprietor of the bar in this postcard, used the card as a New Year's greeting the following January: "This is my saloon, the wader was to the floor. behind poast is my self and Berne and the man with white coat is my bartender. good night."

250
Selling Their Relicks of the Flood at Austin, Pa., 1911
Austin, Pennsylvania
Henry M. Beach (1863–1943)

This card shows the aftermath of the Bayless Dam Failure of September 30, 1911, a disaster that resulted in the deaths of seventy-eight people, millions of dollars in damage, and the destruction of much of the town of Austin, Pennsylvania.

Henry Beach was born near Lowville, New York, and was the most active Adirondack-area photographer of this period. A savvy businessman, he issued all of his cards with unique backs that prominently featured his name; in this case "BEACH-SERIES" is set just above the word "POSTCARD."

251
Two women at the Grand Canyon, 1929
Azo 8

252
70-Foot Cut on the New Mindoro Road,
about 1908
West Salem, Wisconsin

The "Mindoro Cut" on highway 108, a passage created in 1908 by an arduous process of hand-cutting, created a shortcut from Mindoro to La Crosse, the nearest big city.

253
Kodak advertisement, 1912 or later
Velox 15

254
Kodak advertisement, 1912 or later
Velox 15

255
Olive Hill, Kentucky, June 10, 1917
C. E. Scarlett
Azo 5

This local photographer adapted his motor vehicle to create a portable darkroom.

256
Shuey's Pretzel Stand, 1927 or later
Azo 8

The Shuey family began selling soft pretzels from this Lebanon, Pennsylvania, roadside stand in 1927. The billboard advertises the Tastykake snack and dessert company, founded by Philip J. Baur and Herbert T. Morris in 1914. Both Philadelphia-area businesses continue to operate today.

257
See Scenic Utah This Year, 1936 or later
Bill Shipler Photos, Salt Lake City, Utah
Azo 8

Bill Shipler was the third of four generations of a prominent Salt Lake City-area family of photographers. His grandfather James Shipler was called the "dean" of Utah photographers.

258
Tourists at Mariposa Grove of Big Trees,
about 1914
Azo 5

259
Tourists at the Wawona Tree, 1908 or later
Noko

This Yosemite Valley tree was named "Wawona" for the Mono Tribe word for a Redwood Sequoia tree. The tunnel, cut out of the tree in 1895, eventually led to its collapse in 1969.

260
Swimmers at Saltair, 1918
Levene
Azo 6

261
Family at Umbrella Rock, 1926 or later
Near Chattanooga, Tennessee
Azo 8

Thousands were photographed at Umbrella Rock (reportedly a record fifty at once) between the mid-nineteenth century and 1939, when erosion and heavy traffic caused the National Park Service to declare the rock unsafe.

262
Badlands near Miles City, Montana, about 1914
Azo 5

The back is inscribed: "Just miles of dirt."

263
Devil's Den on Pennington River, near
Tishomingo, Oklahoma, 1909
Azo 5 (?)

Devil's Den, a southern Oklahoma tourist attraction known for its pink-granite boulders, was reportedly home to outlaws in the nineteenth century, and became a popular recreational site in the early twentieth.

264
Children diving, about 1914
Azo 5

265
Swimmers at Saltair, postmarked 1929

266
Drinking tourists, 1926 or later
Miami, Florida
Azo 8

267
Curio Shop, 1917 or later
Tarpon Springs, Florida
Azo 6

This shop sold natural loofahs, harvested by divers who came from Greece around the turn of the century, providing the engine for the industry that turned Tarpon Springs into the "Sponge Capital of the World."

268
Mount Manitou, possibly 1937
Azo 8

The Mount Manitou Scenic Incline was a one-mile funicular cable tram built in 1907 to ascend Pike's Peak and deliver tourists to Mount Manitou Park at the top.

269
Three tourists, 1917 or later
Azo 6

270
Start for Pike's Peak, 1912
Manitou, Colorado
Paul Goerke & Son
Artura 5

Paul Goerke & Son, a photography studio in Manitou, Colorado, capitalized on the influx of tourists by purchasing the land around Balanced Rock, a popular attraction, offering free admission, but charging for portraits.

271
Women touring Hot Springs, Arkansas, 1926 or later
Too Cute Studio
Azo 8

The name of Too Cute studio in Chickasha, Oklahoma, owned by S. R. Whitten, came from the non-postcard prints they offered, which, at 2 by 3 inches, were about the size of those of other studios but sold at half the price.

272
Tourists photographing, about 1914
Azo 5

This composite image of amateur photographers is inscribed on the back "me in lower right hand."

273
Bathers, 1905 or later (?)
George Bishop, over Bayside Market, Watch Hill, Rhode Island
Defender 2 (?)

274
Marie and Kittie Bebert, Saginaw Mich. to Frisco. Hikers, about 1918
Noko

A fad for long-distance walking developed in the face of rapid industrialization around the turn of the century; many walkers documented stops on their journeys on postcards.

275
Skier, 1926 or later
Azo 8

276
Cuba Fair, 1909
Cuba, New York
H. F. Wilcox
Azo 5

This fair ran from September 7–10, 1909, and drew a crowd of six to seven thousand, who gathered to hear New York Governor Charles Evans Hughes.

277
Big Novelty Exhibition, about 1914
Azo 5

278
Circus, about 1914
Azo 5

Sideshow attractions accompanied the main circus. Here, they include a magic show by Professor Tampa, a Punch and Judy puppet show, a ventriloquist, and what were called "working acts," such as Miss Nora Walking on Swords and The Flying Lady.

279
Man and woman in an automobile, 1918
Azo 6

The poster on the building in the background advertises the movie *The House of Glass*, released in 1918.

280
Men and women in an automobile, 1912 or later
Velox 15

281
Thrasher the Photographer in his Automobile, 1917 or after
Azo 6

282
The Bridge, 1914
Cincinnatus, New York
Herbert A. Myer & Co.
Azo 5

Though he didn't began his photographic career until age 49, Herbert A. Myer (1858–1925) became one of the most prominent Syracuse-area photographers. He operated out of Jordan, New York, starting in 1910 and documented many towns along the Erie Canal.

283
Socony gas station, 1920
Upstate New York
Azo 6

284
Man in front of a Chrysler dealership, 1926 or later
Topeka, Kansas
Harold B. Wolfe
Azo 8

This appears to be an advertisement for one of the earliest Chrysler automobiles, which debuted in 1924.

285
Standard Oil Company gas station, 1917 or later
Azo 6

The Standard Oil Company of New York, founded in 1870 by John D. Rockefeller, controlled 90 percent of United States oil production by 1880. The name of its subsidiary, Socony, may have seemed like another company, but is an acronym its powerful parent, dissolved by the Sherman Antitrust Act of 1890.

286
Train depot and post office, postmarked 1909
Otter Lake, New York
Kruxo 7 (?)

287
Union Station, postmarked 1911
Marysville, Kansas
Azo 5 (?)

288
New Big Four Depot, postmarked 1909
Carey, Ohio
Azo 5

289
Rome City Depot, postmarked 1907
Rome, Indiana
Artisto 3 (?)

290
Campbell's Island Bridge, postmarked 1907
East Moline, Illinois
George Brown
Azo 4 (?)

The bridge seen here was built in 1904 after a streetcar company purchased Campbell's Island — a rock mass and unincorporated community in the middle of the Mississippi River on the Illinois and Iowa border — and turned it into a popular resort. A poster for vaudeville entertainment can be seen on the front of the trolley.

291
Steamboats, 1907 or later
Azo 4

292
S. S. Washington, 1917 or later
Cassville, Wisconsin
Azo 6

293
H. N. Atwood, about 1914
H. F. Dutcher
Nyack, New York
Azo 5

294
Airplane, after 1910
Pittsfield, Massachusetts
W. H. Benedict
Cyko 5

295
Getting Ready for a Flight, postmarked 1910
Fresno, California
Solio 2 (?)

Real photo postcards documented the spectacle of early aviation. In astoundingly flimsy flying machines, pioneering aviators flew record-breaking distances, delivered mail, and dazzled crowds at meets with aerial stunts and distance, altitude, and speed competitions.

SIMPLER TIMES?

296
Playing croquet, about 1914
Azo 5

297
Doris with peaches, W. A. Clark Orchard, 1926 or later
Littlefield, Texas
Azo 8

298
Field day and play picnic, postmarked 1910
Springfield, Vermont
Azo 5

This postcard documents two leisure phenomena, both of which had their origins around 1885: volleyball, created by William G. Morgan in Holyoke, Massachusetts, and the "field day," the first reportedly organized at Vassar College in 1895.

299
July 4, 1913
Azo 5

300
Aunt Dinah's quilting party, postmarked 1912
Rutherford, New Jersey
Azo 5

The women here gathered at 47 Ivy Place, in Rutherford, New Jersey, for a quilting party at "Aunt Dinah's." Anna Ford, the woman standing at right, was the recipient of this memento, mailed on August 12, 1912.

301
Washerwomen, postmarked 1913
Kruxo 10

This card of a seemingly unremarkable workaday scene traveled a long distance. It was mailed from Waltham, Massachusetts, to Gothenburg, Sweden.

302
East Brady Bottling Company float, 1907 or later
Pennsylvania

303
S. W. S. Annual Clambake at Ashokan Dam, 1915
Brown Station, New York
Kruxo 11

304
Seen in Chinatown, 1912 or later
San Jose, California
R. & H. Photo
Velox 15

In addition to the U.S. flag, this child holds the "Five-Colored Flag" of the Republic of China, which represented the union of the country's five major ethnic groups: the Han, the Manchus, the Mongols, the Hui, and the Tibetans. It flew from 1912–28.

305
Ku Klux Klan rally, 1917 or later
Azo 6

306
Ku Klux Klan parade, 1924 or 1925
Kittery, Maine
Azo 6

307
Ku Klux Klan march on Washington, D.C., 1925

308
Ku Klux Klan women marching, 1925
Enfield, Maine
Azo 6

Sparked by rising nativist and white-supremacist sentiment, the 1920s saw a resurgence and attempted rebranding of the Ku Klux Klan. Its August 8, 1925, march down Pennsylvania Avenue in Washington, D.C., attracted a crowd of 30,000 participants and 150,000 onlookers. In addition to targeting African Americans, the Klan attacked immigrants, Catholics, and Jews.

309
Children wearing patriotic garb, 1917 or later
Azo 6

The "Cult of the Flag" began with the outbreak of the Civil War and gained steam during the Spanish-American War in the 1890s.

310
The Children's Playground, about 1914
Possibly New York City
Azo 5

This scene likely shows a tenement in New York City. The Lion Brewery was located on the Upper West Side, and the Piel Brewery in East New York.

311
Y.M.C.A. & Indian Relay Runners, Chautauqua Assembly, about 1914
Gladstone Park, Oregon
Azo 5

The Willamette Valley Chautauqua Association belonged to the nationwide Chautauqua movement, which sponsored annual summer assemblies with lectures, cultural events, and sporting contests, such as the race shown here.

312
Boy wearing patriotic garb, about 1914
Azo 5

313
Man in Uncle Sam costume, postmarked 1908
Patchogue, New York
Chapman Bros., Photographers
Velox 12

Uncle Sam as a symbol for the U.S. was ensured not only by the works of nineteenth-century cartoonists like Thomas Nast and James Montgomery Flagg's "I Want You" recruiting poster during WWI, but also because of everymen like this one, who emulated Sam's long white whiskers and stars-and-stripes suit.

314
Woman wearing patriotic garb, 1910 or later
Cyko 5 variation C

315
Anti-immigrant flag-waver, 1925 or later
Azo 7

This card was made just after the 1924 Johnson-Reed Act severely restricted immigration to the U.S. The act reflected the belief that recent arrivals from Eastern and Southern Europe and Asia had failed to assimilate. The law was reversed only in 1965.

316
Woman in American flag costume with rifle, 1910 or later
Cyko 5

317
Living American flag, Gloversville High School, about 1914
Gloversville, New York
Azo 5

The "Living Flag" or "Human Flag" trend seems to have begun in Baltimore in 1914 and was especially popular in schools.

An Azo 5 stamp box from the reverse of card 137

DETAILS

p. 1: no. 239; pp. 2–3: no. 295; p. 4: no. 167; p. 6: no. 113; p. 12: no. 2; p. 32: no. 36; p. 58: no. 57; p. 100: no. 96; p. 170: no. 185; p. 204: no. 222; p. 230: no. 251; p. 264: no. 297; p. 290: no. 55; p. 310: no. 80; p. 312: nos. 174, 205, 192; front endpaper: no. 17; back endpaper: no. 16

Contributors

Lynda Klich is Assistant Professor, Department of Art & Art History and Macaulay Honors College, Hunter College, CUNY, and curator of the Leonard A. Lauder Postcard Collection.

Leonard A. Lauder, an art collector and philanthropist, is Chairman Emeritus of the Estée Lauder Companies, Inc. and Chairman Emeritus of the Whitney Museum of American Art. He has been collecting postcards for most of his life.

Eric Moskowitz, a longtime journalist working on his first book, is a postcard collector and former staff writer at *The Boston Globe*.

Jeff L. Rosenheim is Joyce Frank Menschel Curator in Charge, Photographs, at The Metropolitan Museum of Art.

Annie Rudd, Ph.D. is Assistant Professor, Department of Communication, Media & Film at the University of Calgary.

Christopher B. Steiner, Ph.D. is the Lucy C. McDannel '22 Professor of Art History & Anthropology, and Director of the Museum Studies Certificate Program at Connecticut College.

Anna Tome is a curatorial and research associate at the Leonard A. Lauder Postcard Collection and an art writer and editor at the *Brooklyn Rail*.

Benjamin Weiss is Leonard A. Lauder Senior Curator of Visual Culture, Department of Prints and Drawings, at the Museum of Fine Arts, Boston.

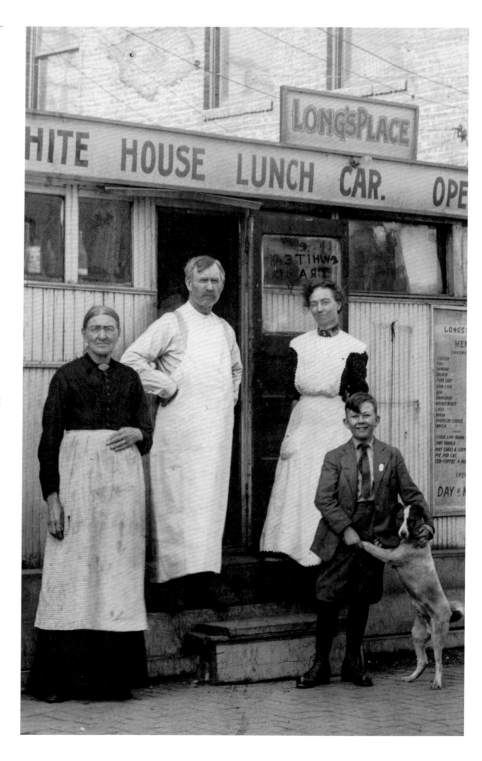

Acknowledgments

Real photo postcards communicate through both the big picture and the smallest detail. Cards speak differently to each person, opening up innumerable perspectives along the way. We are grateful to the many interlocutors whose keen eyes and minds have enriched this book.

Our greatest debt is to Leonard A. Lauder, whose vision of real photo postcards as early manifestations of photojournalism provided key inspiration for our understanding of them as works of art and as testimony to a pivotal moment in history. As always, we thank him for the opportunity to explore this rich and complex collection. The conversations and debates we've had along the way have been enlivened by Judy Glickman Lauder's generous spirit and deep knowledge of photography.

We have been fortunate recipients of wisdom from the book's contributors, who shared many insights gained from their trips down rabbit holes with individual cards in this book and beyond. They collegially shared their time and expertise to produce remarkable and varied essays in what was, by the standards of publishing, the most abbreviated imaginable schedule. Anna Hiroko Tome's painstaking research and cataloguing of these cards propelled and organized us at every stage.

As the book moved into production, Hope Stockton, associate editor for MFA Publications, steered the ship with wit and grace and expertly shaped our texts. Damon Beale photographed every card, front and back, and then circled back to photograph some cards again, just to make the images that much better. And Susan Marsh pulled word and image together in a design that shows, as always, her immaculate sense of rhythm and keen eye for the telling detail.

The book, of course, accompanies the exhibition, which has been in the hands of the always creative team at the Museum of Fine Arts, Boston. Our designers, first Kyla Hygysician and then Keith Crippen, embraced the multidirectional quality of the show. John Carleton and Melissa Krok-Horton carefully set each card in place for display. Interpretive planner Catherine Johnson-Roehr tended our words, and graphic designer Tatiana Klusak gave them elegant form. George Scharoun provided thoughtful and elegant solutions to the show's multimedia features. Mary Nelson led the whole team with great patience and good humor.

In New York, the collegiality of Lauder Collection colleagues smoothed the road in many instances. We thank Emily Braun, Jennifer Franklin, Ema Gualano, Nancy Hernández, Jane Hogan, Anna Jozefacka, Stephanie Kurs, Alice Momm, Dominick Moreo, Michelle Sampaio, Judith Simsovits, Eatira Solomon, Lisa Somar, Margaret Stewart, Nelida Valmoria, Dorian Woodruff, Leah Zimmerman, and Erin Zseller.

The mark of the wonderful community of postcard scholars, dealers, and fellow real photo collectors can be found throughout this book. We extend special gratitude to Robert Bogdan who, in collaboration with Todd Weseloh, "wrote the book" on real photo postcards; we have also learned much from conversations with Bob about the medium in the years following the publication of his book. We have benefitted from others who helped us find some of the wonderful cards in this book over the years, but also from the breadth and depth of the knowledge they bring to this fascinating world. We thank Doug Aikenhead, Steven and Pam Cohen, Natalie Curley, the late Jim Dehne, George Gibbs, Dennis Goreham, Francis Gresse, John Kasmin, Susan Lane, Mary L. Martin, Don and Newly Preziosi, Joe Russell, Jim Taylor, Douglas Wayne, and Joel Wayne.

We are grateful to the MFA for giving postcards a role in the stories told by the museum. The enthusiasm of former Ann and Graham Gund Director Malcolm Rodgers and deputy director Katie Getchell, which brought postcards to the MFA, has thrived under the leadership of Matthew Teitelbaum.

Finally, we thank the many family members and friends who have taken this journey with us.

LYNDA KLICH AND BENJAMIN WEISS

mfa
BOSTON

MFA Publications
Museum of Fine Arts, Boston
465 Huntington Avenue
Boston, Massachusetts 02115
www.mfa.org/publications

Published in conjunction with the exhibition *Real Photo Postcards: Pictures of a Changing Nation*, organized by the Museum of Fine Arts, Boston.

Funds for this publication and accompanying exhibition provided by the American Art Foundation, Leonard A. Lauder, President.

© 2022 by Museum of Fine Arts, Boston

ISBN 978-0-87846-884-3
Library of Congress Control Number: 2021950900

The Museum of Fine Arts, Boston, is a nonprofit institution devoted to the promotion and appreciation of the creative arts. The Museum endeavors to respect the copyrights of all authors and creators in a manner consistent with its nonprofit educational mission. If you feel any material has been included in this publication improperly, please contact the Department of Rights and Licensing at 617 267 9300, or by mail at the above address.

While the objects in this publication necessarily represent only a small portion of the MFA's holdings, the Museum is proud to be a leader within the American museum community in sharing the objects in its collection via its website. Currently, information about approximately 400,000 objects is available to the public worldwide. To learn more about the MFA's collections, including provenance, publication, and exhibition history, kindly visit www.mfa.org/collections.

For a complete listing of MFA publications, please contact the publisher at the above address, or call 617 369 4233.

Illustrations in this book were photographed by the Imaging Studios, Museum of Fine Arts, Boston, except where otherwise noted.

Editing and production by Hope Stockton
Proofread by Jessica Altholz Eber and Diana Sibbald
Designed by Susan Marsh
Typeset by Matt Mayerchak in National, Tungsten, and Rockeby
Principal Photography by Damon Beale
Printed on 135gsm Gardapat Kiara
Printed and bound at Graphicom, Verona, Italy

Distributed by
ARTBOOK | D.A.P.
75 Broad Street, Suite 630
New York, New York 10004
www.artbook.com

FIRST EDITION
Printed and bound in Italy
This book was printed on acid-free paper.

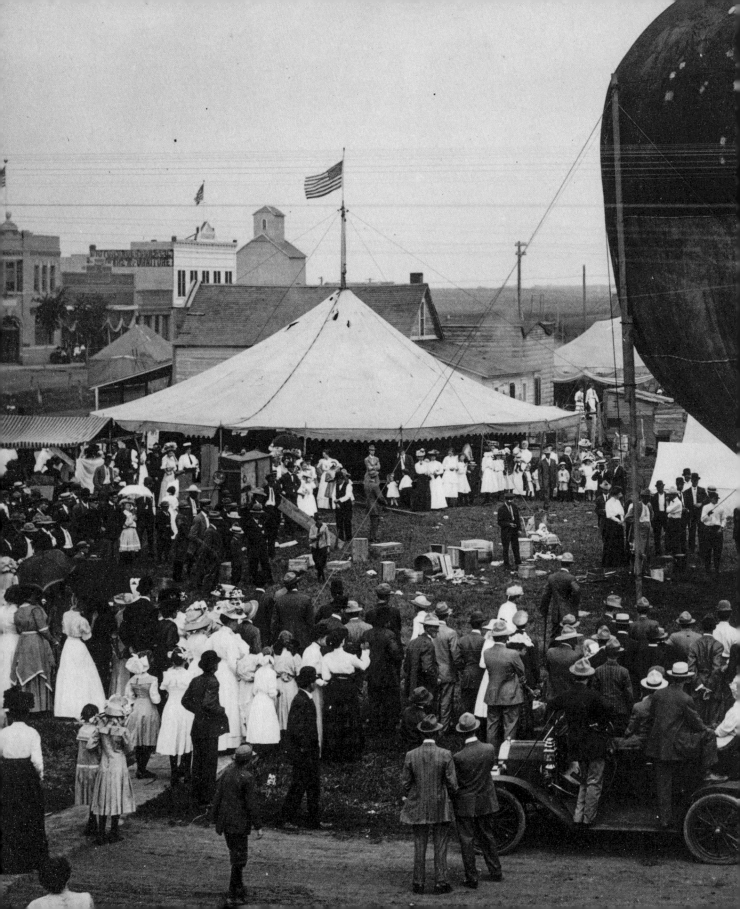